To the memory of the Jews of Czechoslovakia
who died during the Holocaust, and particularly
the curators of the Jewish Museum in Prague,
who perished while struggling to sustain
the precious legacy.

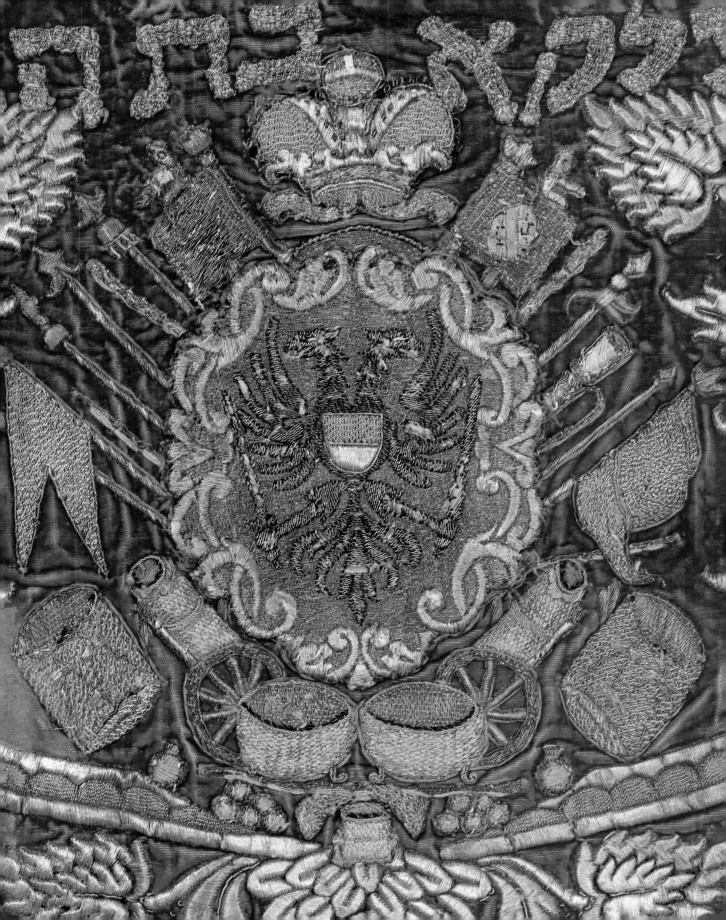

כל את אפך ואת אמך למען יארכון ימיך

כ"ת

לזכרון
בהיכלה
ולכבוד אבותינו אשר בארץ המה
ז"ל
כ' יצחק בן שלמה יהודה וונקלער
ואשת
מ' טארעלכה שלמה גרבים ע"ה
מאת בניהם גרשון יוסף משה יהודה לבן
להורה בער הטובה שעשו עמם
בשנת תר"לו לפ"ק
ברכה מרכו לט' סלה

שמע בני מוסר אביך ואל תטוש תורת אמך

THE PRECIOUS LEGACY

JUDAIC TREASURES FROM THE
CZECHOSLOVAK STATE COLLECTIONS

Edited by
DAVID ALTSHULER

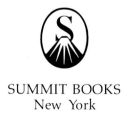

SUMMIT BOOKS
New York

SMITHSONIAN INSTITUTION
TRAVELING EXHIBITION SERVICE
Washington

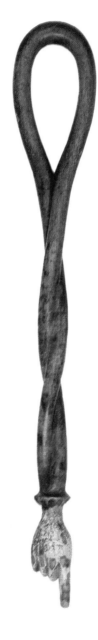

Published by SUMMIT BOOKS
A Division of Simon & Schuster,
Inc.
Simon & Schuster Building
1230 Avenue of the Americas
New York, New York 10020
SUMMIT BOOKS and colophon
are trademarks of Simon &
Schuster, Inc.
Designed by Grafik
Communications, Ltd.
Manufactured in the United States
of America

3 4 5 6 7 8 9 10

Frontispiece
Fig. 1. *Detail of Torah valance,
Austrian Empire, early 19th century
(cat. 15).*

Page 2
Fig. 2. *Detail of Torah curtain,
Salzburg, 1894/5 (cat. 10).*

*Library of Congress Cataloging in
Publication Data*

The Precious Legacy.

 A catalogue for the traveling
museum exhibition of Judaic
objects from the State Jewish
Museum in Prague.
 Includes index.

 Contents: The precious legacy /
Linda A. Altshuler, Anna R.
Cohn—Autonomy and inter-
dependence / Hillel J. Kieval—
Symbols of the legacy: commun-
ity life / Vivian B. Mann—[etc.]
 1. Jews—Czechoslovakia—Ex-
hibitions. 2. Judaism—Liturgical
objects—Exhibitions. 3. Jews—
Czechoslovakia—Addresses, es-
says, lectures. 4. Czechoslo-
vakia—Ethnic relations—Ad-
dresses, essays, lectures. 5. Státní
židovské muzeum (Czechoslo-
vakia)—Catalogs. I. Altshuler,
David A. II. Státní židovské
muzeum (Czechoslovakia)

DS135.C95P73 1983
305.8'924'0437 83-17898
ISBN O-671-49448-1
ISBN O-671-49498-8 (pbk.)

Fig. 3. *Torah pointer, Prague, first
half of 19th century (cat. 69).*

CONTENTS

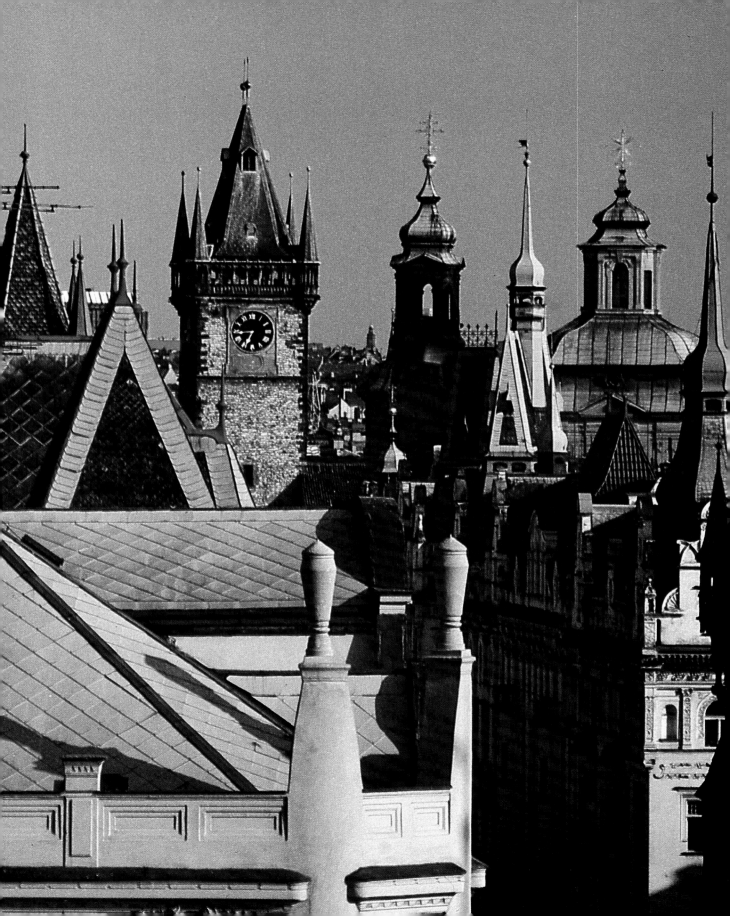

This book presents the work of distinguished scholars from Czechoslovakia and the United States. Their efforts to discover, preserve, and commemorate the past met with invaluable encouragement and support from the governments of their two nations. The Precious Legacy celebrates the beauty and vitality of Czechoslovak Jewish culture, even as it mourns the devastation of Czech Jewry during the Holocaust. This book also bears witness to the enduring power of humanistic learning, which bridges the generations and spans the oceans, giving meaning to today and hope for tomorrow.

From the United States of America:

David Altshuler, Charles E. Smith Professor of Judaic Studies, George Washington University, Washington, D.C.

Linda A. Altshuler, Director, B'nai B'rith Klutznick Museum, Washington, D.C.

Emily D. Bilski, Assistant Curator, The Jewish Museum, New York, New York

Anna R. Cohn, Director of Museum Development, U.S. Holocaust Memorial Council, Washington, D.C.

Hillel J. Kieval, Assistant Professor of History and Fellow of the Tauber Institute, Brandeis University, Waltham, Massachusetts

Vivian B. Mann, Curator of Judaica, The Jewish Museum, New York, New York

Menachem Schmelzer, Librarian, The Jewish Theological Seminary of America, New York, New York

From the Czechoslovak Socialist Republic, the State Jewish Museum, Prague:

Jana Čermáková, Curator of Textiles

Jana Doleželová, Curator of Ethnography and Metalworks

Vlastimila Hamáčková, Head of Archives

Yvetta Michálková, Curatorial Assistant for Textiles

Bedřich Nosek, Head of Collections Department

Arno Pařík, Curator of Paintings and Keeper of Collections

Markéta Petrášová, Curator of the Terezín Collections

Vladimír Sadek, Head of Research Department

Jiřina Šedinová, Chief Librarian

Jarmila Škochová, Head of Holocaust Documentation

Jana Zachová, Assistant Librarian

Fig. 4. *Rooftops of Prague, 1983.*

FOREWORD

The State Jewish Museum in Prague houses one of the largest and most significant collections of Judaica in the world. This treasure of cultural and religious artifacts is representative of the oldest continuous Jewish community in Europe. Included in the collections are objects ranging from manuscripts and printed books to glasswork and porcelain, precious metals and textiles, woodwork and oil painting and the folk arts. Collectively, they illustrate the diversity and dynamism of their creators and the community that both inspired and nurtured them.

These objects testify as well to the tragic and catastrophic dimension of European Jewish life, which culminated in the Holocaust. One hundred fifty-three local Jewish communities were destroyed in Bohemia and Moravia, and little but these cherished possessions remains to testify to the beauty and meaning of their existence. Paradoxically, the Nazis, who confiscated these objects with an intention to build a pathological "research" and propaganda institute in Prague, instead laid the groundwork for a museum collection that for all time will document the inhumanity of their genocidal program.

Today, we who survive must struggle together to build a world that protects and enlightens humankind. It is heartening, then, to note that The Precious Legacy was made possible by the encouragement and assistance of the Government of the Czechoslovak Socialist Republic, which since 1950 has sponsored the State Jewish Museum in its work of preservation, research, and education.

Arrangements for this major international cultural exchange, under the auspices of the Smithsonian Institution Traveling Exhibition Service (SITES), were facilitated by the efforts of the U.S. Information Agency, the American Embassy in Prague, and the Department of State. Generous support for the project was also forthcoming from the private sector. It is a pleasure to acknowledge in particular the continued leadership of Philip Morris Incorporated in promoting major cultural events both in this country and abroad.

This exhibition, together with the publications and educational programs developed to complement it, represents a major outreach effort on the part of SITES to present the story of this "precious legacy" to a large American audience. SITES has, therefore, provided the forum for research by teams of Czech and American scholars, as well as the administrative, educational, and legal support systems critical to the success of an international loan exhibition of this scale and importance.

A final word of appreciation is due Mr. Mark Talisman, who, for fifteen years has held fast to a vision that now, through the fruit of the many labors he began, has become reality. The Precious Legacy celebrates the strength of the human spirit, even as it adjures each of us to safeguard all that inspires our humanity.

S. Dillon Ripley
Secretary, Smithsonian Institution

ACKNOWLEDGMENTS

For fifteen years it has been my dream that millions of Americans someday might have the chance to view and learn from the extraordinary collections of the State Jewish Museum of Czechoslovakia. After years of arduous effort by scores of public and private officials in the Czechoslovak Socialist Republic and the United States of America, the dream has been translated into reality. The Precious Legacy, a landmark exhibition organized by the Smithsonian Institution Traveling Exhibition Service [SITES], will tour the United States for the next two years. It is a distinct honor and personal pleasure for me to acknowledge here the individuals and institutions that helped to sustain The Precious Legacy.

This project began to be conceived in 1968—though at the time we scarcely could have imagined so—when I accompanied then Congressman Charles Vanik, for whom I was working, on a trip to his ancestral home outside Prague. We visited the State Jewish Museum and learned of its unique story. Upon our return to Washington, we began conversations with Czechoslovak Embassy officials as to how I might explore the collections more fully. These conversations extended over more than a decade, until in 1979 Congressman Vanik arranged for me to visit Prague again, accompanied by Professors Michael Meyer and Hillel Kieval, specialists in European Jewish history.

At this point, serious negotiations began, and it was my great fortune to enjoy the support of Sam Golman, a prominent St. Louis businessman. This sensitive and committed man joined forces with me after coming under the spell of Prague during a visit he and his wife made in 1976; he generously provided the means by which the life of the project survived.

Joseph Duffy, then Chairman of the National Endowment for the Humanities, also gave his spiritual support at this early stage of development.

The many preliminary stages of this project culminated in April of 1982, when agreement in principle was reached among the various parties. This agreement came about in large part due to the efforts of the Ministry of Culture of the Czech Socialist Republic, the Federal Ministry of Foreign Affairs of the Czechoslovak Socialist Republic, the National Committee of the Capital of Prague, and the Embassy of the Czechoslovak Socialist Republic. While acknowledging the contributions of each of these highly important agencies, I would like to add personal thanks to several individuals for their close attention to this project: Dr. Rudolf Jakubík and Dr. Dan Dvořák of the Federal Ministry of Foreign Affairs; Dr. Miroslav Stoje, Dr. Luboš Trávníček, and R.N.Dr. Zlatica Kličková of the Ministry of Culture; and Edward Kukan and Jaroslav Kubišta of the Czechoslovak Embassy in Washington.

Congressman Vanik was the first of what turned out to be a very long list of United States Government officials who helped to make The Precious Legacy possible. Congressman Sidney Yates and his wife Addie have helped at many sensitive moments, and Senator Carl Levin responded whenever difficult details had to be resolved. Senators Thomas Eagleton and John Danforth also added their counsel and assistance, as did Representatives Norman Sisisky, Marjorie Holt, William Dickenson, Melvin Price, Steve Chase and Larry Smith. Stuart Thompson and Alan Chase also were extremely helpful.

The role of the United States Embassy in Prague was crucial. Ambassador Francis Meehan offered considerable time, advice, and support during the early years, while Ambassador Jack Matlock gave significant aid more recently and signed the final agreement in the midst of his own shift to important work in Washington for

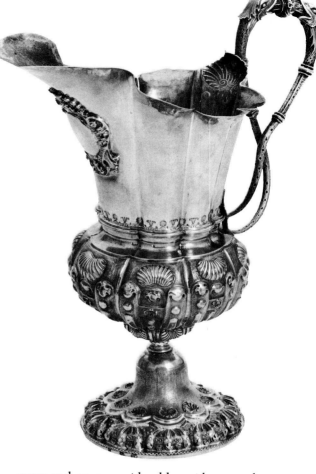

Fig. 5. *Laver,*
Augsburg, 1708/10 (cat. 79).

President Reagan. Martin Wenick, former Deputy Chief of Mission, was the vital and highly professional American connection in Prague as the bi-lateral discussions proceeded. Alice Tetelman, Wenick's wife, also played an integral role by working tirelessly to facilitate communications between the two countries. Byron Morton and Bruce Koch offered assistance beginning in 1979, while more recent efforts to insure the project's success were made by R. William Farrand, James and Pia Connell, William and Pam Kiehl, John H. Brown, and Dan Gamber.

Many officials of the United States Department of State in Washington were particularly helpful. Robert Johnson was an early and avid contributor. Later, during the critical period of negotiations, Ronald Neitzke took on daily responsibilities with sensitivity, skill, and understanding. Recently, Quincy Krosby and Chris Meyers have assisted generously.

Under Charles Wick's leadership, the United States Information Agency was very efficient and constructive in easing the process of negotiations. My colleagues and the staff of the United States Holocaust Memorial Council also gave useful assistance.

The spirit of international cooperation characteristic of The Precious Legacy is nowhere better represented than among the museum officials who have worked on this project. The Smithsonian Institution, led by its Secretary, S. Dillon Ripley, has left its imprint on every dimension of the exhibition. Paul Perrot, Assistant Secretary for Museum Programs, was deeply involved and committed to the effort. Kennedy Schmertz, Director of the Office of International Activities, assisted during many stages of the negotiations. My friend Larry Taylor, Coordinator of Public Information, also gave generously of his time and counsel. And a singular contribution was made by Peggy Loar, Director of SITES, who visited Prague with Mr. Perrot and the curatorial

team and gave considerable guidance and support to all who were associated with the exhibition.

Officials of the State Jewish Museum, led by the new director Otakar Petřík, have been most cooperative and helpful. Dr. Vladimír Sadek, Vice Director and Head of the Research Department, has joined me for the longest period of time over the past fifteen years in seeking success for this project, which truly depends so much upon his life's work. Dr. Bedřich Nosek, Head of the Collections Department, has given graciously and unstintingly of his commitment and learning to assure that the collection he oversees receives the attention and care it deserves.

The Precious Legacy represents an enormous achievement in international cooperation and in cultural creativity. Naturally, to accomplish the successful completion of these goals requires considerable financial assistance as well. Fortunately, an extraordinary response came from Philip Morris Incorporated, long known for its generous support of the arts. Chairman of the

10

Board George Weissman, joined by his wife Mildred, have exhibited incredible sensitivity to this effort. The corporate leadership of Senior Vice President James Bowling and Vice President Frank Saunders also has been most helpful. Director of Communications Paul Gibson has attended to innumerable details. William Ruder has been persuasive and creative, able as always to produce positive results under difficult circumstances. I am pleased to acknowledge the close personal attention of Stephanie French to many aspects of the project, both here and in Prague. Marilynn Donini's help also is very much appreciated.

Since 1979, efforts to secure an international loan exhibition of Judaica from the Czechoslovak State Collections has been organized under the aegis of Project Judaica. Particularly over the past year, many individuals and institutions have contributed financial support to The Precious Legacy; each of them is acknowledged in a separate list that follows. Here I wish to add special thanks to Mrs. Phyllis Tishman, Mrs. Sandra Weiner, and Mr. Arnold Greenberg, each of whom worked personally to develop support for this project. The honorary committee of supporters included Mr. Lester Crown, Mrs. William Rosenwald, and Baron Guy de Rothschild, and the national committee included Mr. and Mrs. Melvin Cohen, Mr. Stuart Eisenstat, Mr. Joseph Finer, Mr. and Mrs. Michael Gelman, Mr. Gil Gertner, Mr. and Mrs. Richard N. Goldman, Mrs. Louis Nathanson, Mr. Charles I. Petschek, and Mr. and Mrs. Myron Stone.

Leaders of the Czech and American Jewish communities have made invaluable efforts to insure the integrity and success of this extraordinary cultural exchange. Dr. Desider Galský, President of the Council of Jewish Religious Communities in the Czech Socialist Republic, has offered superb leadership and utilized every opportunity to open further the doors of cooperation and knowledge in a relationship we confidently know will grow in the future. Secretary General of the Council Artur Radvansky has been equally effective and helpful. Historian Jiří Lauscher and his wife Irma, one of the last teachers of children at Terezín, have provided unique insights and inspiration. Truly, we look forward to a perpetual association with the entire Jewish community of Czechoslovakia, whose affection we reciprocate and from whom we have so much to learn.

On the American scene, Philip Bernstein, Robert Hiller, and Carmi Schwartz, former and current Executive Vice-Presidents of the Council of Jewish Federations, gave unstinting support to this project. Phil Bernstein's special encouragement and deep understanding of every dimension of this endeavor gave strength when it was sorely needed. My colleague Sue Stevens never lost faith and always has been helpful. Finally, it is appropriate to single out for special mention the Society for the History of Czechoslovak Jews, which is dedicated to the preservation of Jewish culture in the Czech lands. My warm personal thanks go to President Lewis Weiner and to Fred Hahn, Professor Emeritus at Columbia University.

This book will provide a lasting record of The Precious Legacy, and it therefore is a pleasure to acknowledge with appreciation the decision of Summit Books to serve as copublishers with SITES. This arrangement was made possible by James Silberman and Arthur H. Samuelson of Summit; they have given generously of their professional expertise and personal concern.

The magnitude and complexity of The Precious Legacy make it impossible for me adequately to thank each of the individuals who have helped bring it to fruition. Each of these generous persons I shall name will forgive me, I hope, for the fact that I must list them without fully detailing the nature and significance of

their role in this project.

From SITES: Mary Jane Clark, Antonio Diez, Joan Fram, Janet Freund, Vera Hyatt, Marie-Claire Jean, Irene Owsley, Eileen Rose, Marjorie Share, Mary Sheridan, Ann E. Singer, and Fred Williams.

From the Ministry of Culture: Dr. Jiřina Foloejová, Mr. Frankišek Vintr, and Mrs. Dagmar Vodičková.

From Výstavnictví: Mrs. Alena Skybová.

From Art Centrum: Dr. Ivo Digrin, Dr. Jaroslav Jauris, and Mr. Joseph Šíma.

From Studio Blumenfeld: Mr. Michael Baumbruck and the late Mr. Pavel Blumenfeld, whom we miss very much.

From the United States Air Force: The 435th Aerial Space Port Squadron, the 3rd and 30th Military Airlift Squadron, and the 438th Military Airlift Wing.

From the Council of Jewish Federations Washington Action Office: Henrietta Berger, Melinda Bernstein, Ralph Grunewald, Fany Kuznets, Alix Meyerson, Paula McMartin, Margaret Longo, and Ellen Witman.

From the U.S. Holocaust Memorial Council: Helen Chittick.

And my friends and coworkers: Liz Bader, Gordon Kerr, Joseph Kinneary, David Lissy, William Lowery, Arnošt Lustig, Sondra Myers, Eleanor Sreb, Mark Ugoretz, and Joseph Zengerle.

Following the Jewish adage, I have saved the dearest individuals for last. Each of them is acknowledged elsewhere in this volume; each made a unique and lasting contribution to The Precious Legacy.

Anna Cohn served as Project Director, an awesome task and responsibility that she executed with unlimited dedication, intelligence, and perseverance. Every facet of this project came under her supervision, and the efforts of all who participated were made stronger by her guidance.

Mary Beth Byrne worked tirelessly at Anna's right hand; her spirit and affection somehow has bound us all together.

David Altshuler's Judaic scholarship and editorial skill are clearly in evidence both in this volume and in the exhibition.

Linda Altshuler's expertise in Judaica and museum education means that students of all ages will know and understand.

Emily Bilski brought insight and diligence to her curatorial labors, particularly through her specialized field of 19th–century European art.

Katherine Chambers assisted with the myriad details of preparing this book.

Eileen Harakal coordinated media relations for The Precious Legacy. The strong and positive public response to the exhibition is a tribute to her efforts.

Hillel Kieval introduced all of us to the currents and issues of Czech Jewish history, a world he knows intimately and deeply.

Vivian Mann marshalled the abilities that give her an international reputation as a Judaica curator, and in this project she has reached new heights.

Andrea Stevens supervised the production of this book, and her commitment and professional skills touched many other aspects of this project as well.

Judy Kirpich's creativity and understanding made this book a jewel.

Chris White designed the exhibition of The Precious Legacy with extraordinary talent, untiring devotion, and a loving heart.

Mark Gulezian, Alex Jamison, and Edward Owen ingeniously captured and interpreted through their camera lenses the beauty and meaning of Jewish Prague.

My dear friends from the State Jewish Museum, each a scholar and a teacher, have made all of us richer by their knowledge and the grace with which they share it. We all thank Jana Čermáková, Jana Doleželová, Arno Pařík, Vlasimila Hamáčková, Yvetta Michálková, Markéta Petrášová, Jiřina Šedinová, Jarmila Škochová, Martin Stein and Jana Zachová.

Finally, I express my deepest respect and gratitude to my wife and partner, Jill. This effort could not have been concluded successfully without her support and guidance. Through unexpected illness and sometimes grave discouragement, Jill made me perservere.

The greatest and most enduring tribute, will, we hope, be paid for eternity to those who lived in the millenium of Czech Jewish life described in this volume, and more poignantly to the hundreds of thousands of Czech Jews who died during the Holocaust. The Precious Legacy exhibition and this book are meant to record, now and for generations to come, the artistry, learning, and reverence of a society that in our own generation suffered nearly total destruction. This record stands for people of every age and background to know and understand. It challenges each of us to guard what the past has bequeathed us in hopes of investing these riches to the betterment of our future.

Mark E. Talisman
Chairman, Project Judaica
Vice-Chairman, United States Holocaust
Memorial Council

Fig. 7. *Torah binder,*
Bohemia, 1734 (cat. 33).

"L'Chaim!" That ageless Hebrew toast—"To Life!"—comes from a people who have survived for 3500 years and more. In the works of art and artifact in this exhibition, the irrepressible life force that has sustained a people bursts forth, a tribute to the indomitable human spirit.

Philip Morris has a long commitment to strengthening, enriching, and celebrating life through the arts. We are deeply honored to be the exhibition's sponsor. Our support reaffirms our conviction that the precious legacy of life vested in Holocaust survivors belongs to all people, everywhere, for all time.

George Weissman
Chairman and Chief Executive Officer
Philip Morris Incorporated

NATIONAL CORPORATE SPONSOR
Philip Morris Incorporated

PRINCIPAL PATRON
Arnold C. Greenberg

PATRONS
ARCO Foundation
Warner Communications

BENEFACTORS
Weiler Arnow Family
The Samuel Bronfman Foundation
The Crown Family
The Horace W. Goldsmith
 Foundation
The Isadore & Bertha Gudelsky
 Family Foundation
Mrs. Walter A. Haas
The Lauder Foundation
Mr. Richard Levy

The Regis Foundation (Myron
 Kunin)
Mr. & Mrs. Robert Russell
Phyllis & Robert Tishman
United Jewish Endowment Fund of
 UJA Federation of Greater
 Washington, D.C.
Sandra & Leon Weiner

Fig. 8. *Ring, Moravia,*
19th century (cat. 220).

DONORS
Samuel I. Adler Family
Best Foundation
Melvin Cohen
Federation of Jewish Philanthropies
 of New York
Foundation of Jewish Philanthropies
 of the Greater Miami Jewish
 Federation
Susan & Michael Gelman

Gilbert Gertner
Mr. & Mrs. Richard N. Goldman
Alan C. Greenberg
Mr. & Mrs. Sam Kane
Kekst & Company, Incorporated
Jack Nash
Mr. & Mrs. Charles I. Petschek
Victor Posner
The RGK Foundation
Rite Aid Corporation
United Jewish Appeal of Greater
 New York
Mrs. Bernard Weinberg
Mr. & Mrs. Louis I. Zorensky (in
 tribute to Sam & Louise Golman)

Fig. 9. *Sabbath and festival ring,*
Poland (?), 18th century (cat. 120).

CONTRIBUTORS
Mr. & Mrs. Harold Abroms
Anheuser-Busch Companies,
 Incorporated
Ivan Boesky
Mr. & Mrs. Jacobo Furman
Congressman Bill Green
Mr. & Mrs. Peter Haas
Jesselson Foundation
Jewish Community Foundation,
 United Jewish Federation
 MetroWest New Jersey
Mr. & Mrs. Abe Katz
Mrs. David Klau
H. Irwin and Jeanne Levy
Mrs. Louis Nathanson
Albert Nerken
Mrs. Madeleine H. Russell
Abraham & Edita Spiegel
Jerry & Lynne Speyer
Mr. & Mrs. Myron Stone
Mr. and Mrs. Laurence A. Tisch
Mr. Sherwood Weiser
Mr. & Mrs. George Weissman

ASSOCIATES
Theodore & Mina Bargman
 Foundation
Nancy Beren
Diane and Norman Bernstein
Blum-Kovler Foundation
Mr. and Mrs. Herschel Blumberg
Jewish Federation of Cincinnati &
 Vicinity Endowment Fund
Continental Services Corporation
Marlyn and Alyn Essman
Mrs. Joseph Finer
Philip William Fisher
Joan & Alan Gerson
The Gimprich Family Foundation
Aaron and Cecile Goldman
Richard W. Goldman
Mr. and Mrs. Clifford H. Goldsmith
Homer & Martha Gudelsky
 Foundation

Mr. & Mrs. Joseph Gurwin
Mr. & Mrs. Leon Hess
Roberta and Marvin Holland
Stanley Imerman Memorial
 Foundation
Dr. & Mrs. Joseph Jacobson
Mr. Ezra Katz
Mr. & Mrs. Herbert Katz
Mr. George Klein
Mr. & Mrs. Donald Lefton
Mr. & Mrs. Morris Levinson
Sam & Anna Lopin
William J. Lowenberg
Dr. and Mrs. E. Ralph Lupin
Philip & Phyllis Margolius
William & Helen Mazer
Betty and Norton Melaver
Minneapolis Federation for Jewish
 Services Endowment Fund
Mr. & Mrs. Howard Polinger
Esther Leah Ritz Philanthropic Fund
Mr. & Mrs. Charles Primus
Mrs. William Rosenwald
Leo Rosner Foundation (in memory
 of Leo Rosner)
Mr. William Ruder
S. H. & Helen R. Scheuer Family
 Foundation
Ms. Selma Shavitz
Jane F. Sherman
Mr. & Mrs. Irving Schneider
Mr. & Mrs. Larry Silverstein
Herbert M. Singer Philanthropic
 Fund
Sigmund Strochlitz
Mrs. Peggy Tishman
Carl R. Tuvin
Harold M. & Anna M. Weinberg
 Family Foundation
Peter Weisz
Harriet M. Zimmerman
The Zwerdling Foundation

FRIENDS
Dr. & Mrs. Larry Averbuch
Dr. & Mrs. Richard Bader
Mrs. Henrietta Berger
Leonard Block
Marshall Brachman
Jeffrey Breslow
George & Phyllis Cohen
Victor & Ellen Cohn
Joyce Arnoff Cohen
Mr. & Mrs. Harry J. S. Dworkin
Mrs. Allan Emil
Mrs. Susan Feer
Mr. & Mrs. Paul S. Fenton
Mr. & Mrs. Jack Freedman
Fred P. Goldhirsch
Mrs. Janet J. Hampton
Fredrick Jaffe
Simon Konover
Congressman William Lehman &
 Mrs. Lehman
Miles Lerman
Suzanne S. Levatin
David & Marjorie Lissy
Mr. & Mrs. Edward Low
Steven A. Ludsin
Barbara & Morton L. Mandel
Florence & Joseph C. Mandel
Lilyan & Jack N. Mandel
Mrs. Robert Mayer
Mrs. Melvin Moore
Sondra Myers
Gerald & Lynn Ostrow
Mr. & Mrs. Mortimer Propp
Rose Associates
Mr. & Mrs. Ricardo Rosenberg
Norman & Dulcie Rosenfeld
Salem Management Company
Gary N. Schahet
Mr. & Mrs. Ivan Schick
Steven Schwarz
Mr. & Mrs. Sander Shapiro
Elliot Stein
Susan Tomchin
Julius Trump
Mr. & Mrs. Mark Weinstein

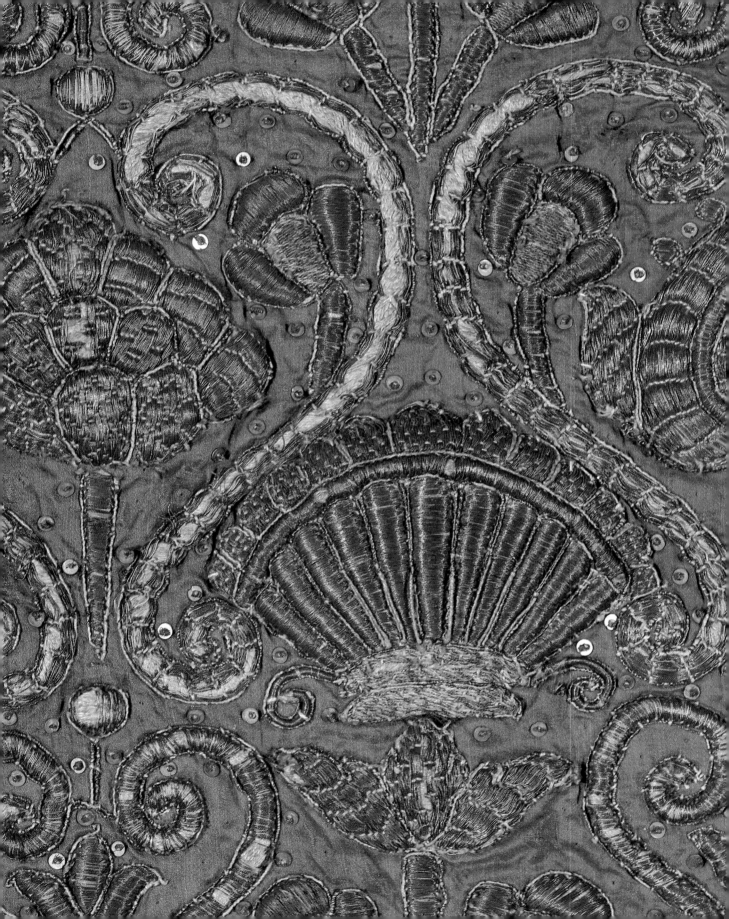

THE PRECIOUS LEGACY

Linda A. Altshuler
Anna R. Cohn

Museum collections enlighten and inspire. They carry the imagination into other times and distant places, recreating the sundry passions of eccentric collectors and the artist's talent for infusing with beauty the substance of everyday life.[1] For even the casual visitor, the collections of Prague's State Jewish Museum reveal just such imagery and insights. The eye delights in richly woven textiles of silk, brocade, and velvet, finely wrought objects of silver and gold, stately portraits, and delicately etched glass. The mind, too, is engaged, curious to rediscover the world that issued forth these objects of creativity and splendor.

The Judaic treasures of the Czechoslovak State Collections stand as symbols of the precious legacy bequeathed by European Jewry. For more than a thousand years their community flourished in Bohemia and Moravia, with the extraordinary city of Prague serving as its political, economic, cultural, and religious center (fig. 14).

Here, at the crossroads of Eastern and Western Europe, was a world deeply rooted in the distant past yet ever-resounding with the spirit of renaissance.

Even from the recent annals of this community, its impact on Jewish and general history is apparent. Gustav Mahler was born in Bohemia, Sigmund Freud was a native of Moravia, Franz Kafka spent nearly his entire life in Prague, and Albert Einstein conceived and published the principles of his theory of relativity while serving as a professor at the University of Prague. Contemporary Jewish thought was enriched by Leopold Zunz, leader of the *Wissenschaft des Judentums* school, Zechariah Frankel, spiritual forebear of conservative Judaism, Solomon Judah Rapoport, a central figure of the *Haskalah* ("Enlightenment") movement, and philosopher Martin Buber, each of whom lived or taught for a time in Prague. Among Jewish immigrants to America were Isaac Mayer Wise of Bohemia—the founding father of American Reform Judaism—and the Prague-born parents of Louis D. Brandeis. These individuals gained prominence

Fig. 10. *Detail of Torah curtain, Prague, 1685/6 (cat. 3).*

Fig. 11. *Early photograph of Louis Brandeis (1856–1941).*

Fig. 12. *Louis Brandeis' parents, born in Prague.*

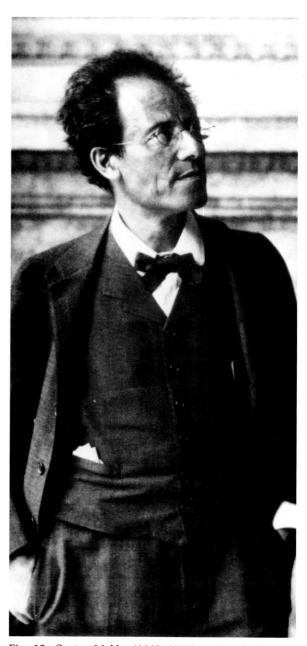

Fig. 13. *Gustav Mahler (1860–1911), native of Bohemia.*

and exercised influence, yet the civilization from which they emerged transcended each and all of them.

The establishment of a Jewish museum in Prague was a natural result of the central role that city played in modern Jewish scholarship. Traditionalist students of Judaism long had ventured into such academic fields as the natural and mathematical sciences, philosophy, and linguistics, but art history had never found a place in their curriculum largely due to sensitivities raised by the second commandment of the Decalogue, which prohibits making images for idolatrous purposes [Ex. 20:4-5]. The advent of liberal Jewish studies, however, engendered a growing respect for various scientific approaches to Jewish history, and by the turn of the twen-

tieth century Jewish museums began to appear in many European cities.

The fledgling effort to establish such a museum in Prague was conceived by historian Salomon Hugo Lieben (1881–1942), who taught religion in Prague German-language secondary schools. Lieben's initial motivation was to preserve the rich inventory of Judaic artifacts from the Prague synagogues that had fallen into disuse, and this work he began in 1906 by creating the Organization for the Founding and Maintenance of a Jewish Museum in Prague. A discerning collector, Lieben first searched throughout Prague for antiquities, then scouted rural villages and urban auction houses for rarities that would illustrate the broad range of Jewish religious life and cultural history.

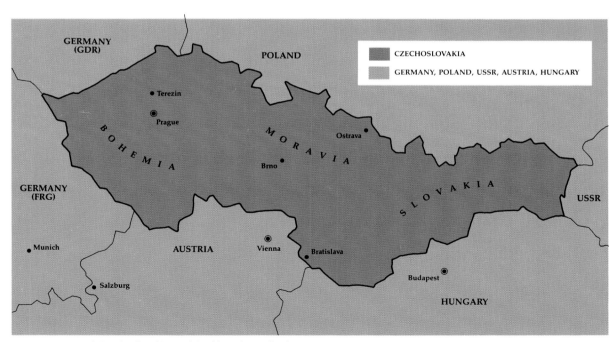

Fig. 14. *Map of Czechoslovakia and its historic territories.*

His efforts yielded impressive results: a collection of approximately 1,000 ceremonial and folk art objects and 1,500 rare Hebrew books and manuscripts. Artifacts associated with milestone events in the Jewish life cycle included a rare nineteenth-century cradle and ceremonial chair used at circumcision, eighteenth-century gold betrothal and wedding rings, richly illuminated seventeenth-century marriage contracts and eighteenth-century faience pitchers, replete with miniature illustrations, from European Jewish burial societies. Decorative seventeenth- and eighteenth-century flags identifying Jewish organizations and important historical events, as well as a unique cast-iron sculpture from 1620 depicting the insignia of the butcher's guild in Prague, were among the objects that Lieben acquired to illustrate community life. Synagogue implements, too, were carefully chosen and included not only finely wrought Torah crowns, breastplates, and pointers, but also many exemplary textiles created in the sixteenth, seventeenth, and eighteenth centuries. One of the earliest Torah curtains exhibited in The

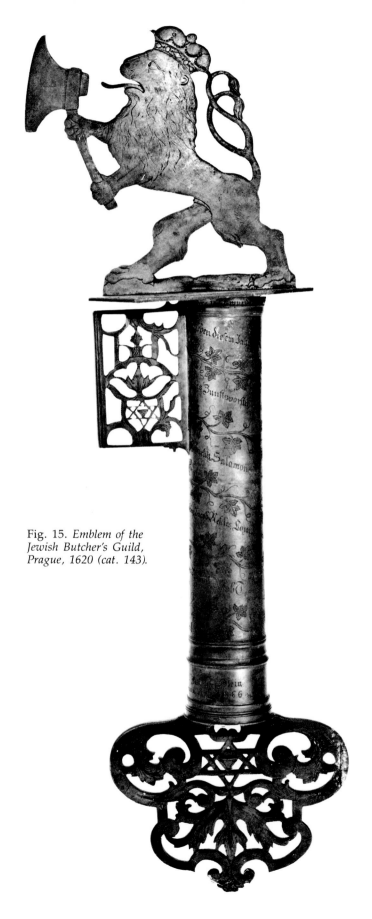

Fig. 15. *Emblem of the Jewish Butcher's Guild, Prague, 1620 (cat. 143).*

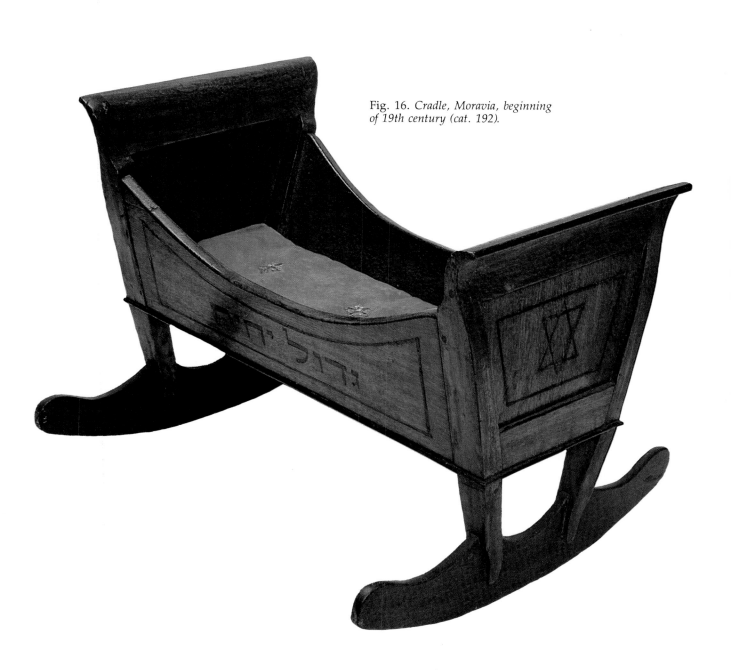

Fig. 16. *Cradle, Moravia, beginning of 19th century (cat. 192).*

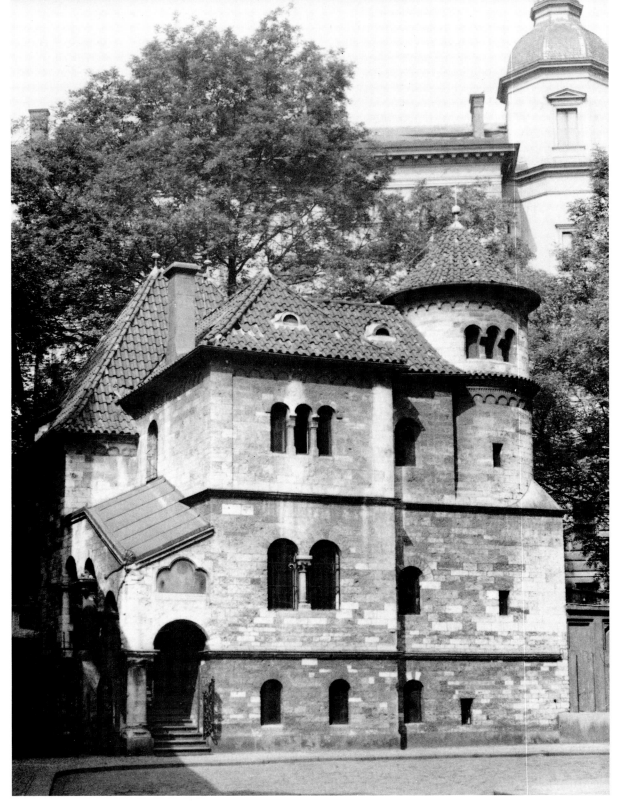

Fig. 17. *Early 20th century photograph
of Ceremonial Hall, Prague, 18th century.*

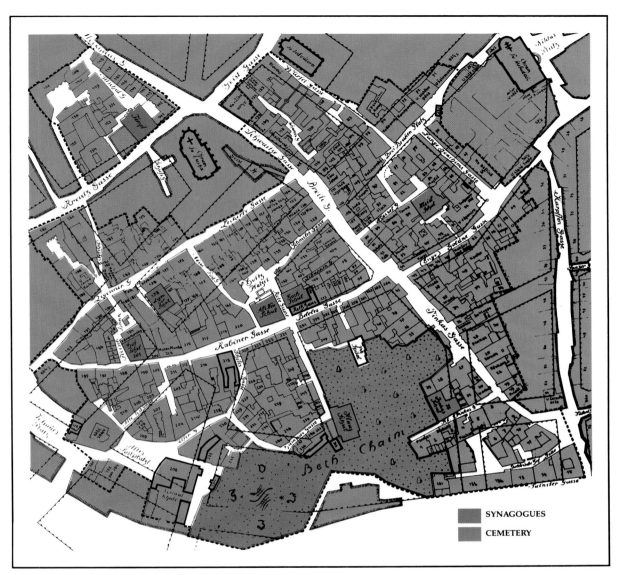

SYNAGOGUES

CEMETERY

Fig. 18. *Map of Prague's Jewish Quarter, 19th century.*

Precious Legacy—an expanse of velvet, lavishly embroidered and appliquéd with silk and metallic threads—was a Lieben find.

Prague's Jewish community officially rewarded its amateur museologist in 1912 by turning over to Lieben the building that once housed the prestigious Jewish Burial Brotherhood Society. In these quarters the Jewish museum strengthened its professional reputation, adding not only more high-quality art objects, but also a curatorial staff. So great was the momentum of de-

velopment that in 1926 the community acknowledged Lieben's contribution by giving him a still larger building—the Ceremonial Hall in the heart of Prague's Jewish Quarter (fig. 17).

Alongside these developments in Prague, Jewish museums were being organized for Slovakia in Prešov (1929) and for Moravia and Silesia in Mikulov (1936). Soon, however, the Jews of Central Europe were swept into the vortex of the Holocaust. During this tragic period, such individuals as the historian Alfred Engel, co-founder

23

of the Mikulov museum, and art historian Josef Polák, who had helped to organize the Přešov collection and later became director of the East Slovak museum in Košice, joined with colleagues including architect František Zelenka and curator Tobias Jacobovits in a desperate effort to make the Prague Jewish Museum a symbol of Jewish survival in an era of utter devastation.

Paradoxically, the Nazis became the overseers of a project that resulted in one of the world's greatest collections of Judaica. On January 28, 1940, Adolf Hitler ordered the creation in Frankfurt of the *Hohe Schule* ("Academy"), which was to be "the center of nationalist-socialist doctrine and education." By March 1941, Reichsleiter Alfred Rosenberg had created as a branch of the Hohe Schule the Institute for Exploration of the Jewish Question, thereby activating throughout Nazi-occupied territories a massive plan to confiscate Jewish libraries, archives, religious artifacts, and all manner of personal property.[2] By the middle of 1942, Reinhard Heydrich, Hitler's chief officer with Protectorate of Bohemia and Moravia, had established the Central Bureau for Dealing with the Jewish Question in Prague, and SS-Untersturmführer Karl Rahm had asserted full authority over the newly retitled "Central Jewish Museum."

The new charter of the museum announced that "the numerous, hitherto scattered Jewish possessions of both historical and artistic value, on the territory of the entire Protectorate, must be collected and stored."[3] The outside world was told only that property was being taken into temporary custody until it could be returned to its "rightful" owners. But museum acquisitions in fact were the corollary to deportations of the "donors"—first to captivity, then to extermination. No category of personal possessions was left untouched. Liturgical books and popular novels, portraits and genre paintings, religious

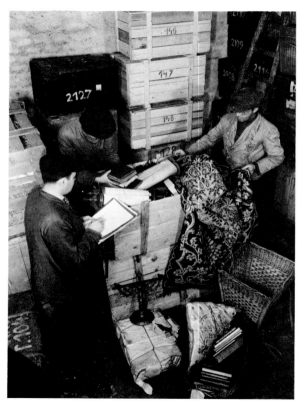

Figs. 19, 20. *Jewish curators, wearing Stars of David, sort and catalogue ceremonial and household items, 1942–45.*

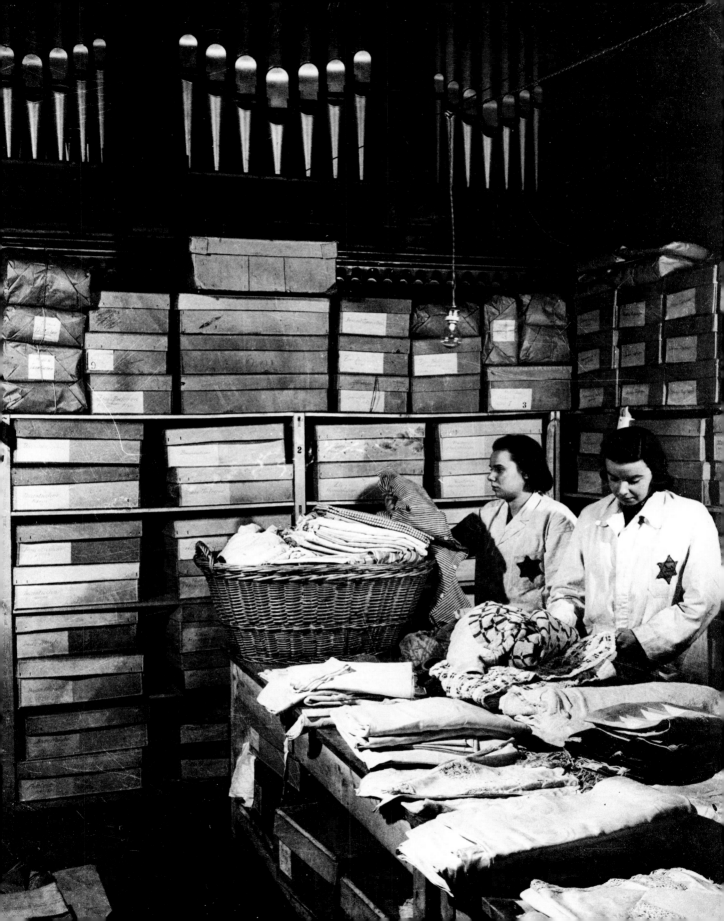

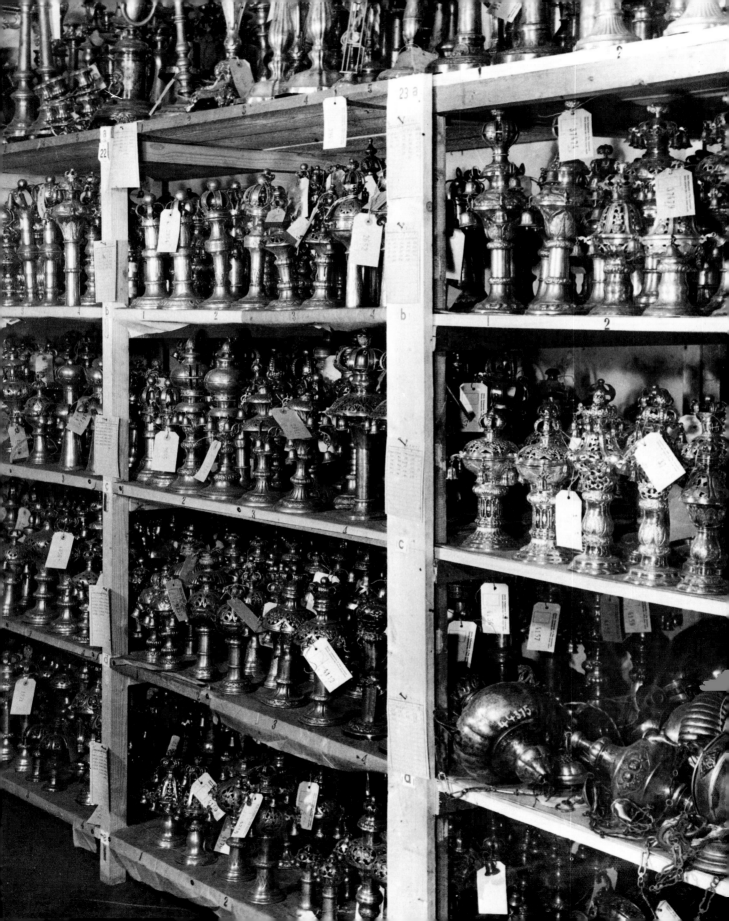

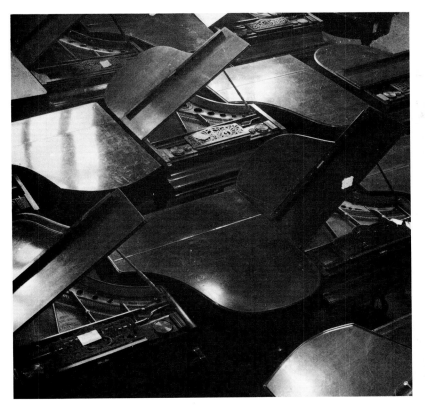

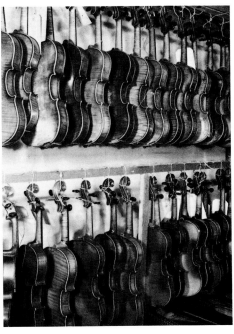

Figs. 21–24. *Wartime storage of confiscated items: Torah finials and other metalworks (far left), pianos, violins, and paintings, 1942–45.*

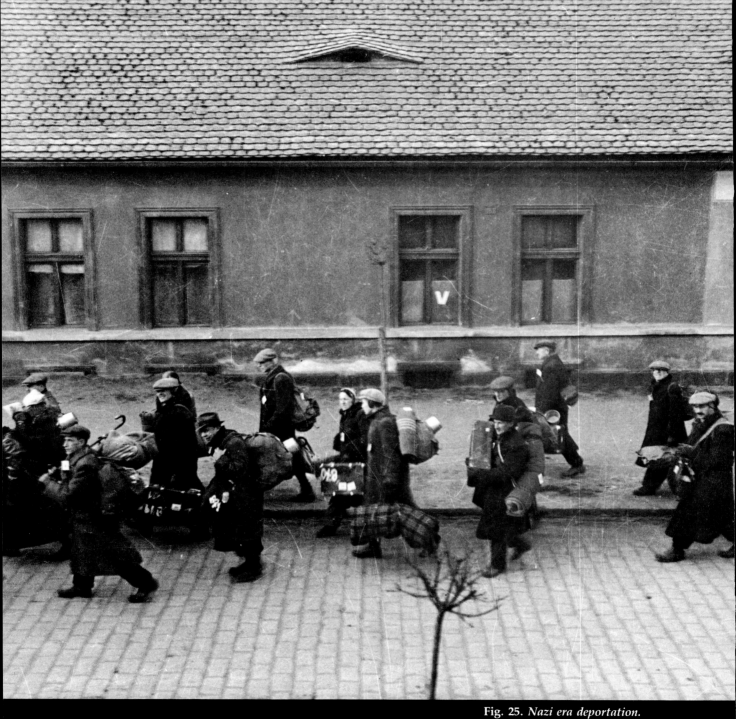

Fig. 25. *Nazi era deportation.*

ceremonials and folk crafts, furniture, kitchen utensils, clothing, pianos, and synagogue implements all were amassed (figs. 19-24). Items arrived first from the provinces, as Jews in small towns and villages struggled to meet the terms of the Nazi mandate to centralize and inventory all Jewish property in Prague. By August 1942, post offices throughout Bohemia and Moravia overflowed with packages of all shapes and sizes.

The Nazis forced experts previously employed by Prague's original Jewish Museum to participate on an Official Planning Commission for the new Nazi museum. Thus Jewish art historians, already responsible for cataloguing tens of thousands of confiscated Jewish items, also were required to develop the administrative and exhibition programs of a museum dedicated to depicting a rapidly diminishing Jewish population. From the onset these curators must have suspected that they were inheriting the legacy of the dead. For as the volume of objects being sent to Prague grew, so too did the number of deportations to nearby concentration camps.

In all, one hundred fifty-three Jewish communities from Bohemia and Moravia sent items to the Central Jewish Museum. The coincidence of the dates of shipments arriving at the museum with the timing of their donors' deportation is apparent. On one day, for example—November 30, 1942—transports from fourteen communities carried 1,355 persons to Terezín [Theresienstadt], the concentration camp near Prague; museum records show that between August 17 and November 30, 1942, shipments of objects arrived from each of these communities,

in all a total of 2,213 artifacts.[4] Helpless to save the lives of their coreligionists, the museum staff could find solace only in preserving items that later might become the mute but compelling testimony of a persecuted people.

For these curators, maintaining meticulous museological standards became an act of spiritual resistance. If objects could be catalogued with precise detail, if careful conservation methods could insure that items would be restored to their original splendor, if the organization of storage depots could guarantee easy access, then perhaps the legacy of European Jewry would not be forgotten. Yet the emphasis that museum director Joseph Polák and his Jewish colleagues placed on detail had another, ironic advantage. On the surface, such methods appeared to conform exactly to the Nazi penchant for precision and discipline. Heydrich and Rahm therefore could be immensely satisfied by the "progress" of Hitler's Central Jewish Museum, while all along its curators secretly were preserving evidence of a culture whose people already were headed for destruction.

The Nazis pushed to extreme the work capacities of the museum staff, thus compounding the effects of their confinement and malnourishment. In addition to sorting and cataloguing thousands of individual items between September 1942 and October 1943, the curators also prepared a collections guide and four major exhibitions, which also required the partial restoration of synagogue buildings. When available manpower no longer could handle the multiplicity of tasks, the Nazis supplied still more

27

Early 20th century photographs of historic Prague synagogues. Fig. 26. Pinkas Synagogue entrance. Fig. 27. High Synagogue interior. Fig. 28. Spanish Synagogue interior. Fig. 29. Maisel Synagogue interior.

workers, ultimately assigning to their Central Jewish Museum scores of Jews expelled from professional work in the arts and letters.

The Nazis were quick to recognize the merits of using, for propagandistic exhibition purposes, the synagogues and religious ceremonial buildings in Prague's historic Jewish Quarter. Not only were these venerable structures intrinsically picturesque—each one embellished with elaborate architectural details of great cultural significance—but they also were available. Jews had been prohibited from participating in public wor-

26

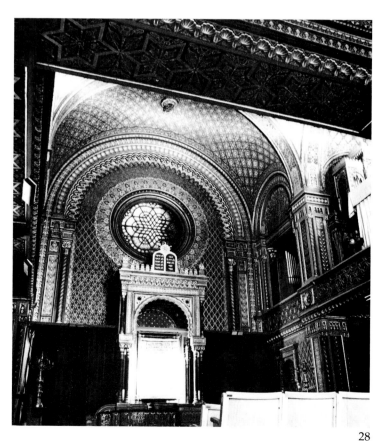

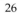

28

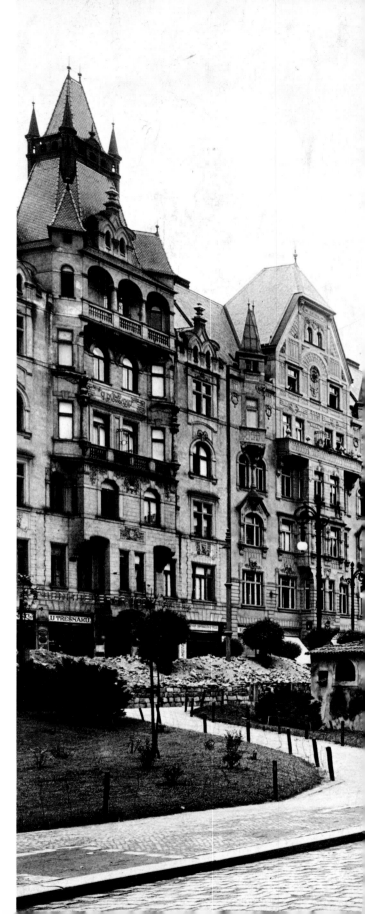

Fig. 31. *Early 20th century photograph of Altneuschul exterior (center) and Town Hall (right).*

ship, so the Nazis could easily convert the seven religious institutions that lined the charming winding streets of the Jewish Quarter into ideal sites in which to show Judaica, ironically enough, in context.

The Nazis' private exhibition program began in Prague's oldest Jewish synagogue, the Altneuschul, with an impressive exhibition of rare Hebrew books and manuscripts. The architect František Zelenka was assigned responsibility for measuring and cleaning this thirteenth-century early Gothic building and for adapting its medieval character to fit the needs of modern museum exhibits. Tobias Jacobovits selected book items from Central and Eastern Europe as well as from Italy, France, Turkey, Amsterdam, and London for this first exposition under Nazi

Fig. 30. *František Zelenka (1904–1944).*

32

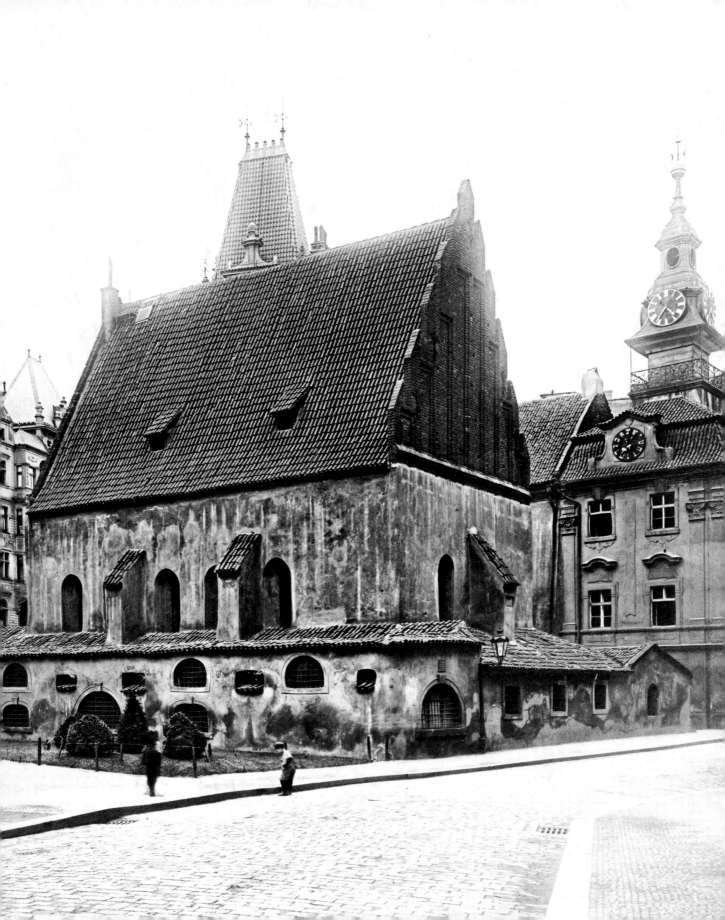

Fig. 33. *1983 photograph of Community Center entrance, 19th century.*

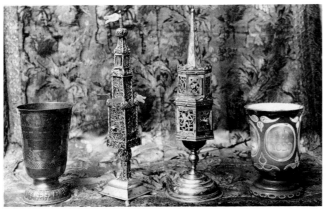

Fig. 32. *Cups and spice boxes collected by Lieben.*

Fig. 34. *Klaus Synagogue interior.*

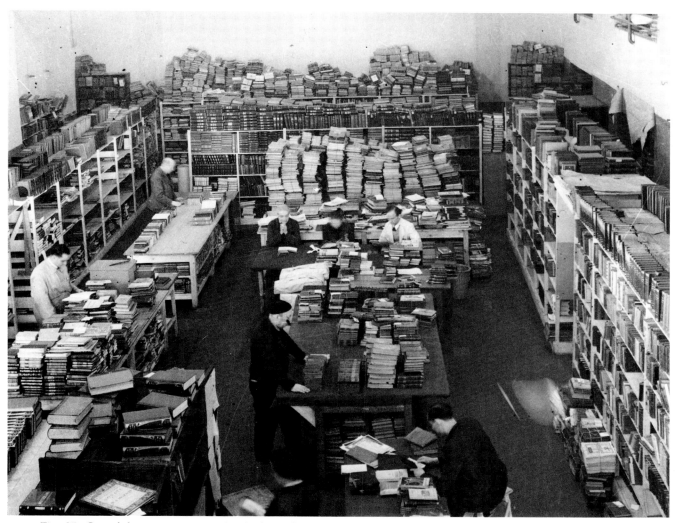

Fig. 35. *One of the many rooms storing books confiscated by the Nazis, 1942–45.*

domination. The former chief librarian of Prague's Jewish community, Jacobovits chose hallmark examples of Jewish liturgical and scholarly manuscripts that illustrated Prague's preeminence as a center of Jewish printing and book manufacture as early as the sixteenth century.

The Altneuschul exhibition barely was complete in November 1942 when the museum curators again were hard at work on an even larger undertaking. For the Nazis had ordered Polák and his colleagues to prepare in the seventeenth-century Klaus Synagogue an exhibition of imagery associated with Jewish festival and life-cycle

observances. Here, unbeknownst to the Nazis, the museum staff selected objects and interpreted them in such a way as to emphasize humanistic values that implicitly defied the Third Reich. For example, items associated with the Jewish festivals of Passover and Purim, which celebrate freedom and express thanksgiving for the joy of redemption from slavery and near-annihilation in ancient times, were shown alongside labels that in Hebrew quoted biblical passages on hope and deliverance. In the section on life-cycle events, the exhibit on circumcision was made particularly attractive and joyful, thus im-

plicitly discrediting the Nazis' caricature of this religious ritual as a barbaric, austere custom. The exhibition opened—for SS staff only—in March 1943, and when Sturmbannführer Günther first toured the collection on April 6, he demanded various changes, including the translation of all Hebrew texts and the addition of an exhibit on kosher butchering.

In 1943, the curators turned their attention to transforming Prague's Jewish Ceremonial Hall, the site of Lieben's original Jewish Museum, into an exhibition featuring portraits of prominent Jewish leaders and works by significant Jewish artists of the nineteenth century. Simultaneously, restoration work was begun on the sixteenth-

Fig. 36. *Joseph Polák.*

century Pinkas Synagogue. For this latter site, the curators had proposed an exhibition on the secular life of Jews in Bohemia and Moravia from the Middle Ages until the nineteenth century. The plan submitted to the Nazis included not only an elaborately detailed exhibition but also numerous architectural modifications that would enable visitors to enter the Pinkas Synagogue directly from the site of the Old Jewish Cemetery.

Ultimately, however, this exhibition never was mounted. Even as they planned so meticulously to commemorate Jewish life, the museum officials were being condemned to death. Zelenka and Engel were transported to Terezín and perished in the spring of 1943. Polák was arrested in August 1944 for his involvement in the resistance movement and expired on a death march. Jacobovits was murdered in Auschwitz in October 1944. The Central Jewish Museum no longer could be the embodiment—however frail—of Jewish values and the will to survive. During the final years of the war it could be only a warehouse for material remnants of a doomed people. Thousands of historical objects continued to arrive for the Prague collection even after there were no museum professionals to catalogue them. And as the outcome of the war became clear, the most valuable confiscated property— gold and jewelry, coins, banknotes, and even thousands of gold teeth—began to flow from Auschwitz into the Reichsbank (fig. 37). At the

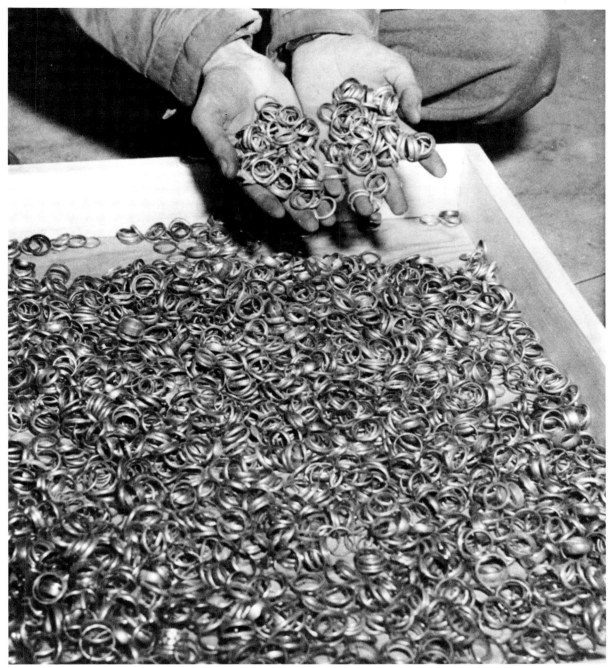

Fig. 37. *Wedding rings confiscated by the Nazis.*

end of April 1945, Adolf Eichmann arranged for his personal hoard of twenty crates of gold to be transferred from Prague to Austria. The "Final Solution to the Jewish Question" that he had supervised nearly had achieved its purpose when the Russian army liberated Terezín on May 8, and thus over the next year Prague's Jewish Museum received its final bequest—drawings, diaries, photographs, and clothing from the victims of that camp and others. Among these remnants was the scrapbook of SS officer Walter Bernhard; titled *Memories from Auschwitz*, it contained 263 photographs documenting in meticulous detail the process by which countless innocent men, women, and children had been annihilated.

This was the macabre pathology the Nazis imposed on European Jewry. In Prague, the only Jewish museum had swollen into a disfigured mass which from every angle of vision betrayed the cancer that had caused its rapid growth. By the spring of 1945, the Central Jewish Museum filled not one Jewish community building but eight, as well as more than fifty warehouses that stretched across an entire quadrant of the old city of Prague. Virtually overnight, the museum had become the repository of an entire people's material culture. The all too few survivors who returned to Prague encountered in shock and disbelief this awesome evidence of the destruc-

tion of tens of thousands of Czech Jews. Today Prague gives us two legacies. One is that of a great historic site, presenting intact a centuries-old Jewish Quarter that paints a vivid picture of the Jewish experience. The other legacy is a haunting reminder of the totality with which humankind can enoble life but also wreak destruction. It is to the credit of the Czechoslovak Socialist Republic that these complex and important dimensions of the human experience are preserved for future generations.

The post-war Jewish Museum first came under the aegis of Prague's Jewish Community Council. Overwhelmed by the need to re-establish—despite the volume and diversity of their inherited collections—a viable professional museum institution, the Council employed in 1946 the few surviving curators to create in Prague yet another Jewish museum. However, by 1949, the consensus was clear: the Jewish community had neither the human nor financial resources left to preserve its legacy. Thus in November 1949 the Council offered as a gift to the Czechoslovak government both the historic monuments of Prague's Jewish Quarter and the thousands of objects that had come to reside in its buildings. The State Jewish Museum—at once a memorial, historic preservation agency, and research institute—was established formally on April 4, 1950.

Fig. 38. *Confiscated Torah scrolls.*

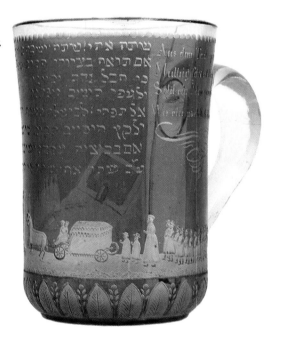

Fig. 39.
Portrait of Lezer Zekeles, a member of the Prague Burial Society, 1772/3 (cat. 170).

זה כ״ה ליזר זעקעל״ש
שתדלן דתפוסים ויבאי
דק״ק גיר״ה יל״י
תרבנו לא״י

Today's visitor sees in the State Jewish Museum the results of remarkable achievements. In the years since the war, Prague's historic Jewish Quarter has been restored entirely. Permanent and temporary exhibitions are housed in the Ceremonial Hall adjoining the Old Jewish Cemetery as well as in the Maisel, Klaus, High, and Spanish Synagogues (fig. 41). The Altneuschul is restored to its medieval character. Cemetery tombstones that contain detailed imagery identifying the names, lineage, and professions of Jewish scholars and other citizens from the fifteenth to the eighteenth centuries also benefit from ongoing conservation work. The Pinkas Synagogue, after a ten-year effort begun in 1950, has become a memorial to the Nazi victims from Bohemia and Moravia. Inscribed on its interior walls are the names of those who perished, along with their birthdates and the dates of their deportations to Terezín and Auschwitz (fig. 51).[5]

The vast collections have been organized carefully. The visitor at once confronts both

Fig. 40.
Burial Society beaker, Mladá Boleslav, Bohemia, 1837/8 (cat. 160).

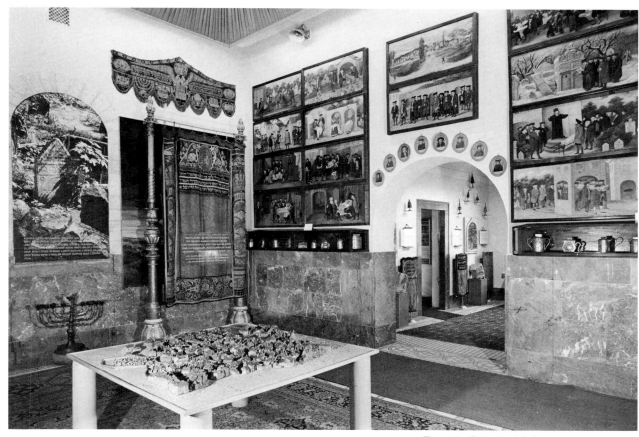

Fig. 41. *State Jewish Museum exhibition, 1950s.*

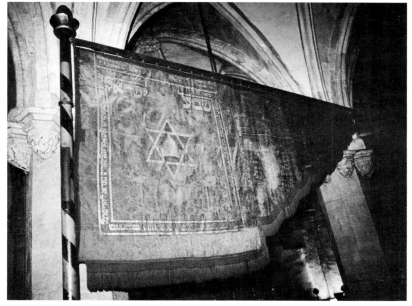

Fig. 42. *Flag of the Jewish Community, Altneuschul (see p. 75).*

41

מִן הָאָרֶץ · וַיְעַנּוּנוּ כְּמָה שֶׁנֶּאֱמַר לְמַעַן עַנֹּתוֹ
בְּסִבְלֹתָם וַיִּבֶן עָרֵי מִסְכְּנוֹת לְפַרְעֹה אֶת **פִּתֹם**
וְאֶת **רַעַמְסֵס** · וַיִּתְּנוּ עָלֵינוּ עֲבֹדָה קָשָׁה כְּמָה
שֶׁנֶּאֱמַר וַיַּעֲבִדוּ מִצְרַיִם אֶת בְּנֵי יִשְׂרָאֵל בְּפָרֶךְ ·
וַנִּצְעַק אֶל יְיָ אֱלֹהֵי אֲבֹתֵינוּ וַיִּשְׁמַע יְיָ אֶת קֹלֵנוּ
וַיַּרְא אֶת עָנְיֵנוּ וְאֶת עֲמָלֵנוּ וְאֶת לַחֲצֵנוּ ·
וַנִּצְעַק אֶל יְיָ אֱלֹהֵי אֲבֹתֵינוּ · כְּמָה שֶׁנֶּאֱמַר
וַיְהִי בַיָּמִים הָרַבִּים הָהֵם וַיָּמָת

וַיִּבֶן אֶת פִּתֹם וְאֶת רַעַמְסֵס וַיִּפֶן כֹּה וָכֹה וַיַּרְא אֶת הַמִּצְרִי

מֶלֶךְ

Fig. 43.
Haggadah for Passover, Moravia, 1728/9 (cat. 258).

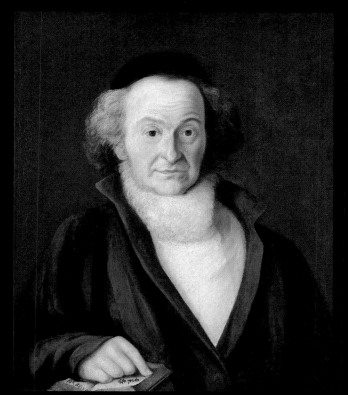

Fig. 44. *Portrait of a Scholar, Prague, 1817 (cat. 227).*

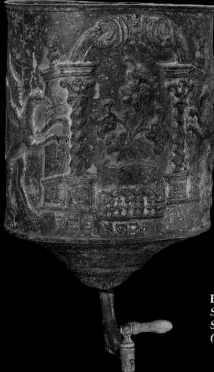

Fig. 45.
*Synagogue lavabo,
Slovakia, 1800/1
(cat. 80).*

the staggering volume of items and the patent rarity of the many unique artifacts that also are hallmarks of the State Jewish Museum. On exhibition, for example, are the robe and banner of the famous messianic pretender, Solomon Molcho, condemned to death as a heretic during the Inquisition in 1532 (fig. 60). A 1592 Torah mantle, given to the Maisel Synagogue by its founder Mordecai Maisel, also is displayed. An unparalleled collection of Judaic textiles reflects not only Jewish ritual observances but also the history of the European fabric trade. Finely etched Bohemian glass and stylized metalwork also is represented. Early books printed in Italy, Poland, Turkey, Holland, and England illustrate centuries of popular artistic styles in engravings with family crests, figural representations, and floral decorations.

Today more than forty staff members, including curators, archivists, librarians, researchers, conservators, and exhibit technicians, are employed at the State Jewish Museum. The work of the museum reflects the high degree of academic

43

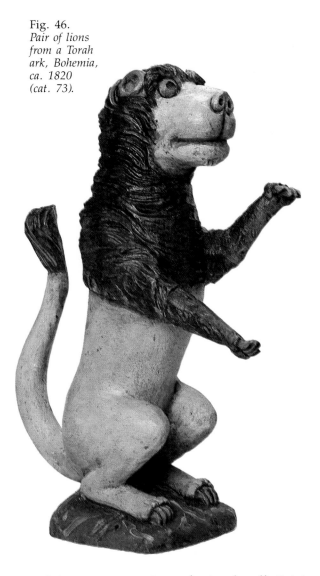

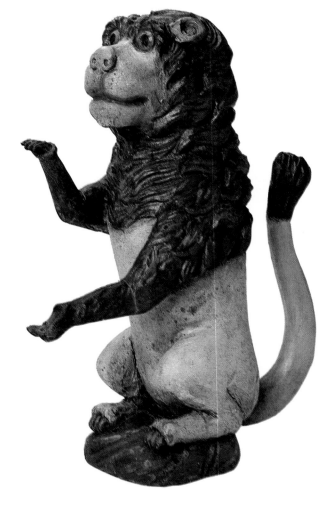

Fig. 46.
*Pair of lions
from a Torah
ark, Bohemia,
ca. 1820
(cat. 73).*

training common to its professional staff. Original research flourishes, with regular publications and photographs and the internationally recognized journal *Judaica Bohemia*. Alongside the active efforts to restore the historic character of major buildings in the old Jewish Quarter is an impressive program to conserve a large number of museum objects.

The Precious Legacy is an extraordinary exhibition, not merely for the rare and beautiful Judaic treasures that it reveals for the first time to the American public. These objects allow us today to glimpse beyond the veil of history to the era when modernity was but aborning. They elicit memories of a community whose religious and cultural life was a diadem in the world of European Jewry. Above all, these artifacts bring back to life a people who confronted the challenges of history by struggling for eternality. Today, each precious remnant of a now-destroyed past calls on all of us to cherish the legacy of inspiration, to struggle anew, and to hope.

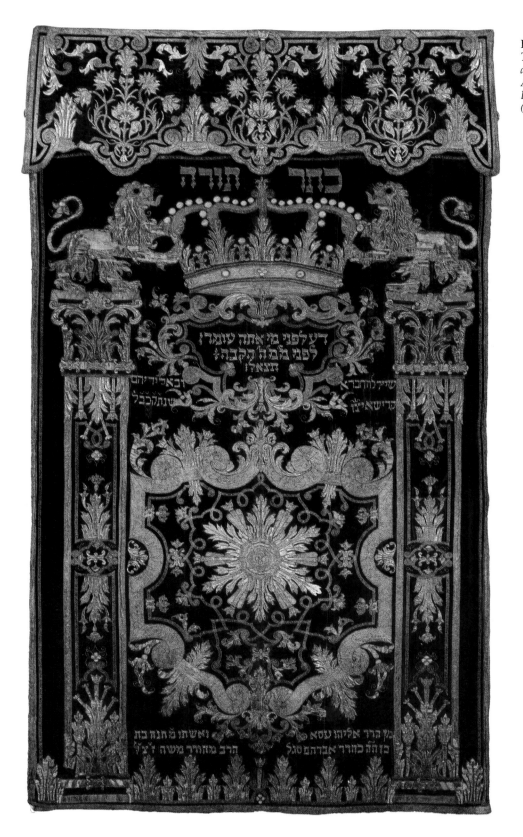

Figs. 47, 48.
*Torah curtain
and valance,
Austro-Hungarian
Empire, 1730/1
(cats. 6, 12).*

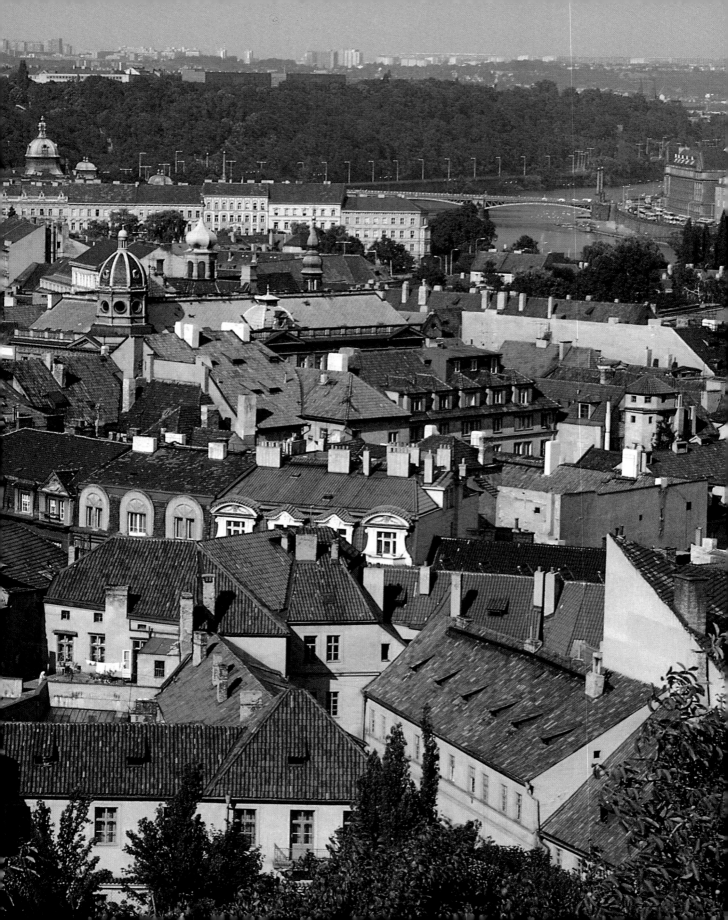

AUTONOMY AND INTERDEPENDENCE:

THE HISTORICAL LEGACY
OF CZECH JEWRY

Hillel J. Kieval

Prague, the capital city of Bohemia and of modern-day Czechoslovakia, is an architectural marvel. Having been spared the physical destruction that was meted out to most of the other great cities of Central Europe during World War II, it offers both visitor and resident a panoramic view of its own history in the form of building styles. Romanesque churches and rotundae link up to Gothic cathedrals; renaissance palaces stand alongside the ornate edifices of the baroque and rococo eras; the pseudo-historical styles of late-nineteenth century monuments mix freely with the art nouveau restaurants and clubs of the fashionable neighborhoods of the early twentieth. Prague—through its very streets and houses—emits the glories of the medieval Czech state, the romantic mystery of the city during the late Renaissance, the excessive zeal of its own Counter-Reformation, the crude confidence of middle-class ascendancy and industrial growth, and the irrev-

erent experimentation of its recent artists and intellectuals.

There is a building, a synagogue, on the right bank of the Vltava (Moldau) River which offers in microcosm this same picture of historical-architectural juxtaposition. Excavations have revealed that the original structure on this site—which has gone by the name of Pinkas Synagogue as long as anyone can remember—was built in the Romanesque style and must have been standing since the eleventh century. The remains of a ritual bath (*mikvah*), attached to the ancient foundations, date from the thirteenth century. And the Hebrew inscription on a memorial stone indicates that the synagogue was rebuilt in 1535 in the late-Gothic style by Žalman Horowitz, one of the most influential Jews in Bohemia at the time. In 1625 the building was redesigned again, this time by Goldsmied de Herz, according to late-Renaissance tastes: he widened the structure and added a women's gallery, a vestibule, and a meeting room. Since 1958, the stark interior walls of the synagogue have been covered with inscriptions: 77,297

Fig. 49.
Vista of Prague, 1983.

47

names, the names of every Jew from Bohemia and Moravia deported by the Nazis to the death camps of Eastern Europe.[1] Thus from the eleventh century to the twentieth, the Pinkas Synagogue has recorded, preserved, and displayed its heritage.

It is not only the longevity of Czech-Jewish history, its successive layers of development, and its tragic demise that are represented on the walls of this unique building. Rather, this monument also stands for the dynamic themes of Jewish life in the Czech lands: the distinguished careers of its native sons in commerce and industry, scholarship and the arts; the proud and independent tradition of an autonomous ethnic and religious community; the interaction and interdependence of the Jewish community and the non-Jewish milieu, reflected both in the incorporation of architectural styles and in the centrality of this monument for the civic culture of Prague; the trauma of annihilation; the uncertain quiet of the present.

These are the themes that I will attempt to highlight in the pages that follow, stressing continually the major lines of development in Jewish life, the independent political and cultural tradition of the Jews of the Czech lands, and the processes of cross-cultural influence, discernable throughout the Czech-Jewish past but a truly dominant feature following the end of the eighteenth century. Nothing in this narrative will prepare the reader for the penultimate chapter, the deliberate and organized destruction of nearly all Jewish life in the country. Like the inscribed names of the Jewish victims of Nazism which disfigure the beautiful interior of the Pinkas Synagogue but add a necessary and important new dimension, the Holocaust has marred and disfigured the Czech-Jewish past. One no longer can view the white walls of the synagogue without seeing those haunting letters. And one never again will be able to examine the history of Czech Jewry free of the burden of hindsight, the terrible knowledge of how it was all to end. But the names were not intrinsic to the walls; they had to be superimposed. And there is nothing in the history of the Czech-Jewish relationship to suggest the inevitability of mass murder. We are simply left with the merging of two contradictory themes and must accept their co-existence. As observers we now stand outside both historical processes and try to make sense of the pattern left behind.

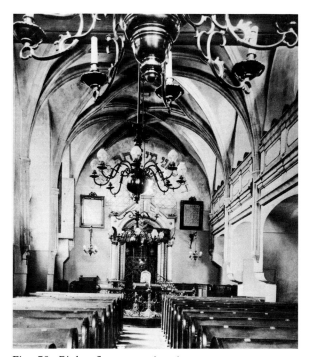

Fig. 50. *Pinkas Synagogue interior.*

1942 GERTRUDA 12.VII 1921 RUTH 4.X 1924-6.IX 1943*OTA 7.VII 1889-1.X 194. OTA 10.I
A 14.IV 1888-15.V 1944*ZIKMUND 1.XII 1864-11.III 1944*ALŽBĚTA 19.II 1871*JULIUS 15.XII
FRANTIŠKA 26.IV 1921-3.X 1941*IDA 25.II 1892-20.VIII 1942*KATEŘINA 7.VII 1906-3.XI 1941
III 1860-19.X 1942*ZUZANA 14.IV 1929-6.IX 1943*FLUSSMANN WALTER 3.VII 1907 NEŽ
V 1912-19.X 1942*MAXMILIÁN 31.XII 1870*JOSEFA 8.V 1874-19.X 1942*VILÉM 24.VII 1901 ID
I 1889-15.XII 1943*EDUARD 21.VII 1872*ELIŠKA 28.VII 1872-15.X 1942*AMALIE 31.XII 1875-1
1940-15.V 1944*FOGL DAVID 15.VII 1934-18.XII 1943*SÁRA 22.VII 1914-18.XII 1943*FOLKA
04-6.IX 1943*MOŘIC 1.II 1899 OLGA 11.II 1905 PAVEL 14.IX 1936-31.X 194*FOLPRECHT
ORGACS JOSEF 24.XII 1894-31.VIII 1942*EMILIE 5.V 1901-6.IX 1943*FORSCHER MAJ
Oskar 16.VII 1882-3.XI 1941*FRÄNKEL EMIL 6.II 1894 MARTA 26.IX 1908 ILSA 23.I 1931 D
nezvěstný*JAQUES 1.VII 1898 LEONTINA 7.X 1896 KATEŘINA 18.XII 1926 EDNA 24.V 19
ní*ANNA 11.IX 1898-6.IX 1943*CECILIE 26.VII 1873-15.XII 1943*EDITA 1904 nezvěstná
1942*PAVEL 8.V 1905-30.IV 1942*ZDĚNKA 27.VII 1883-18.XII 1943*FRAISS ISIDOR 29
6.V 1912-1.X 1944*FRANCOUSKÝ ABRAHAM 1.VII 1906 HELENA 14.X 1916-6.IX 1943
32 JIŘÍ 13.X 1935-23.XI 1944*FRANK ALFRED 17.VIII 1931-20.VIII 1942*ANTONÍN 12.VII 190
*HUGO 12.V 1865-3.IX 1942 OLGA 2.VII 1874-19.X 1942*JAN 19.II 1891-9.X 1941*JAN 3.I
28.IV 1907-20.VIII 1942 JOSEV 30.IV 1910-28.IX 1944*KAREL 1895-28.IX 1944*KAREL 190
III 1900-11.I 1942*OTTO 24.II 1902 IRENA 12.II 1906 ARNOŠT 21.V 1931 JIŘÍ 4.VII 1935-20.VIII
X 1943*ROBERT 25.II 1885 HILDEGARDA 21.II 1896-16.X 1941*ROBERT 18.XII 1897-21.XI
1924-29.IX 1944*VIKTOR 24.V 1886-3.XI 1941*FRANKEL JIŘÍ 11.III 1895-9.II 1942*EMA 12.I
25.VIII 1944*EMIL 16.IV 1885 MARIE 25.II 1884-23.X 1944*EDUARD 10.III 1866-19.X 1942*FR
920-6.IX 1943 JIŘÍ 15.XII 1941 JOSEF 15.III 1875 HERMINA 10.IV 1881-18.V 1944*KAREL 1.
09-18.XII 1943*OTA 17.IX 1874-23.III 1943*VILÉM 19.IX 1915-1.X 1944*EDITA 21.IX 1905 20.V
942*OLGA 5.VIII 1878-18.III 1943*VALERIE 11.V 1882 KURT 20.V 1903-20.II 1943*FRANKEN
KA 15.VIII 1877-19.X 1942*RŮŽENA 13.III 1873 nezvěstná*FRANKENSTEIN ALFRED 4.V II
YLDA 12.XII 1870-18.XII 1943*OTA 3.XII 1909 RŮŽENA 29.X 1904-18.XII 1943*OTTO 26.X 18
X 1942*SELMA 26.IX 1899-14.VII 1942*TEREZIE 12.III 1874-19.X 1942*FRANKFURTEROVÁ H
4.XI 1892-20.VIII 1942*FRANKL ADOLF 9.VII 1883 ANNA 2.IV 1884 MARKÉTA 8.VIII 1921-16.XI
90-6.IX 1943 LILY 11.VII 1921-5.III 1943*EVŽEN 15.XI 1880-30.IV 1942*FRANTIŠEK 14.XII 190
1898 ANNA 7.I 1909-6.IX 1943*JULIUS 1.X 1878-6.IX 1943*JULIUS 1.VII 1889 OLGA 18.IV 19
1-26.II 1943*KAREL 6.IV 1910 ILONA 14.VII 1912-21.X 1941*KAREL 1.I 1921-1.IX 1942*MOŘIC 4.
1941*OTA 4.XII 1919-29.IX 1944*VILÉM 19.20-6.IX 1943*ZDENĚK 20.VII 1912-9.II 1942*ANN
1944*AUGUSTINA 28.VII 1851-19.X 1942*ELIŠKA 17.V 1879-17.III 1942*EMILIE 16.II 1881 O
3.IX 1895-19.X 1942*JULIE 26.III 1871-19.X 1942*KLOTYLDA 5.II 1891 FRANTIŠKA 25.III 1919-1
MALVINA 14.II 1866-19.X 1942*MARIÁNA 28.IV 1921-13.X 1942*MARTA 14.IX 1888 PETR 2.
29.X 1886-1.IX 1942*FRANKMANN JOSEF 22.III 1876 EMILIE 30.XII 1887-26.X 1941*HEDVI
X 1944*ANNA 26.VIII 1889-20.VIII 1942*AUGUSTA 7.XII 1882-6.IX 1943*ELLA 14.VIII 1906-13.I
HEDVIKA 28.IX 1866-25.IV 1942*HELENA 20.X 1889-8.X 1942*HELENA 28.III 1909 MARIE 2
1941*JANA 31.X 1859-19.X 1942*JINDŘIŠKA 2.VI 1916-15.X 1942*LUDMILA 1.III 1884-26.II 1943
23.X 1944*RŮŽENA 11.XI 1911-14.VII 1942*FRÁNOVÁ FRANTIŠKA 22.XII 1902-22.X 1942*FRA
9.IV 1940-15.V 1944*ŠIMON 29.XII 1873 LAURA 14.III 1881-28.X 1944*JOSEFA 17.III 1864-16.III
RUDOLF 1.III 1916-28.IX 1944*BOHUMIL 17.VII 1904-6.IX 1943*EMIL 31.II 1883 PAVLA 27.II 18
41*KAREL 18.X 1913 FRANTIŠKA 26.VI 1878-16.X 1941*LILLY 15.VIII 1925-28.VII 1942*FREILIC
SAMUEL 26.VII 1896 ANNA 24.XII 1897 ARTUR 30.IV 1924 LILY 28.V 1925 IMRICH 24.XII 1927.
HEDVIKA 15.III 1891 HANA 22.III 1926-16.X 1944*BEDŘICH 20.II 1893 ELEONORA 21.VII 19
XII 1877 OLGA 21.II 1891 MARIANA 24.II 1914-13.VII 1942*MOŘIC 3.VII 1867-19.X 1942*IDA 21.X
08-6.IX 1943*FREISINGER JOSEF 1903-25.V 1942*KURT 22.VII 1901 GERTRUDA 22.XII 190
20 GERTRUDA 20.II 1923-11.III 1942*NATAN 26.XI 1875 HEDVIKA 18.IV 1883-22.X 1942*MA
1890-18.V 1944*ELSA 29.IV 1883-20.VIII 1942*FREMROVÁ RŮŽENA 21.II 1909-17.III 1942
I 1.VIII 1876 JOSEFA 13.II 1885 ARNOŠT 10.V 1879-28.VII 1942*BERNARD 19.IV 1873-29.VI I
ERICH 3.V 1901-8.X 1942*FRANTIŠEK 1911-1.X 1944*JOSEF 10.III 1872-9.X 1943 OLGA 12.
1944*KAREL 29.III 1883-16.X 1944*OTA 23.I 1882 HEDVIKA 27.II 1886-28.IV 1942*PAVEL 1.V
A 30.VII 1893-11.III 1942*FREUDENBERG JULIUS 16.XII 1891 IRMA 23.XI 1888-8.IX 1942
OLD 24.IX 1873 HERMÍNA 25.III 1884 VILÉM 14.I 1907-15.XII 1943*GUSTAV 20.XII 1907-16.V
A 24.VII 1891 ZUZANA 15.VIII 1924-11.III 1942*RUDOLF 4.IX 1903-28.IX 1944*RUDOLF 4.III 19
ĚSTNÁ*FREUDENFELS JIŘÍ 6.VIII 1904-28.X 1944*LEOPOLD 2.VI 1868 HEDVIKA 23.IX 18
ŠT 12.XII 1912-26.II 1943*FREUDOVÁ ANNA 7.II 1877-15.X 1942*ANNA 31.VIII 1883-28.VII 19
MARKÉTA 21.XII 1915-17.III 1942*VALESKA 26.VIII 1898-30.IV 1942*FREULER KAREL 29
91-18.II 1943*FREUND ALFRED 12.III 1874 OTILIE 24.IV 1883-19.X 1942*ALFRED 25.VII
2 KAROLINA 20.II 1863-6.XI 1942*ALOIS 8.IX 1902 KAMILA 13.VIII 1898 RUTH EVA 4.X 1
ZDENĚK 14.XII 1928-28.VII 1942*ANTONÍN 191.-26.X 1942*ARNOLD 7.XII 1895 MARKÉTA 4.V
194.*ARNOŠT 21.VIII 1889 ELIŠKA 28.XI 1889-15.XII 1943*ARNOŠT 22.XII 1893-29.XI 194
888-28.V 1942*BEDŘICH 5.VII 1909-1.X 1944*BERTOLD 30.XI 1860-20.VIII 1943 BEDŘIŠK

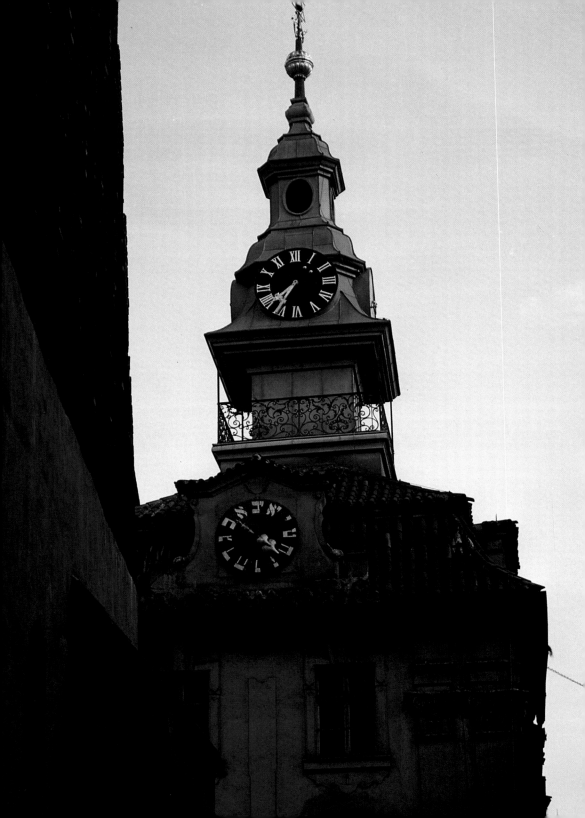

THE JEWISH COMMUNITY
TO THE END OF THE MIDDLE AGES

It was a beautiful day and K. felt like going for a walk. But hardly had he taken a couple of steps when he was already at the cemetery. The paths there were very winding, ingeniously made, and unpractical, but he glided along one of them as if on a rushing stream with unshaken poise and balance. From a long way off his eye was caught by a freshly heaped grave mound which he wanted to pause beside. This grave mound exerted almost a fascination over him and he felt he could not reach it fast enough. But he often nearly lost sight of it, for his view was obscured by banners which veered and flapped against each other with great force; one could not see the standard-bearers, but there seemed to be a very joyous celebration going on.

Franz Kafka, "A Dream"[2]

A journey to the picturesque quarter of Josefov near the center of Prague leads one to the ancient hub of a once-thriving and vibrant Jewish community. Prague's historic Jewish Quarter no longer resembles the dense, chaotic tangle of dark buildings and narrow streets which sheltered most of the city's Jews until the middle of the nineteenth century. An urban re-newal project, dictated by considerations of health and middle-class aesthetics, demolished the old buildings and widened alleyways into streets during the late 1890s. Only a few synagogues and some recognized historical landmarks escaped the wreckage. These now stand shoulder to shoulder with the tall, ornate houses of Prague's turn-of-the-century wealthy in an unlikely juxtaposition of historic and pseudo-historic styles and of the distant and the more recent past.

But the splendor of the old quarter has been retained in the names of streets and shops: the restaurant *U staré synagogy* (At the Old Synagogue), for example, or the wine room *U golemu* (At the Golem's); in the Hebrew characters that adorn the backwards-running clock which sits atop the baroque Jewish Town Hall. Two places in particular seem to have been imbued with a special aura. The first is the venerable but inviting Altneuschul (*Staronová synagoga*) whose Gothic vaulted ceilings have received the prayers of Jews uninterruptedly for more than seven hundred years. There in the small main chamber of the sanctuary, against the eastern wall, stands the high-backed chair of the sixteenth-century rabbi Judah Loew ben Bezalel,

Fig. 52. *Clock Tower atop Jewish Town Hall, 1983.*

better known in Jewish tradition by his acronym Maharal, which is formed by combining the first letters of the words in his Hebrew title: *Morenu ha-rav rabi Liva.* There, above the fifteenth-century wrought-iron grille that surrounds the center pulpit, hangs the historic banner of the Prague Jewish community, symbolizing political autonomy and collective pride with privileges granted and renewed by Bohemian and Austrian kings.

The second spot lies across the street and in back of the Altneuschul. The Old Jewish Cemetery is a cramped, urban enclosure of veritable hills, overgrown in the spring and summer and crowded with tombstones. The community buried its dead here from the fourteenth to the end of the eighteenth century, but long before then had exhausted all the available space. The solution was to cover existing graves with earth, bury the new dead on a second level, and top the surface with tombstones from the two layers combined. No one knows exactly how many times this process was repeated before the cemetery was closed in 1787; perhaps as many as twelve. Hence one has the feeling of walking up and down hills when visiting the site. The visual image is of tombstones packed together, leaning on one another, indicating the names and dates of the deceased but hiding their precise location.

The combined effect of these two cultural monuments sometimes has led to false impressions. For the Altneuschul (as its name in fact implies) was not the oldest synagogue in Prague, and the Old Cemetery was not its first Jewish burial spot. Nor was the present Jewish Quarter the only area of Jewish residence in the city. The oldest Jewish settlements in Prague, dating from the ninth or tenth century, grew up in two locations: the neighborhood of the so-called "Old Synagogue," to the east of Josefov by the Holy Ghost Church, and on the right bank of the Vltava near the spot where the Pinkas Synagogue later was built. In subsequent centuries communities sprang up in a number of other locations on both sides of the river: outside the Vyšehrad Castle just south of the city; across the Vltava in Prague's Újezd district, protected by the residents of the Hradčany Castle; in the area

Fig. 53.
*Early 20th century photograph
of Altneuschul interior.*

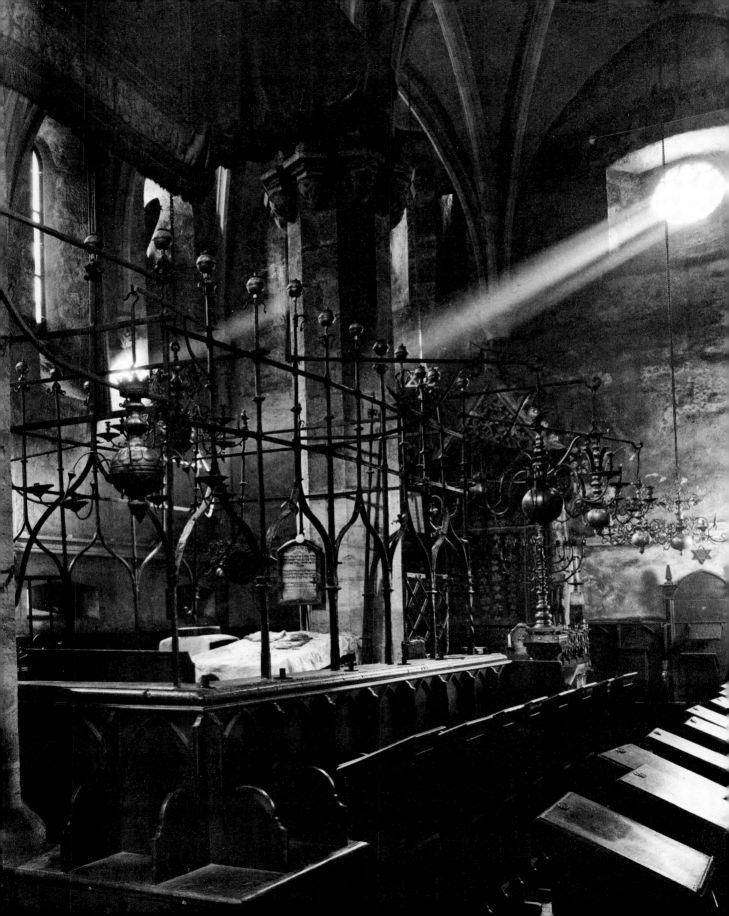

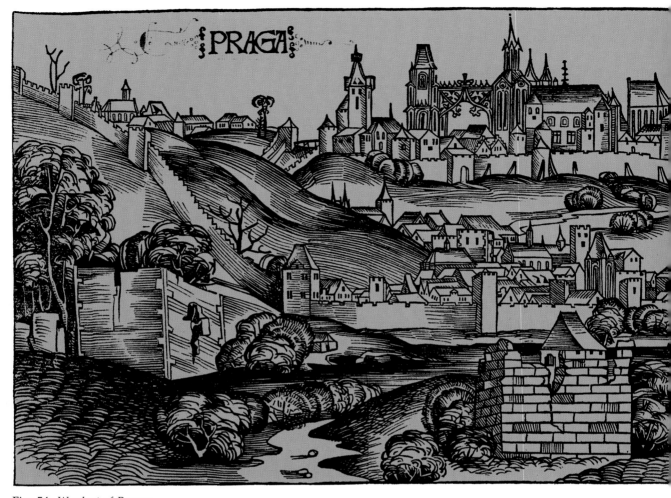

Fig. 54. *Woodcut of Prague,*
dominated by the Castle, 1493.

of the Altneuschul; and even in parts of the New City (*Nové Město*), founded in the thirteenth century by members of the burgher estate.

However, the community that grew up around the Altneuschul soon proved to be the largest and most stable in Prague, possibly because of its prime location near the marketplaces in the center of town. During the High Middle Ages the Jewish Town, as it had become known, emerged as the focal point of the social and cultural life of the community and the seat of its political institutions. The plague of 1473 mortally weakened Prague's satellite Jewish communities, and those that managed to revive toward the end of

the century fell prey to the instability of the last years of the Jagellon dynasty. Frequent popular disturbances against the Jews, combined with their (temporary) expulsion in 1541, had the effect of consolidating the Jewish presence in Prague in one vital spot.

Prague's medieval Jewish community did not live in a ghetto, if by this word we understand a single, closed area of enforced residence. Jewish settlement, as we have seen, was not limited to one area of the city alone, nor were Jews prevented from moving about freely. More accurately, one might describe the state of affairs in medieval Prague as the following: the burgher

estate divided into several political-geographic units—the Old Town, the New Town, and the Lesser Town, for example. Membership in these communities was limited to the Christian residents living within their borders (and excluding members of other estates, such as the Church, the nobility, and the few peasants who might happen to have been wandering through). The Jewish Town, though associated geographically with the Old Town, formed an independent juridical-political entity. Within its borders the Jews comprised a proud and independent group enjoying legally guaranteed rights and responsibilities, such as were spelled out, for example, in

the Royal Charter of Přemysl Ottokar II in 1254. This document declared that the Jewish corporation in Bohemia belonged to and existed under the protection of the king; it outlined the rights and responsibilities of the Jews vis-à-vis the crown, defined and guaranteed their economic role in society (principally as petty bankers or moneylenders), and promised them freedom to practice their religion.

As its primary responsibility the Jewish corporation was obliged to provide regular monetary payments to the suzerain, in this case (though not always) the king. In return, the Jewish community (*kehillah*) enjoyed autonomy

in its social, political, legal, and religious affairs. It was a self-governing entity whose basic institutions were the synagogue, the council (*kahal*), the courts, the schools, and charitable societies.

Like most of their medieval coreligionists in northern Europe, the Jews of Prague naturally chose to live in close proximity to their schools and synagogues, their ritual baths and law courts. Moreover, the Jewish Town could provide protection from hostile outside forces. The six gates of the Jewish quarter, for example, could be fortified to withstand attack and were used to protect those who lived within, not to keep them from venturing out. We cannot locate with any precision the point at which the idea of a Jewish Town in Prague became associated with that of a forced ghetto. It may well be, in fact, that no specific legislation accompanied this transformation in status. We do know, however, that until 1523 the only barrier between the Jewish Town and the Christian districts of the city consisted of the above-mentioned gates and the exterior walls of houses tightly packed together. Later on, the community erected a free-standing wall to enclose the last spaces that had remained open.

Still, the Jews of the Czech lands lived with severe disadvantages and often with the threat of violence. When the first Crusaders swept southward from the Rhine in 1096, they inflicted heavy casualties on the Jews of Prague. In 1142,

during the siege of the Prague Castle, the oldest synagogue in the city and the Jewish Quarter below the castle were burned to the ground. In 1389, members of the Prague clergy spread stories of Jewish blasphemy and desecration of the host (the eucharistic wafer). They encouraged angry mobs to ransack, loot, and burn the Jewish quarter. Hundreds of Jews were murdered; numerous women and children were forcibly baptized. Noted scholar, Rabbi Avigdor Kara, whose 1439 tombstone is the oldest found in the Old Jewish Cemetery, witnessed the massacre. He captured the anguish of the community in a moving elegy (*kinah*) titled "All of the Hardships That Befell Us":

The worst of our foes crimes
occurred in the year 5149 [1389],
when heavy fell our Lord's scorn
on Golden Prague, the city of beauty we mourn . . .
Without any reason they drew their knives
and slaughtered our men, children, and wives . . .
And many a father his son has buried;
And many a mother the child she had carried
beneath her heart, to give it life,
now its body pierced with a knife
to spare it being forced to abjure
the creed of its fathers so proud and so pure.
May the offering please God: be it lamb or sheep
or the innocent children over whose suffering we
 weep. . . . [3]

This prayer continues to be recited by the Jews of Prague on Yom Kippur, the Day of Atonement.

When times were more peaceful, Jews still had to bear the burden of discriminatory legislation. Such laws as those enacted by the Fourth Lateran Council in 1215, which mandated distinctive Jewish dress, prohibited Jews from holding public office, and limited the rates of interest Jews might charge on loans, contributed to the unfavorable social and economic position shared by all the Jews of Europe.

The government policy that rendered the Jews servants of the royal chamber *(servi camerae)* did not go unchallenged for long. Already by

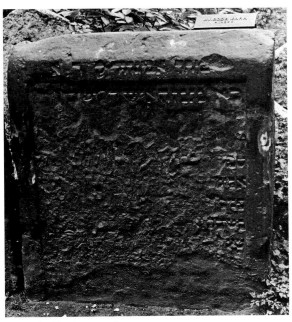

Fig. 55. *Tombstone of Rabbi Avigdor Kara (d. 1439).*

the middle of the fourteenth century Emperor Charles IV faced direct competition for control of Jewish taxes from the city councils in his realms. Both Charles and his son and successor Wenceslaus occasionally made the mistake of allowing the control over Jewish affairs to slip from their hands in return for cash indemnities. And at times they would bow to public pressure to cancel the debts owed to the Jews by one or another estate, again in return for a lump sum of money. By the fifteenth and sixteenth centuries the challenge to royal prerogative in the Czech lands had produced a complex situation of political, social, and religious conflict. A marked decline in royal authority occurred during the Hussite wars of the fifteenth century—waged equally against the Church of Rome and the German Emperor—with the new political balance favoring the nobility in the countryside and the burgher estate in the independent towns. All three sides in the ensuing conflict coveted the prize of granting the Jews "protection" in exchange for both regular and exceptional monetary payments. The Jews, needless to say, were placed in the unenviable position of having to play one side against the other, not knowing which demand for taxes was legitimate or which umbrella would provide the most security in the long run.

The jurisdictional disputes in the Czech lands corresponded by and large to the political up-

heavals affecting Central Europe as a whole. Throughout the Holy Roman Empire political authority was becoming decentralized as more and more power accrued to the small principalities and city-states. Meanwhile the burgher population in the cities began to assume many of the banking and commercial functions that previously had been performed almost exclusively by Jews. Partially as a consequence of this growing economic competition, the German cities rose up one by one during the middle years of the fifteenth century to expel their Jewish population. In 1454 five of the six royal cities of Moravia (Jihlava, Brno, Olomouc, Znojmo, and Neustadt) followed suit. The sixth, Uherské Hradiště, evicted its Jews in 1514. Those who were expelled settled in the small towns and villages that were tied to the landed nobility; there the Jews continued to perform useful and necessary economic functions, converting the surplus produce of the noble domains into cash, producing luxury goods for noble households, and making petty loans to the peasantry.

As was the case in Germany, the expulsions of the fifteenth century effectively removed Moravian Jewry from the cities. For the next four centuries, the Jews of Moravia, like their counterparts in Poland, were concentrated in the large and small towns throughout the countryside. The individual communities were, for the most part, strong enough to support the full range of Jewish institutions, but there was no large urban center to direct and dominate the periphery. And yet, what Moravian Jewry lacked in the way of a glorious center like Prague it made up for in the area of Jewish autonomy. Already by the end of the fifteenth century, the individual kehillot had banded together to form a super-communal authority, a *medinah* (literally, "state"), for the collection and distribution of taxes, the representation of Jewish interests to the authorities, and legislation in matters which affected the larger Jewish community. The chief rabbi, or *Landesrabbiner*, whose seat was in the southern Moravian town of Mikulov (Nikolsburg), had jurisdiction over both secular and religious matters; under him stood a small governing council composed of two representatives from each of the three provinces of the land, and a larger legislative council which met in regular fashion every three years. Thus organized, Moravian Jewry bequeathed to posterity a formidable legacy of legislative activity. The collection of ordinances known as *Takkanot medinat mehrin* (Laws of the Moravian Jewish Council), dating from 1650 to 1748, represents a high water mark in Central European Jewish autonomy and continues to offer much information about the social life of the European Jews at the end of the Middle Ages.

PRAGUE JEWRY
DURING THE RENAISSANCE

During the sixteenth century all the intellectual currents of the time met in Prague, in the heart of Europe.

Frederic Thieberger,
The Great Rabbi Loew of Prague[4]

For the Jews of the Czech lands, the sixteenth century brought an intensification of the social insecurity they had come to expect from medieval life. Having already witnessed close to home the nearly complete elimination of their coreligionists from the cities of Germany, Austria, and Moravia, they subsequently watched from afar—but with greater horror—the expulsion of the Jewish communities of Spain in 1492 and the brutal forced conversion of the Jews of Portugal five years later.

In the midst of this orgy of expulsion, Prague and Bohemia stood out as islands of refuge; they had, in fact, attracted large numbers of Jews migrating east from the German parts of the Empire. Moreover, there was reason to hope after 1526, when the Czech lands became part of the Habsburg domains, that the Jews would reap the benefits of a new political stability under the rule of Ferdinand I. In fact, Ferdinand did manage over the course of his reign to wrest control of Jewish affairs from the hands of the burghers and the nobility. However, in the course of a protracted struggle between Crown and Estate, the burghers of the royal cities of Bohemia rose up in 1541 to demand the expulsion of the Jews from their midst. Ferdinand acceded to the wishes of the Bohemian cities, announcing at the same time that the Jews of Prague would have to leave as well. Thus, by the middle of the sixteenth century, it looked as though Bohemia would be following the pattern of the rest of Central Europe, ridding its cities and large towns of Jews and leaving only the small towns and rural domains of the nobility for Jewish settlement.

The expulsion order for the royal cities remained in effect until the Revolution of 1848, but the case of Prague proved to be quite different. Apparently the Jews were not as detrimental to the religious health of the country or as superfluous to its economy as the urban estates contended. The government lifted the ban on Jewish settlement in Prague four years after it had been announced and only two years after it had gone into effect. Another temporary expulsion followed in 1557, but both decrees represented exceptions to the general pattern. For despite all of the upheavals going on around it, Jewish life in the Bohemian capital flourished throughout the sixteenth century.

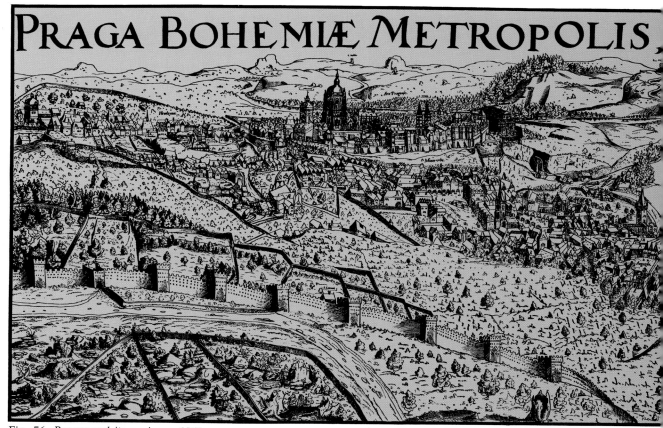

PRAGA BOHEMIÆ METROPOLIS,

Fig. 56. *Prague and its environs, 1562.*

One sign of vitality was simply the growth in population. From the 1480s to the 1520s open spaces in the Jewish Quarter gave way to the construction of new buildings, colonies of Jews sprang up in new areas of the city, and the surface area of the Jewish Quarter itself was enlarged by purchases of non-Jewish houses. From 1522 to 1541—during which time the Jewish population of Prague is thought to have doubled—the quickly growing number of Jews could be accommodated only by increasing the human density in Josefov. A new phase of physical expansion took place during the early years of the Thirty Years War when the Jewish community once again was allowed to purchase blocks of adjacent buildings to ease the demographic pressures within its walls.

The economic foundations of Jewish life appear to have been improving as well. The Bohemian Landtag, dominated by the landed nobility, reaffirmed in 1501 all of the ancient privileges of the Jews and set forth generally favorable terms for their economic activity. True, Jewish fortunes could not be guaranteed by any single political proclamation nor even by the apparent alliance of Jewish and noble interests. But these facts do indicate long-term social and economic improvement. Even the battles which raged between the Crown, the urban estates, and the nobility over the ultimate jurisdiction in Jewish affairs points not only to the absence of a clear center of power but also to the attractiveness of the Jewish community and the potential wealth that it possessed.

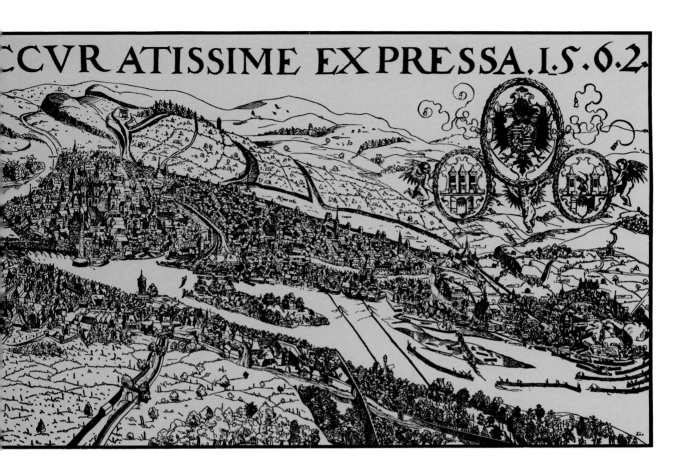

The sixteenth century was the age of the Prague Renaissance when artistic and literary styles from Italy, the Copernican revolution in science, and northern German humanism and religious reform set in motion a flurry of cultural creativity. The Jewish Quarter remained in many respects insulated from the "high" culture of the gentile population. Nevertheless, some of its sons took part in the cultural explorations of the new era. Jewish mathematicians and astronomers emerged, as did geographers and historians, philosophers and artists, pedagogues and publishers. While many of the new cultural forms were borrowed from the non-Jewish Renaissance environment, the end product of these efforts was a distinctly Jewish creation. The artists, scientists, and philosophers who were active in the Prague ghetto during this period drew upon the values and concerns of preceding generations of Jews; they were constructing additions to the Jewish cultural edifice rather than creating alternatives to it. At the same time, their work resonated with the wider range of hopes and experiences of contemporary European Jewry.

The works of the late-Renaissance humanists found their way to large segments of the population thanks to the introduction of mechanized printing during the second half of the fifteenth century. Jewish arts and letters flourished in much the same way. The first Hebrew press was established in Prague in 1512. Its earliest ventures were modest—a prayerbook, followed in 1518 by an edition of the Pentateuch. Soon,

however, the Hebrew press in Prague established a reputation for excellence and artistic innovation unmatched in the Jewish world. Gershom ben Solomon Ha-Cohen, one of the original partners in the printing venture, set out on his own after 1518. In 1526, together with his brother Gronem and the artist Hayyim ben David Shaḥor (Schwartz), he published an illustrated Passover Haggadah which has been described as "one of the chief glories in the annals of Hebrew printing." The text of the Prague Haggadah was adorned with no less than sixty woodcut illustrations, some borrowed from the repertoire of illustrative material that had accompanied non-Jewish imprints in Prague since 1488. Others, such as the depiction of the search for leaven in the Jewish home and the portrayal of the "four sons" introducing one of the major sections of homiletic narrative, were executed specifically for this volume.

Gershom Ha-Cohen's enterprise produced a stunningly beautiful book which not only was appreciated by Jewish communities around the world but also served as the preeminent model for subsequent Haggadot, establishing iconographic genres and pictorial traditions that have remained closely associated with the Passover celebration. One such tradition, based on an ancient rabbinic exegesis of scripture, places Pharaoh bathing in a tub of the blood of Jewish children; another portrays the "wicked son" as a soldier, a striking motif which repeatedly appeared in succeeding generations of Haggadot until the twentieth century. In a recent example, the Berlin Haggadah of 1923, illustrated in German Expressionist style by the Polish-born artist Jacob Steinhardt, presents the wicked son again as a soldier, but this time dressed in a Prussian uniform with a spiked helmet on his head.

One of the iconographic motifs of the Prague Haggadah—already long established in medieval Hebrew manuscripts—features a scene involving a hunter and his hounds chasing hares. Having no thematic connection to the content of the service, the scene originally may have been introduced because it served as a convenient mne-

Fig. 57. *Page from the Prague Pentateuch, 1530 (cat. 278).*

בעזרת השם יתע ה׳ ה׳ ויורוכתינו תיכמיח ותע ל׳ה

סייוהי ה׳חומשי תו רה׳ ויהי חשכינו ליו רה׳

ותמש חק לת׳ ויצו כל סרל׳ ונסרל׳ הפטו רות׳

ברוך האקום שתל׳ק לרייונו וחכמ תו׳

והשפיע עלינו שפע טובתו וברכ תו׳

ונתן לו כח וחיל לגמור דת תור תו׳

בנתן ונמסר והר סיני ופי׳ גבור תו׳

עם חסירות ויתירות וכל תיבה ותיבה בנקיב תו׳

וכל יתות ונקות דחיק ורחיק כנקור תו׳

חוק יהוגן וובלי כחקתו ובמשפט ך תו׳

ועם האלכים הביעים להל׳ך כל יוהר כקרייו תו׳

ולבטל חוק בנך כפת יוחר יהון לו להרפו תו׳

וכאשר זכינו לחזק יתה׳הרדת תפאר תו׳

כן נזכה לקיים את כל הכתוב ב לעשן תו׳

לתמן השם ית׳ ולכבור זו׳ נ׳ולת שכיב תו׳

רקריכו ועיינו כרקריק רב לעשות מהל׳ תו׳

ונ׳גה היוב עם שני ובבים נתעוררן לגהור תו׳

נחוקך מה בחך פרגות הב׳ רה׳

בחומשת יולפים ר׳כינו ר׳יב׳ רה׳

פרשות והנה ומוצים יולה בחלהו תו׳

ביום ב׳ט׳ן כסלו היה הגרות תו׳

ובזכות זה יקכק י׳ עמו חכל מחל תו׳

ויגמו לימות בנינך בית בחדר תו׳

ויומרו כל העמהים ל׳ יוחר ויפם זל׳ תו׳

במהרה בימינו ועניינו ירינו ינו תו׳

אמן בנך יהי רצון :

מ ש ל ה

ער יה קיומים ל׳ה וחרי יוהבים

ויחוזקים הגרשומים קים לעגרת עולים

בָּרוּךְ אַתָּה יְיָ אֱלֹהֵינוּ מֶלֶךְ הָעוֹלָם
שֶׁהֶחֱיָנוּ וְקִיְּמָנוּ וְהִגִּיעָנוּ לַזְּמַן הַזֶּה :

| צורת הציד מקונן על יהח ' | כי לא יקרוך רמייה צידו ' |
| על כן שוער רעשו מרט ' | והא ה גמלטו יורק יוררט ' |

משבּיע ראש השנה בליל מוצאי שבת מתחיל ואומר זה '

בָּרוּךְ אַתָּה יְיָ אֱלֹהֵינוּ מֶלֶךְ
הָעוֹלָם בּוֹרֵא פְּרִי הַגָּפֶן :
רוּךְ אַתָּה יְיָ אֱלֹהֵינוּ מֶלֶךְ
הָעוֹלָם אֲשֶׁר בָּחַר בָּנוּ מִכָּל
עָם וְרוֹמְמָנוּ מִכָּל לָשׁוֹן וְקִדְּשָׁנוּ ﭏ

Fig. 58. *Hare hunt illustration*
from Sabbath Songs, Grace after Meals and Blessings, Prague, 1514
(cat. 277).

monic device: the German "Jag den Has" could be transformed into the Hebrew acronym "YaKNeHaZ," which in turn reminded one of the correct order of benedictions for a holiday which fell at the conclusion of the Sabbath. With the Prague edition of 1526, the "YaKNeHaZ" motif became firmly ensconced in the tradition of Hebrew printing. It naturally appeared again when Hayyim ben David Shaḥor, who had previously worked in Prague, brought out his own edition of the Haggadah in Augsburg in 1534. This time, however, there was a twist. The scene appeared twice; in the first picture the dogs seem to have driven the hares into a net, while in the second the hares have escaped to the other side of the net to safety.

With the Augsburg Haggadah, the hare-chasing motif obviously had dropped its purely technical function as a mnemonic device. Now it had become an allegory of salvation with the hares representing the Jewish people and the dogs their oppressors. Shaḥor was expressing the

hope that the redemption embodied in the Exodus from Egypt also would be realized in his own day. In so doing he was echoing the dreams of most of the Jews of his time. The calamities of the turn of the century, together with the stirrings of the Reformation in Central Europe and the rise of the Muslim Ottoman Empire to the East, produced a heightening of messianic expectations. In the 1520s and 1530s there arose prophets and messianic messengers who rattled the foundations of Jewish life in Europe. The Jews of Prague were in the center of some of these developments and felt the tremors quite strongly.

Perhaps the most famous of the messianic agitators of this period was the Arabian world traveler, David Reuveni. Claiming to represent the Jewish kingdom of Habor, composed of descendents of the northern tribes of Israel, Reuveni managed to make a favorable impression on the Pope in 1524. Thereafter he shuttled among some of the mightiest courts of the Christian

Fig. 59. *Hare hunt illustration from the Prague Haggadah, 1526.*

Fig. 60. *Flag of Solomon Molcho,*
probably Italy, before 1628 (cat. 282).

world—Lisbon, Regensburg, even Abyssinia—
urging support for a military uprising against
the infidel Ottoman empire. During his stay in
Lisbon, Reuveni stirred up a great deal of inter-
est among the Marrano population, whose fami-
lies had been converted to Christianity less than
three decades earlier. One such devotee was the
courtier Diogo Pires, who, determined to return
to the Jewish fold, asked the messenger from the
East to perform on him a ritual circumcision.
When the latter hesitated, Pires did the operation
himself, barely escaping death in the process. He
thereupon revealed his new religious identify
and fled to Turkey to escape the wrath of the
Christian authorities.

Under his newly chosen name of Shlomo [So-
lomon] Molcho, the former Portuguese courtier
studied Jewish mystical teachings, the *kabbalah*,
in the Ottoman city of Salonika. Toward the end
of the 1520s he became convinced of the immi-
nent messianic redemption. Traveling and
preaching throughout Italy, Molcho gained the
confidence and protection of the Pope in 1530, a
feat which saved him from being burned at the
stake as a judaizer barely two years later. Then,
in 1532, he accompanied Reuveni to the German
court at Regensburg to seek an audience with
the Emperor Charles V. The meeting went badly,
and Charles had Molcho brought to Mantua
where, after refusing to recant and return to
Christianity, he indeed was burned at the stake.
Reuveni was imprisoned in Spain where he
probably died in 1538.

Already during his lifetime Molcho had
achieved considerable popularity; many Jews
quite frankly believed him to be the Messiah. By
1531 the messianic movement that he had
helped to spawn reached as far as Poland. Jews in
Prague, meanwhile, watched Molcho's progress

with eager anticipation. Some even may have
followed him on his mission to Charles V at Re-
gensburg. In any event, a number of Prague
Jews managed to save some of his personal be-
longings and proudly displayed them after his
death. One of the oldest articles on display today
at the State Jewish Museum in Prague is a ban-
ner, bordered with fringes and covered with
Hebrew inscriptions, which is said to be the flag
Molcho carried on his mission to Regensburg in
1532.

Only after the death of the emperor Ferdinand
in 1564 were the Jews of Bohemia and Moravia

to enjoy the peace and stability that had eluded them for so long. With the accession of Rudolph II to the throne in 1576, the Prague Jewish community entered a miniature "golden age" which lasted into the first decades of the seventeenth century. In fact, there may have been no direct relationship between the personality occupying the throne at any given time and the vitality of Jewish life. Rudolph, after all, had the reputation of being an indecisive and weak ruler who recoiled in horror from the maneuvering for power and influence which he saw all around him in Vienna. However, he does appear to have been, if not tolerant of other religions, at least indifferent to the proselytizing fervor of the Catholic Counter-Reformation in the Habsburg lands. He granted the Protestant Bohemian estates guarantees of religious freedom, and his decision to remove his capital from the intrigues of Vienna and transfer it to the more peaceful environs of Prague seemed to augur well for the Jews.

Cultural life under Rudolph and his successor Matthias benefited from the atmosphere of benevolent anarchy that was regnant in Prague. Astronomers and astrologers, mathematicians and alchemists, Rosicrucians and religious re-

formers mingled together unimpeded by the strict controls and intellectual limits of the medieval Church or the political and ethnic purges that were to wreak havoc on Bohemia following the defeat of the Czech forces by the Habsburgs at White Mountain. During this time the Jewish community retained the autonomy and self-sufficiency of past centuries, and the guardians of Jewish traditions were careful not to allow the faith to succumb to alien beliefs and practices. Nevertheless, the intellectual elite of the Jewish community participated in the broad give-and-take which was going on about them and made significant achievements in the fields of astronomy, mathematics, historical writing, and religious thought.

Two figures in particular loomed large over the literary and scientific activities of Prague Jewry. The first was the chronicler, astronomer, and mathematician David Gans (1541–1613), and the second was Rabbi Judah Loew ben Bezalel (ca. 1525–1609). Gans, originally from the Rhineland, had studied traditional religious subjects with several of the prominent rabbinic personalities of his day—including Moses Isserles in Cracow and Judah Loew in Prague. He then took the unusual step for a Jew of his era of devoting himself entirely to the study of the secular sciences of mathematics, astronomy, geography, and history. Gans was a friend and collaborator of two of Europe's major astronomers, the Dane Tycho Brahe and the German Johannes Kepler, who were living in Prague at the time, enjoying the patronage of the imperial court. He describes the scientific atmosphere around Rudoph's court in his own astronomical work, *Neḥmad ve-Na'im* (Delightful and Pleasant):

In the year 1600, His Majesty the Emperor Rudolph invited the famous scholar in astronomy, Tycho Brahe, a nobleman from Denmark, to reside in the castle of Benatek. There he leads a solitary life with his students, and he allowed him 3,000 thaler a year, as well as bread and wine and beer, apart from bestowing many other gifts on him. . . . And I, the writer, was there thrice, always for five consecutive days, and was sitting with them in the observational rooms, and saw the wonderful things not only with the planets but also with the fixed stars. . . . In truth, I must say that in all my life-time I have not seen, nor heard of, such great effort and investigations: neither our forefathers told us nor did we see it in any book, be it from the children of Israel—to distinguish them—or from the nations of the world.[5]

Interestingly, Gans acknowledged the work of the astronomer Copernicus, calling him "a great scholar and excellent astronomer, greater than all the scholars of his epoch."[6] However, he did not feel the need to reconcile Copernicus' heliocentric view of the universe with that held by both the Jewish and Christian authorities of his day, namely, that the earth was the center of the cosmos. Thus in most respects Gans' labors in the field of astronomy are principally of antiquarian interest. He is better known today as a historian and chronicler of contemporary events. His major contribution, *Zemaḥ David* (Offspring of David), appeared in Prague in 1592 and still stands out as a prime example of the renewal of Jewish interest in historical writing in the sixteenth century.

By far the dominant personality in the Czech Jewish community at the end of the sixteenth century, one whose life has become emblematic of the richness of the Prague renaissance, was Judah Loew ben Bezalel (the Maharal). Born in the Polish province of Poznań (Posen), the Maharal brought to the task of communal leadership those ingredients which were to insure a lasting contribution to the shape and content of Jewish life in the region: a fertile mind, a clear program of educational and institutional reform, and the desire to attain high public office. Between 1553 and 1573 he served as Landesrabbiner of Moravia in the town of Nikolsburg, but he devoted most of the remaining thirty-six years of his life to serving the Jewish community of Prague, returning briefly in the 1580s to Moravia and in the 1590s to Posen, frustrated in his efforts to be named chief rabbi in the Bohemian capital.

The Maharal left an indelible mark on the religious and educational institutions of the kingdom. During his early years in Prague he founded a yeshivah which gained international prominence, organized groups for the study of the early rabbinic document, the Mishnah, which tended to be overlooked in favor of the later and more expansive Talmud, and helped to reorganize the Jewish burial society, the Ḥevra Kaddisha, which had been established in 1564. The Maharal's pedagogical theories and his criticisms of contemporary Jewish education continued to inspire pioneers in the field up to the modern period. He urged the Jewish communities of his day to gradually introduce children to the sources of tradition—the Bible, the commentaries, and the Talmud—with due regard for their age and ability to comprehend what they were being taught. He stood implacably opposed to the methods of *pilpul*—dialectical argument that incorporated extraneous matters in order to elucidate a difficulty in the rabbinic text—advocating instead an approach to the Talmud which extracted the plain meaning of the text and which highlighted its function as explicator of the Mishnah. He furthermore encouraged the pursuit of scientific study as long as this did not contradict the "principles of Judaism."

Judah Loew deserves to be reckoned among the most original thinkers of his century. Some of his major writings include: *Gevurot Ha-Shem* (The Might of the Lord), a magistral commentary on the Haggadah; *Netivot 'Olam* (The Ways of the World), a treatise on ethics and morality; *Tiferet Yisrael* (The Glory of Israel), *Be'er ha-Golah* (The Well of the Exile), and *Neẓaḥ Yisrael* (The Victory of Israel), all of which contemplate the fundamental issues of Jewish existence—the relationship between Israel and God, the mediating function of Torah in the world of revelation, the dilemma of exile, and the promise of redemption.

Sometime after his death, the career of the Maharal entered the worlds of both Jewish and Czech folklore. Why this occurred is not evident from the details of Loew's actual biography, although his pervasive influence on Jewish life in Prague made him an ideal candidate for postmortem veneration. That he also should have found his way into the treasure-house of Czech

lore is indicative of the familiarity that existed between Jewish and gentile society in early-modern Prague. Interestingly, in both the Jewish and non-Jewish literary sources, the Maharal is credited with having created an artificial being, a golem, by virtue of a magical act involving the use of the holy name. The concept of a golem in Judaism long had been connected with magical tendencies in kabbalistic exegesis. A version of the legend that held that the golem could become a living creature capable of serving his master actually began to appear among German Jews in the fifteenth century. By the seventeenth century, according to the traveling Italian rabbi Joseph Solomon Delmedigo, such stories were told by all.

Hence, the fact that the latest and best-known form of the popular legend was appended to Loew's life reveals more about popular Jewish culture in the seventeenth (or even the eighteenth) century than it does about actual events in Prague during the Maharal's lifetime. The tale of a monster who was summoned to life by a wise and righteous rabbi and defended the Jewish community against attacks from the outside gave eloquent expression to the hopes and fears of East European Jewry following the Chmielnicki massacres of 1648–49. That the golem story, also tied to the figure of Loew, should reveal itself as an integral component of Czech folk wisdom is more difficult to explain. The fact owes much, it seems to me, to popular images of esoteric culture and occult science during the reign of Rudolph II, since Czech legends about the Maharal place him in the circle of astronomers and alchemists who associated with the emperor at the time. Yet this dual tradition involving the Maharal points to something more: an extensive area of shared culture, partic-

Fig. 61. *Tombstone of Rabbi Judah Loew ben Bezalel (ca. 1525–1609).*

ularly on the popular level. The legendary feats of the Maharal and his clay monster-defender belonged simultaneously to the heritages of both Jews and non-Jews. A powerful attestation to this fact came at the turn of the twentieth century. When the city had completed leveling most of the old Jewish Town, the sculptor Ladlislav Šaloun was asked to adorn the New Town Hall with statues recalling the spirit of old Prague. He chose two themes: one was a figure representing the "Iron Knight" of the medieval city, and the other was Judah Loew, the embodiment of Josefov, whose name was familiar to every resident of Prague.

BOHEMIAN BAROQUE: JEWISH LIFE DURING THE AGE OF ABSOLUTISM

The community [after the victory of the Imperial forces at White Mountain] was forced to borrow money to pay a large tax. When the time for repayment approached, quarrels broke out over the issue of the amounts [to be levied]. Hearts were divided; friends separated; parties were formed in secrecy. All of my efforts to calm and unite the hearts [of the community] were in vain. As the Rabbis correctly remarked in the Talmud: "It begins with a pitcher and ends with a barrel."

Rabbi Yom Tov Lipmann Heller,
Megillat Eva (Scroll of Hatred)[7]

The Thirty Years War, inaugurated by the revolt of the Protestant Czech estates in 1618, devastated the human landscape of Bohemia and Moravia. Despite the international nature of the conflict, most of the war's battles were fought on the Central European plains, and the ensuing carnage claimed no less than a third of the Czech population. For Bohemian Jewry, the war brought to an end the all-too-brief period of peace and prosperity. On the most basic level, Jews had to face the same threats to physical safety as the rest of the population. But the war also brought in its wake a further complication of their political situation resulting from the open rift between the local citizenry and the imperial government. No matter what strategy they adopted, Jews ran the risk of being considered traitors by one of the two major sides in the conflict. Finally, the Jewish community had to face new and onerous tax burdens, the bequest of an imperial government in desperate need of capital in order to continue the military campaign.

In 1627 the pressures of extraordinary taxa-tion produced in the Prague Jewish community a dramatic confrontation which centered on Yom Tov Lipmann Heller (1579–1654), a prize pupil of Judah Loew and the current chief rabbi. Heller had spent twenty-eight years as *dayyan* ("judge") in Prague (having begun at the age of eighteen) and was recently returned from Vienna where he had enjoyed great success in re-establishing the Jewish community after its 1421 banishment. Upon his arrival in Prague, he immediately confronted the task of somehow repaying the loans that the community had been forced to take in order to meet Ferdinand II's special tax. Together with other Jewish leaders, Heller sought to raise the outstanding funds by direct taxation. This step set in motion a chain of events that laid bare the unseemly side of Jewish communal politics in Prague, a picture of intrigue, betrayal, and persecution. A segment of the Jewish community, opposed to the tax, accused Heller of favoring the wealthy over the poor and endeavored to have him removed from office. When this failed, anonymous individuals reported to the emperor's advisors that Heller had committed political misdeeds and had slandered the Christian religion.

Heller was arrested, imprisoned, and soon transfered to Vienna, where he faced interrogation by the Church. A court of Catholic priests passed a sentence of death on the unfortunate community leader. However, Ferdinand, a pragmatist at heart, commuted the decree to a large monetary fine. Heller spent a total of forty days in prison before returning in August 1629 to Prague. Not surprisingly, he concluded that the political atmosphere there was unhealthy and in 1631 made his way to Poland. There he served a distinguished career, becoming the head of the Cracow rabbinate in 1643 and the director of its

yeshivah five years later. Heller wrote about his tribulations in Prague in his fascinating autobiography *Megillat Eva* (Scroll of Hatred). He died in 1654, one of the most renowned halakhic commentators of his age.

This may not have been the first time that state authorities were called upon—however deceitfully—to intercede in a political dispute within the Jewish community, and it certainly would not be the last. Nor would factions within the community shrink from having rabbis imprisoned in the future. Conflict and the pursuit of power are facts of life in any political community, and one should not be surprised to find these themes in the history of Jewish autonomy in Prague. In any event, the Jews of Prague proved to be no less resilient than their former leader. In 1629 Ferdinand II renewed and extended the privileges of the Jews of Bohemia (though the following year, it is true, he ordered them to attend conversionist sermons preached by the Jesuits). During the last year of the war the Jews of Prague participated valiantly in

Fig. 62. *Prague under seige, 1648.*

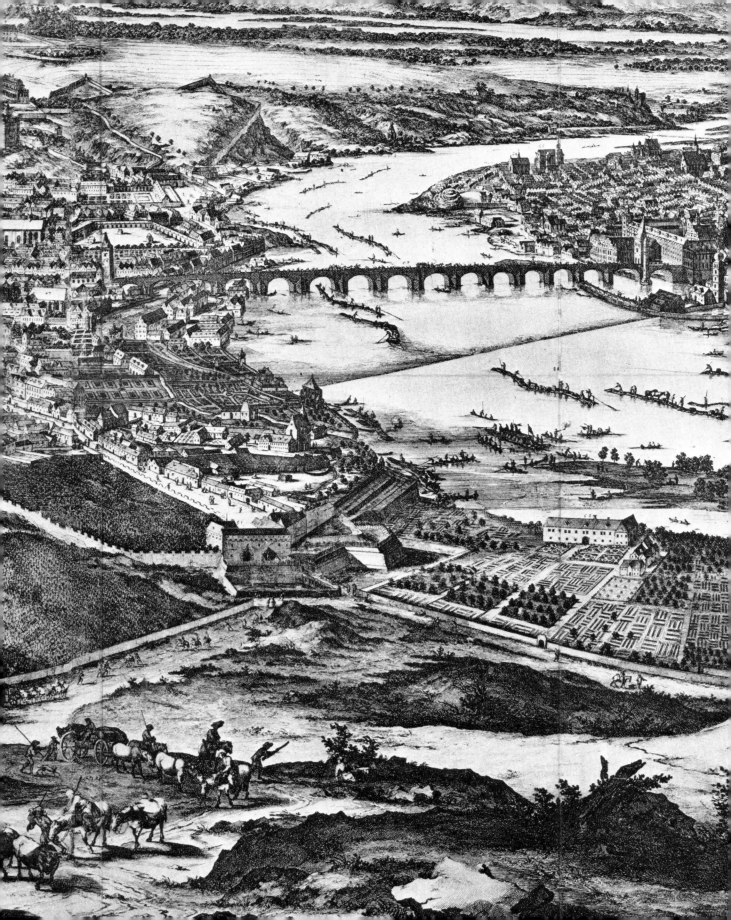

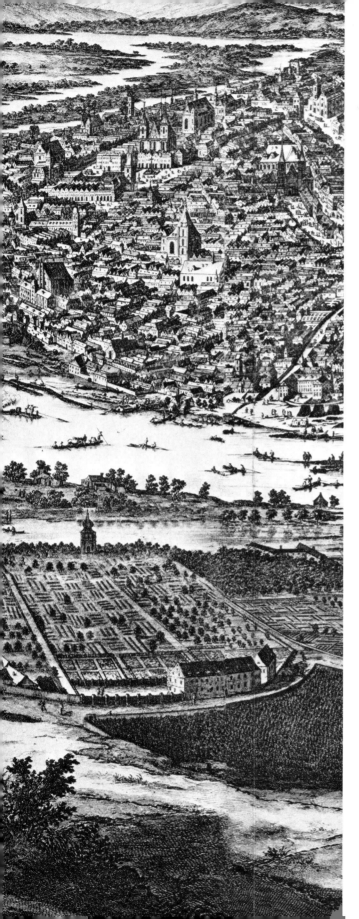

the defense of the city against the Swedes, and in recognition of their bravery, the Emperor presented the Jewish community with a special flag. Its design, a Swedish cap in the middle of the Star of David, became the official emblem of the Prague Jewish community. The flag hangs to this day in the Altneuschul, prominently displayed above the central balustrade.

Eventually, however, the war and events relating to it began to take their toll. Bohemia had absorbed many refugees from Poland and the Ukraine in the aftermath of the Chmielnicki massacres of 1648–49, the Cossack-led assault on hundreds of Jewish communities over the course of the Ukraine's military uprising against Polish overlordship. Government authorities, together with the Bohemian estates, began to express fears of uncontrolled growth of the Jewish population. In 1650 the Bohemian Diet took the first step in what was to be a two-hundred-year, often unsuccessful, program to limit the size of the Jewish community. The Diet decided to curtail the number of Jews permitted to reside in Bohemia and restricted their residence to places where Jews had been allowed to live before 1618. It combined a steady stream of restrictive legislation with frequent demands for higher Jewish taxation. A special committee was even appointed—the *Judenreduktionskommission*—charged with the task of finding ways to reduce the Jewish population in Prague. This flurry of legislative activity provided the backdrop for the more systematic exertions of the government to control the Jewish communities of the land in the

Fig. 63. *View of Prague, from Castle side of the Vlatava River, 1685.*

Fig. 64. *Torah curtain, Prague, 1685/6, (cat. 3).*

early decades of the eighteenth century, efforts which, on the whole, were more successful and long-lasting.

The fears of the authorities that the Jewish population of Bohemia following the close of the Thirty Years War was increasing at an unprecedented rate had at least some basis in fact. In Prague alone, the number of Jews grew from about 6,000 at the start of the seventeenth century to 7,800 in 1636 and then to about 10,000 to 11,000 by the beginning of the eighteenth century, making it the largest Jewish community in the world! It is somewhat more difficult to ascertain the precise Jewish population in the countryside at this time, since the first real census was not taken until 1724. Meanwhile, in 1635 the government indicated that there were 14,000 Jewish "taxpayers" in Bohemia. What the word taxpayer means is not at all clear and unfortunately cannot simply be equated with "head of household." What is clear is that many Jews from Central and Eastern Europe were finding refuge in the small towns and villages controlled by the local nobility. By 1724 the number of Jews living outside Prague (in Bohemia) had reached at least 30,000, a level that points to a decisive shift in the demographic balance between the metropolis and the countryside.

Originally all of Bohemian Jewry had been subsumed under one representative structure, and the only religious authority recognized by the Habsburg government was the chief rabbi of Prague. However, by the middle of the seventeenth century the growth of village and small-town Jewry had produced a major challenge to the status quo. In the beginning the communal leaders in Prague reacted to the growth of the provincial congregations by redistributing the tax burden to their disadvantage. Rural Jewry protested and demanded separation from the Prague Jewish corporation. In 1659 the *Böhmische Landesjudenschaft* achieved formal recognition as an independent entity whose main function was to collect and distribute Jewish tax monies (by now it had inherited more than half of the total burden). Only the chief rabbi Aaron Spira-Wedeles served to connect in a formal way the Jewish communities of Prague and the provinces.

Divisions both between Prague Jewry and the provinces and within the two Jewish communities seemed to proliferate following the death of Spira-Wedeles in 1679. Racked by internal dissension and inflicted with natural disasters—including a plague which claimed three thousand lives in 1680 and a fire which destroyed much of the Jewish Quarter in 1689—the Prague Jewish community seemed incapable of choosing a successor. Eventually it settled for dividing the functions of chief justice of the rabbinical court and head of the Talmudic academy. The Landesjudenschaft, meanwhile, went ahead and appointed its own chief rabbi, Abraham Broda, whose term began in 1689. This action brought an immediate challenge from representatives of the Prague community, jealous of the new prestige accorded the Landjuden. Within two years the realms of the Landesrabbiner were divided in two, the western half remaining under Broda's jurisdiction and the other eight districts given to the chief justice of the Prague rabbinical court, Wolf Wedeles.

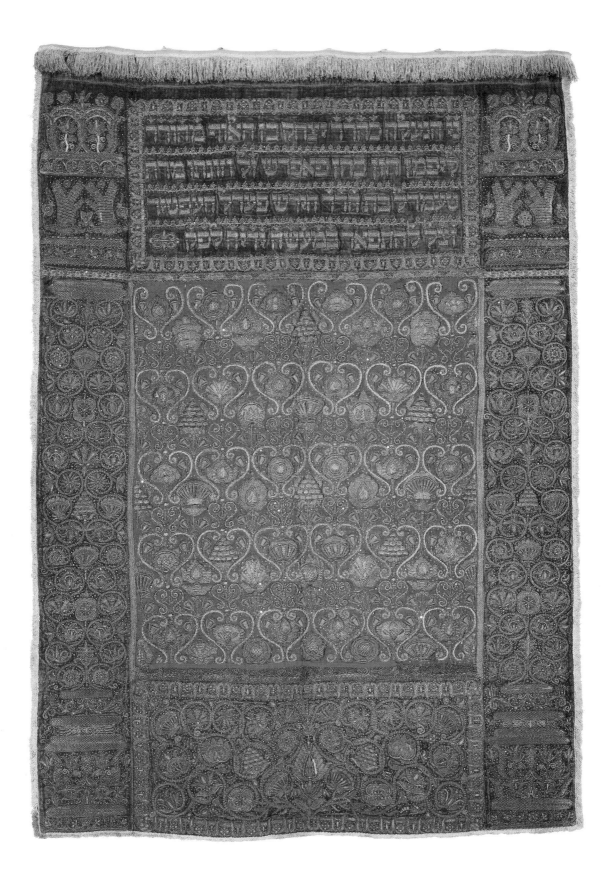

77

In effect, there were four chief rabbinates, although the two Prague positions were not officially designated as such. They were not to be reunited until the second decade of the eighteenth century under the leadership of David Oppenheim. Like the Maharal, Oppenheim had established his career as Landesrabbiner of Moravia (in Nikolsburg) before being named first chief rabbi of Prague by the Emperor in 1702. Over the next sixteen years Oppenheim consolidated his authority over all of Bohemian Jewry, assuming the two provincial rabbinical posts in 1713 and 1715 and the function of *rosh yeshivah* in 1718. He managed to maintain a unified chief rabbinate until his death in 1736. Already during Oppenheim's lifetime, however, the government attempted to rationalize the structure of the Landesjudenschaft by appointing district rabbis (*Kreisrabbiner*), and these eventually made the function of the Landesrabbiner obsolete; the position was abolished in 1749.

All indications from the social, political, and cultural life of the Jews of the Czech lands over the course of the seventeenth century lead to one conclusion: the Jews were in the process of becoming a mass community. In sheer density the community resembled the Jewish population of Poland and Lithuania. But it also enjoyed the unique dimension of the Prague metropolis, which lent political strength and prestige to the Jews of Bohemia while it vied for institutional dominance over the swelling ranks of the Landesjudenschaft. One of the more impressive indications of the social evolution of Czech Jewry during this period was its increasingly diversified occupational structure. Medieval Jewries by and large had participated in limited areas of banking and commerce. In the cities they performed the necessary functions of pawnbroking, moneylending, and dealing in secondhand goods. In the country Jews served as leaseholders of noble estates and productive enterprises such as distilleries and mines, and as overland traders and peddlers. The manual trades and crafts they pursued were limited to meeting the specific needs of the Jewish community, such as ritual slaugh-

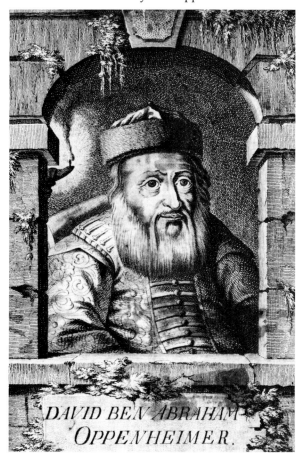

Fig. 65. *Portrait of Rabbi David Oppenheim (1664–1736), Prague, 1773 (cat. 244).*

Fig. 66.
*Torah mantle,
Prague, 1701/2
(cat. 20).*

Fig. 67.
Torah mantle,
Prague, 1725/6
(cat. 21).

tering, the production of books and religious articles, candle making, and some tailoring. On the whole, however, both artisan production and the sale of new commodities remained closed enterprises, controlled and regulated by the guilds, which insisted on limiting competition and preserving the Christian character of the profession.

However, as the Jewish community expanded, its economic profile changed as well. By the second half of the sixteenth century, more and more Jews were learning and practicing the trades. Many could make a living servicing the Jewish Town alone; others vied for clients among the non-Jewish population in the public

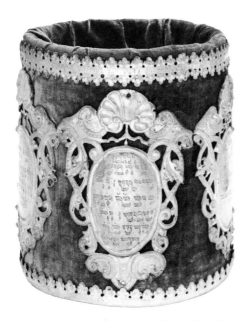

Fig. 68. *Ballot box for Burial and Benevolent Society, Mikulov, Moravia, mid-18th century (cat. 149).*

marketplaces and elsewhere. Nor were the Christian burghers in the Old Town able to do much to prevent the growth in Jewish competition. Rudolph II turned a deaf ear to their demands that he should prohibit Jewish involvement in the trades. In 1627 Ferdinand II accorded Jewish merchants equal rights with non-Jews at fairs as well as equality in the payment of customs duties. He permitted Jews to learn the crafts without interference. His successor, Ferdinand III, expanded upon these provisions in 1648 when he declared nearly all of the crafts open to Jews, allowed Jewish craftsmen to work for non-Jewish patrons, and permitted the sale of their finished products to the Christian residents of Prague and Bohemia at weekly markets, annual fairs, and in their own shops.

Census data from the early eighteenth century reveals just how far Jewish participation in the trades and crafts had progressed by this time. Of some 2,300 "gainfully employed" Jews in Prague in 1729, more than 700 were listed as artisans. These included 158 tailors, 100 shoemakers, 39 hatmakers, 20 goldsmiths, 37 butchers, 28 barbers and bath attendants, and 15 musicians! Similarly, in provincial Bohemia more than 19 percent of the Jewish heads of families practiced trades and crafts, and an additional 13 percent worked as leasers of distilleries, tanneries, and potasheries, or as innkeepers.

The Christian guildmasters of Prague vehemently protested the wartime concessions that had been made to the Jews by the Habsburg rulers. The non-Jewish artisans tried as best they could to prevent Jews from joining their

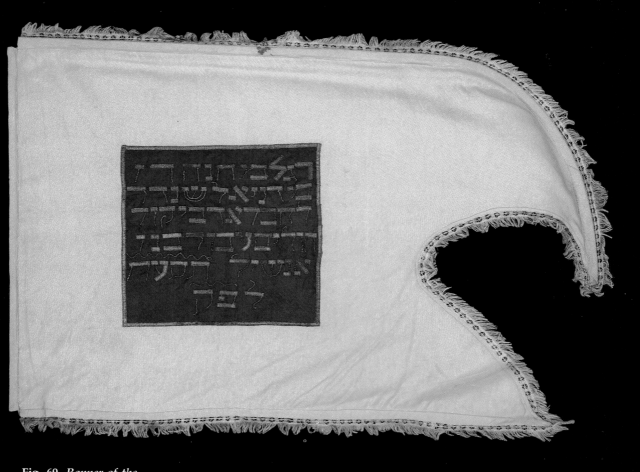

Fig. 69. *Banner of the
Society for Visiting the Sick,
Bohemia, 1817/8 (cat. 150).*

own associations, but they did not succeed in reversing the decision of government officials to allow Jews to produce and sell goods freely throughout the city. Whether as a result of the growing hostility of Christian masters, or simply because the Jewish Town itself had produced so many of its own artisans, independent Jewish guilds began to emerge with some frequency following the close of the Thirty Years War. Patterned after the Christian model, the Jewish guilds, too, served essentially as economic organizations which established rules governing the relations between members, fixed the status of craftsmen, trainees, and apprentices, and insti-

tuted standards and quotas of production. Yet, as we learn from the statutes of the Jewish Tailors' Guild, the social obligations of its members were defined as well:

[14.] A journeyman shall work six years for a master before he is permitted to marry. By applying to the elders of the Prague Jewish community for permission to marry he shall produce a testimonial to his good conduct from the Wardens of the Guild.

[15.] A journeyman who is betrothed shall work for his master until his wedding day, even if he was working on his own wedding clothes.

[16.] Every journeyman is required to attend shul *[synagogue] every day, especially on Mondays and*

Fig. 70. *Procession of Prague Jews
with guild flags and emblems at the
1741 celebration of Prince Joseph's birth.*

*Thursdays [days, other than Sabbaths and Holidays,
on which the Torah is read publicly].*

*[17.] Also, every journeyman and every apprentice
shall have half an hour free to learn how to write.[8]*

Like their Christian counterparts, the Jewish
guilds of Prague designed their own flags and
emblems which they displayed at festivals and
pageants, such as those marking the 1741 cele-
bration of the birth of Prince Joseph, at which
they put on a particularly dazzling display of
pomp and color. Each guild had its own band
precede it as it marched along the streets of the

city: the tailors with their banner made of odds
and ends of cloth topped with a pair of gold-em-
broidered scissors; the furriers, whose members
wore Persian furs and carried banners and stuff-
ed animals; the shoemakers, whose emblem was
a large goblet shaped like a boot; barbers, featur-
ing a razor; the druggists with a mortar; down
to the lace-, braid-, cord-, and button-makers'
guild, whose symbol was an artisan's work-
bench. Scenes such as these, unadorned by com-
mentary, conveyed precious information about
the economic vitality of the community, its deep
sense of civic pride, and its place in the human
ecology of Bohemia.

83

THE MAKING OF A
MODERN JEWISH COMMUNITY

*It by no means is my intention to expand the Jewish
nation in the hereditary lands or to re-introduce
them to areas where they are not tolerated, but
only—in those places where they already exist and
to the extent that they are already tolerated—to
make them useful to the state.*

Declaration of Joseph II, October 1, 1781[9]

Political autonomy and traditional culture—the
hallmarks of most pre-modern Jewish commu-
nities—also characterized Jewish life in the
Czech lands until the second half of the eigh-
teenth century. Although conversant in the day-
to-day culture of the environment, the pre-mod-
ern Czech Jewish community operated primarily
within the confines of Jewish language (a form
of Yiddish), normative practices, and traditional
attitudes and beliefs. Although integral to the
social and economic life of the city or village at
large, Jews also constituted a separate legal cor-
poration with specific rights and obligations dis-
tinct from, but comparable to, those of the other
medieval estates. As long as the institutional
structure of the community and of society at
large remained the same, as long as the cultural
outlook of previous centuries held sway, Jewish
life proceeded along these lines—limited but fre-
quent contact with outside culture, communal
independence and self-sufficiency, and the over-
whelming influence of Judaism's religious
norms.

The seeds for the transformation of Jewish life
toward the end of the eighteenth century lay in
three separate, but often parallel, developments.
The first involved the social and economic mod-
ernization of society at large, those changes
which, taken together, marked the transition
from a land-based, feudal economy to one stim-
ulated by capitalist enterprise and industrial pro-
duction, and from a corporatist social structure
to a class society in which individuals—not
groups—formed the basic legal unit. Under such
conditions Jews were drawn into the new modes
of economic activity and the new forms of social
organization. They began to relate to society and
state as individuals whose existence and status
no longer depended entirely on the official com-
munity from which they had emerged.

Developments in the political sphere which
aimed at centralizing authority, rendering the
machinery of government more rational and ef-
ficient, and eliminating competing centers of
power, formed the second group of changes that
helped to push Jewish society into the modern
age. They did so by incorporating that society
into the modern state—which was, after all, the
end product of these political developments—and
by redefining the relationship between the Jews
and the state. The juridical autonomy of the Jew-
ish community would not be recognized; such a
throwback to the intermediate political bodies of
medieval society no longer could be tolerated.
The state demanded civic conformity and loyalty
on the part of Jews as individuals. It regarded
these individuals as subjects capable of rendering
service to the state and, eventually, as citizens
deserving equal treatment under its laws.

The third major trend involved the weakening
of religious attitudes and beliefs, the substitution
of enlightenment notions of rational truth, vir-
tue, and beauty for the revealed truths and re-
ceived assumptions of traditional culture.
Developments in this sphere affected both gen-
tile and Jewish society, creating in the former a
social context in which individuals from different
religious backgrounds could meet on some kind

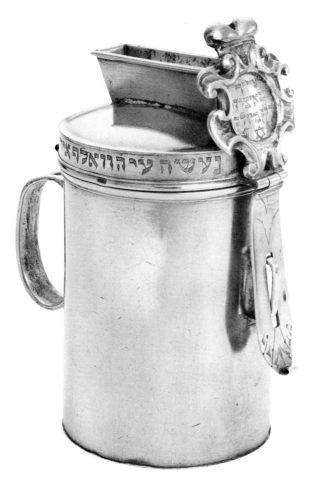

Fig. 71. *Alms box, possibly Brno, Moravia, 1763/4 (cat. 82).*

of common ground, and in the latter a desire to appropriate vast amounts of western culture, to approximate general society more and more in dress, manners, and standard of living. The Enlightenment, then, produced crucial attitudinal changes on both sides of the Jewish-gentile divide. It encouraged non-Jewish society to become more open to participation from formerly excluded minority groups, and it moved individual Jews to demand of their own culture the removal of ingrown defenses which had served it well in another era.

Of these three trends, the social and economic sphere was the least developed in the lands of the Habsburg monarchy. Yet the occupants of the throne, beginning with Maria Theresa (1740–1780) and her co-regent and successor, Joseph II (1765–1790), were determined to integrate the disparate domains of the realm into an efficient and powerful state. They set about this project in a variety of ways: by strengthening the institutions of the central government; by instituting educational, social, and legal reforms; and by promoting international trade and new forms of production. Faced, then, with a relatively underdeveloped economy and a traditional society, the newly-emerging state took it upon itself to institute many of the modern transformations that were occurring more naturally in the West. Change was imposed and regulated from above in a grand effort to overcome perceived backwardness, achieve great power status, and at the same time avoid the pitfalls of radical social and political upheaval.

Joseph II's accession to the throne in 1780 ushered in an era of direct government interference in the affairs of the Jewish community and the institution of reforms so wide-ranging as to change decisively the face of Jewish life in the region. The first salvo in a decade-long volley of proclamations and laws was also the most dramatic. The Edict of Toleration *(Toleranzpatent)*, issued for Bohemia in October 1781 and for Moravia the following February, not only affirmed the principle of religious toleration (for Protestants and Orthodox Christians as well as for Jews), but also aimed at restructuring Jewish economic life and reorienting Jewish culture. Joseph's expressed purpose in introducing the edict was neither to encourage Jewish settlement in his lands nor to remove the demographic restrictions under which Jews had been living since the early eighteenth century. His goal quite simply was to render the Jews already living in Aus-

85

tria "more useful" to the state. To this end he opened all forms of trade and commerce to Jewish participation, encouraged Jews to establish factories, and urged them to engage more fully in artisanal production and agriculture (it appears that Joseph and his advisors were in fact rather ignorant about the extent to which Jews were already active in the crafts).

The most far-reaching changes occasioned by the Edict of Toleration took place not in the area of economic activity but rather in the cultural and educational realm. The government was in the process of redesigning the entire elementary school system in the country and, toward this end, invited all of the Jewish communities which were large enough to set up government-supervised schools of their own to instruct students in mathematics, geography, German language, and morality. Parents who lived in communities

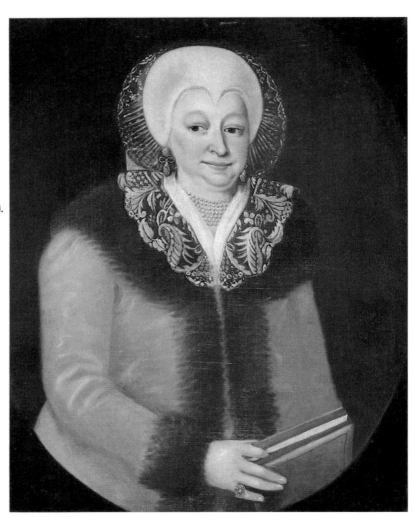

Fig. 72. *Portrait of Sara Moscheles (1745–1815), Prague, ca. 1790 (cat. 224).*

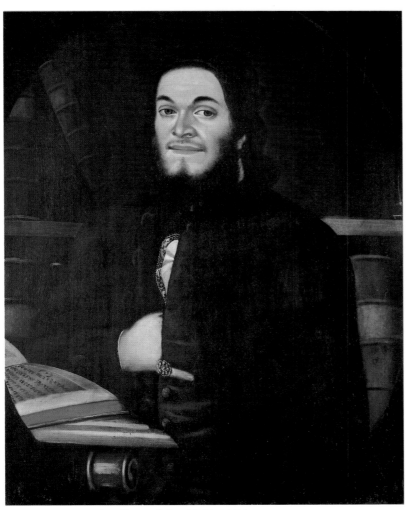

Fig. 73. *Portrait of Wolf Moscheles (1744–1812),*
Prague, ca. 1790 (cat. 225).

that could not afford to construct their own schools could send their children to gentile schools. Meanwhile the doors of the universities and institutions of higher education were opened for Jewish enrollment. Of course, the Jews of Bohemia and Moravia could hardly have been accused of neglecting education, but the government's purpose in creating a new educational tract was to break down what it considered to be cultural barriers to the formation of useful and productive subjects. A traditional *ḥeder* (Jewish elementary school) education could not, in the government's view, perform this function, because these schools taught only in Hebrew and Yiddish, perpetuated long-established patterns of Jewish exclusivity, failed to instruct students in the basic accounting skills needed to run an efficient business or trade, and, most importantly, failed to impart unto the students a

proper foundation in social morality. The edict's further provision that business and communal records no longer could be kept in Hebrew or Yiddish underscored the government's commitment to the cultural assimilation of the Jews; it was also a necessary step in assuring that henceforth the state would be able to monitor the books and records of its Jewish population.

Just as the Josephine ordinances were being presented and enacted, the Jewish communities of Bohemia and Moravia appeared to be enjoying one last great surge in cultural vitality and communal leadership. The Prague community had struggled with a number of setbacks in the eighteenth century. These included violent clashes in the early 1720s between supporters of Chief Rabbi David Oppenheim and those of Rabbi Jonathan Eybeschütz, who headed a major yeshivah in the city; the temporary expulsion order of Maria Theresa, which lasted from 1745 to 1748; and yet another devastating fire which swept through the ghetto in 1754. The following year, however, a new chief rabbi and rosh yeshivah assumed office—Ezekiel Landau (1713–1793), who until then had been serving the Polish-Ukrainian province of Podolia. From 1755 until 1793 he restored order and prestige to Prague's Jewish metropolis, re-established the preeminence of its yeshivah, and served as the undisputed spiritual head of Bohemian Jewry in

all dealings with the authorities. The author of a major commentary on the Talmud as well as a famous collection of responsa (*Noda bi-yehudah*, 1776), Landau provided decidedly conservative leadership to the Prague community during an era of transition.

The chief rabbi distrusted both the motives and the potential effects of the Haskalah, the Jewish movement for enlightenment, and western acculturation which had its most active circle at the time in Berlin, and was no less wary of government attempts to redirect the traditional affairs of the Jewish community. After the promulgation of Joseph's Edict, he urged the congregants at the Altneuschul "to maintain both the fear of God and the fear of King, to fulfill the wishes of His Majesty . . . but take very great care to fear God." "The essence of things," Landau warned, "is faith, not reason and investigation."[10]

Hence, prudence prevailed when the director of educational reform in Bohemia (a liberal priest by the name of Kindermann von Schulstein) assured Landau a central role in the planning and supervision of the new German-Jewish schools. In this way, Kindermann silenced a potentially powerful voice of opposition within the Jewish community and, sacrificing radical change to more gradual reform, nevertheless assured the success of his overall program. Be-

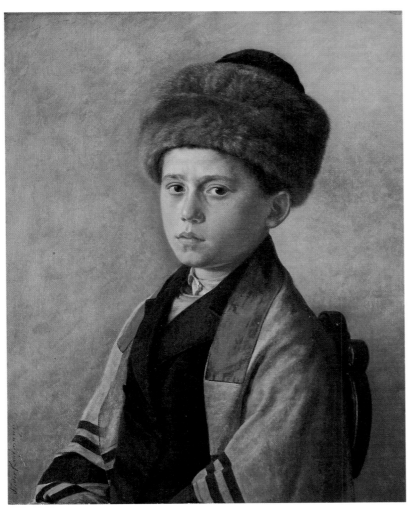

Fig. 74. *Portrait of a Boy, probably Vienna,*
end of 19th century (cat. 242).

tween 1790 and 1831, years
during which attendance rec-
ords were kept, some 17,800
children received a western-
style education at the Prague
Jewish school. This figure rep-
resented a yearly average of
424 students, approximately 40
percent of those who would
have been eligible to attend.
The various communities of
the Landesjudenschaft proved
to be at least as willing as
Prague Jewry to support the
new educational program of
the government. A report for
the year 1787, five years after
the project was begun, claimed
that 559 students were attend-
ing twenty-five rural Jewish
schools; another 278 Jewish
children had enrolled in Chris-
tian schools in over fifty differ-
ent localities. Over the course
of the next half century Ger-
man acculturation reached
nearly all segments of Bohe-
mian and Moravian Jewish so-
ciety. One can date the cultural
modernization of Czech Jewry

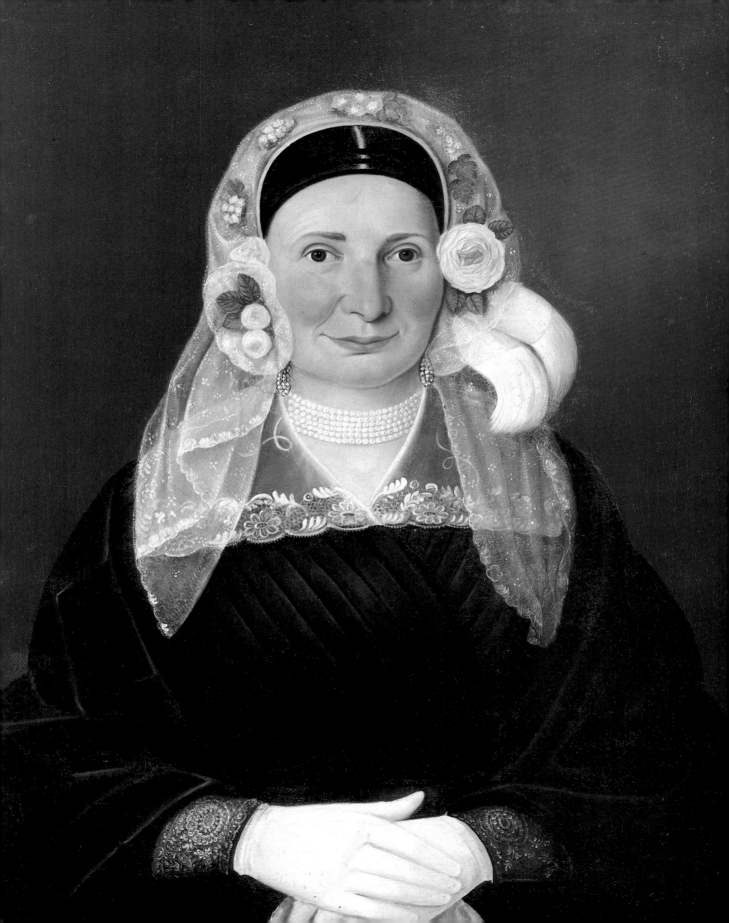

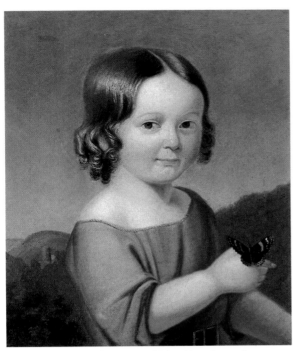

Fig. 76. *Portrait of a Young Girl with a Butterfly, probably Legnica, 1848 (cat. 234).*

from these years.

The Habsburg monarchs of the late eighteenth century may have prided themselves on their enlightened outlook; they even may have encouraged a degree of cultural and economic movement in the kingdom. But they remained absolute rulers to the end and displayed no inclination to broaden political participation or introduce democratic reforms. Thus political emancipation never entered into Joseph II's or Leopold II's prescriptions for the Jews. And, with the onset of political reaction following the death of Leopold in 1792, the processes of social and cultural integration stagnated somewhat. A systematic review of recent Jewish legislation in

1797 (the so-called *Judensystemalpatent*) acknowledged and affirmed the extent to which the Jews of Austria had been incorporated into the state and society. However, no further legislation was enacted until the heady, revolutionary days of 1848–49. Then from 1848 to 1867 a series of laws and constitutional decrees gradually removed all of the remaining restrictions on Jewish life. The legal validity of the ghetto was abolished formally in 1848, and Jews were permitted to reside in all areas of Bohemia and Moravia. Emperor Franz Josef's Constitutional Edict of 1849 granted Jews equality with Christians under the law. After 1859 the last barriers to free economic activity and association were torn down and the government also confirmed the right of Jews to own land. Finally, with the creation of the Dual Monarchy in 1867, full political emancipation for Jews was proclaimed officially.

It was one of the ironies of the process of emancipation in Bohemia and Moravia that the expectations placed on the Jews for cultural conformity and political loyalty quite soon became enormously complicated. The Enlightenment reforms of Joseph II were instituted according to the assumption that the language and culture of society at large were German and that loyalty to the state meant allegiance to the Habsburg House in Vienna. However, the Austrian Empire did not comprise a uninational state like France or England, and hence the question of into what

Fig. 75. *Portrait of an Older Woman in a Tulle Cap with Roses, Prague, ca. 1850 (cat. 235).*

nation and through what language the Jews were to assimilate was not as straightforward as it appeared to be at the time.

The German population of Bohemia and Moravia indeed did constitute a privileged group and did dominate urban life in the region. However, Czech-speaking peasants (together with an increasingly Czech-speaking aristocracy) formed the majority. But the turn of the nineteenth century, advances in universal education, together with the beginnings of urbanization and industrialization, had produced an articulate, Czech-speaking middle class which, in turn, was engaged in a full-fledged cultural and linguistic revival of its own. Thus, at the precise moment that the Jews of the Czech lands assiduously were adopting the German language and assimilating German cultural patterns as a means to civic improvement, an increasingly vociferous and influential group in Czech society was challenging the very position of German in the balance of political and cultural forces.

This is not to say that the Jews were oblivious to the changes that were going on about them. Although the majority of Jews, together with a great many Czechs, were content to reap the rewards of a German education and take advantage of the general flowering of German culture, a

Top, Fig. 77. *Seal of the Nikolsburg High School Directorate, 19th–20th century (cat. 139).*

Middle, Fig. 78. *Seal of the Jewish Society for the Poor and Hospital Director(s) in Nikolsburg, 19th–20th century (cat. 138).*

Bottom, Fig. 79. *Seal of the Rousínov Community, Moravia, 19th–20th century (cat. 142).*

small number of intellectuals associated with the Young Bohemia literary movement thought differently. Bohemian Jews such as Moritz Hartmann, Siegfried Kapper, and Alfred Meissner, all of whom studied at the University of Vienna in the 1840s, advocated a program of political democracy based on a rapprochement between Slavs and Jews in the old monarchy. Hartmann employed Hussite symbols in his book of poems *Kelch und Schwert* (Chalice and Sword) as did Meissner in his poem about the Hussite general Žižka. Siegfried Kapper achieved recognition with the publication of his first book of poems, *Slavische Melodien*, and created some excitement in Czech literary circles in 1846 when his second volume of poetry, *České listy* (Czech Leaves), appeared, the first work to be written in Czech by a Jewish author. In one of the poems Kapper appealed to the Czech people to accept his overture:

Only a non-Czech call me not, I pray,
For I too am a son of Czech domains!
The way your heart beats for your native land,
Thus fervently mine courses through the veins.

What if my tribe once dwelt near Jordan's shores,
This need not break my brotherhood with thine!
Or is there a law to hinder my resolve.
To place my heart and soul upon my country's
 shrine?[11]

By and large the tentative efforts at a Czech-Jewish alignment in the 1840s went either unnoticed or unappreciated. Czech nationalism had not yet fully matured into a political movement for cultural autonomy, and its leaders did not put a very high value on the prospects of Jewish cooperation. The Jews, for their part, felt no compulsion to alter a course of cultural assimilation which was still less than a century old and which continued to hold the promise of social and political rewards. When the Jews were granted, at least temporarily, civic equality under law in 1849, they recognized that the initiative once again had come from Vienna and that the Austrian state offered in the long run the clearest path to social and political advancement. The middle decades of the nineteenth century (ca. 1830–1870) had the overall effect of solidifying the German-Jewish cultural synthesis: Jews, particularly in the cities and towns of Bohemia-Moravia, were commited devotees of German language and education, loyal servants of the Habsburg king, and ardent supporters of the Progressive Party.

Not until the 1870s and 1880s did the full effects of the national antagonisms in the country come to be felt by large segments of the Jewish population. The growing forces of the Czech na-

Fig. 81. *Jewish Quarter, turn of 20th century.*

tional movement in provincial Bohemia and Moravia took exception to the existence of German-language schools in an overwhelmingly Czech milieu and pointed an accusing finger at the Jewish sponsors of these institutions (these were, after all, remnants of the Josephine school system), complaining that they served to per-

petuate German cultural and political domination. At the same time large numbers of rural, Czech-speaking Jews were migrating to the cities and new industrial centers of Bohemia and Moravia. Many of the sons and daughters of these Jews had themselves been influenced by the aspirations of Czech nationalism and reacted to the

Fig. 80. *Family portrait, turn of 20th century.*

German domination in the urban centers with much the same dissatisfaction as their non-Jewish counterparts. During the last quarter of the nineteenth century an extensive network of Jewish institutions emerged which was dedicated in one way or another to the achievement of a genuine Czech-Jewish acculturation. Academic organizations such as the *Spolek českých akademiku-židu* (Association of Czech-Jewish University Graduates), political movements like the *Národní jednota českožidovská* (National Union of Czech Jews), and even new religious

Fig. 82–83. *Turn-of-the-20th century photographs of Prague's Jewish Quarter.*

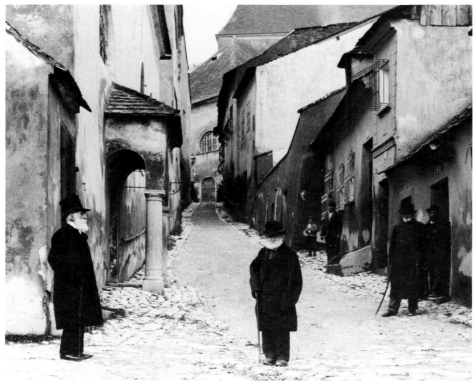

Fig. 84. *Turn-of-the-20th century photograph of the Mikulov (Nikolsburg) Jewish Quarter.*

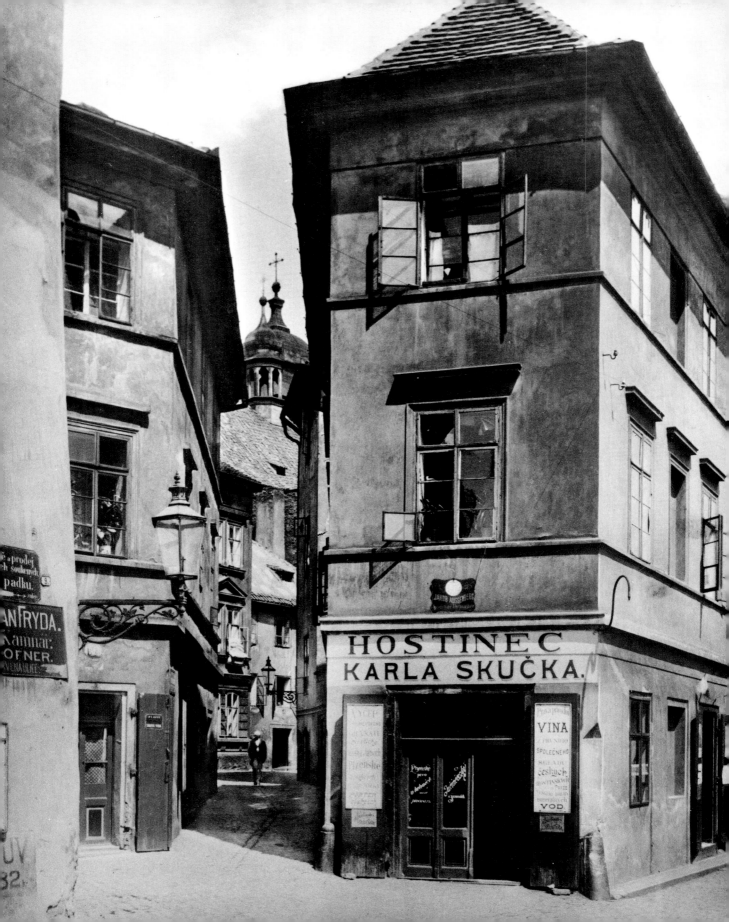

Fig. 85. *Jewish Quarter,*
turn of 20th century.

formations such as the *Or Tomid* society loosely comprised what has been referred to as the "Czech-Jewish movement" (*Svaz Čechu-Židu*). Taken together, the efforts of these groups reflected the beginnings of a cultural reorientation of Czech Jewry, an answer to the complexities of nationalism in a post-emancipatory era, and a preparation for the challenges of integration in a Czech-dominated society in the not-too-distant future.

A third alternative to the Czech and German national camps presented itself with increasing cogency during the turbulent half decade which brought the nineteenth century to a close and in the early years of the twentieth. While Jewish nationalism sought to restore a Jewish homeland in the historic Land of Israel, it also strove to reestablish a positive sense of Jewish national culture in post-emancipatory Europe. Small but quite active pockets of university students, businessmen, and young professionals throughout Bohemia and Moravia felt called upon to question the very premise of national assimilation, to insist that their ethnic affiliation was neither German nor Czech, but Jewish, and set to the task of creating a modern, national, Jewish culture appropriate to the multinational context of Central Europe. Many of the more creative minds of the younger generation of Prague Jews—among them the philosopher Hugo Bergmann, the historian Hans Kohn, the journalist Robert Weltsch, and the writer Max Brod—applied themselves with tremendous en-

ergy to the cause of the Jewish national movement. Most had emerged from the Prague student Zionist organization Bar Kochba, which was founded in 1899; a number were active in the influential Zionist bi-weekly *Selbstwehr*, which was published in Prague from 1907 to 1938; but all were committed to the cultural and political renaissance of the Jewish people and

Fig. 86. *Family portrait,*
turn of 20th century.

Fig. 87. *Family portrait, turn of 20th century.*

consciously drew upon the example of the Czech rebirth of the previous century. "The Jewish nation has been woken," commented *Selbstwehr* in its introductory issue of March 1, 1907, "roused from its torpidity and relaxation, and stretches everywhere to new life."[12]

Prague Zionism and the Czech-Jewish movement stood in many ways as diametrical opposites. The Jewish nationalists wished to abstain, as it were, from the national conflict, to remain neutral on the question of the use of the German or the Czech language, and to create an autonomous community of culture drawing on the remnants of collective memory, the rich fountain of the East European Hebrew revival, and popular interpretations of traditional Jewish thought and expression. The Czech-Jewish assimilationists, no less nationally committed than the Zionists, resented the efforts of their rivals to denigrate the progress of acculturation since the Enlightenment and saw the future of Jewish life in the Czech lands in terms of a more complete rapprochement between Jews and Slavs based on a fuller appropriation of Czech language, literature, and political aspirations. However, these two movements shared at least one fundamental characteristic: they both pointed to the disintegration of the liberal German-Jewish synthesis of the nineteenth century. Rejecting the identification of German interests with Jewish ones, both Prague Zionism and the Czech-Jewish movement wished to introduce a post-liberal alternative to the terms and conditions of Jewish emancipation in the Czech lands. The new face of Czech-Jewish culture would be more responsive to the climate of national diversity in Central Europe and would serve as a more promising vehicle for the perpetuation of the Jewish community in the twentieth century.

Despite the indications of growing cultural discontent among the Jews of Prague and the Czech lands, the position of the German language and the value accorded a German education did not suffer any real deterioration until after 1930. By 1910 the official number of German speakers in Prague had dwindled to a minuscule 7 percent of the total population of the city, but Jews made up nearly 40 percent of this group, thus providing crucial moral support at a time of steady and visible decline. Indeed, census figures alone do not attest to the full extent of Jewish support for German institutions. While it is true that as early as 1900 over 55 percent of the Jews of Bohemia and over 50 percent of the Jews of Prague declared their language of daily use to be Czech, it also is true that most of these same "Czech speakers" were sending their sons and daughters to German-language schools and universities. Over 90 percent of Jewish primary schoolchildren were enrolled in German institu-

tions; the figure for Jewish children in the secondary schools as late as 1910 reached 83 percent; meanwhile, in 1901–1902 some 395 Jewish students attended the German University in Prague, comprising over 28 percent of the total student body, and only 84 joined the ranks of the Czech University, representing a mere 2.4 percent of the total there.

As if to compensate for its own demographic decline, German-speaking Prague during the first three decades of the twentieth century engaged in a frenetic outpouring of literary creativity. These were the years when the phenomenon known as *Prager Deutscher Literatur* broke through the confines of provincial culture and emerged as one of the truly great achievements in world literature, when writers (nearly all of them Jewish) such as Oskar Baum, Max Brod, Ernst Weiss, Franz Werfel, and Franz Kafka were defining the very contours of modern German letters. Kafka, perhaps the most famous of all Prague Jews, had the ability to translate the turmoil and confusion of his own inner world into a universal language of psychological uncertainty which continues to captivate readers of all nationalities. Works such as *The Trial* and his masterly story "The Judgment" highlight the modern dilemmas of guilt (real and imagined), punishment (self-inflicted and meted out by society), and justice (seemingly undeliverable, certainly incomprehensible). In his novel *The Castle*, Kafka epitomizes modern man's unattainable spiritual quest, the ceaseless trek after the source of all truth, power, and authority which never manages to reach its mark and yet is never far off.

Fig. 88. *Franz Kafka (1883–1924).*

The creative works of the German-Jewish writers of Prague reflected not so much their confidence in the long-term viability of German culture as their sense that they were standing at the end of a historical process. Theirs was to be the last generation educated before World War I, the last to enjoy the rewards accorded German speakers in the multinational empire. Yet this generation was also the first to represent Prague Jewry under the new Czechoslovak Republic (founded in October 1918). As such, the German-Jewish writers of Prague, no less than the leaders of other Jewish cultural movements, were helping to outline the overall cultural reorientation that was in progress. Members of the Prague circle as a rule detested (and certainly received no support from) the radical German nationalists of Austria and Bohemia. Max Brod

Fig. 89. *Group of Czech Jewish schoolchildren, turn of 20th century.*

turned his writing to the service of the Jewish national movement; Oskar Baum and Franz Kafka likewise showed an interest in Zionism. Kafka spent much of 1911 and 1912 encountering the mysteries of East European Judaism at the hands of a Yiddish theater troupe from Warsaw; during his struggle with tuberculosis he entertained notions of emigrating to Palestine, where he would open a restaurant; on other occasions he was known to have frequented the gatherings of Czech anarchists. No writer with this kind of personal history, having emerged from that peculiar cultural mixture that was Prague, can be considered to have been simply a German. Kafka was a Czech Jew, born and raised in Prague, bilingual, though educated in German, with strong leanings toward the Jewish national revival and an abiding fondness for the landscape of the Czech countryside.

An even more striking sign of the special posi-

tion of these writers and artists within the broad spectrum of German culture can be found in their role as translators and cultural mediators. During this period of bitter national struggle, many of the German-Jewish writers of the Czech lands took it upon themselves to serve as a bridge between two worlds, bringing the literature, thought, and music of the Czech masters to the much larger German-reading public in Europe. It was Max Brod who lifted Leoš Janáček out of obscurity in Moravia and introduced his operas to Central European audiences. The writer Otto Pick devoted many years to translating the works of Otokar Březina, František Langer (a Jewish playwright who wrote exclusively in Czech), Karel Čapek, and others. Rudolf Fuchs produced Petr Bezruč's *Schlesische Lieder* (Silesian Songs) as well as an anthology of one hundred years of Czech poetry. On the other side of the cultural divide, Otokar Fischer, professor of German at the Czech university in Prague, busily translated the works of Heine, Kleist, Schiller, Hofmannsthal, and also the French-Jewish poet André Spire into Czech.

The list of mediators between Czech and German culture goes far beyond the few names that we have shown. All of this activity points to a central fact: the modern Czech-Jewish community went through not one but two distinct processes of cultural adaptation. The first, which lasted from approximately 1780 to 1870, was encouraged by the enlightened policies of the central government. It was defined by the standards of Austrian-German culture and pursued in large measure because of the promise of emancipation. The later adaptation, which occurred during the last third of the nineteenth century and the first third of the twentieth, was marked by the post-liberal and post-emancipatory demands of national conflict in an industrialized society. Jews during this period responded to pressures to define both personal identity and social position according to individual support for an aspiring national group. The Jewish contribution to all of this, whether in the form of participation in the Czech national movement, Zionism, or modern German culture, was remarkably consistent: insistence that the tone of the national debate be modulated, that broad areas of understanding and mutual cooperation be established, and that the ethnic, religious, and linguistic diversity of the state be preserved.

Fig. 90. *Procession to dedicate a new Torah scroll, Prague, turn of 20th century.*

EPILOGUE:
THE HOLOCAUST AND BEYOND

Czech Jewry's transformation to an increasingly diversified ethnic and religious minority was cut short, tragically, by the turn of events. Like Czechoslovakia's own brief history of political democracy and national integration, the Jewish experiment in cultural adaptation enjoyed rapid success; but both appear to have been doomed in the face of foreign aggression and a murderous occupation. Whether the humanistic, liberal nationalism of Masaryk and Beneš would in the long run have succeeded in fashioning a cohesive and viable state will forever remain a mystery. And we will never know if the pluralistic, though intensely loyal, stance of Czech Jewry would have worked to accomplish the necessary political and social integration of the country's Jews while preserving their own national distinctiveness.

Czechoslovak Jewry in the 1920s and 1930s consisted of three separate communities, cut off from one another by history and geography, and distinguishable in terms of their respective degrees of westernization: the Czech Jewish community, made up of Jews living in Bohemia, Moravia, and Silesia; Slovakian Jewry, which until 1918 had existed under Hungarian rule and hence was largely Hungarian-speaking; and, at the far eastern corner of the country, worlds apart from their largely assimilated coreligionists in the Czech lands, the Jews of Subcarpathian Ruthenia. Czech Jewry comprised the second-largest group. Its population stood at about 125,000 in 1921 (35 percent of the total Jewish population of Czechoslovakia); thereafter the number of Jews proceeded to decline—the com-

bined result of emigration, low birth rate, and rapid assimilation—so that by the time the 1930 census was taken, less than 118,000 remained (just under 33 percent of the total). With the victory of National Socialism in Germany in 1933, the movement of political refugees into the Czech lands temporarily reversed the pattern of decline. The Jewish population in 1938—before the Munich Accords—stood at 122,000.

However, the fate of Jewish life in Czechoslovakia relied entirely on the survival of the fragile and troubled state. Czechoslovakia's own demise at the hands of Germany (and the forces of appeasement in the West) began with the country's dismemberment in September 1938. It is also this date which opens the final chapters in the history of Czech Jewry. The Munich Accords inaugurated a chain of events which both radicalized Czechoslovak politics and traumatized the Jewish population. As many as 25,000 Jews from the Sudetenland found themselves in the position of becoming disenfranchised overnight and subject to the officially sanctioned anti-Semitism of Nazi Germany; they chose to become refugees in a truncated Czechoslovakia rather than hand themselves over to the German authorities. Parts of Slovakia and Subcarpathian Ruthenia—with a Jewish population of about 80,000—were ceded a few months later to Hungary. Meanwhile the now autonomous Slovakia, under the direction of Andrej Hlinka's People's Party, was becoming increasingly anti-Semitic. On March 14, 1939, Slovakia declared its independence from Prague and proceeded to sign a Treaty of Protection with Nazi Germany. Germany sealed the fate of the Czech lands—and concomitantly of its Jewish population—on March 15. As German troops speedily occupied the country, the

Fig. 91. *"Work makes [one] free" proclaims sign painted over entrance to Terezín Small Fortress.*

last vestiges of Czech independence were erased and the area transformed into a German "Protectorate."

During the period of time which lasted from the occupation of March 1939 to the establishment of the concentration camp ghetto in Terezín in October 1941, many within the Czech-Jewish community managed to escape to safety. Some twenty-six to twenty-seven thousand Jews emigrated to Palestine, the United States, South America, and Western Europe. Yet approximately 92,000 remained behind. The vast majority of these people—some 74,000—were forced to occupy the camp at Terezín. The German authorities only intended this as a way station on the road to the extermination camps in Poland, and, indeed, over 80 percent of the Terezín detainees were eventually deported to places such as Auschwitz, Maidanek, Treblinka, and Sobibor. Other Czech Jews were sent directly to the death camps. Researchers in postwar Czechoslovakia, working from actual trans-

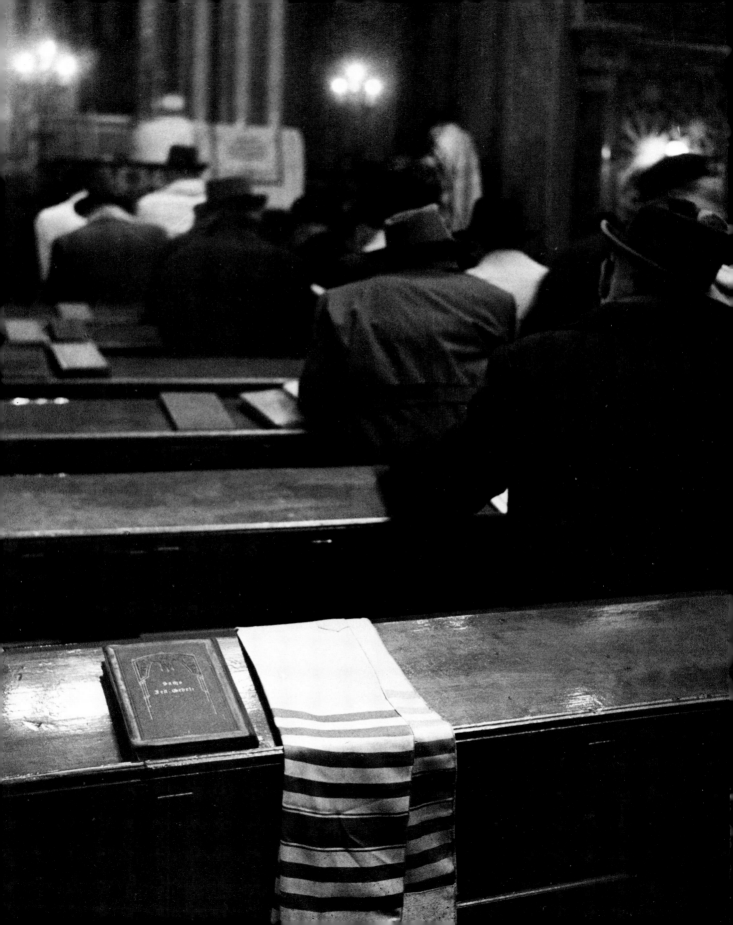

port lists, have arrived at a final death toll for Czech Jewry of 77,297. The names of these individuals now eerily embellish the walls of the Pinkas Synagogue.

Given the enormity of the loss of life and property during the Holocaust, it would have been inconceivable for the post-war Jewish community in Czechoslovakia to have recaptured anything close to its pre-war strength and vitality. And yet the decline of Jewish life in Czechoslovakia since 1945 has proceeded far apace of what might ordinarily have been expected, prompting one to conclude that tragedy breeds despair and that beyond a certain point a precipitous reduction in numbers will complete itself of its own momentum. More than 19,000 people registered with the Jewish communities of Bohemia and Moravia in 1948, and this number included many refugees from Subcarpathian Ruthenia, which was incorporated into the Soviet Union. Slovakia at the time showed a Jewish population of 24,500. Well over half of Czechoslovakia's Jews chose to leave the country within a few years—nearly 19,000 emigrated to Israel between 1948 and 1950, and more than 7,000 emigrated to other countries. In 1950 the Jewish population stood at around 18,000. A second wave of post-war emigration took place in 1968 and in 1969. That year approximately 15,000 people registered with Czechoslovakia's Jewish congregations.

Today by rough estimation some 15,000 to 18,000 Jews live in Czechoslovakia; some 6,000 of them are registered with organized religious communities, of which there are five in Bohemia and Moravia and eleven in Slovakia. There is regular public worship in the larger towns, and kosher restaurants exist in Prague, Bratislava, and Košice. Some smaller towns with very few Jewish families still maintain synagogues. Prague is the seat of the Council of Jewish Religious Communities in the Czech Socialist Republic, while Bratislava is the seat of the Central Union of the Jewish Religious Communities in the Slovak Socialist Republic. Prague remains the most active community religiously—with regular services in the Altneuschul and the Jeruzalémská Street Synagogue—and culturally—with the Council of Jewish Religious Communities publishing a monthly journal, a quarterly bulletin in German and English, and a literary yearbook.

The glorious heritage of Czechoslovak Jewish culture today looms as an overpowering backdrop to a community which is but a whisper of its former self. Will the whisper itself someday be silent? One cannot predict so far into the future. Certainly, any East European Jewry in the aftermath of the Holocaust would have enormous obstacles to overcome simply to maintain itself as a viable and active cultural entity. Yet the Jews of Czechoslovakia are survivors who already have outlived the forces of evil in our century. To be sure, Czech Jewry is but a small island—as the Spanish Jewish poet Yehuda Halevi once wrote, "the remnant of your flocks." Now these survivors, together with their children, face with stoicism and some hope the old-new task of rebuilding Jewish life.

Fig. 92. *Jewish worship continues in Prague in the aftermath of the Holocaust, 1950s.*

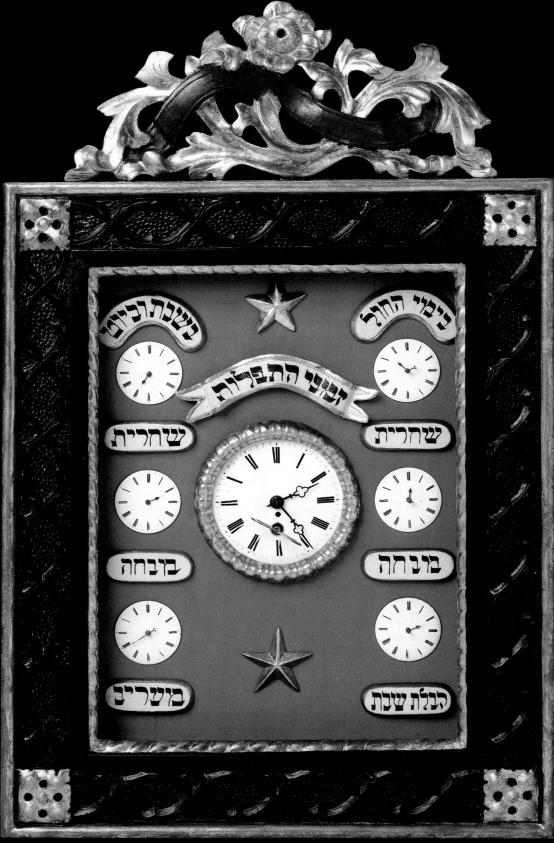

Fig. 93. *Synagogue clock, Písek, Bohemia, ca. 1870 (cat. 89).*

SYMBOLS OF THE LEGACY:
COMMUNITY LIFE

Vivian B. Mann

Historians trace the origins of the Jewish people back to nomadic movements in the Near East some 3,500 years ago. To these facts of history, though, the Bible adds a spiritual context by affirming that the particularistic identity of the Jews must be understood within a universalistic vision of creation. According to Judaic tradition, all of humanity descend from Adam and Eve. The Jewish people are but one branch of the human family, the descendants of Abraham, his son Isaac, and his grandson Jacob who was called Israel. For more than a millenium, this people constituted a small nation living on the eastern shore of the Mediterranean. Then followed a long and sometimes tortuous history of this family, this people, who were scattered in hundreds of locations throughout the civilized world. Wherever they lived in the Diaspora ("dispersion"), Jews recreated in microcosm the life of their ancient nation by establishing local and regional institutions of Jewish community life. At the same time, Jewish individuals and groups participated, under greatly varied circum-

stances, in the political, cultural, and social milieu of the larger worlds in which they lived.

By the ninth century of this era, groups of Jews established settlements in two areas of Western Europe, in Germany (*Ashkenaz* in Hebrew) along the banks of the Rhine, and in Spain (*Sepharad*), that became the main ethnic groups of the Jewish people, the Ashkenazim and Sephardim. As the result of their expulsion from the Iberian peninsula in the years 1492–97, Sephardi Jews and their distinguished culture spread through Western, Central, and Southern Europe, North Africa, and the Near East. In many cities where they settled in significant numbers, even those with indigenous Jewish populations like Constantinople, the Sephardim soon became the dominant force within the Jewish community.

In western and central Europe, the Jewish population was largely Ashkenazi. Its practices and customs were formed in the great Jewish centers of the Rhineland, like Mainz, Worms, and Frankfurt, whose outstanding rabbis and scholars established patterns of Jewish life that

111

are still followed today. To some extent, these patterns were set in response to surrounding Christian culture from which Jews were largely isolated, socially, religiously, and even economically, in contrast to the greater openness and integration of Jews in Muslim Spain and North Africa, the formative culture for Sephardi Jewry.

Nevertheless, despite the different circumstances of their development and periods of isolation from one another, Ashkenazi and Sephardi Jewry have always remained strongly bound together by their common origins, beliefs, and religious practices. These religious practices and the teachings of Judaism serve to reaffirm each new generation's links to its origins in the house of Jacob, and, simultaneously strengthen its ties to all other Jewish communities. In many ways, then, the Jewish community of Prague is both a paradigm of an Ashkenazi community and of all other Jewish communities in a line reaching both back in time and across space. Its institutions and concerns reflect those of Jewish communities throughout the world, and arose out of the same religious requirements and moral imperatives accepted by Jews elsewhere.

These religious practices require communal forms. Rabbi Simon the Just (ca. 200 B.C.E.) aptly summarized the Jew's obligations: "The world is based on three principles: Torah, worship, and benevolence" (*Ethics of the Fathers* 1:2). Although these obligations might be fulfilled privately, the Jew was enjoined not to separate from the community.[1] Though private prayer has an important place in Judaism, recitation of the complete worship service and the reading from the Torah can only take place with a quorum of ten men, a *minyan*. The prayers which mark major events of the life cycle, the naming of a child, marriage and death, should also be said in the presence of a minyan, thus linking the life of the individual to that of the larger community.[2] Likewise, the requirements of studying the Torah and performing acts of kindness imply reaching out beyond oneself. This necessity is deemed a virtue, "If I care only for myself, what am I?" (*Ethics of the Fathers* 1:14). The individual is, thus, both morally and religiously committed to the community.

The Jewish community, in turn, represented the Jew to the non-Jewish world and regulated the internal affairs of the community according to Jewish law.[3] It also assumed responsibility for providing the means of ritual observance, for the social welfare of its members, and for assuring continuity by teaching the young. Communities like Prague established houses of worship, schools, study centers, and charitable organizations to care for the poor and the sick and to bury the dead. Their primary locus has always been the major institution of the community, the synagogue.

After the destruction of the Temple in Jerusalem in 70 C.E., worship in Judaism focused exclusively on prayer. Three services became the

Fig. 94. *Synagogue key, Prague, end of 19th century (cat. 97).*

norm: morning, afternoon, and evening. On Sabbaths, holidays, and the New Moon an additional service is appended to the morning prayers, and a portion of the Torah, the first five books of the Hebrew Bible, is read from a scroll, the ancient form of books in which the Torah is still written. Part of the weekly Sabbath portion is read also on Mondays and Thursdays, the market days of ancient Israel. Formal reading of the Torah scroll, the most sacred object in Judaism, thereby is an integral part of the prayer services of the Jewish people. Consequently, the synagogue is a house of prayer and of study, and its architecture must accommodate these dual functions by providing both a place of assembly and facilities for storing and reading the Torah scrolls.

One of the few preserved synagogue complexes that survived from the Middle Ages to the twentieth century is located in the city of Prague. Many of the buildings belong to the State Jewish Museum and are among its most important holdings; two are the property of the Jewish community and are still in use. Their range of artistic styles, from Gothic through nineteenth-century revival, illustrate the manner in which Jews always have adapted prevailing artistic modes to the functions required by Judaism.

Though the origins of the community date to the tenth century, we do not know when the Jews of Prague first dedicated a building as a

house of worship. The earliest documentary mention of one dates to the year 1142 and notes a fire outside the walls of the city which damaged the synagogue.[4] This synagogue may not have been identical with the Altschul or Old Synagogue, the latter originally a small vaulted structure, which stood in the Prague ghetto until the nineteenth century. The earliest surviving synagogue in Prague, the Altneuschul, was completed ca. 1265 and seems to have been given its name at the beginning of the seventeenth century to distinguish it from both the Altschul and a later building (fig. 95).[5] Today it is the oldest extant European synagogue and represents the many others known only from archaeological and documentary remains and from the pages of illuminated medieval manuscripts.[6]

The main hall of the Altneuschul is divided into two naves of three bays each by rectangular piers which rise to support the rib-vaulted ceiling. An impression of soaring verticality is achieved despite the smallness of the space (15 × 9 m) through the lowering of the floor level below that of the adjacent street. This device often was used by architects to circumvent ecclesiastical restrictions placed on the height of synagogues during the Middle Ages, which were intended to diminish Jewish houses of worship in comparison with churches. As is customary in the interiors of Gothic buildings, sculptural decoration in the Altneuschul is confined to capitals, keystones, and the consoles of the ribs, and, in accord with Jewish reticence over the presence of three-dimensional figural sculpture, the motifs are all vegetal in character.[7] More elaborate floral reliefs fill the tympana of the doorways and the gable surmounting the ark holding the Torah scrolls, the focal point of the eastern wall. Over the centuries various additions were made to the original building, including a vestibule and a women's synagogue with apertures opening onto the main hall. In the fifteenth century, the building's distinctive crenellated gable was added, and the original stone *bimah*—a raised platform with reader's desk from which the Torah scroll is read to the congregation—was replaced by a wooden one with a wrought-iron superstructure that fills the central space between the two main piers.

Still a third synagogue, perhaps older than the Altneuschul, was in use in Prague during the thirteenth century, according to the results of recent excavations undertaken by the State Jewish Museum.[8] Beneath the well-known Renaissance hall of the Pinkas Synagogue lie the remains of an older house of worship on the same site which became inadequate by the second decade of the sixteenth century. Aaron Meshulam Ho-

Fig. 95. *Altneuschul exterior.*

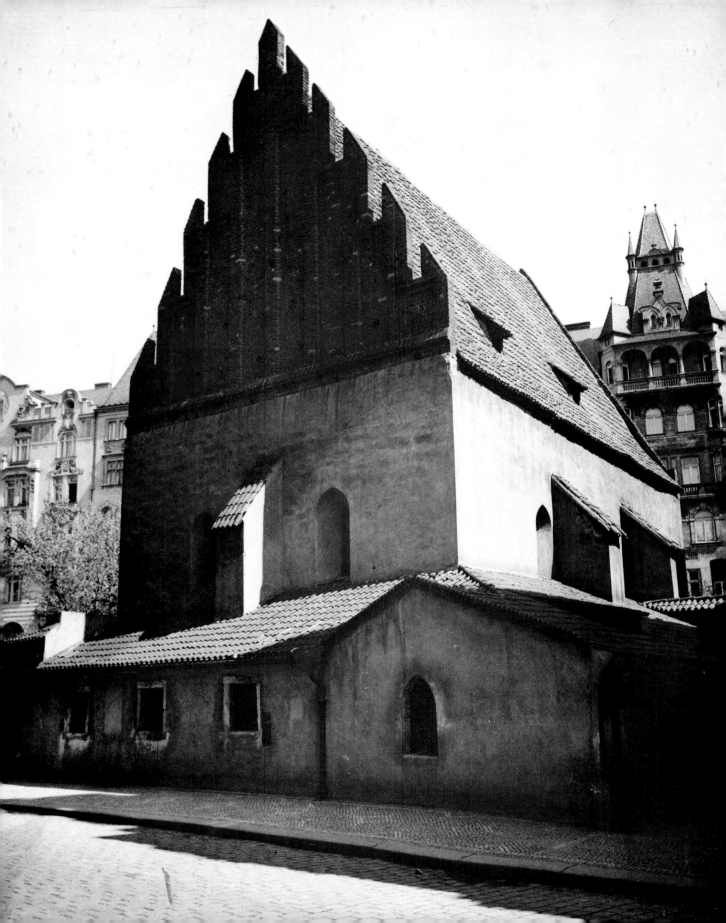

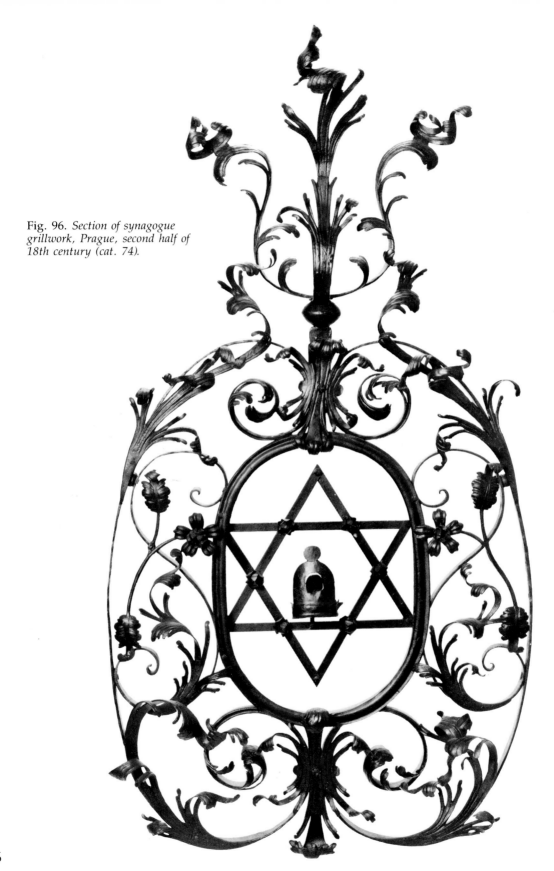

Fig. 96. *Section of synagogue grillwork, Prague, second half of 18th century (cat. 74).*

rovicz, the most prominent Jew of his time, whose family owned the synagogue, undertook its expansion. This rebuilding occurred in two stages between ca. 1520 and 1535 and resulted in a new hall whose architecture is a blend of the older Gothic style seen in the Altneuschul and newer, Renaissance elements (fig. 50). In the Pinkas Synagogue, Renaissance pilasters support late-Gothic rib vaults and the outer windows are framed by classical moldings. A two-storied women's gallery and additional subsidiary spaces were added in the seventeenth century by Judah Goldsmith de Herz (d. 1626), whose epitaph in the Prague Jewish cemetery indicates that he also worked on the Maisel Synagogue.[9] The enlargement of the Pinkas Synagogue and the erection of the Maisel Synagogue were part of an extensive building program in the Prague ghetto begun by its mayor Markus Mordecai Maisel (d. 1601). He also was responsible for the High Synagogue, for rebuilding the town hall, enlarging the Old Jewish Cemetery, and undertaking other public buildings. In the same period the Klaus complex of synagogues, ritual bath, and yeshivah (rabbinical school) was founded; its transformation in 1694 to include a two-storied women's section opening onto a main hall reflects the influence of the Pinkas Synagogue plan.[10] All of this activity was the result of the increased prosperity and security of Jews in Prague after the mid-sixteenth century.

In the succeeding centuries, other communal buildings were constructed in the prevailing style; some of them no longer are in existence. However, the nineteenth century penchant for the revival of earlier modes still can be seen in three buildings that now are part of the State Jewish Museum: the Maisel Synagogue, rebuilt 1893–1905 in a neo-Gothic style; the Hall of the Burial Society in the Old Jewish Cemetery, which is neo-Romanesque; and the Spanish Synagogue, erected in the 1860s on the site of the Altschul, whose decoration is moorish in character. The museum also supervises remaining synagogue buildings in smaller cities and towns of Bohemia and Moravia. Many of these are simple in form, but larger centers like Mikulov, seat of the chief rabbi of Moravia, once possessed imposing structures.[11]

Fig. 97. *Bimah surrounded by grillwork.*

Fig. 98.
*Eternal light,
Prague, 1850s
(cat. 75).*

Fig. 99.
*Eternal light,
Prague (?), 1892
(cat. 76).*

Since an essential aspect of Jewish worship is the reading of the Torah, the ark which houses the scroll and the desk from which it is read are focal points of a synagogue's architecture and are often incorporated into the building's fabric. Wherever possible, a synagogue is oriented eastward and the Torah ark placed within the eastern wall so that the prayers of the congregation are directed to the scrolls and simultaneously toward Jerusalem, site of the ancient Temple. In Ashkenazi communities like Prague, it was customary to emphasize the sanctity of the Torah by hanging an elaborately decorated curtain, and, sometimes, a valance in front of the ark. The traditional names given to these, *parokhet* and *kapporet* respectively, derive from the names for the veil and ark cover of the innermost sanctuary of the biblical Tabernacle.[12] Similarly, the *ner tamid* ("eternal light") hung near the ark recalls the continuous burning of the menorah in the Tabernacle and the Temple. The presence of these objects reinforces the association of individual synagogues and communities with ancient Jewish religious life.

The second focus of the synagogue is the bimah, which is usually aligned with the ark along

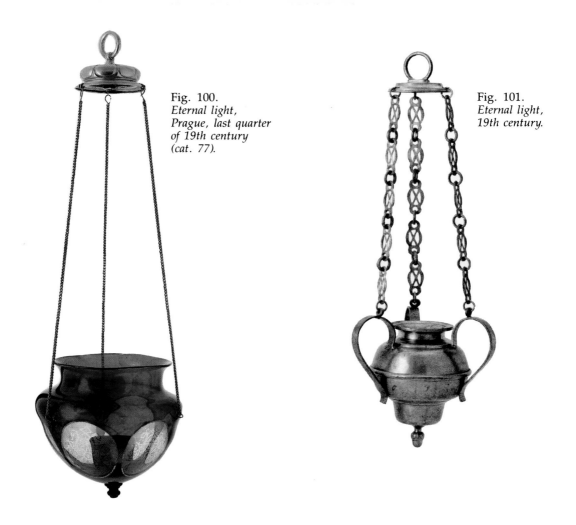

Fig. 100.
*Eternal light,
Prague, last quarter
of 19th century
(cat. 77).*

Fig. 101.
*Eternal light,
19th century.*

the major axis of the building and raised on a platform for further emphasis. Like the synagogue's structures themselves, the ark and bimah were often transformed over time so that their present appearance no longer harmonizes with the original style of the the building, as was the case in the Altneuschul. Similarly, the first bimah of the sixteenth-century Pinkas Synagogue, which was carved of stone and decorated with classical Renaissance forms, was later discarded. In the late eighteenth century, this bimah was furnished with an elaborate wrought-iron frame of exuberant floral scrolls surrounding the coat of arms of the Jewish community. A similar grill from the same period decorated the bimah of the Čikanová (Gypsy) Synagogue (fig. 96).

Because of its special sanctity, the form and care of the Torah scroll was of special concern to the rabbis of late antiquity. They mandated precise procedures for its replication; thus the form of the Torah has varied little over the centuries.[13] Since the first century of this era, the Five Books of Moses have been written on a single scroll, whose consequent length has necessitated the support of two staves and the binding of the scroll by means of a strip of cloth in order to preclude damage to the parchment (fig. 105). Further protection is provided by a mantle which covers the scroll when it is not in use (fig. 103). To facilitate the reading of a specific portion of the Torah, a practice was instituted in the late fifteenth century of affixing a shield indicating the place to which the scroll is turned (fig. 106).

119

The Torah scroll and some of its appurtenances.

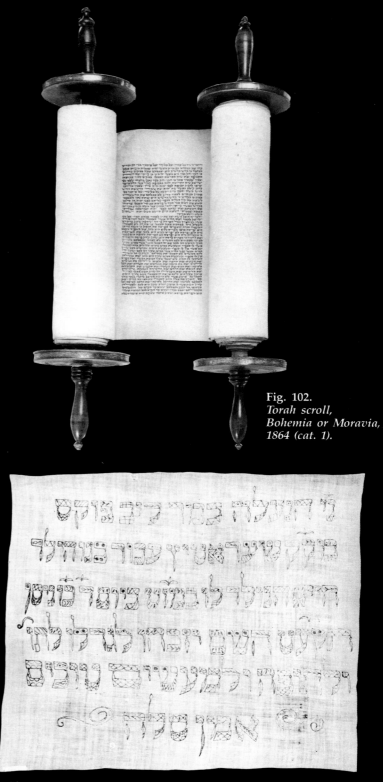

Fig. 102.
Torah scroll,
Bohemia or Moravia,
1864 (cat. 1).

Fig. 103.
Torah mantle,
Bohemia,
1819/20 (cat. 27).

Fig. 104.
Torah cover,
Šaratice, Moravia,
1819 (cat. 39).

Fig. 105.
*Torah binder,
Moravia, 1857/8
(cat. 36).*

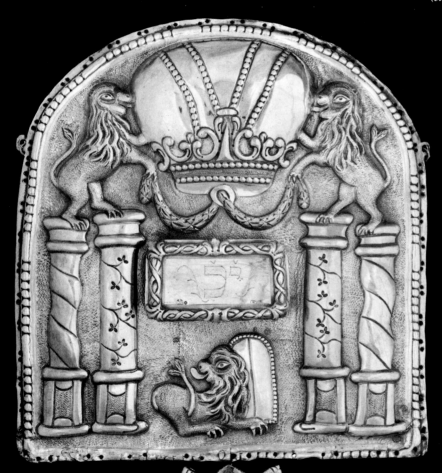

Fig. 107.
*Torah finials
(rimmonim),
Prague, 1776–84
(cat. 50).*

Fig. 106.
*Torah shield,
Prague, 1816
(cat. 46).*

None of these appurtenances for the Torah ever has been viewed as merely a utilitarian device. Instead, they have been fashioned of fine materials and embellished to reflect the Jew's regard for the sanctity of the Torah and desire to perform religious commandments in the most beautiful manner possible.[14] The binder, the mantle, and the shield became works of art whose beauty symbolizes the exalted position of the Torah in Jewish life. In addition, the staves came to be decorated in a variety of ways: by artful carving of the wood, the addition of silver or gold finials *(rimmonim)*, or by the placement of a crown over the poles (fig. 126). Other objects used in conjunction with the reading of the Torah emphasize its sanctity by separating the scroll from that which is profane. A cloth covers the reader's desk before the Torah is placed upon it; another cloth covers the "undressed" Torah between lections (fig. 104), and the reader himself never touches the scroll but uses a small rod or pointer to follow the text (figs. 108, 128).

As the result of the Torah's centrality and sanctity in Jew-

Fig. 108.
*Silver torah pointers
(from left, cats. 60, 63,
58, 62, 64, 56, 61).*

123

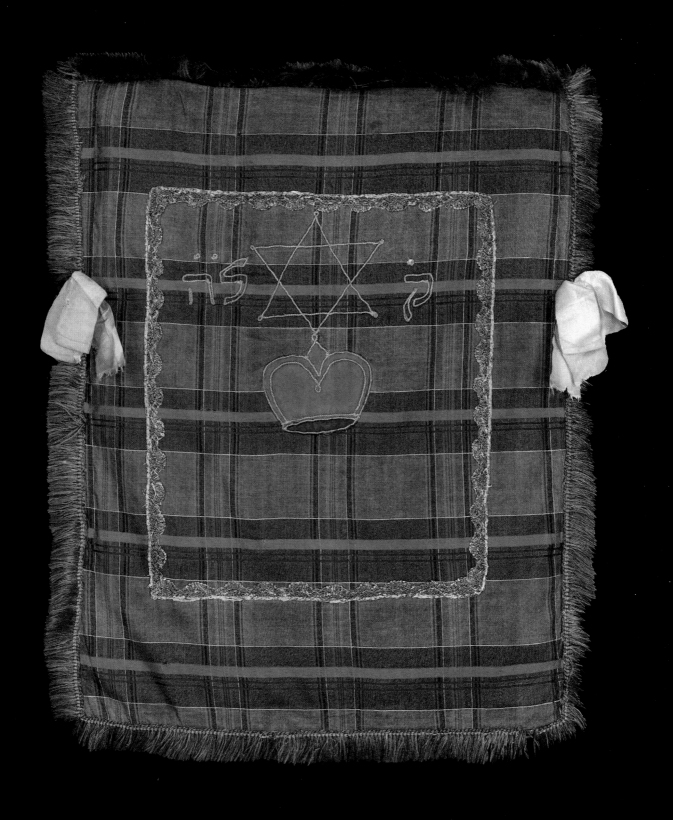

Fig. 109. *Torah mantle, Bohemia, late 19th century (cat. 30).*

ish life, the donation of a scroll or its appurtenances to the synagogue is a highly esteemed form of philanthropy. Donations are made by individuals, families, or communal organizations like the Burial Society. If by individuals or families, then these gifts may be made in commemoration of a life cycle event, a practice that once again links the life of a single Jew to the larger community. The Torah binder, in particular, came to be associated with the birth and growth of a male child among Ashkenazi congregations in German-speaking lands. It was fashioned from cloth used at the circumcision and was inscribed with the child's name, date of birth, and a passage drawn from the circumcision service. This practice was widely, though not exclusively, followed in Bohemia and Moravia. In the collection of the State Jewish Museum there are binders with other kinds of dedicatory inscriptions and some lacking any inscriptions at all. Among Bohemian and Moravian congregations, it was also customary to donate covers for the Torah with the same type of decoration and inscriptions as are found on the binders (fig. 104). Communal events like the founding of a synagogue or its renovation after a fire—a frequent occurrence in the ghetto of Prague as elsewhere—likewise stimulated the donation of objects to synagogues. For example, the Pinkas Synagogue received a large number of Torah curtains in 1601, on the occasion of an unknown event.[15]

Who made these donations? The answer varies depending on many factors: the type of object, the skill needed to fabricate it, the residence of the donor, and the extent of his resources. For example, works in metal require special equipment and skilled training for their fabrication. Since the Middle Ages, individuals who possessed the necessary skills organized into guilds which strictly regulated production. Generally, Jews were excluded from Christian guilds, though in Prague this exclusion did not prevent Jews from making metal objects and forming their own guilds, as will be seen below. Still, the finest works in metal were usually made by those who had benefitted from the intensive training of the Christian guild system.

Thus many pieces of metalwork used for Jewish religious purposes were commissioned from non-Jews. Similar levels of skill were needed to fashion complex textiles with intricate embroidery, but Jewish participation in the tailoring and embroidery professions appears to have been far more extensive than in metalworking, for a variety of reasons which will be discussed. However, the production of textiles that are simple in construction and modest in their decoration and materials was within the capabilities of most householders, and many synagogues in Bohemia and Moravia received donations of textile folk art, even those of Prague. The same is true of wooden folk art such as Torah pointers.

Fine metalwork and textiles were mainly produced in Prague and other large cities but they were donated to synagogues throughout the country where they often served as models for locally made works. The synagogue art of

Fig. 110. *Torah mantle, Bohemia or Moravia, ca. 1750 (cat. 24).*

Bohemia and Moravia mirrors local folk art to an unusual degree, due to the large proportion of Jews who were, until the Industrial Revolution of the nineteenth century, dispersed in small towns and villages throughout the countryside where local artistic traditions influenced Jewish ceremonial art. The very thoroughness of the Nazi confiscation of Jewish communal property assured the preservation of numerous examples of Judaic folk art, along with the silver and textiles that were fashioned by professional artists.

That the synagogues of Bohemia and Moravia, and especially of Prague, were very rich in Torah curtains, mantles, and other synagogue cloths, is indicated by the numbers extant in the State Museum's collection—more than 4,000 mantles, 2,500 Torah curtains, 360 valances, 1,500 binders, and 1,000 other cloths—a total of 9,000 synagogue textiles gathered from 153 Jewish communities, some of which had more than one house of worship at the time of the Nazi invasion. An inventory of the Maisel Synagogue written in 1684 describes the resources of a prosperous congregation of the seventeenth century: 22 Torah curtains, 29 mantles and 23 Torah covers.[16] Only two of the 29 mantles mentioned in the Maisel inventory are today part of the collection of the State Jewish Museum. Its holdings would be even more numerous had all synagogue textiles survived fires, pogroms, and the catastrophic events of the Holocaust. Nevertheless, the numbers of such cloths in the collection, their elaborateness and fine quality, indicate that textiles were especially popular donations to synagogues in Bohemian and Moravian communities.

A number of reasons can be adduced to explain this phenomenon. During the medieval period, the Jews of Bohemia and Moravia generally were active in moneylending and many valuable textiles came into their hands as unredeemed pledges for loans.[17] This continued to be true in the sixteenth century when the Jewish economic role became more diversified, as Jews began trading internationally in a wide variety of wares including both new and used textiles. By the second half of the seventeenth century, the Bohemian textile trade, including both cloth and decorative materials, was concentrated in Jewish hands.[18]

Yet, these economic factors alone, which were also operative in other Jewish communities, cannot explain the richness of the Prague synagogue textiles. A major factor must have been the historical emphasis placed on textiles in Bohemia and Moravia. Ibrahim ibn Yaqub, a Jew who traveled in the region during the second half of the tenth century, reported that textiles were used then as a medium of exchange, a practice also documented by a twelfth century source.[19] Embroidered textiles also were viewed as a major art form in Bohemia during the later Middle Ages, and figured embroidery executed with small pearls was a local specialty that often was employed on ecclesiastical textiles,[20] so that the terms *Perlstücker* and *Perlhefter* came to be traditionally used in Bohemia to designate embroiderers.[21]

Another important factor is the expanded role the Jews of Prague began to play during the sixteenth century in various crafts, encouraged by royal privileges which were amended and con-

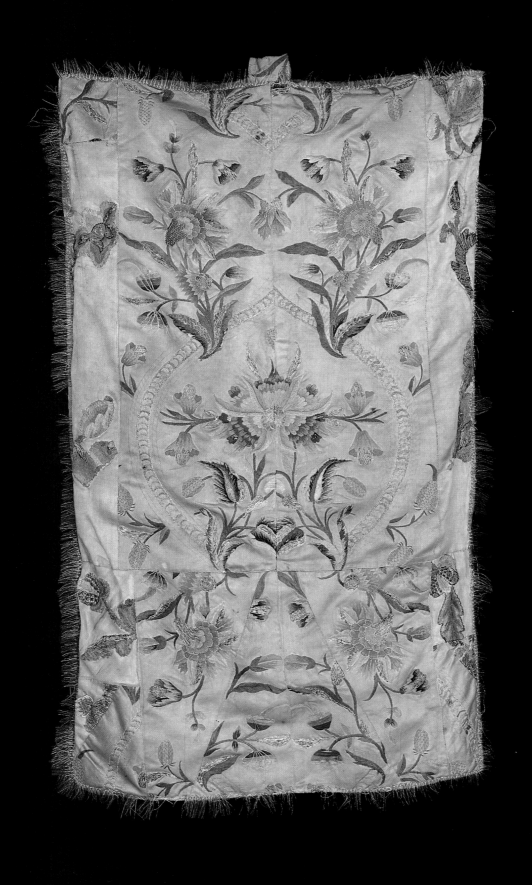

Fig. 111. *Torah curtain, Prague, 1601/2 (cat. 2).*

firmed in the seventeenth century.[22] This expanded activity was continuously opposed by the Christian guilds who complained of the inferior workmanship of Jewish masters who were denied the rigorous training of the guild system.[23] Nevertheless, by the end of the sixteenth century, Jewish and Christian tailors labored together in large shops[24] and significant numbers of Jews had surnames suggesting that they were professional embroiderers. In fact, the earliest extant Torah curtain now in the State Jewish Museum, which was begun in 1547 and renovated in 1592, incorporates pearl embroidery and was donated by Salomon Perlsticker.[25] The size, complexity, and richness of curtains like this one, products of skilled artisanship, have raised the question of the extent of Christian participation in their fabrication. In any event, one must accept the existence of artistic interchange between the fabricators of Torah curtains and mantles and the makers of embroidered church textiles since both exhibit the same use of luxurious woven fabrics and similar embroidery techniques, motifs, and compositional elements,[26]—with the single, major difference that large synagogue textiles generally do not incorporate fabrics woven with human figures, nor are these part of their embroidered decoration.

The Perlsticker Torah curtain is one of a small group of fine sixteenth and seventeenth century curtains decorated with flat appliqué embroidery, a Renaissance technique popular in Italy, one of the countries from which the Jews of Prague regularly imported textiles. Another of the group was commissioned by Nathan (known as Karpel Zaks) and his wife Hadasi in 1601/2 and donated to the Altneuschul, as were most of the other curtains of this type (fig. 111). Here the appliqués form a "portal" composition in which the center field (an eighteenth century damask that is a later replacement) is framed by two columns and an entablature that is filled with flowering vines emanating from a medallion enclosing the donor's coat-of-arms—three carp. Below this rectangular field is another bearing the dedicatory inscription embroidered with pearls. A third ornamental panel with cornucopias, scrolls, and a vase with flowers fills the space between the bases of the columns. The employment of such architectural elements as framing devices reflects Renaissance usage, while the composition as a whole was probably influenced by the title pages of Hebrew books printed in Prague during the sixteenth century (c.f. fig. 135), or by the form of Torah arks.[27] An architectonic sense is conveyed in this curtain by the perspective rendering of the column bases. On later examples, such as the 1685 curtain donated by Isaac Poppers and his wife Temerl, the daughter of Hirsch Perlhefter, the columns are stylized and flattened, and their capitals are completely transformed into symbols—two pairs of priestly blessing hands surmounted by abstract crowns (fig. 64). The emphasis on the inscription and its placement within a broad rectangle at the top on both of these examples becomes canonical for curtains and also for Torah mantles produced in Prague. Though the appliqué technique of the earliest Torah curtains continues to be employed until the very end of the seventeenth century, the intricate metallic thread embroidery of the Poppers curtain is more typical of the early baroque period. The effect of its densely-placed floral and abstract forms is to overlay the curtain

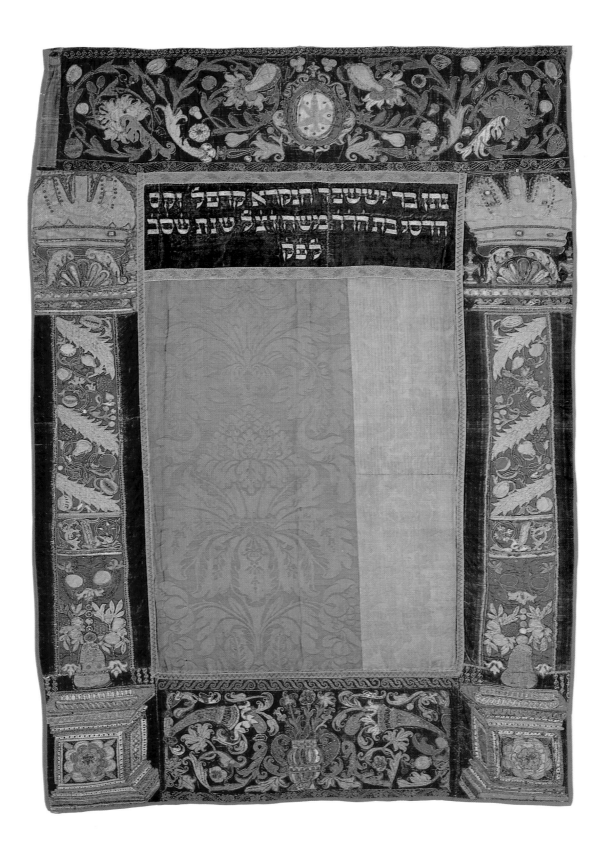

תחזר ישנה הנקרא קפפל וקם
הרס בתהר ב משנציל שנה שב
לפק

129

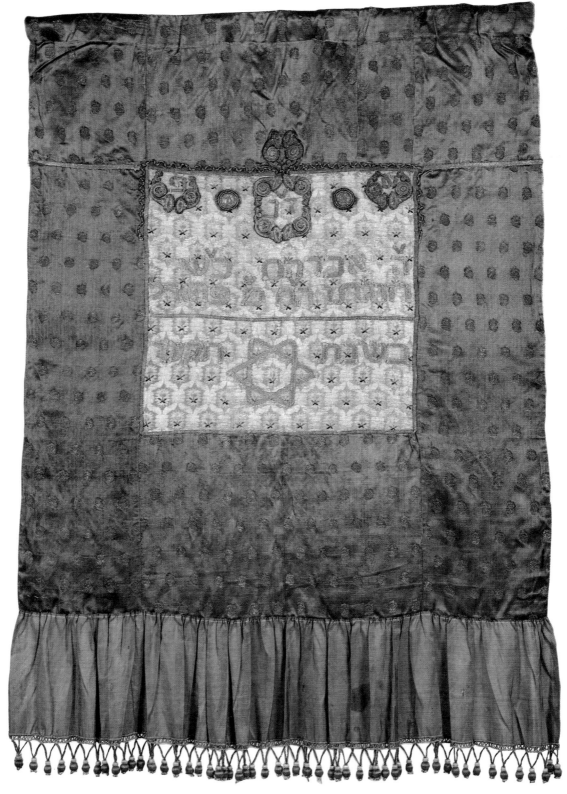

130 Fig. 112. *Torah curtain, Moravia, 1813/4 (cat. 7).*

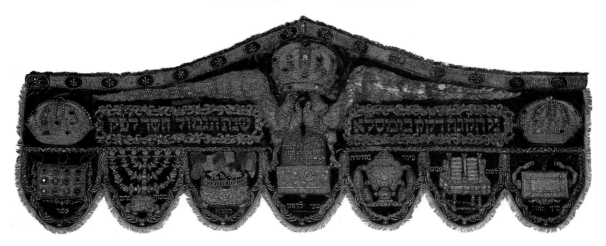

Fig. 113. *Torah valance,*
Prague, 1718/9 (cat. 11).

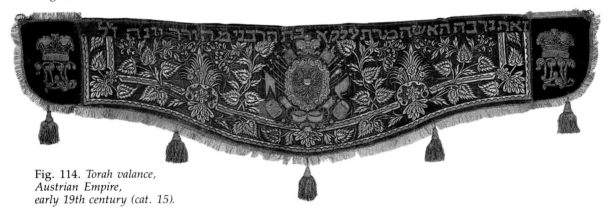

Fig. 114. *Torah valance,*
Austrian Empire,
early 19th century (cat. 15).

with a shimmering surface that is anchored by the boundaries of the portal composition. Other curtains are variations of this basic type; their center may be occupied by a beautiful piece of antique cloth, or the architectural elements may be further reduced. Curtains produced in rural areas, outside professional workshops, often are inventive combinations of precious fabrics, mundane textile trimming, crudely executed inscriptions, and images of folk character that still are composed along the rectangular format established by the portal composition of the earliest Prague curtains (fig. 112). Only in the nineteenth century do designers deviate from the traditional format.

If a Torah curtain was made together with a valance, then the two harmonized in size, material, and decoration (fig. 47). Beginning in the early eighteenth century, an elaborate iconographic program developed for the valances (fig. 113). Included were ritual implements from the

ancient Temple in Jerusalem, among them the menorah, altar, laver, table for the shewbread, portions of the high priest's costume, and the Tablets of the Law in the Holy Ark. These images symbolize the strong sense of historical continuity within Judaism and also may express eschatalogical hopes for the rebuilding of the Temple in the Age of the Messiah. The iconography of the valances also included three crowns symbolic of the Torah, priesthood, and royalty, which represented, according to the ethical maxims of the rabbis, worthy areas of human achievement exceeded only by the crown of a good name.[28] Ashkenazi Torah curtains often display heraldic badges and emblems of princely authority; on one Prague valance an Austrian badge with military emblems became a substitute for the crown of royalty (fig. 114). The appearance of this rich iconographic program on the valances coincides with the popularization of stumpwork embroidery, a technique in which

131

Fig. 115.
Torah mantle,
Prague, 1670/1
(cat. 19).

Fig. 116. *Torah mantle, Bohemia, 1842 (cat. 28).*

images are raised in relief lending rich visual emphasis to the symbols. Another type of valance popular from the eighteenth century on largely depends for its visual effect on the beauty of the fabric over which an inscription is sometimes appliquéd (cat. 16).

Closely related to the form and decoration of the Torah curtains are the Torah mantles. The earliest of these in the State Jewish Museum's collection is a fine piece, donated to the synagogue by Mordecai Maisel and bearing his

name and the date 1592.[29] It already represents a canonical composition which was to be utilized in Prague for centuries (fig. 115). The top portion of a mantle of this kind is occupied by several lines of inscription embroidered in heavy, block letters; the lower section is a treasured, woven fabric. Variations on this basic type are the substitution of a richly embroidered area for the woven fabric, and the enframement of the inscription by a cartouche or of the lower portion by a pair of columns similar to those on the curtains (fig. 66). A simpler type lacks the embroidered panel and depends for its aesthetic appeal solely on the beauty of the woven or embroidered fabric (fig. 110). As was true of the Torah curtains, the smaller communities of Bohemia and Moravia possessed many mantles of folk character fashioned of less luxurious fabrics and decorated by means of less sophisticated embroidery techniques (fig. 103). An unusual example from Horovice, Bohemia, dated 1842, was made of white linen and decorated with red yarn (fig. 116). The embroidery forms a Crown of Torah with appended drapery festoons, a motif common on Prague Torah shields, and a Star of David enclosing an inscription stating that the mantle was given in honor of the birth of a son. The material and embroidery style of this mantle closely resemble two other types of synagogue textiles from Bohemia and Moravia that were donated on the occasion of the birth of a male child—Torah binders and cloths to cover the Torah between readings (figs. 195, 104). Though similar binders for a male child were ubiquitous among German-speaking Ashkenazim, the extension of this style to mantles and covers appears to have been a special Bohemian and Moravian usage influenced by local folk customs.[30]

133

ולכסי סבנ ... אל ...

אשה ... התורה

Fig. 117.
Torah binder,
Bohemia or Moravia,
1749/50 (cat. 34).

ולמעשים טובים אמן סלה

ולחופה

... יגדל ...

... במדינ' ... דליד'

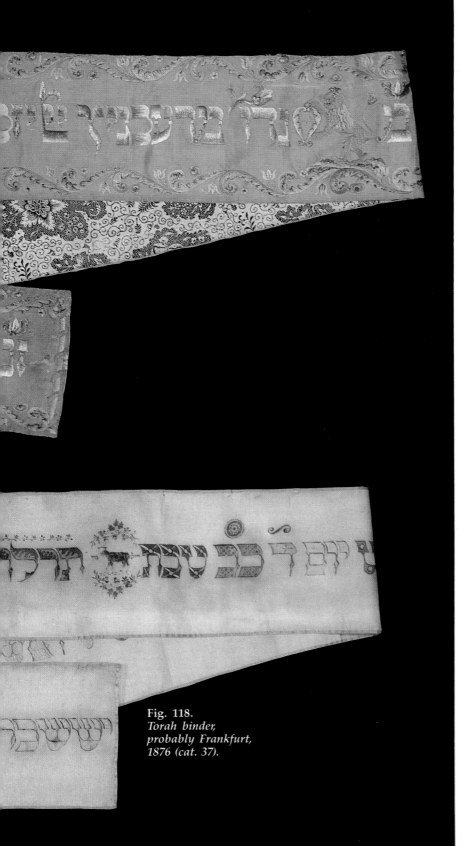

Fig. 118.
Torah binder,
probably Frankfurt,
1876 (cat. 37).

Binders, composed of long strips of linen with simple embroidered inscriptions in red or blue yarn that celebrate the birth of a boy, form the bulk of the museum's collection (fig. 195) and include its earliest example dated 1668. Examples stemming from Moravia are embroidered with motifs characteristic of the folk art of that region (fig. 105). The binder illustrated bears the name of a woman, a donation more typical of the Sephardi communities of Italy and the Ottoman Empire than of the Ashkenazi Rhineland and related areas. Still, this binder is not an isolated example in the Prague collection; other dedicatory inscriptions refer to weddings, deaths, and to the establishment of synagogues.[31] Such variant inscriptions are generally found on binders that also differ in type from the usual Ashkenazi examples.[32] The variety of custom and type of binder in the Prague collection may be attributed to the cosmopolitan nature of the Bohemian and Moravian communities whose members emigrated from both the East and West and from the South.

The most common decorative motifs found on the binders, aside from their inscriptions, are flowers and animals. Most are embroidered or painted, but one unusual example from Sušiče, Bohemia, has stamped floral borders (fig. 195). Only eighteen binders of the entire collection of 1,500 are decorated with human figures (fig. 117). These are all donations in honor of a young boy, and their illustrations refer to the traditional text of the circumcision service "may he be raised to the Torah, the marriage canopy, and good deeds."[33]

In comparison with the riches of the State Jewish Museum's textile collection, its holdings of synagogue silver are not as broad. The numbers of Torah ornaments in the museum (600 shields, 1,000 pairs of rimmonim, 200 crowns, 1,000 pointers), though rich by any other standard, are smaller than those of the textile collection and do not match the number of extant mantles or the number of Torahs collected by the Nazis. In addition, few pieces remain that are earlier than the beginning of the eighteenth century, and most of these are products of great

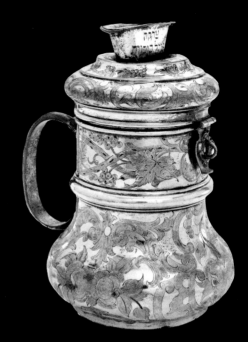

Fig. 119. *Alms box, Eastern Europe (?), 1877 (cat. 85).*

Fig. 120. *Tankard for wine, Vienna, mid-16th century; lid, 19th century (cat. 90).*

136

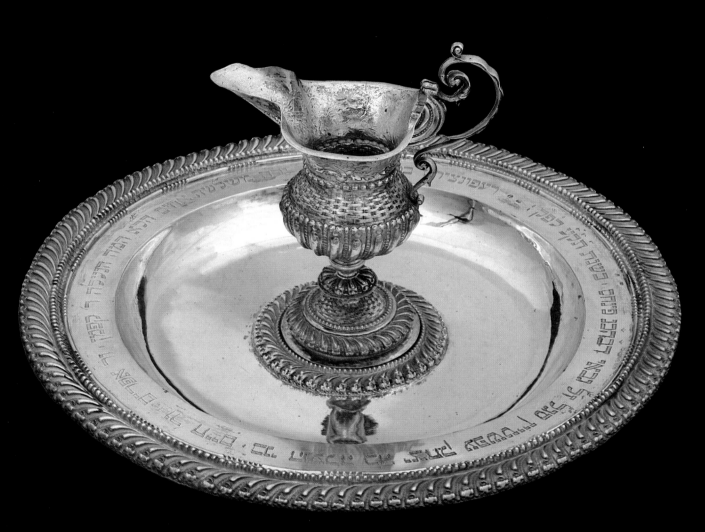

Fig. 121. *Laver and basin,*
Prague, 1702 (cat. 78).

centers like Vienna—for example, a late sixteenth-century tankard for wine which eventually was dedicated to a Bohemian synagogue (fig. 120). The lack of early pieces from Prague is particularly striking in light of the documented activity of Jewish goldsmiths during the reign of Rudolf II (1576–1612), and the continuous complaints of the goldsmith's guilds against the competition and shoddy workmanship of Jews who practiced their craft illegally, without benefit of guild training.[34] These written complaints, recorded in the city's archives, continue throughout the seventeenth and eighteenth centuries. In 1627, in the first of a series of royal privileges from this period, Ferdinand II granted Jews the right to practice "learned crafts" including goldsmithing, a privilege that was confirmed in 1648.[35] The 1729 census lists seventy Jewish goldsmiths; this number decreased after the Jews returned from the exile of 1744.[36] By the end of the eighteenth century Jewish goldsmiths clamored for the right to establish their own guild, a right finally granted in 1805. Furthermore, the existence of early synagogue silver in Prague is documented in Jewish communal records of 1581 which note the ordering of Torah pointers from Christian silversmiths of the court.[37] The lack of early material must be attributed to catastrophes like the fire which swept the ghetto in 1689 and the expulsion of 1744. According to late seventeenth century records of the pewter makers guild, the city's Jews possessed a large quantity of melted tin as a result of the fire, which they

stored in a warehouse outside the ghetto.[38] We may presume that a great many works in silver melted as well. Other types of synagogue silver, like the lavers and basins used for ritual handwashing, may have been lost because they were converted to other purposes, since in form and decoration they did not differ from those used in churches or in homes.

Today, the bulk of the State Jewish Museum's silver collection dates from the eighteenth and nineteenth centuries and was made in Prague or in other cities of the Austrian Empire. One of the earliest pieces is the laver and basin fashioned by the Prague silversmith J.G. Lux in 1702 for the Pinkas Synagogue (fig. 121). This set, in which graceful forms and outlines are combined with rich surface texture, is also one of the finest works in the collection. The majority of the shields, rimmonim, crowns, and pointers fall into a series of basic types which enjoyed long favor, as is evidenced by the numbers of each that are extant. The master Thomas Höpfel, who was active in Prague in the second and third decades of the nineteenth century, fashioned a Torah shield that was extremely popular (fig. 122). Its design features two lions perched on low pedestals, who support the box of interchangeable placques inscribed with names of the holidays. Behind the lions rise two large cornucopias surrounded by a crown from which ribbons are suspended. Similar iconographic elements appear on a contemporaneous shield from Brno by the master "F.K." where they are,

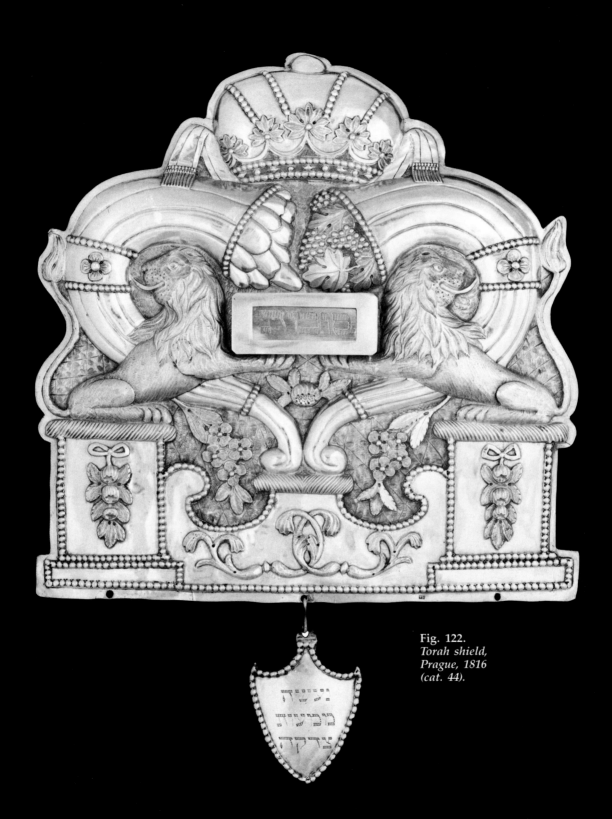

Fig. 122.
*Torah shield,
Prague, 1816
(cat. 44).*

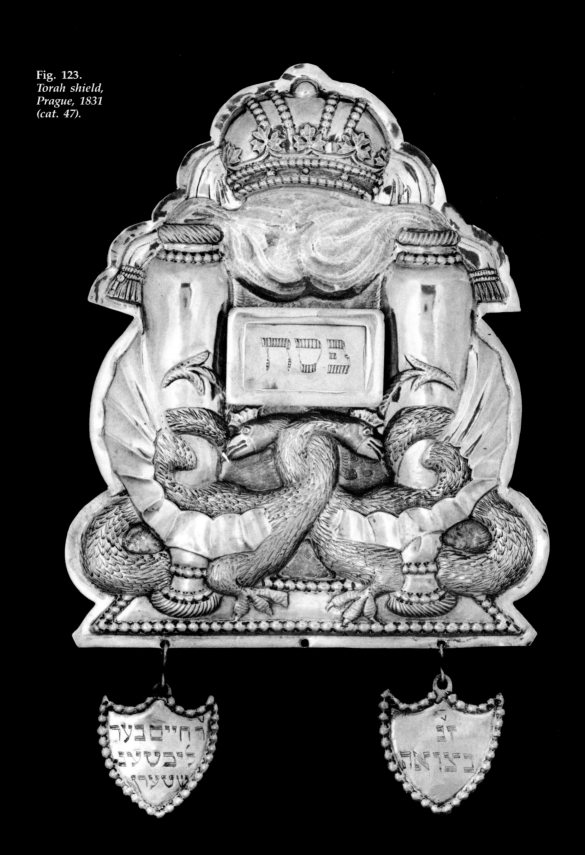

Fig. 123.
*Torah shield,
Prague, 1831
(cat. 47).*

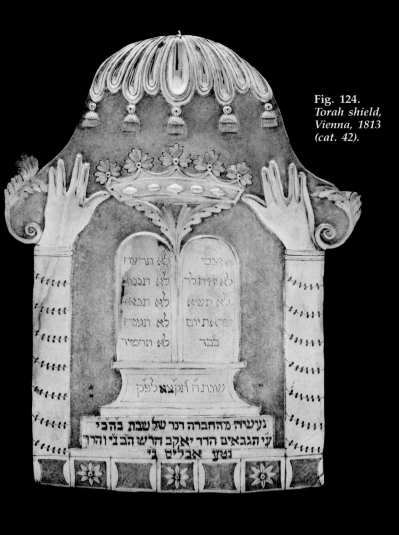

Fig. 124.
Torah shield,
Vienna, 1813
(cat. 42).

however, executed in lower re-lief and in a more delicate style (fig. 125). The Brno shield also bears vine scrolls animated with dragon's heads; a sign of the taste for fantastic beings that is a noteworthy aspect of Bohemian shields. Thomas Höpfel, for example, created a shield on which two muscular, intertwined griffins are a dom-inant element (fig. 123). A sense of whimsy is also evident on many of the Torah shields. In 1816, Carl Skremenec of Prague made a shield with tra-ditional iconographic elements, columns, lions, and a crown of Torah, but a playful air is en-gendered by the smiling faces of the lions and by the addi-tion of a third lion at bottom who supports the Decalogue while jauntily holding his tail aloft (fig. 106). On another shield, fashioned in Vienna in 1813 for a synagogue in Brno, the enframing columns are transformed into long arms from which emerge two bless-ing hands (fig. 124).

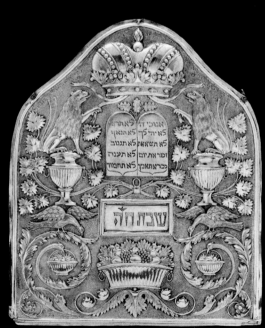

Fig. 125.
Torah shield,
Brno, 1813
(cat. 41).

141

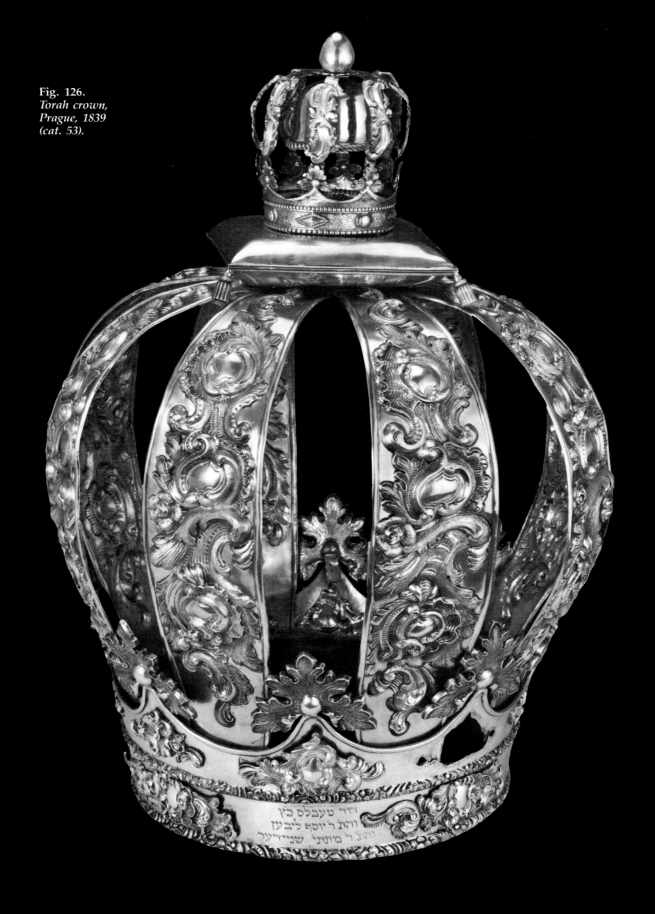

Fig. 126.
*Torah crown,
Prague, 1839
(cat. 53).*

דוד טעבלס כ"ץ
והתך ר' יוסף ליבען
יהלל מותתי שנײדער

Fig. 127.
Torah finials (rimmonim),
Prague, 1707
(cat. 49).

A series of basic types also dominates the museum's collection of Torah finials. One of these consists of baluster forms rising from a broad base that are topped by an openwork crown. Early examples, executed in the eighteenth century, are overlaid with rococo forms, curvilinear scrolls, and shells (fig. 127). The same type continues throughout the nineteenth century but decorated with lower relief and more openwork. An unusual pair of rimmonim by the Prague silversmith Richard Fleischman that was donated to the Pinkas Synagogue in 1784 reflects the current neo-classical style (fig. 107). The shaft, a fluted column, rises from a base decorated with suspended wreaths. The shaft supports three encircling balustrades and is topped by an urn. Most rimmonim are, however, capped by bulbous openwork crowns whose forms reflects those of the actual crowns donated to Prague synagogues (cat. 52). This bulbous shape is a distinctive feature of Bohemian and Austrian crowns; many also are unusually large.

143

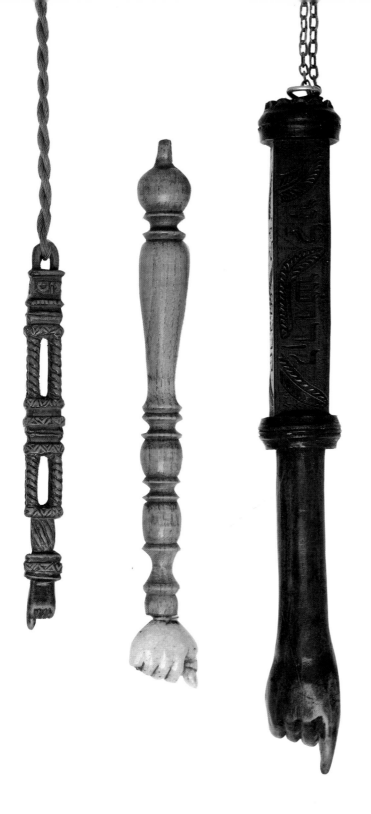

In contrast to the Torah ornaments we already have discussed, the forms and decoration of silver pointers in the collection are indistinguishable from those of German-Jewish communities or from those known to have been used in Viennese synagogues (fig. 108). Indeed, many are the work of Viennese silversmiths, a consequence of Austrian rule over Bohemia and Moravia. However, the large group of wooden Torah pointers in the State Jewish Museum are an extraordinary aspect of its holdings (fig. 128). The size of this group may reflect the manner of their seizure, which protected these fragile pointers from the more familiar causes of destruction; but the number of wooden pointers must also be seen as part of the unusual degree to which the synagogue art of Bohemia and Moravia mirrors local folk art.

Fig. 128. *Wooden torah pointers (from left, cats. 70, 72, 67, 66, 69, 65, 68, 71).*

145

Some of these works of Judaic folk art are extremely rare, for example, the two hooks for holding back Torah curtains (figs. 129, 130). The iron hooks are mounted on wooden plaques of heraldic shapes whose painted surfaces are decorated with flowers and inscriptions indicating that the donors were female. The art of the wood-carver embellished many other synagogue furnishings as well. A pair of lions now in the museum, once were part of elaborate Torah arks (fig. 46). These figures have a sense of vitality and movement though their carving is not always skillful. The carver achieved a rich sense of texture by allowing his tool marks to remain on the surface of a unique synagogue alms box (fig. 131). Several other wooden alms boxes in the collection belong to a distinctive group largely stemming from Bohemian synagogues.[38] On these, the aperture is part of an outstretched cast brass hand whose arm terminates in a wooden collection box (fig. 132).

In the collection of brass and pewter synagogue furnishings are examples of both folk and fine art. An *eruv* holder of brass and copper decorated with floral forms and rosettes partakes of the character of the copper household utensils in the State Jewish Museum (fig. 133). Its function, however, was purely ritualistic. The food within symbolized the unification of individually held private property into one collective entity. This entity, when fenced, could be considered private property, within which Jews are permitted to carry things on the Sabbath. Other brass ceremonial objects incorporate folk motifs within an elaborate compositional structure which suggests the influence of book illustrations on pieces of silver, like the Torah shields. For example, the

Fig. 129.
*Torah curtain hook,
Bohemia, 1829
(cat. 17).*

Fig. 130.
*Torah curtain hook,
Bohemia, 1840/1
(cat. 18).*

Fig. 132.
*Alms box, Bohemia,
beginning of 19th century
(cat. 83).*

מתן בסתר
יכפה א

Fig. 131.
*Alms box, Kasejovice, Bohemia,
early 19th century (cat. 84).*

147

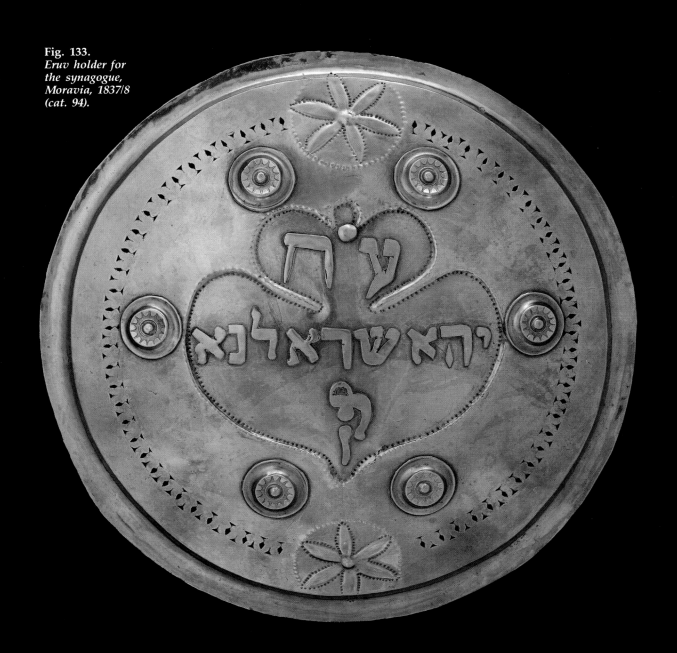

Fig. 133.
*Eruv holder for
the synagogue,
Moravia, 1837/8
(cat. 94).*

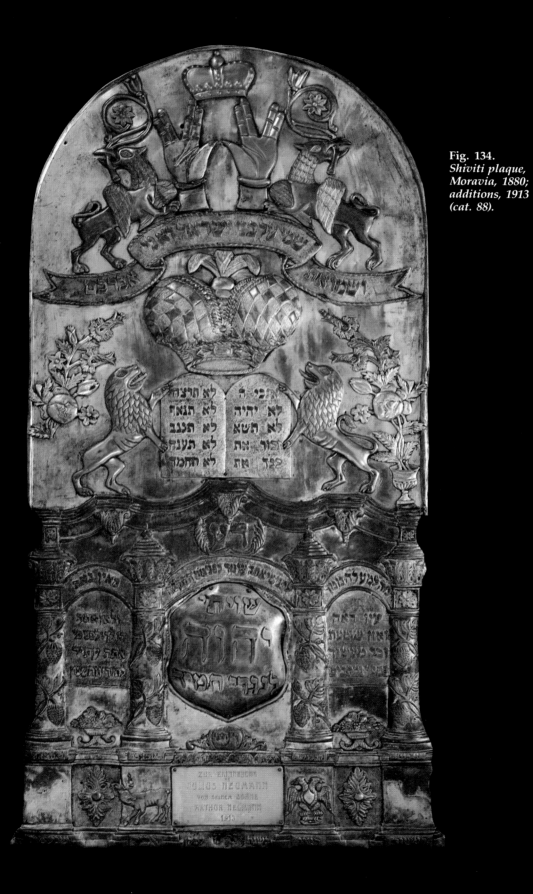

Fig. 134.
Shiviti plaque,
Moravia, 1880;
additions, 1913
(cat. 88).

central motif of a flowering tree which grows from a pot, probably the Tree of Life, occurs on a Prague Torah shield of the first quarter of the nineteenth century (cat. 45), and on an unusual painted and gilded brass lavabo where it is set within an elaborate architectural frame guarded by two elegant rampant griffins (fig. 45). Griffins of more prosaic, folk character flank a pair of blessing hands on a large silvered brass *shiviti* tablet of a type also found in Polish synagogues (fig. 134). Below are lions holding the Decalogue beneath a crown, a composition generally found on Torah shields, and in the lowest zone is a series of texts inserted in an arcade, an arrangement recalling the title pages of printed books.

That the synagogue art of Bohemia and Moravia is related to the decoration of printed books and manuscripts can be demonstrated in relatively recent works of the nineteenth century back through the earliest textiles of the sixteenth century. A number of eighteenth and nineteenth century pewter Ḥanukkah lamps in the collection, including a rare, large example for synagogue use, are decorated with figures of Moses and Aaron (fig. 136). These biblical figures are not directly associated with the holiday, but often occur as pendants on the frontispieces of Hebrew books, beginning with a Haggadah printed in Amsterdam in 1695. This frontispiece composition was widely imitated by painters of the Moravian school who were active in the first half of the eighteenth century, both locally, in Bohemia and Moravia, and in Vienna, where they executed commissions for the Court Jews and their circles. In 1728 the scribe Aaron Wolf of Jevíčko decorated the frontispiece of a Circumcision Book with a composition drawn from the

Fig. 135. *Page from the Prague Pentateuch, 1530 (cat. 278).*

Amsterdam Haggadah of 1712, including Moses and Aaron figures placed within a rich architectural format that also enframes biblical and genre scenes (fig. 193). These narrative scenes are similar in style and composition to those that decorate the ceremonial beakers belonging to Bohemian and Moravian Burial Societies. Other narrative and genre scenes appear in Books of Blessings and in the numerous haggadot which the artists/scribes of this school wrote and decorated for private patrons, for example the 1728/29 Haggadah of Nathan of Mezerič. The earliest works in the State Jewish Museum's collection, synagogue textiles, likewise reflect the influence of book decoration. As we have noted,

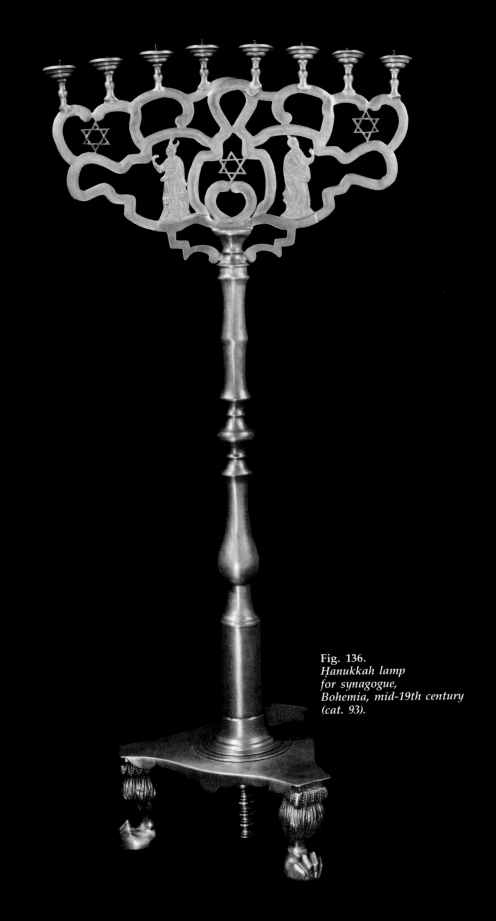

Fig. 136.
*Hanukkah lamp
for synagogue,
Bohemia, mid-19th century
(cat. 93).*

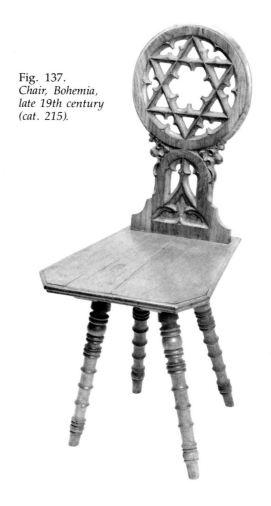

Fig. 137.
*Chair, Bohemia,
late 19th century
(cat. 215).*

the composition of the appliqué curtains probably was drawn from the frontispieces of Hebrew books printed in Prague and individual motifs used on the curtains can be traced to the same source. For example, the leaves which curl around the bottom of the column shafts on the Perlsticker curtain are a prominent feature of the frontispiece of a book by Rabbi Judah Loew, the *Derush Na'e*, published in 1589.[39]

This close affinity between book decoration and synagogue art is not surprising given the importance of Hebrew printing in Prague. The first Hebrew press north of the Alps was established in Prague ca. 1512 by the Gersonides family, who emigrated from northern Italy, bringing with them decorative motifs already in use in the south (fig. 135). By 1605, the Bak family had established a second firm in Prague. Books were also printed in Prostejov in the early seventeenth century and in Brno in the eighteenth century. Besides service books, Hebrew printers published traditional scholarly works by Prague rabbis like Judah Loew, the Maharal, and David Pollak (cat. 279) as well as the more unusual subjects of David Gans, astronomy and a chronicle of world history until the year 1592 *(Sefer Ẓemaḥ David)*.

Rabbis and scholars like the Maharal and David Gans were drawn to Prague because of opportunities to serve its large and prominent community as religious leaders and as teachers. Mordecai Maisel persuaded the Maharal to settle in the city as head of the Klaus yeshivah, a rabbinical school housed in a building complex that also contained a small synagogue. In the beginning, then, the Klaus Synagogue was associated with a school, illustrating the close connection that always has existed in Jewish communities

between the two institutions.

As we have discussed, the synagogue service incorporates study in the form of readings from the Torah scroll. At the conclusion of this reading on the Sabbath, a portion from the writings of the prophets, related thematically to the Torah reading, is recited. There are further occasions when study is integrated into worship. Traditionally, the time between *minḥah*, the afternoon prayers, and *maariv*, the evening service, is reserved for the study of rabbinic literature. These opportunities for study by the general Jewish population are augmented by classes in other texts meeting after morning services or at night. In addition, larger communities like Prague and Mikulov supported rabbinical aca-

demies whose associated students and scholars spent their entire time studying Jewish law and lore. It also was the duty of the community to provide primary education for youth. Many of the educational reforms instituted in this area by the Maharal in the sixteenth century, such as his emphasis on primary texts, also a concern of the humanists, spread far beyond Prague, still influencing educational practice in nineteenth-century Germany.[40]

In other ways, too, the general character of European Jewish communal life was affected by the particular history of the Prague community. As in other cities, the Jews of Prague were intensively organized for the purpose of social welfare. The imperative to do kindnesses in the world, mandated by the rabbis, was institutionalized in various charitable organizations, whose purpose was to feed the poor, to care for the widowed and orphaned, and the like. The general community participated in the work of these organizations through charitable donations. Alms boxes and dishes inscribed with the name of the group, such as the benevolent society or the women's society, were regular features at communal and personal gatherings such as weddings and funerals (fig. 71, cats. 163-67).[41] These inscriptions, as well as the dedicatory inscriptions on textiles, alms boxes, and synagogue silver that were donated from charitable funds, provide partial knowledge of the activities of these social welfare organizations, which is supplemented by the record books of the societies' meetings and transactions (cats. 256, 268, 274).

By far the most comprehensive organizational holdings of the State Jewish Museum are those concerned with the ritual preparations for burial. References in the Talmud indicate that during the early centuries of this era, these preparations were considered the responsibility of the entire community or its representatives.[42] Later, in the Middle Ages, special associations were formed for general charitable purposes, with one of its privileges of membership being the performance of burial functions. The first modern organization of a burial society responsible for the entire community was formed in Prague by Rabbi Eleazar Ashkenazi in 1564. Its rules and regulations were codified by the Maharal. They became the model for all other Jewish burial societies. As the result of the general Jewish community's responsibility for burial, all of the required ritual objects were communal property, and entered the State Jewish Museum in great numbers as part of the gathering of all synagogue and congregational goods by the Nazis. Another reason for the richness of this portion of the collection may have been the early emphasis given to the activities related to burial by the rabbis and leaders of Bohemian and Moravian Jewish communities, and the prestige attached to membership in burial societies, whose activities are considered the highest acts of kindness which an individual may perform, because for this act of charity there is no thanks.

The functions of the Burial Society (or Hevra Kaddisha, literally "Holy Society") arose from two Judaic principles: that reverence must be accorded to the deceased commensurate with the fact that the body once housed the soul, and secondly, that no profit should be made from burial of the dead. A unique cycle of fifteen paintings commissioned by the Prague Hevra Kaddisha ca. 1780, probably as decoration for its meeting hall, details the major stages in the preparations, beginning with a visit by members of the society

Cycle of Burial Society paintings, Prague, ca. 1780.

to the bed of a terminally ill man, through the fashioning of shrouds and the casket, the ritual washing and cleansing of the body, and the actual burial, with various phases accompanied by prayers and the giving of charity.[43] In the scene of the cleansing, one man dries the corpse which has just been rinsed with water, while an older individual combs the hair with a mixture of egg and vinegar (fig. 142). For this combing and the cleansing of the fingernails, burial societies possessed special implements, often made of silver and engraved with dedicatory inscriptions (fig. 154). At right in the painting of the cleansing, a member of the society holds the deceased's *tallit* ("prayer shawl") which will be laid over the shrouds.

Four additional scenes were added to this cycle in the nineteenth century. They depict members of the society at their

Fig. 138. *Visiting the Sick Man (cat. 177).*

Fig. 139. *Prayers at the Deathbed (cat. 178).*

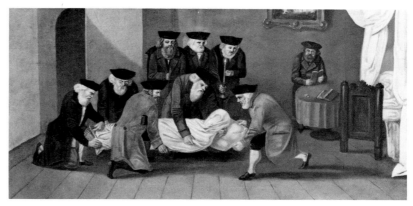

Fig. 140. *Taking Custody of the Dead Man (cat. 179).*

154

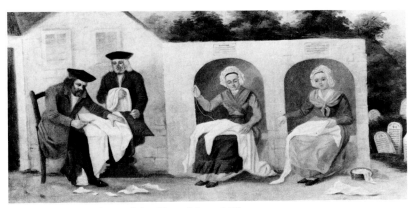

Fig. 141. *The Making of the Shroud (cat. 180).*

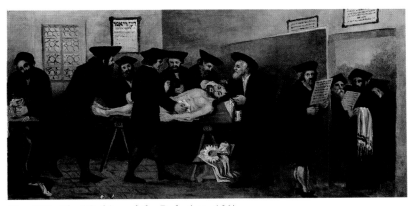

Fig. 142. *The Washing of the Body (cat. 181).*

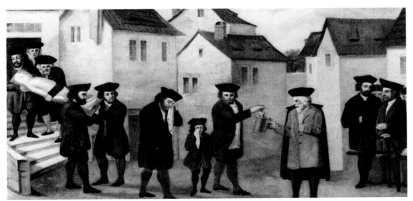

Fig. 143. *Carrying the Body out of the House (cat. 182).*

annual banquet and praying at the grave of Rabbi Judah Loew, who was instrumental in forming the character of the Prague Ḥevra Kaddisha. The institution of the annual banquet, like the commissioning of paintings depicting activities of the society, was adopted by Jewish burial societies from the practice of Christian guilds, which generally excluded Jews partly because of the guilds' participation in religious occasions like funerals.[45] Since the guilds had social and religious functions as well as economic ones, they easily served as models for Jewish communal organizations of a social and religious character. The annual banquet of the Ḥevra Kaddisha was generally held on the traditional anniversary of the death of Moses and followed a day of fasting, in expiation of any deviations from correct practice by members of the society. At the banquet, new

155

members and officers were elected. It was also the practice to drink wine from a beaker owned by the burial society, which was similar in form to beakers possessed by Christian guilds. In most communities, the Ḥevra Kaddisha commissioned silver beakers which were decorated with appropriate inscriptions often including names of the members. But in Bohemia, burial society beakers were made of enameled glass, and in Moravia of painted porcelain, because of the high regard in which works in these materials were held locally.[46] Large decorated Bohemian and German beakers of the type used by the Ḥevra Kaddisha are known from the late sixteenth century on,[47] but the earliest extant Jewish example comes from the city of Polin, Bohemia, dated 1692.[48] Now in the collection of the Jewish Museum in New York (F 3211), this cyl-

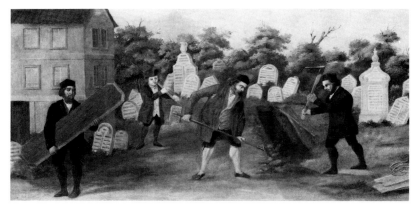

Fig. 144. *The Digging of the Grave (cat. 183).*

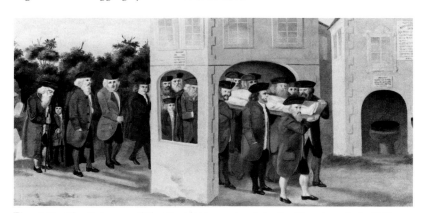

Fig. 145. *The Entrance of the Burial Procession into the Cemetery (cat. 184).*

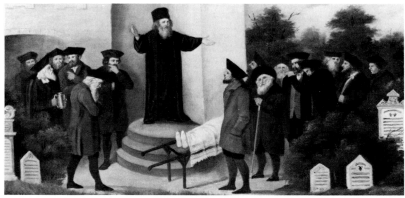

Fig. 146. *The Oration over the Dead Man (cat. 185).*

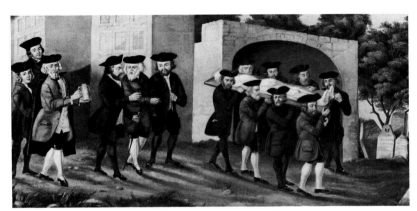

Fig. 147. *Carrying the Body to the Grave (cat. 186).*

Fig. 148. *The Making of the Coffin (cat. 187).*

Fig. 149. *Lowering the Body into the Grave (cat. 188).*

indrical beaker is decorated with a dedicatory inscription and a representation of members of the society bearing the bier; all are dressed in long black coats, white ruffs, and large flat hats. These elements and their composition in a frieze around the circumference of the beaker, even the dress of the participants, remain relatively constant for nearly one hundred years on three other extant enameled glass beakers, all the property of the Prague Burial Society. Two of these in the State Jewish Museum that were painted in the 1780s include processions of women, a reminder of the existence of the women's burial society which cared for female members of the community (fig. 156).[49] Interestingly, though these two beakers are nearly contemporaneous with the burial society painting cycle, their decoration is decidedly anachronistic in

terms of costume and spatial treatment.[50] One explanation of this phenomenon is the conservative nature of Jewish ceremonial art that led to the close copying of earlier forms, a sense of traditionalism already seen in the composition of Torah curtains and mantles. Several faience pitchers that are Moravian counterparts to the Bohemian glass beakers bear inscriptions indicating they are replacements for older, broken examples.[51] One well-executed piece for Mikulov dated 1836, formerly in that city's Jewish museum, bears a burial procession whose members are dressed in early eighteenth century garb and are painted in a flattened style akin to that found on the glass from Polín (fig. 153). Similar figures appear on a silver lid, also from Mikulov, whose original pitcher was broken and replaced by a later copy (fig. 155).

Fig. 150. *After the Burial (cat. 189)*.

Fig. 151. *Washing Hands upon leaving the Cemetery (cat. 190)*.

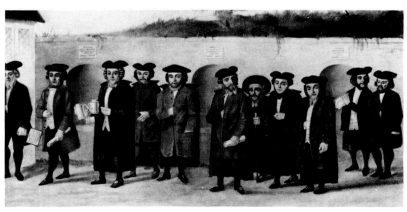

158

Fig. 152. *Group Portrait of Members of the Prague Burial Society (cat. 191)*.

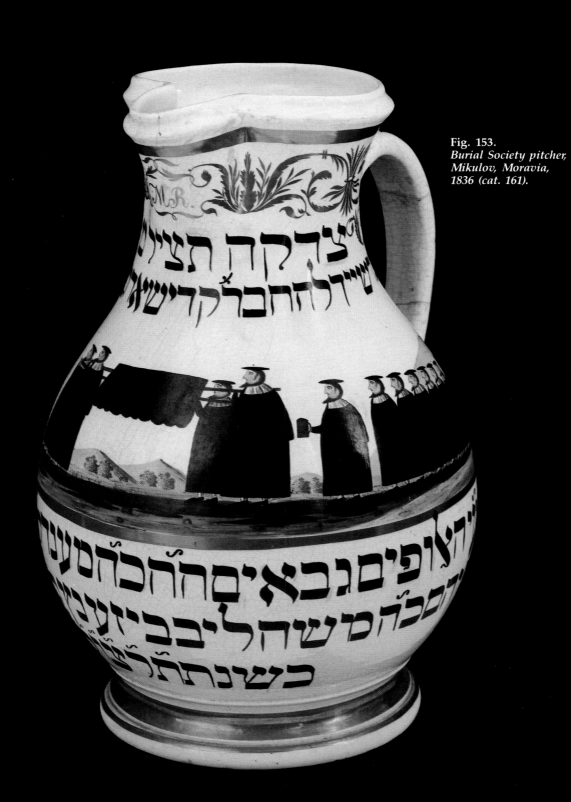

Fig. 153.
Burial Society pitcher,
Mikulov, Moravia,
1836 (cat. 161).

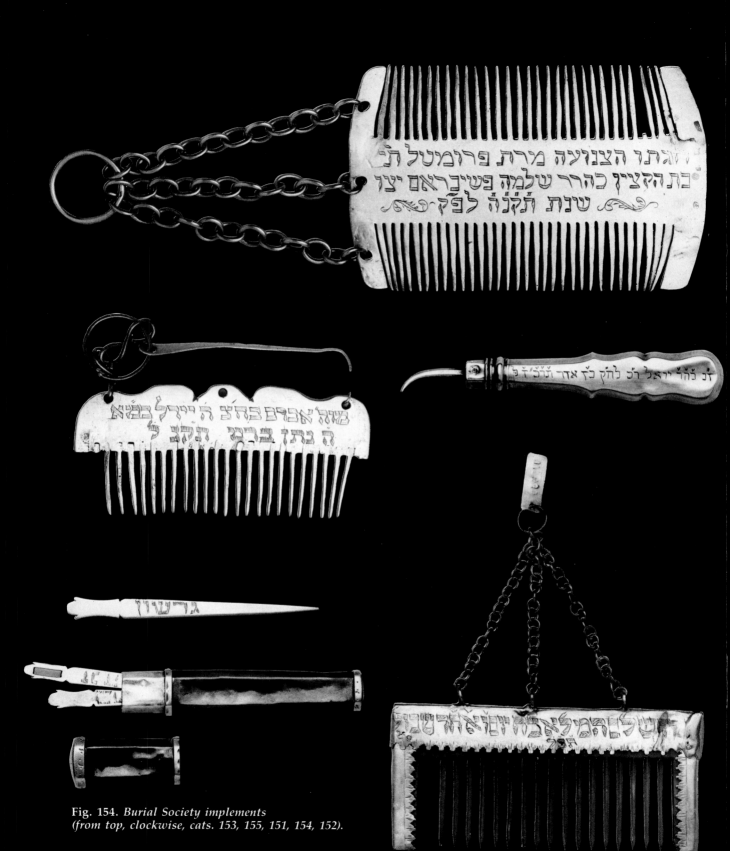

Fig. 154. *Burial Society implements
(from top, clockwise, cats. 153, 155, 151, 154, 152).*

Several beakers from the end of the eighteenth century and the beginning of the nineteenth indicate a turn to the more naturalistic style of the burial society paintings. One is a faience beaker made for the Prague Ḥevra Kaddisha in 1798/99 (fig. 200). On it two scenes are depicted, the visit to the dying man and the procession into the cemetery. Both are peopled by well-dressed figures in contemporary clothing shown within architectural and landscape settings incorporating three-dimensional perspective. Similar figures and space, though more stiffly executed due to the change in technique,

appear on an etched amber beaker commissioned for the Ḥevra Kaddisha of Mladá Boleslav in 1837/38 (fig. 40).

Though this series of beakers and pitchers is the most well-known portion of the Ḥevra Kaddisha collection in the State Jewish Museum, it is by no means the only part. The museum also counts among its holdings portions of china services with Hebrew inscriptions that were used at the annual banquets, as well as an entire set of tableware and serving dishes in their original box, acquired from the Jewish community in the late 1970s (cats. 163-167). Nineteenth-century

Fig. 155. *Lid for Burial Society beaker, probably Prague and Mikulov, 1724/5 (cat. 162).*

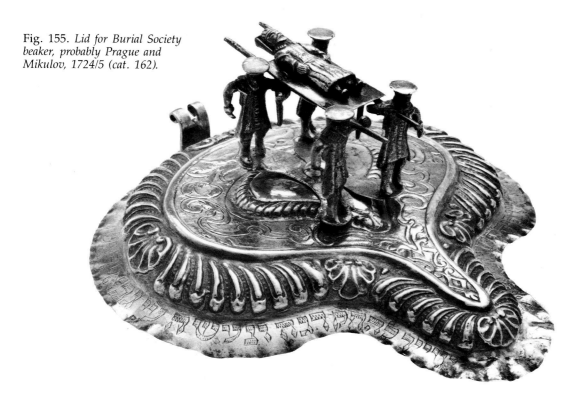

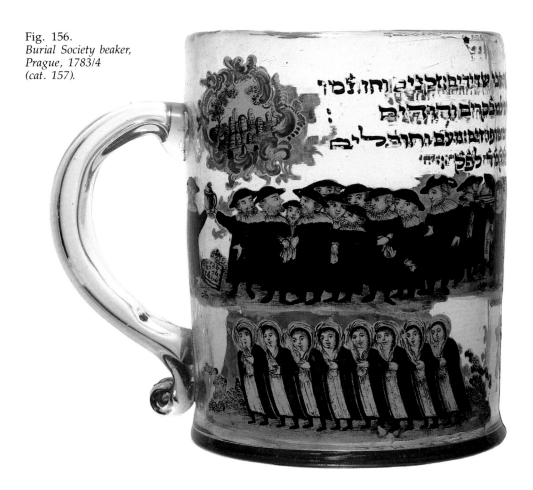

Fig. 156.
Burial Society beaker,
Prague, 1783/4
(cat. 157).

wooden boards used in the ritual purification of the dead, a wooden tombstone dated 1835, and a series of twentieth-century uniforms for members of the society are also part of the collection, as are manuscripts relating to the activities of Bohemian and Moravian societies, like the illuminated *Sefer Maavar Yabok* (cat. 256) and books of statutes from burial societies in cities like Prostejov (Prossnitz) and Kounice (fig. 157).

The burial society is an example of communal organizations which affected the lives of all Jews. Whereas some societies serviced only portions of the population, such as the orphaned; the Ḥevra

Kaddisha, the groups organized in support of education, and the societies that supervised ritual needs like *kashrut* (dietary laws), directed the lives of each individual to live in accordance with Jewish religious and ethical ideals. The work of these communal organizations aided the individual Jew, but was in no way a substitute for his or her own efforts to lead a full Jewish life, to sanctify his days on earth in accord with God's commandments.

Fig. 157. *Statutes of the Burial Society of Kounice, Moravia, 1801/17 (cat. 268).*

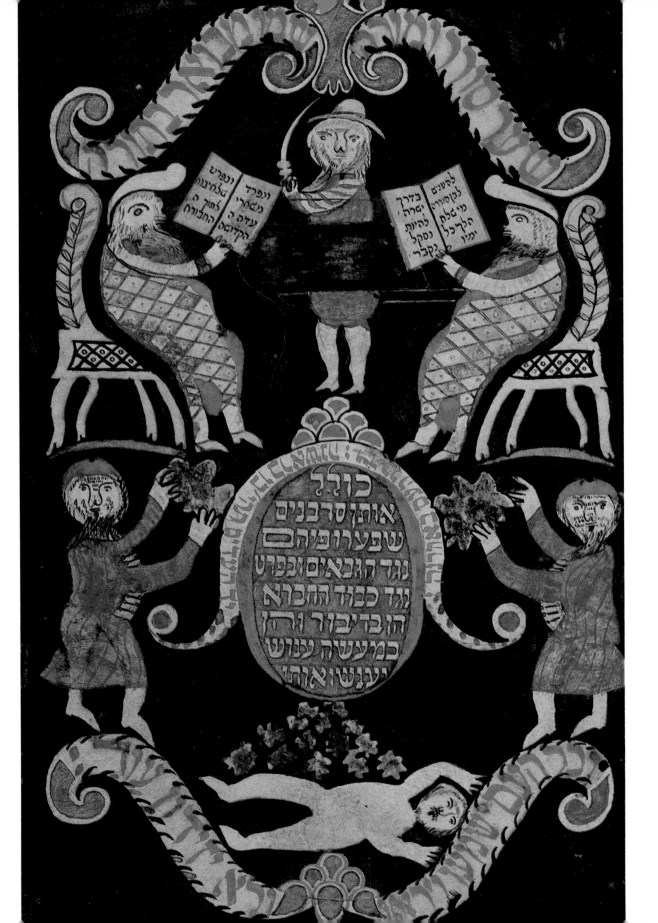

Fig. 158.
Passover plate,
Vienna, ca. 1900
(cat. 127).

SYMBOLS OF THE LEGACY:
FAMILY AND HOME

Vivian B. Mann

The collective life of the Jewish people in synagogues and other community institutions is complemented by a set of personal and familial religious practices whose primary setting is the home. Here in an intimate and constant way, Jews seek to sanctify every dimension of time and space in God's creation. In contrast to other religions, Judaism understands the physical and spiritual natures of humanity to be inseparable. Thus the biblical commandment, "You shall be holy, for I the Lord your God am holy" (Lev. 19:2), is the preamble to an elaborate system of laws and customs whose aim is to hallow every aspect of mundane life.

The satisfaction of physical needs is guided by codes which require the individual to recognize divine dominion and the task of emulating God, even at the moment of catering to impulses which link human beings to animal life. Eating is sanctified through the observance of dietary laws which mandate what people may eat; sexual life through a code of family purity which regulates when, during the woman's menstrual cycle, relations are permitted. The rabbis who elaborated the legal code that is the basis of traditional Jewish life emphasized the importance of productive labor for the sustenance of mankind. "One who does not teach his son a trade, teaches him highway robbery."[1] If people must labor, must be involved in the physical order to survive, how can they sanctify the daily order of their existence? In several ways, according to Judaism. First, through regular prayer and rituals, then by performing good deeds such as visiting the sick and the study of Torah, and by reserving Sabbaths and festivals for rest and spiritual refreshment. In establishing the Sabbath, Judaism gave the world an entirely novel concept, the sanctification of time, which has become for each Jew a primary means of raising earthly life to a high spiritual level. A life of holiness is, then, open to all Jews and is not the achievement of a caste who live apart from the world.

In sanctifying time by observing the Sabbath, people also emulate God, who rested on the seventh day of creation. Another dimension of the Sabbath, then, is the remembrance of history, a

165

recalling of humankind's earliest day on earth. Similarly rich in meaning are the Jewish festivals which sanctify the seasons and the yearly passage of time and simultaneoulsy recall major historical events. Passover, for example, marks both the spring harvest in ancient Israel as well as the Exodus from Egypt, the emergence of the Jewish people from slavery to freedom. For the Jew, historical events like the Exodus are moments of divine intervention, points of interaction between God and the people of Israel. In observing Passover and other holidays, Jews both celebrate the change in the natural order and renew their links to a past held in common with all Jews. By so doing, they reinforce their ties to Jews elsewhere who are sharing in similar religious observances at virtually the same moment.

Just as Judaism sanctifies the natural order of the world—the diurnal, seasonal, and annual—so, too, it invests the order of individual existence with holiness through rituals marking major events of the life cycle, birth, marriage, and death. Crucial moments in personal life become religious occasions which link the individual to the community, and through it, to the Jewish people as a whole. Each individual and household become a microcosm of the people of Israel and a reflection of its universal values and practices.

The State Jewish Museum in Prague possesses rich resources of material culture that reflect these Jewish observances. A portion of its collection of home objects stems from four smaller Jewish museums which were established in Bohemia and Moravia before World War I: one in Prague founded in 1906, a second in Mikulov, the third in Přešov, and the fourth in Mladá Boleslav. Most of the ethnographic collection and ceremonial objects for home use were acquired when the Nazis confiscated all Jewish property—from homes as well as synagogues—in Bohemia and Moravia. This fund of Judaica has been supplemented by recently acquired works.[2] Yet, compared with the vast holdings of synagogue material, the number of home objects in the museum barely represents the Jewish population of Bohemia and Moravia at the outbreak of the Second World War. The personal objects that remain generally are those whose form or decoration is particularly Jewish, for example, lamps used to celebrate the festival of Ḥanukkah or china dishes with Hebrew inscriptions. Other objects, such as silver or glass wine beakers, whose function is required by Jewish ritual but whose form is indistinguishable from those used by the rest of the Czechoslovak population, have disappeared.[3] Such objects were used easily by others. As a result, the numbers of various types of home objects in the museum are, in general, too small to allow for extensive art historical treatment. Our discussion consequently will emphasize their function in Jewish life.

With one exception, a Jewish home does not

Fig. 159. *Wartime storage of household dishes, 1942–45.*

differ in outward appearance from those surrounding it. The exception is a small wooden, metal, or leather container that is affixed to the doorposts of all living rooms. Within is a scroll inscribed with the *Shma*, one of the central portions of Jewish liturgy. It begins, "Hear O Israel the Lord our God is one," and continues,

"You shall love the Lord your God with all your heart, with all your soul, and with all your might. And these words which I command you this day shall be in your heart. You shall teach them diligently to your children and you shall speak of them when you are sitting at home and when you go on a journey, when you lie down and when you rise up. You shall bind them for a sign on your hand, and they shall be frontlets between your eyes. You shall inscribe them on the doorposts (mezuzot) *of your house and on your gates"* (Deut. 6:4–9).[4]

A second, lengthier passage follows (Deut. 11:13–21). The word *mezuzot* used in these verses signified doorposts, and it later was applied to the scroll, affixed to the post, whose writing is governed by many of the same stringent rules applicable to the writing of a Torah, and with similar effect. The mezuzah has changed little in form over the centuries and from one group of Jews to another. No such rigorous laws apply, however, to the containers which vary in form and decoration according to local artistic modes and the wealth of their owners. Prosperous individuals in European communities such as Prague often commissioned silver mezuzot from popular artisans, while humbler householders placed the scrolls in carved wooden and leather holders.[5] Surviving examples of the latter are rarer due to the fragile and perishable nature of their commonplace materials. Some examples in the State Jewish Museum are decorated with architectural motifs. These frame an aperture which is a regular feature of mezuzot. Through it can be seen the name *shaddai* ("Almighty"), written on the back of the rolled scroll. An even more rustic mezuzah in the collection is carved to simulate braided strips (fig. 160). Whatever their form and composition, the primary purpose of all mezuzot is the same: to serve as reminders to keep the words of God at all times and in all places, especially the home, the place emphasized in the text of the mezuzot scrolls. For Jews the home is the arena of important rituals that sanctify life and elevate the mundane into a religious experience.

While physical sustenance is a basic human need, its satisfaction is given a spiritual dimension in Judaism through observance of the laws of *kashrut* (literally "fitness"). Basically, these dietary laws prohibit the eating of birds of prey, of all fish which do not have both fins and scales, and of animals that do not both chew their cud and have split hooves (Lev. 11). In addition, a

Fig. 160.
Mezuzot, Bohemia or Moravia,
18th–19th century
(cats. 208, 209, 210).

שרת בעל הבית ומשתו שובתים וגולוכה · כמרדכי היהודי ומסתר בת אביחיל ·
והוא שותה לב · והיא תובעת כס של ברכה · כזה · האיץ הגל והיא עשתו תבנל ·

רוֹם הַשִּׁשִּׁי וַיְכֻלּוּ הַ שָׁמַיִם
וְהָאָרֶץ וְכָל צְבָאָם · וַיְכַל אֱלֹהִים בַּיּוֹם
הַשְּׁבִיעִי מְלַאכְתּוֹ אֲשֶׁר עָשָׂה וַיִּשְׁבֹּת
בַּיּוֹם הַשְּׁבִיעִי · מִכָּל מְלַאכְתּוֹ אֲשֶׁר
עָשָׂה · וַיְבָרֶךְ אֱלֹהִים אֶת יוֹם הַשְּׁבִיעִי

kosher animal must be slaughtered by slitting the throat with a smooth, sharp knife, a method that causes the animal little pain. Meat then is checked for disease and subsequently soaked in water and salted on a board, causing excess blood to drain away, "for the life of the flesh is in the blood" (Lev. 17:11 ff.) and the drinking of blood was a common practice of ancient idolators. One other basic principle governs the ways in which food is eaten. Milk and meat may not be consumed together, a prohibition that, like the interdiction against consumption of excess blood, reflects sensitivity toward the animal world.

Fig. 162. *Slaughtering knife, Brno (?), Moravia, 19th century (cat. 144), and koshering board, Prague, second half of 19th century (cat. 145).*

"You shall not cook a kid in its mother's milk," says the Torah, and the prohibition is repeated three times.[6] This law is elaborated in later rabbinic legal texts and became the basis for the double sets of dishes, pots and pans, and cutlery in all traditional Jewish homes. The significance of the laws of kashrut is complex and their effects are far-reaching. They are a major factor preventing the complete assimilation of the Jew into general society. With every meal and in all preparations of food, individuals are forced to take cognizance of their religious identity and of their obligation to remember the words of God. Eating also is an occasion for acknowledging divine munificence and for thanking God with appropriate blessings. One of the first books printed in Prague and the earliest extant work that is complete is a Book of Blessings *(Birkat ha-mazon)*, published in 1514 (fig. 161).

The obligation to recognize divine goodness and to serve God is associated not only with acts tied to human physical existence. The individual Jew also is required to pray three times daily—in the morning, afternoon, and evening—an order of worship whose institution Jewish tradition ascribes to the patriarchs Abraham, Isaac, and Jacob. Since these prayers are tied to specific times of day, women are freed from this requirement and others like it in recognition of the pressing nature of the familial obligations most fulfill. When praying in the morning, a male past the age of thirteen, the age of bar-mitzvah, the assumption of obligation for the commandments, binds on his arm and on his head small leather boxes containing parchment scrolls *(tefillin)*,

Fig. 163.
Tefillin bag,
Bohemia, early 20th century
(cat. 100).

thereby fulfilling the command recorded in the passage from Deuteronomy discussed above. The scrolls contain two of the same texts as the mezuzah, in addition to two others, and are written according to the same rules. To prevent damage to the tefillin boxes, which would render them ritually unfit, they are covered and kept in a small pouch. Like the containers of the mezuzah scroll which have a similar protective purpose but no ritual function, tefillin pouches vary in form and decoration depending on their place of origin. The State Jewish Museum's collection has many examples that range from pouches made of plain material to richly-embroidered pieces whose bird and flower motifs can be found also in folk embroideries and on the painted chests used to hold household possessions in Bohemia and Moravia. Others depend on the technique of their fabrication for their aesthetic effect, such as the crocheted examples whose openwork portions often are contrasted with a different color background material (figs. 163-165).

Fig. 164.
Tefillin bag,
Bohemia, second half
of 19th century
(cat. 98).

172

Fig. 165.
Tefillin bag,
Bohemia, 1893
(cat. 99).

Fig. 166. *Prayer shawl (tallit), Germany, second half of 18th century (cat. 101); detail below.*

During morning prayers, a married male also wraps himself in a prayer shawl *(tallit)*, a rectangular cloth with fringes attached to the corners. Prayer shawls usually are fashioned of white or ivory wool woven with black stripes of varying width, and this type forms the bulk of the Prague Museum's collection. Men sometimes own all-white shawls for use on the New Year and the Day of Atonement, since white is a symbol of purity and the prayers for these days center on repentence. A rare example of a white prayer shawl at the museum is made of silk damask and bears an overlay panel of brocade and bands of gilt metallic ribbon (fig. 166). The brocade panel is an eighteenth-century French

Fig. 167.
Skullcap, Moravia (?),
early 19th century
(cat. 106).

Fig. 168.
Skullcap, Bohemia (?),
mid-19th century
(cat. 107).

Fig. 169.
Skullcap, Bohemia, 19th
century (cat. 108).

fabric decorated with leaves and sprigs of flowers. Only seven other examples of this type of tallit are known, all stemming from German-speaking lands.[8] To protect the fringes and the fabric, a prayer shawl is kept in a bag similar to that used for tefillin (cats. 103, 104). Jewish prayer garb also includes a skullcap, generally black, but sometimes fashioned of colored velvet bearing embroidery, with white examples reserved for the High Holidays. (figs. 167-169).

The order of worship established for the first six days of the week changes for the seventh, the Sabbath, which begins at sunset on Friday and ends after sunset on Saturday. An additional service is added, the *musaf,* recited after the public

175

reading from the Torah scroll. Not only do the prayers change, but the whole character of the day is transformed as the result of a complete cessation from creative physical labor and a simultaneous emphasis on spiritual renewal through prayer, study, and positive family experiences. Advance preparations in the physical domain makes this transformation of spirit possible. All food is cooked beforehand, since no fire may be created on the Sabbath; one's house and person are cleansed to welcome the day of

rest, known as "the Queen" in Jewish lore.

Each Jew marks the beginning and end of the Sabbath through ritual, thereby setting it off from the workday and establishing its special character. A woman kindles two or more lights and recites a benediction announcing the onset of the day of rest. The first European Sabbath lights were oil lamps. Their most common form was a star-shaped holder for oil and wicks suspended from a baluster stem. This type of lamp was known as a *Judenstern* or Jewish star, since

Fig. 170.
Bonnet and apron,
Bohemia, early 19th century
(cats. 203, 204).

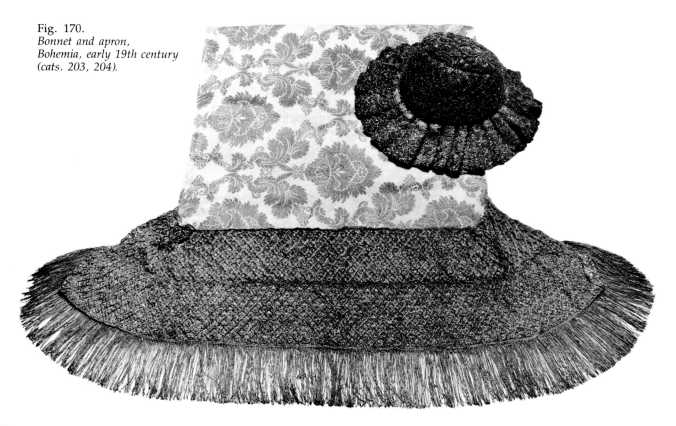

176

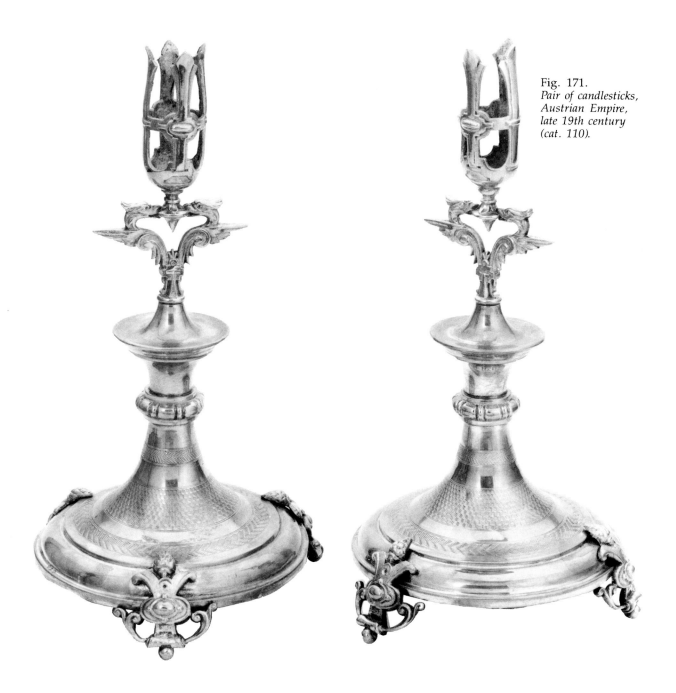

Fig. 171.
*Pair of candlesticks,
Austrian Empire,
late 19th century
(cat. 110).*

its form remained traditional among Jews well into the nineteenth century, long after that type fell out of use by the general population (cat. 109). However, no typical form dominated once the employment of candles became widespread, and the candlesticks used by Jewish women on Sabbaths and festivals are indistinguishable in form and decoration from those of non-Jews, except for those marked with a Hebrew inscrip-

tion. Probably for this reason, very few pairs are included in the State Jewish Museum's collection. One unusual brass set dated to the early part of the twentieth century is an interesting melange of medieval, baroque, and art nouveau forms, and machine-made surface decoration.

The Sabbath is further sanctified through the recitation of *kiddush*, a prayer over wine, whose text recalls the institution of the Sabbath by God

177

at the end of Creation. Though Jewish law does not mandate a specific type of cup for the kiddush wine, it became customary to go beyond the absolute requirements—that the cup be clean, unbroken, and a minimum size—and to reserve fine goblets or beakers for Sabbath and festival use.[9] In most European communities silver cups and beakers, sometimes inscribed with quotations from the kiddush or with the names of their owners, became the norm. Occasionally, these inscriptions record that the cups were donated to synagogues, as it became the custom to recite kiddush at the end of Friday night services for those who could not say it at home (fig. 173). However, the prominence of the Bohemian glass industry resulted in the manufacture of many glass containers for ritual purposes in Jewish communities of Bohemia and Moravia, both as kiddush cups and as wine beakers for communal societies (fig. 172).

The presence of beautiful ceremonial objects like the kiddush cups and candlesticks enhance the appearance of the Sabbath table. Another prominent element are two loaves of bread *(ḥallah)* which remain covered until their consumption at the beginning of the Sabbath meal.[10] No legal requirements govern the appearance of ḥallah covers, though certain iconographic elements were traditionally incorporated into their decoration—depictions of the loaves themselves or of

the Sabbath candlesticks or kiddush cup, plus quotations from the liturgy (cat. 113). Most of the covers in the State Jewish Museum are made of white linen and bear these motifs executed in single-colored embroidery. The material and techniques used are similar to those of the Torah binders and covers discussed previously and likewise echo Bohemian and Moravian folk art. The relative uniformity of design on all these covers, as well as on those used for Passover, suggests the widespread availability of patterns. Other pieces show evidence of individual creativity, for example the patchwork ḥallah cover from Mikulov, Moravia, that dates from the early part of this century (fig. 6).

A parallel ritual, *havdalah* ("separation"), marks the close of the Sabbath on Saturday evening. To announce the resumption of creative physical work a flame is kindled, fueled by a candle composed of more than one wick. Rarely do such candles survive over the years, given their fragility, yet two storage drawers in the museum are filled with havdalah candles, testimony to the utter thoroughness of the Nazi confiscation of Jewish property (fig. 177). The reciter of havdalah holds a cup filled with wine, often the same cup used for kiddush. The distinguishing feature of the havdalah ceremony is the smelling of spices, a practice derived from the Hellenistic custom of burning incense at the

Fig. 172. *Ceremonial goblet,*
Bohemia, mid-19th century
(cat. 111).

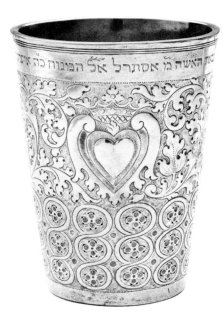

Fig. 173. *Ceremonial beaker,*
Ohlau, Silesia,
1697–1700 (cat. 92).

end of a festive meal.[11] By the time of the High Middle Ages, the spices were no longer burned but only smelled, and a new custom arose of keeping havdalah spices in a special container. In Europe, this container generally took the form of miniature towers in imitation of the architectural form of church vessels, like censers, whose function was similar (fig. 176), and these are the most common type of spice container in the Prague collection. Other forms also are present, and they bear witness to the eastern affiliations of the Czechoslovak Jewish communities. One silver gilt example is a fruit form that rises from a naturalistic leafy stem attached to an irregularly-shaped base (fig. 175). Similar containers were popular among the Jews of Eastern Europe from the eighteenth century onward, and the strong links between Prague and cities like Poznań may have resulted in the appearance of fruit-shaped spice containers in Bohemian or Moravian communities.[12] Another container in the shape of a fruit bears a carved inscription indicating that it is a tourist momento from Safed (fig. 174). This work and others which originated in Palestine in the museum's collection are evidence of increasing ties with the ancient homeland of the Jewish people that may have resulted from Zionist activities in the first half of the twentieth century.

Similar ceremonies herald the beginning of

179

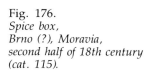

Fig. 176.
Spice box,
Brno (?), Moravia,
second half of 18th century
(cat. 115).

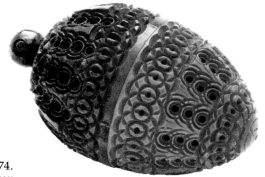

Fig. 174.
Spice box,
Palestine, ca. 1900
(cat. 117).

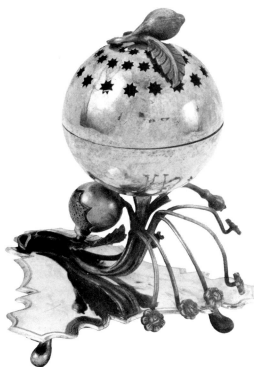

Fig. 175.
Spice box,
Slovakia or Eastern Europe,
19th century (cat. 116).

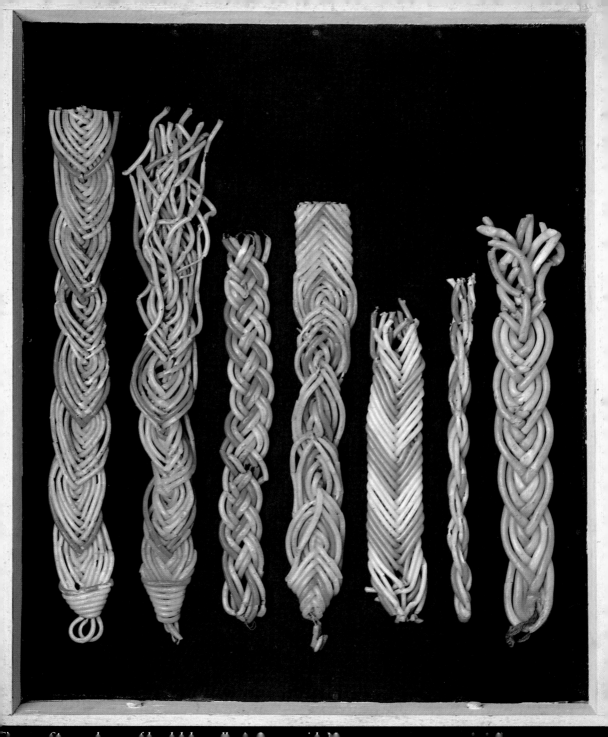

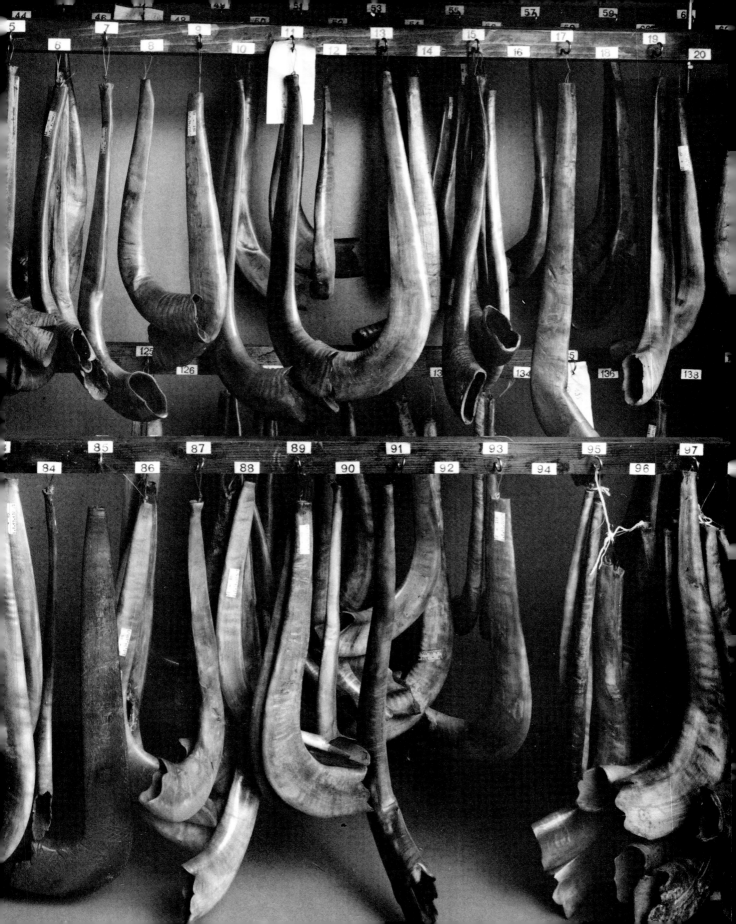

Fig. 178. *Shofar storage at State Jewish Museum, 1983 (see cat. 121).*

Fig. 179. *Belt buckle for Yom Kippur, Lvov, 1847 (cat. 122).*

Fig. 180. *Belt buckle for Yom Kippur, probably Eastern Europe, first half of 19th century (cat. 123).*

major holidays and mark their close. The Jewish year begins with the High Holy Days, the New Year and the Day of Atonement, which fall on the first and tenth days of the Hebrew month of Tishri (September–October). These festivals and the days between them are known collectively as the Days of Awe. They are a time of prayer, repentance, and introspection, as each Jew examines his life over the previous twelve months and prays for life and health in the coming year. In every synagogue on New Year (Rosh Ha-Shanah), a *shofar* is sounded one hundred times as a call to repentance. This ancient musical instrument is fashioned from the horn of a kosher animal, such as a ram. The hundreds of ordinary shofarot in the museum, lacking any aesthetic enrichment such as surface decoration, are mute testimony to the destruction of many synagogues (fig. 178).[13]

The climax of the days of penitence beginning

with Rosh Ha-Shanah is Yom Kippur, the Day of Atonement, a twenty-four hour period of devotion to prayer and complete fasting. This denial of sustenance and the avoidance of other physical pleasures are part of each Jew's attempt to achieve greater spirituality on this day. To symbolize this striving, men and women often dress in white garments, representing purity. For men, this practice means donning a *Kitel*, a loose robe of linen that is part of traditional shrouds, held together with a belt. In the eighteenth and nineteenth centuries, it was fashionable in Ashkenazi communities to wear silver buckles with these belts, one of the few religious articles specifically associated with the Day of Atonement.[14] Their decoration generally consists of two facing rampant lions supporting a cartouche on which is engraved a quotation from the Yom Kippur liturgy, a composition that is in accord with the oblong shape of the buckle (figs. 179, 180).

183

Just four days after the Day of Atonement, Jews begin the celebration of the seven-day holiday of Sukkot (Tabernacles), the first of the three pilgrim festivals in ancient Israel. Each of these holidays was a time of pilgrimage to the Temple in Jerusalem, a celebration of harvest, and a time to commemorate major events in the early development of the Jewish people. After the destruction of the Second Temple in 70 C.E. and the dispersal of the Jewish people outside the lands of Israel, the custom of pilgrimages to Jerusalem and the bringing of harvest offerings fell into disuse. But the other practices associated with Jewish historical events remained in force for these three festivals—Sukkot (Booths), Pesaḥ (Passover), and Shavuot (Pentecost). The name Sukkot derives from the practice of erecting temporary shelters for meals, study, and even sleeping in order to relive the experience of the Jews who wandered in the wilderness of Sinai for forty years before entering the Land of Israel. The other distinctive practice of this holiday is the recitation of a blessing over four plant species that grow in the Land of Israel: the palm, the

Fig. 181.
Etrog container,
Vienna, ca. 1840
(cat. 125).

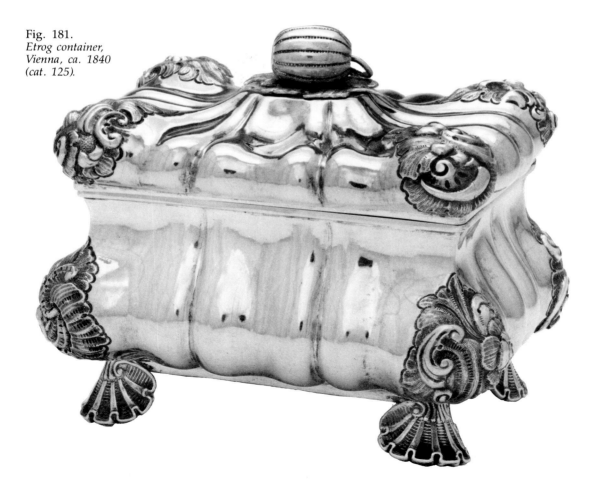

myrtle, the willow, and the citron. The first three are twined together to form a *lulav* which is held with the citron *(etrog)* during the recitation of various prayers. During the *Hallel* ("praise") service of the Sukkot liturgy, the etrog and lulav are carried around the synagogue in solemn procession, a custom which recalls similar processions in the Ancient Temple of Jerusalem.[15] To protect the etrog from damage that would render it unfit for ritual use, the fruit is carefully wrapped and kept in a protective container. Etrog holders take many forms; some are simply adaptations of pre-existing containers (fig. 182). In German lands, silver sugar boxes were often used (fig. 181). The last day of Sukkot takes on a special character. On that day the annual cycle of the reading of the Torah, the first five books of the Hebrew Bible, is completed and begun again. The day is known as Rejoicing of the Law (Simḥat Torah) and it is a time of merrymaking in the synagogue. The second pilgrim festival occurs in the early spring. Passover, as we have noted, marks the Exodus from Egypt. In an elaborate home service *(seder)* conducted

Fig. 182.
Etrog container,
Vienna, 1807
(cat. 124).

זו האשה חשובה מ׳ פערל וויים

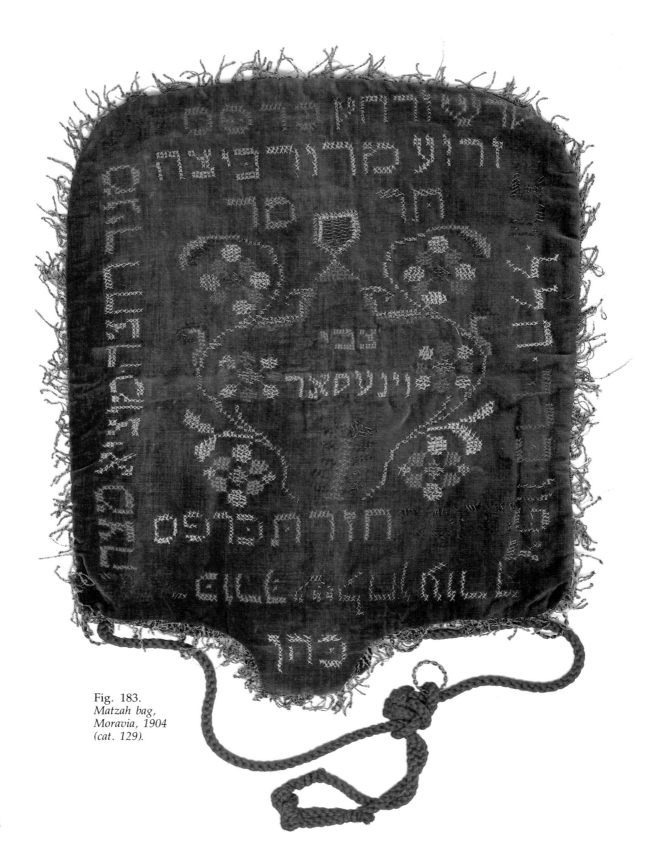

Fig. 183.
*Matzah bag,
Moravia, 1904
(cat. 129).*

on the eve of the first two days of the eight-day holiday, Jews read the Haggadah—a compilation of prayers, selections from rabbinic writings, and songs—and partake of foods that symbolize the bitterness of slavery in Egypt, the redemption by God, and the flight to freedom under the leadership of Moses. By the eighteenth century, if not before, special seder plates were made to hold these symbolic foods. Many eighteenth and nineteenth century European examples are of pewter with incised decoration, since this was the most common type of European tableware (fig. 185). However, because of the popularity of Bohemian porcelain, the State Jewish Museum in Prague possesses numerous china seder plates. Most were mass-produced and are similar to those found in other museums and private collections. However, one white and blue example is an unusual blend of popular Bohemian and Moravian folk motifs, hearts and flowers, and a Jewish star (fig. 158).

Central to the recreation of the ancient Israelites' flight from Egypt is the eating of unleavened bread *(matzah)* on Passover. Due to the haste of their flight, the Jewish nation could not wait for their bread to rise. To this day, matzah remains the quintessential symbol of the Passover story. Its baking is carefully supervised to prevent any rising of the dough; to hasten the baking, the surface is pierced (fig. 184). At the seder three matzot are kept in a divided holder: they symbolize the three religious groups into which the Jewish people was divided: the priests, descendants of Aaron; their helpers, the Levites; and the Israelites. Sometimes, a simple length of cloth was folded to hold the matzah (fig. 186). More common in Ashkenazi communities was the tripartite bag whose top was embroidered with symbols of the holiday or the order of the seder service, iconographic themes also commonly found on the seder plates (fig. 183).

Fig. 184.
Matzah roller,
Bohemia, early 19th century
(cat. 128).

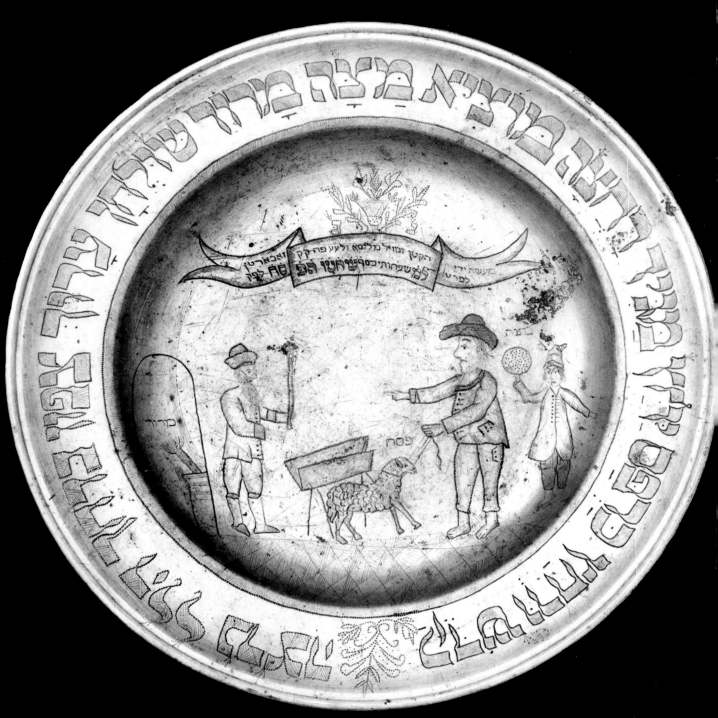

Fig. 185.
Passover plate, probably Bohemia,
early 18th century
(cat. 126).

Fig. 186. *Matzah cloth, Bohemia,
early 20th century (cat. 130).*

The process of redemption
from slavery begun at Passover
with the flight from Egypt
reached its fulfillment only at
Sinai in the giving of the
Torah, the event recalled by
the observance of the third pil-
grim festival, Shavuot. In Ju-
daism, true freedom lies in
commitment to God and the
observance of the Divine com-
mandments. Freedom is not
merely liberation from a state
of bondage but the acceptance
of responsibility. To symbolize
this belief, Passover is linked to
Shavuot by the ritual counting
of the forty-nine days between
the second day of the Passover
and the first of the two days of
Shavuot. This period of seven
weeks is known as the *omer*.
The Hebrew word also signifies
the dry measure of barley of-
fered at the Temple in Jerusa-
lem on the second day of
Passover, the day the counting
begins. Decorated omer calen-
dars often are used in homes
and synagogues, but no special
ritual objects are connected
with the observance of Shavu-
ot proper. This holiday is
marked by the recitation of
special prayers and the study
of Torah, at once the religious
constitution of the Jewish
people and its earliest history.

Fig. 187. *Scroll of Esther,*
Moravia (?), 19th century (cat. 276).

Extraordinary events in later
Jewish history led to the estab-
lishment of two additional
minor holidays, Purim and
Ḥanukkah. The story of Purim
is set in the period of the exile
to Babylon after the destruc-
tion of the first Temple in Je-
rusalem by the forces of
Nebuchadnezzar in 586 B.C.E.
Under the reign of the king
Ahasueras (probably Ataxerxes
II), a wicked vizier named
Haman attempted to destroy
all Jews living in the realm.
The date of their destruction
was fixed through the casting
of lots (*purim,* in Hebrew).
Through the efforts of a beau-
tiful Jewish queen, Esther, and
her wise uncle, Mordecai, the
people were saved. The reading
of the story of Esther from a
scroll *(megillah)* is one of the
central features of this joyous
holiday (fig. 187). In Jewish
lore, Haman became the pro-
totypical enemy of the Jewish
people, and the writing of the
Purim story in scroll form be-
came a model for communal
and familial histories recording
times of great tribulation.
Among the holdings of the li-
brary of the State Jewish Mu-
seum in Prague are a series of

עד כוש שבע ועשרים

על כסא מלכותו

ה לכל שריו ועבדיו

ראהו את עשר כבוד

ומאת יום ובמלואת

שן הבירה ובמלאת

כרפס ותכלת אחוז

זהב וכסת על רצפה

ליב שונים ויין מלכות

על כל רב ביתו לעשות

ה משתה נשים בית

ב המלך בבין אמר

עת הסריסים המשרתים

ני המלך בכתר מלכות

ותמאן המלכה

מלך מאד וחמתו בערה

כבן דבר המלך לפני

רשיש מרס מרסנא

ואשנה במלכות כדת

מר המלך אחשורוש

שריב לא על המלך

יב אשר בכל מדינת

הבזות בעליה

תי המלכה לפניו לא

את דבר המלך

שרי המלך וכדי בזיון

וקצף אב על המלך טוב יצא דב[ר]

מלכות מלפניו ויכתב בדתי פרס ומדי

אשר לא יעבור ושתי לפני המלך אחשורו[ש]

יהן המלך לרעותה הטובה ממנה ונשמע פ

יעשה בכל מלכותו כי רבה היא וכל הנ

לבעליהן למגדול ועד קטן וייטב הדבר בעיני

המלך כדבר ממוכן וישלח ספרים אל כל מדינו

ומדינה כבתבה ואל עם ועם כלשונו להיות כל אי

כלשון עמו אחר הדברים האלה כשך

זכר את ושתי ואת אשר עשתה ואת אשר נגזר על

המלך משרתיו יבקשו למלך נערות בתולות טוב

המלך פקידים בכל מדינות מלכותו ויקבצו את

מראה אל שושן הבירה אל בית הנשים אל יד הגא

הנשים ונתון תמרקיהן והנערה אשר תיטב בע

ושתי וייטב הדבר בעי

יהודי היה בשושן הבי

יאיר בן שמעי בן קיש א

מירושלים עם הגלה א

מלך יהודה אשר הגלה נ

ויהי אמן את הדסה הי

לה אב ואם והנערה יפת תאר וטובת מראה ובמות א

לבת ויהי בהשמע דבר המלך ודתו ובהקבץ נערו

אל יד הגי ותלקח אסתר אל בית המלך אל יד הגי ש

הנערה בעיניו ותשא חסד לפניו ויבהל את תמרוקיה

ואת שבע הנערות הראיות לתת לה מבית המלך ויש

בית הנשים לא הגידה אסתר את עמה ואת מולדתה

אשר לא תגיד ובכל יום ויום מרדכי מתהלך לפני

את שלום אסתר ומה יעשה בה ובהגיע תר נערה וח

אחשורוש מקץ היות לה כדת הנשים שנים עשר ח

megillot telling of difficult incidents in the lives of Jewish families residing in Bohemia and Moravia, and of their establishment of special Purim celebrations to commemorate them. For example, the so-called *Vorhang Purim* ("Curtain Purim") was established on the twenty-second day of the Hebrew month of *Tevet* in 1623 by Ḥanokh Altschul, sexton of the Maisel synagogue in Prague, in thankfulness for his deliverance from prison.[16] Valuable curtains had been stolen from the governor's palace, and an announcement was made to all Jews who might have received the textiles as pawns to transfer them to the sextons of Prague's synagogues. Altschul received the goods, and in accordance with a congregational ordinance he refused to reveal the name of the pawnbroker, for which he was imprisoned. After his release, Altschul wrote of his experiences in a scroll which he instructed his family to read every year on the day he specified as Vorhang Purim (cat. 250).

Ḥanukkah likewise is a joyful festival. It commemorates events which occurred in ancient Israel ca. 165 B.C.E. By that time, the land had fallen under the rule of Hellenized Syrians, who desecrated the Temple and attempted to lure the people into idolatry. Under the leadership of a priest from the town of Modin and his five sons, known as the Maccabees or Hasmoneans, the Jewish people successfully revolted against their Graeco-Syrian overlords. This revolt is the first recorded war for religious freedom. Among the early acts of the new Hasmonean government was the cleansing of the Temple and the reestablishment of its ancient order of worship, including the lighting of the seven-branched lampstand, the *menorah*. According to a story associated with Ḥanukkah (which literally means "dedication" and refers to the cleansing of the Temple), only enough consecrated oil was found in the stores to allow the menorah to burn for one day, yet the lamp continued burning for eight days until new oil could be manufactured. The celebration of Ḥanukkah mandated by the rabbis in the early centuries of this era is based partly on these events: lights are kindled for eight days, beginning with one light on the first, and adding another light for each successive day.

To publicize the miracle of Ḥanukkah in which a few were able to rise up successfully against the many and achieve religious and political liberty, the rabbis also prescribed that Ḥanukkah lights should be placed at the facade of the home.[18] The early and continued association with the architecture of the house appears to have influenced the decoration of many Ḥanukkah lamps.[19] This is true of the earliest European hanging lamps, dated to the thirteenth

Fig. 188. *Ḥanukkah lamp, Bohemia, 19th century (cat. 132).*

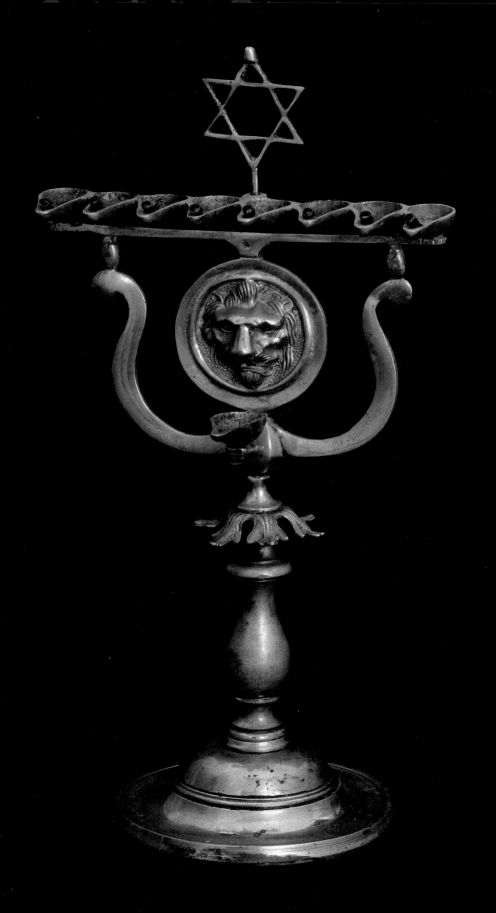

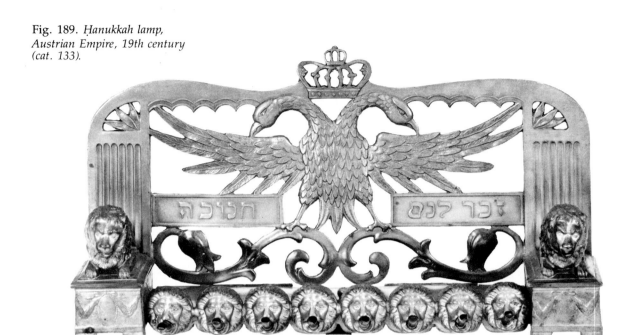

Fig. 189. Ḥanukkah lamp,
Austrian Empire, 19th century
(cat. 133).

Fig. 190.
Dreidlach (spinning tops)
for Ḥanukkah,
Bohemia, 19th–20th century
(c.f. cats. 134–36).

194

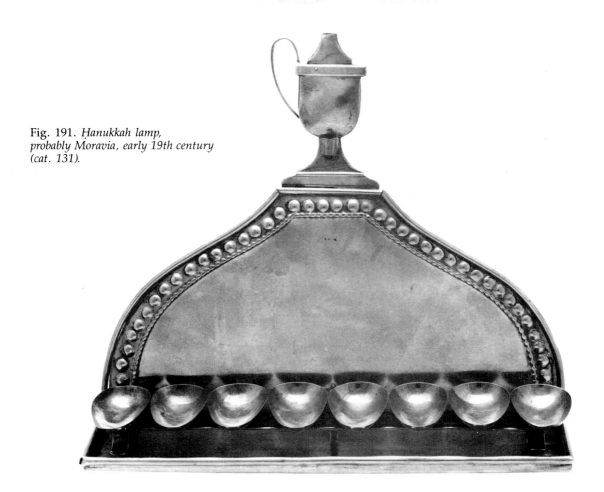

Fig. 191. *Ḥanukkah lamp,
probably Moravia, early 19th century
(cat. 131).*

century, whose backplates are in the form of Gothic tympana with pierced rose windows.[20] The lamps of later centuries range in form from the incorporation of single motifs abstracted from contemporary architecture, such as the gable-shaped backplate of an early nineteenth century brass lamp in the Prague collection (fig. 191), to elaborate recreations of entire facades.[22]

Architectural motifs are only one of the varied types of motifs that have been used to decorate Ḥanukkah lamps. Others include flowers and animals, particularly on the cut-out brass lamps made in Eastern Europe. Many examples of such lamps are part of the State Museum's collection and are material reminders of Bohemian and Moravian Jewry's link to Poland.[22] However, equally strong were the links to Germany, the homeland of many Jewish families, and these are reflected in the pewter Ḥanukkah lamps which replicate German examples. The same medium

was used to fabricate the *dreidlach* (spinning tops) in the State Jewish Museum (fig. 190). Such tops were utilized in the traditional games of Ḥanukkah, one of the light-hearted activities associated with this happy festival.

All of the holy days of the Jewish year—the weekly Sabbaths, the seasonal pilgrim festivals, and the minor holidays—are national observances with multiple meanings. In keeping them, Jews participate in both the past and present of their people and simultaneously sanctifiy the order of their own individual existence. Judaism, like other religions, also provides for the sanctification of each person's life span through ceremonies marking birth, marriage, and death.

The naming of every newborn takes place before representatives of the community—for a girl at the public reading from the Torah, and for a boy at his circumcision. This rite occurs on the eighth day after birth and is the means by which

195

every male Jew enters the covenant between God and Israel, reenacting the covenant established by God with Abraham, the first Jew. Circumcision for this religious purpose is practiced only by a man who has received specialized training, a *mohel* ("circumcisor"). His equipment includes a knife with rounded blade tip and, by at least as early as the seventeenth century, a shield through which the foreskin is drawn thereby protecting the glans. Flasks or other holders for styptic substances, and cups to contain the wine that is drunk at this ceremony could be owned by the mohel as well. These utensils and appurtenances sometimes were lavishly decorated and fashioned of costly materials, like the knife with agate handle and silver filigree fittings in the State Jewish Museum (fig. 192). Such pieces and the illuminated manuscripts containing the circumcision service created by artist-scribes of the Moravian school who were active in the eighteenth century, like the *Mohel Book* of Aaron ben Benjamin Wolf of Jevíčko (fig. 193), all are indications of the significance accorded circumcision in Jewish life.

196

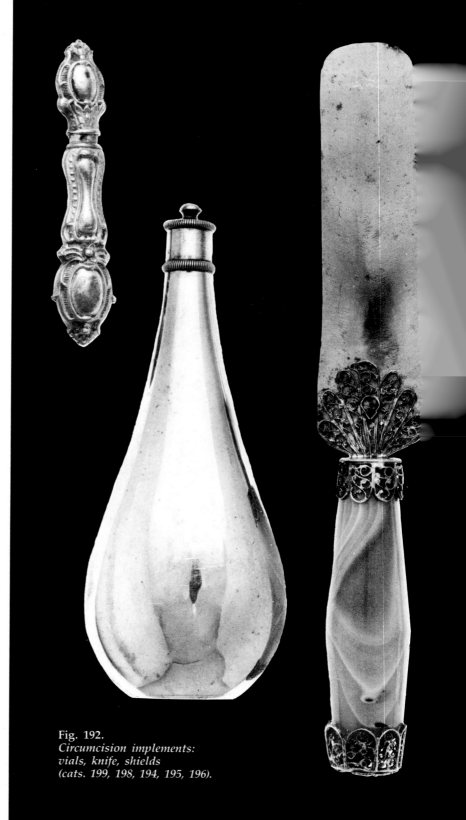

Fig. 192.
*Circumcision implements:
vials, knife, shields
(cats. 199, 198, 194, 195, 196).*

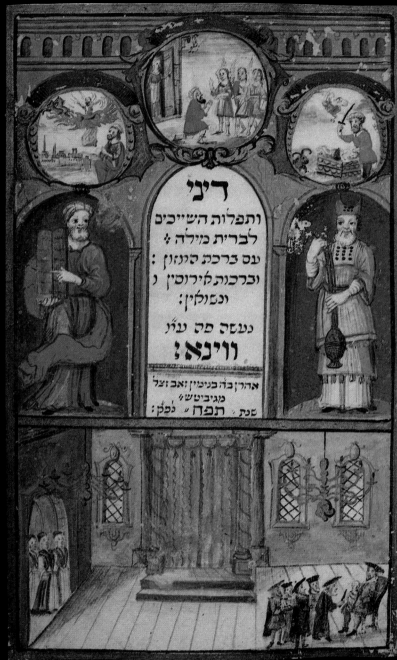

Fig. 193.
*Title page, circumcision book,
Vienna, 1728 (cat. 257).*

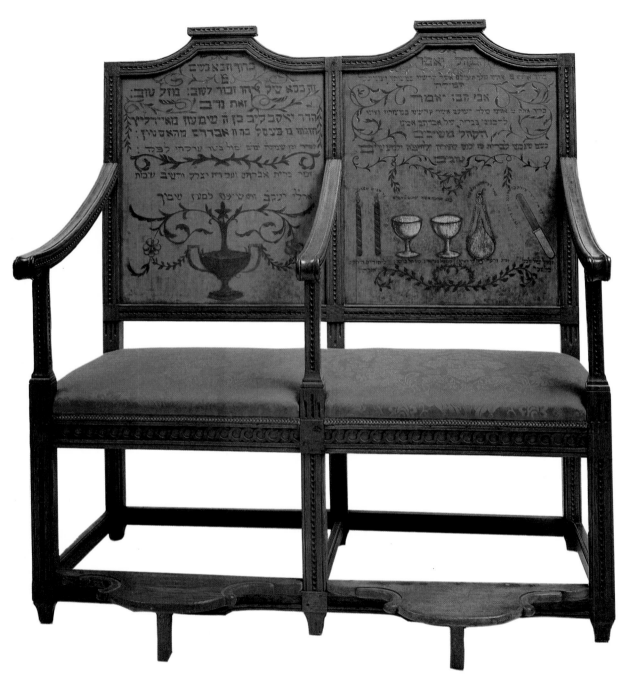

Fig. 194.
*Circumcision bench,
Údlice, Bohemia,
ca. 1805 (cat. 193).*

An infant is carried to his circumcision by a woman who is given the honor by his family; he is held during the rite by a godfather or *sandak* (literally "holder"). Synagogues often possessed special thrones for the sandak. Some had two seats, with the second reserved symbolically for the prophet Elijah, who is thought to protect newborn children and who also is specifically associated with circumcision through rabbinical interpretation of various biblical verses.[23] An early nineteenth-century example of such a double throne was originally part of the Jewish Museum established in Prague in 1906 (fig. 194). The back of the throne is ornamented with representations of the mohel's utensils, selections from the circumcision service, and floral motifs. The inclusion of engraved and painted pictorial decoration is unusual among surviving Elijah chairs. A related piece, also from the early Prague museum, is a cradle (fig. 16) inscribed: "This is the little one," the first words of the last sentence of the circumcision service, which ends with the announcement of the child's name and good

wishes for his future, the same sentence inscribed on Torah binders and covers.[24] The presence of the inscription on the cradle, as well, suggests that it belonged to a synagogue and was used during circumcision. German synagogues often hung special curtains before the Torah ark on the occasion of circumcision. The central panel was embroidered with the main text of the

Fig. 195. *Torah binder, Susiče, Bohemia, 1784 (cat. 35).*

service. Several examples of these curtains are part of the State Jewish Museum's holdings, indicating the spread of this German custom to Bohemia and Moravia.[25]

At puberty, age twelve for a girl and thirteen for a boy, a Jewish child is considered an adult in terms of religious obligation and assumes personal responsibility for the fulfillment of commandments. A boy marks this rite of passage by receiving his first call to the Torah. He recites blessings before and after the reading of a portion of the chapters reserved for the Sabbath after his birthday. Though today this event is given extraordinary emphasis, in earlier times in Europe bar-mitzvah was a less important event

in the life of an individual and his community.

Of far greater significance was marriage. The Bible reads: "It is not good for man to be alone" (Gen. 2:18). This statement about Adam is complemented by the very first commandment recorded in the Torah: "Be fruitful and multiply" (Gen. 1:28). Marriage and childbearing are viewed in Judaism as human imperatives. Consequently, weddings were of major importance and were occasions of great joy for the commu-

Fig. 196.
Bridal wreath and veil in a frame, Bohemia, 19th century (cat. 202).

nity who saw in each union the establishment of another "true household"[26] in Israel and the reaffirmation of the continuity of the Jewish people.

Various types of objects associated with marriage are housed in the State Jewish Museum in Prague. A series of pewter plates bear inscriptions along the rim indicating that they were gifts to a bridegroom from the members of a communal organization to which he belonged. The decoration on the center of these plates consists of generalized motifs or of forms representative of the bridegroom's name or status; for example, a pitcher for Ber Neustadtel who was a Levite (fig. 197). Several carefully preserved objects in the museum belonged to a bride or married woman. One is a dried floral wreath and wedding veil that was enframed as a memento (fig. 196). Except for veiling and the wearing of pre-nuptial gifts such as special belts, Jewish brides did not differ in their dress from other women. After marriage, however, Jewish custom mandates that women cover their hair out of modesty. In the State Jewish Museum's collection is an elaborate bonnet that is completely covered with richly worked metallic embroidery and lace that is similar to that of the decorative collars *(atarot)* with which men's prayer shawls were sometimes embellished and to bonnets worn by Bohemian women (fig. 170).[27] Together with an apron formed of brocade and matching metallic lace and metallic fringe, the bonnet probably was worn on Sabbaths and holidays. Other forms of head covering can be seen in the marriage portraits preserved in the Prague museum, examples of the European

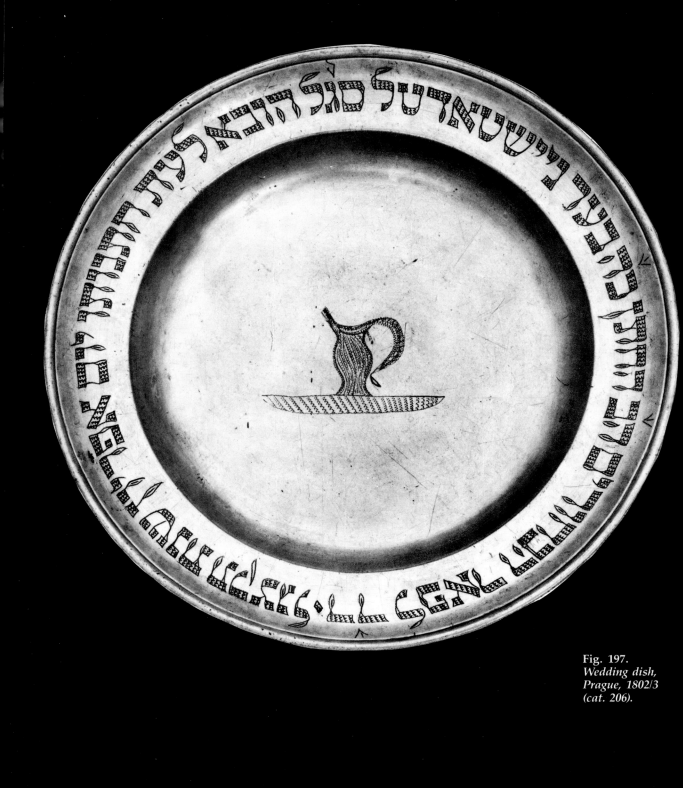

Fig. 197.
*Wedding dish,
Prague, 1802/3
(cat. 206).*

Fig. 198. *Portrait of Amálie Andrée, probably Vienna, ca. 1835 (cat. 230).*

Fig. 199. *Portrait of Karl Andrée, probably Vienna, ca. 1835 (cat. 229).*

bourgeois custom of commissioning such paintings at marriage or sometime thereafter (figs. 72, 73, 198, 199).

The final stage, death, is also the most traumatic for the individual's family. It is then that the Jewish community is most supportive, and most personal. Through the instrumentality of the burial society, the community spares the family some of the more difficult aspects of bereavement. Jewish laws concerning mourning guide the family in the days, weeks, and months following death and establish norms of dignified, respectful behavior. In the decoration of tombstones, however, individuality is allowed expression. Many of the graves in the Old Jewish Cemetery of Prague and in the scattered provincial cemeteries that are still preserved bear only piously composed inscriptions, but others are decorated with reliefs pertaining to the deceased: his name, profession, or status within the community. Several erected to commemorate girls who died young bear reliefs of virgins; one shows a woman spinning and another is carved with double reliefs of Rabbi Aaron Simon Spira-Wedeles in his dual role as rabbi and judge of the community.[28]

The care given to the deceased is but a reflection of the deep reverence given to the living. Out of this reverence for life comes the desire to ennoble man's earthly existence according to the highest ethical and spiritual norms, that is, to sanctify it.

Fig. 201. *Carved relief of virgin,*
detail of tombstone from Old Jewish Cemetery, Prague.

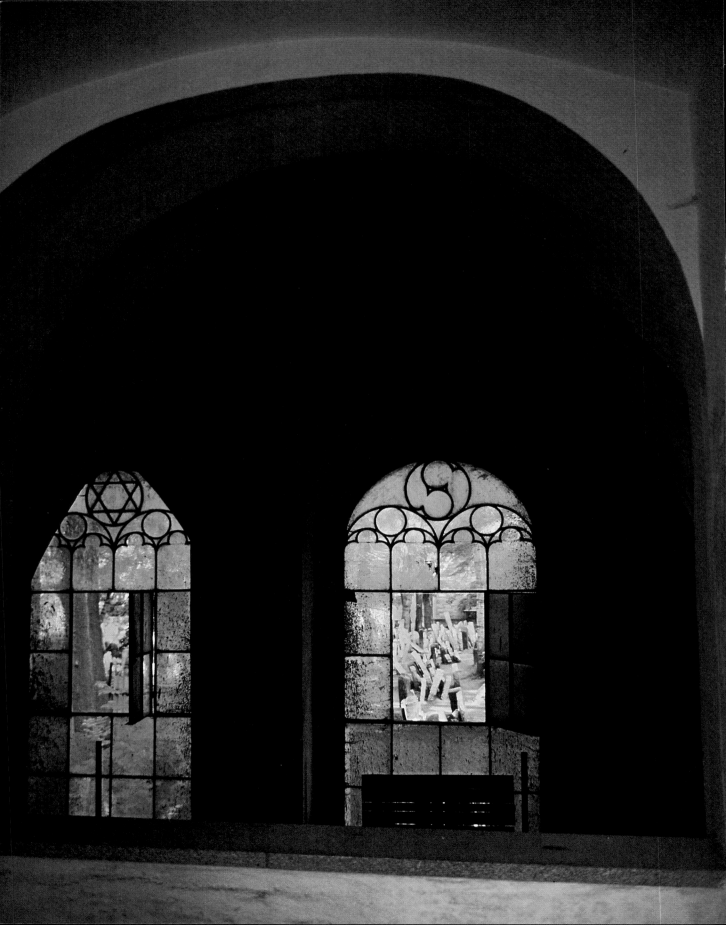

TRAGEDY AND TRANSCENDENCE

Linda A. Altshuler
Anna R. Cohn

T he artifacts in The Precious Legacy are from another time and place.[1] Yet most of these objects would be as much at home in Jewish life today as in any time gone by. Continuity distinguishes the Jewish experience. During nineteen centuries of settlement in more than eighty countries worldwide, Jews have preserved their unique religious beliefs and practices. Judaism is the constant in an ever-changing world. Thus while the artistic forms of Jewish ceremonial art vary in response to the different periods and environments in which they are made, the functions of Judaic objects are rooted in time-honored laws and traditions.

Far from being evidence of a lost culture, The Precious Legacy speaks to a living tradition. That tradition upholds above all a reverence for life as the hope of humankind. Jews hallow life as an affirmation of God's mastery of creation, and so all things of the natural world provide oppor-

tunities for sanctification from the cradle to the grave. Even the most mundane acts are consecrated by special religious observances that at once praise God and celebrate God's creations in a spirit of thanksgiving and hope.

The sacredness with which Jews regard life transcends even death. The famous 1780 cycle of paintings illustrating the activities of Prague's venerable Hevra Kaddisha attests to the respect and honor accorded the dead in Jewish law and tradition (figs. 138-152). An even more concrete manifestation of Judaism's reverence for the dignity of human life is found at a historic site in the very heart of Jewish Prague, in the Old Jewish Cemetery (figs. 202-208). Crowded amidst the houses of worship and study and the living arteries of the neighborhood, some 12,000 tombstones stand atop a graveyard built twelve layers deep. Leaning one upon the other are stones whose very physical appearance marks them as monuments to diverse eras in Prague's history and culture. In this haunting yet serene environment the history of a vibrant, ever-growing community is encapsulated. Countless thou-

Fig. 202. *Old Jewish Cemetery, through the windows of the Pinkas synagogue, Prague, 1983.*

207

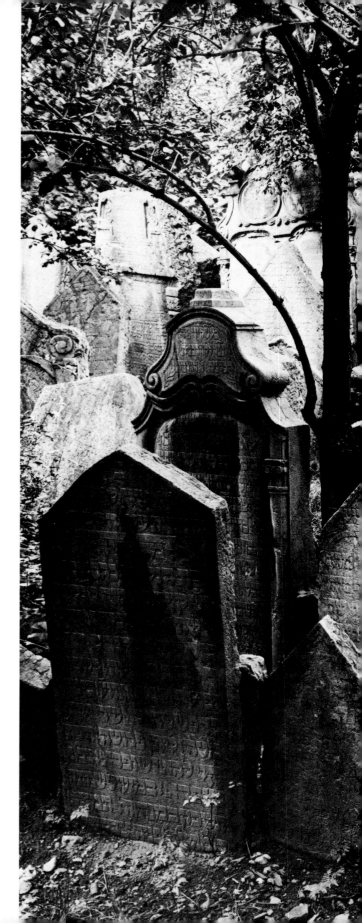

Fig. 203. *Old Jewish Cemetery, Prague, turn of 20th century.*

sands of individuals, spanning generations from the fifteenth through the eighteenth centuries, are buried here, and for each there remains a special testimony: tombstones bearing names and lineage, dates of birth and death, professional affiliations, epitaphs and special benedictions.

So important was the memory of individuals that even fragments of the earliest tombstones are carefully preserved. In the early fifteenth century when this cemetery was founded, these fragments were removed from two older Prague Jewish burial sites that had to be abandoned and were embedded in a special wall here.

The earliest free-standing tombstones, from as early as the second half of the fifteenth century, are characterized by Hebrew inscriptions carved in high relief into square sandstone blocks. Relatively unadorned, they nonetheless illuminate the past with the epitaphs they bear. One reads:

. . . There was no flaw in him during his voyage here on earth; Perfect he was in all his deeds like none other here on earth; He prayed at dusk and dawn and with his brow touched earth; . . . Now here he rests; his fame and glory spread to fill the earth.[2]

The next stylistic generation of tombstones are made of pink and white marble and begin to incorporate elements of Renaissance ornamentation influenced by the general artistic environment, including hybrid animal and floral forms, columns, archways, and decorated capitals. Approaching the turn of the seventeenth century, these decorative elements are incorporated into a more disciplined architectural scheme. Text and ornamentation are integrated, with Hebrew inscriptions framed by symmetrically organized columns, arches, roundels, volutes, and car-

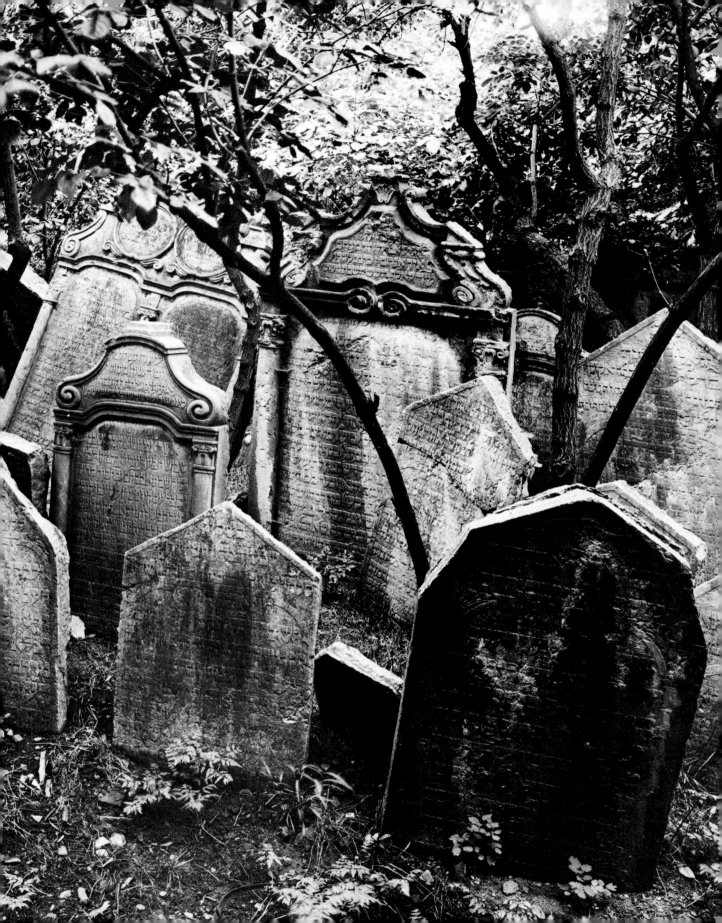

Fig. 204.
Tombstone of
David Gans
(d. 1613).

Fig. 205.
Densely packed
tombstones.

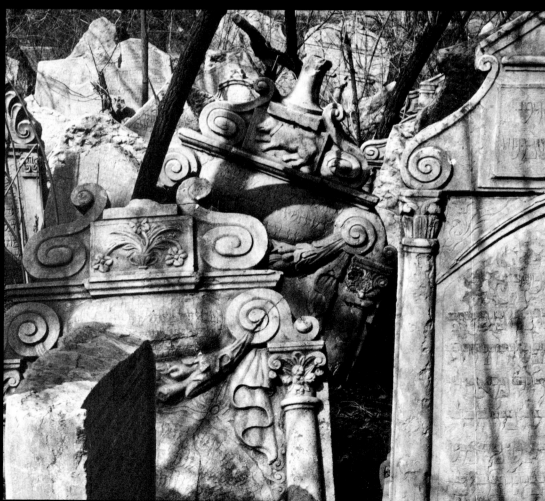

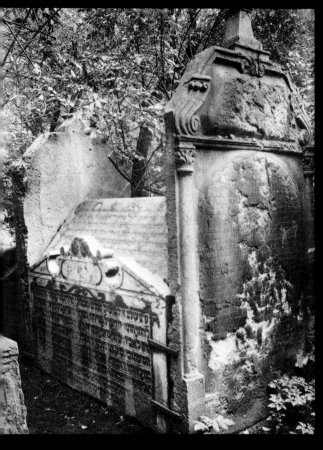

Fig. 206.
*Tombstone of
Mordecai Maisel
(d. 1601).*

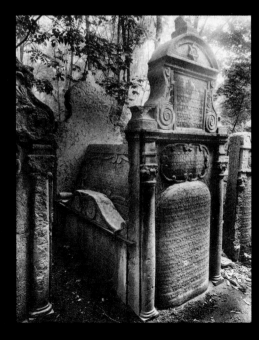

Fig. 207.
*Tombstone of
David Oppenheim
(d. 1736).*

touches bearing family or professional crests. In a later phase of development, tombstone faces have frames carved in elaborate curvilinear designs. Still another feature of this early-seventeenth-century period is the appearance of three-dimensional monuments constructed like tents from two decorated tombstones joined by a roof, meant symbolically to recall the dwellings of ancient Israel (fig. 206).

Even as the range of artistic tombstone styles testifies to the longevity of the Prague Jewish community, so too do their inscriptions recall an extensive list of world-renowned Jewish leaders. These individuals represent the dynamic work of scholarship and piety that distinguished Prague for centuries as a center of European Jewish life and learning. Here lie the poet Avigdor Kara (d. 1430) (fig. 55), the philanthropist Mordecai Maisel (d. 1601), and the preeminent teacher Judah Loew ben Bezalel (d. 1609) (fig. 61). Here, too, are Loew's disciple, the historiographer and astronomer David Gans (d. 1613), as well as the pupil of Galileo, philosopher-scientist Joseph Delmedigo (d. 1655), and bibliophile David Oppenheim (d. 1736).

211

Fig. 208.
*Tombstone details
include symbols
of professions and
family names.*

These luminaries, known to us from their own writings and from works about them, rest intermingled with the thousands of others about whom we can discover only what is discernible from the words and images etched on their gravestones. Yet even these monuments of ordinary folk speak eloquently of the rich diversity and societal dynamism that was Prague Jewry. Honored here in epitaph and symbol are the musicians and writers, physicians and teachers, seamstresses, lawyers and vintners that comprised the fabric of everyday life (figs. 208).

The Old Jewish Cemetery thus bears witness to life as much as it does to death. Its crowded conditions and narrow walkways replicate the circumstances that prevailed in the living streets at whose heart it stands. Extraordinary because it is preserved intact from the Middle Ages, the cemetery mirrors the centuries of continuity of life and culture that resonate in Jewish Prague. The humble piety of its praise of the dead bespeaks a spiritual commitment at the very core of Jewish tradition, affirming the basic goodness of creation, the dignity and worth of human life, and the redemptive essence of history.

These values and ideals not only animated for the Jews of Prague the meticulous practice of religious rituals; they also inspired the courage to withstand successive trials and even catastrophies that marred the lives of Jews throughout Europe both in the Middle Ages and in early modern times. The traditional Jewish expectation of history's ultimate beneficence and the deeply embedded reverence for life that permeates every dimension of Jewish ethics undergirded a kind of spiritual resistance against tragedies, whether individual or communal. Yet no earlier event in the life of Prague Jewry could have prepared this venerable community for the unparalleled catastrophe that unfolded in the 1930s and 1940s. Unleashed in this dark era was destruction that was neither temporary nor partial, killing that was not massacre but genocide, a devastation not only of the Prague Jewish community but of European Jewry in its entirety.

Just thirty miles from the Old Jewish Cemetery stands another burial ground (fig. 211). Its neat, manicured landscape contrasts markedly with the densely clustered gravestones at the older site. Some few hundred small tombstones stand in measured rows here, but the eye is drawn to larger monuments, each commemorating thousands of unnamed victims whose lineage and lives were blotted from historical record. No epitaph sanctifies the memory of these countless men, women, and children who perished at Terezín, the Nazi "model" concentration camp, a "ghetto" as they called it. Between the first deportation from Prague on November 24, 1941, and the last transport on April 20, 1945, more than 140,000 Jews throughout Europe were sent to Terezín. Thirty-three thousand died there; 88,000 others were transferred to the death camps of Auschwitz, Treblinka, and elsewhere to the East.

Emperor Joseph II had built Terezín in 1780 as a garrison town to protect the countryside from invading Prussians. Named in honor of his mother, Maria Theresa, Terezín consisted of two fortresses divided by the Ohre River. The smaller fortress was used continuously as a military prison, but the larger one was converted in 1882 to a small civilian town.

The Nazis occupied the Small Fortress in the

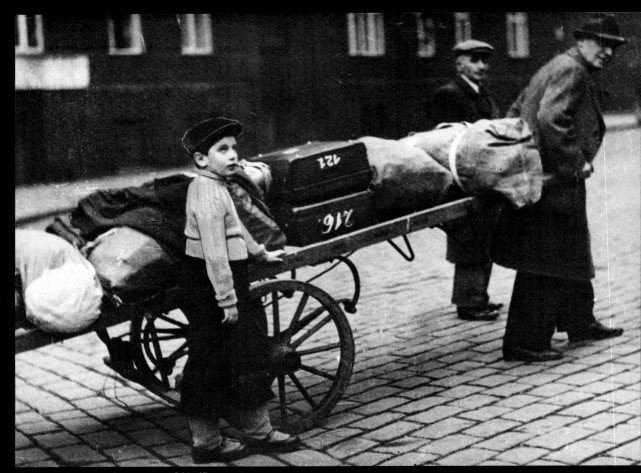

Fig. 209. *Deportation scene, 1941–45.*

Fig. 210. *Main entrance to Terezín Small Fortress, 1983.*

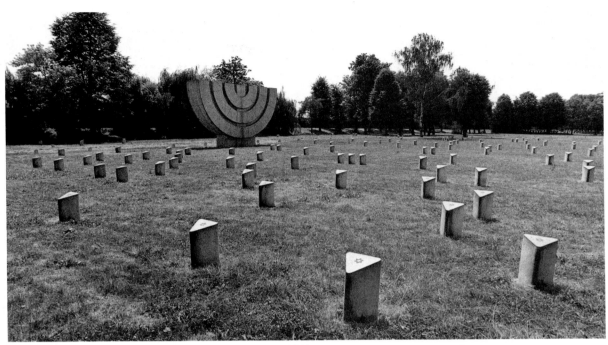

Fig. 211. *Mass graves and memorial, Terezín cemetery, 1983.*

spring of 1940. Then, on October 10, 1941, Reinhard Heydrich and seven other high-ranking Nazi officials including Adolf Eichmann, selected Terezín from among some twenty Bohemian towns to be converted into a ghetto for Jewish deportees en route to annihilation in the East. After the "Final Solution to the Jewish Problem," they determined, the location could be reestablished as a "model German settlement."[3]

The Nazis chose Terezín for perverse, pragmatic reasons. Its internal design and fortifications allowed the town to be controlled and sealed off. Terezín also had the necessary administrative buildings, barracks, and storehouses. And the Small Fortress (where Archduke Ferdinand's assassin, Gavrilo Princip, had died in 1918) was an ideal Gestapo prison, already equipped with solitary confinement cells, gallows, and a plaza for firing squads.

During the first few months of deportations, the Nazis concentrated on interning certain categories of German Jews: invalids, persons sixty-five years of age and older, decorated and disabled veterans of World War I, those married to non-Jews and children of mixed marriages, and prominent figures. These were individuals whose deportation to "work camps" further east would have aroused public suspicion. Later arrivals in 1942 included Jews from Holland, Bohemia, Moravia, and Denmark.

Terezín originally had been built to accommodate 17,000 soldiers. At times during the Nazi era, however, as many as 60,000 deportees were crowded within its confines. Paradoxically, many Jews saw in this garrison-turned-ghetto a hope for escaping deportation further east. Indeed, the Nazis made efforts to give the ghetto the veneer of a modern planned community, hoping that Terezín would hide from Jews and international observers the truth of the Nazi extermination program. They invited Jewish specialists in such fields as economics, city administration, and public transportation to draw up plans for community self-government. But these plans were adopted only when they served the larger Nazi agenda. Within a strict regime, deception of the victims took many forms. Sporting events were staged, replete with bogus award medals. Spe-

215

Fig. 212. *Crematorium near Terezín, 1980.*

cially printed scrip enabled Jews to buy back the remnants of their confiscated property. The Nazis also appointed a Jewish "Council of Elders" whose duties included compiling lists of all individuals slated for transport.

The conditions of daily life in the ghetto clearly reflected Nazi goals. Family members routinely were separated into men's, women's, and children's barracks. They included workshops,

offices, infirmaries, and communal kitchens. Inmates who were suspected as political or security threats were tortured or imprisoned in the Small Fortress (fig. 91). Famine and disease were widespread due to overcrowding and lack of sanitation, and although hospital facilities existed, they were hardly adequate for the ghetto population. The death rate at times was more than one hundred persons daily.

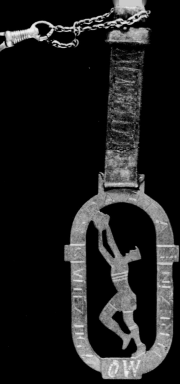

Fig. 213. *Medal for Nazi-organized sports event, 1944.*

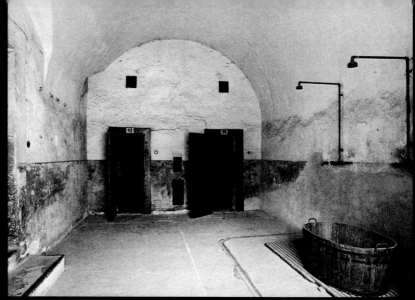

Fig. 214. *Living quarters interior, Terezín, 1983.*

Yet the Nazis at times used propagandistic artifice to showcase Terezín in a positive light. The most notorious instance of this kind of manipulation occurred in June 1944, when members of the International Red Cross were invited to inspect the ghetto. In preparation for this visit, Camp Commandant Rahm attempted to alleviate overcrowding by accelerating the rate of deportations to Auschwitz; he also ordered the immedi- ate fabrication of cafes, schools, and shops. Buildings on the official tour route were cleaned and painted. Flowers were planted and fresh uniforms and linens were given to the hospital. The town temporarily and superficially was transformed from a filthy ghetto to a fairy-tale, pastel-painted village, complete with band music and merry-go-round. The Red Cross representatives never witnessed the squalor behind the scenes.

217

Fig. 215. *Barracks interior, Terezín, 1983.*

The success of this investigative tour inspired the Nazis to produce a propaganda film, *The Führer Presents the Jews with a City*, that purported to show the benefits of Jewish life under the Third Reich. Rahm recruited Dutch prisoner and filmmaker Kurt Gerron to direct the project. The Council of Elders, seeing no choice, encouraged Gerron to agree, and a special film crew was detailed from Berlin. The film documented and elaborated the hoax by featuring such scenes from "normal life" as transactions at the bank and post office, a swim meet, a Council of Elders meeting, a lawn party, and Commandant Rahm welcoming a transport of Dutch children. Immediately after filming was completed, virtually the entire cast was sent to the gas chambers at Auschwitz.

Transports continued to arrive at Terezín through the spring of 1945. In April of that year, 14,000 inmates arrived from other concentration camps near the Allied lines. A typhus epidemic broke out shortly thereafter, and thousands of deaths ensued, even after the Russian Army liberated the camp on May 8.

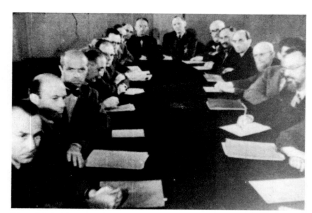

Fig. 216. *Terezín Council of Jewish Elders, 1942–45.*

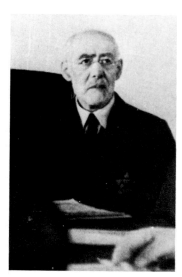

Fig. 217. *Leo Baeck (1873–1956).*

Among the most dramatic aspects of life in Terezín were the educational and cultural activities that inmates initiated in this most unlikely and unseemly atmosphere. A library of some 60,000 volumes was organized. Academic lectures and study groups regularly explored secular as well as Judaic topics. The prominent Berlin rabbi Leo Baeck taught thousands, sometimes in secret, about philosophers from Aristotle to Kant (fig. 217). Other scholars addressed topics as diverse as Jewish ethics, chemistry, European fiction, economics, and geography. Religious observance, too, was kept alive; daily and festival worship was conducted in a makeshift chapel, and ceremonial objects were fashioned from any available scrap materials.

Orchestral, operatic, and theatrical performances also flourished. Musical fare included performances of Bizet's *Carmen*, Verdi's *Requiem*, and Smetana's *The Bartered Bride*. Viktor Ullmann and Peter Kien composed an original opera, *The Emperor of Atlantis*, which premiered in Terezín, as did new jazz and cabaret works as well as original synagogue liturgical compositions. These artistic statements often transmitted to the audiences clandestine messages of freedom and hope. Ullmann and Kien's opera, for example, described the loss of power of the ruler of Atlantis and the courage of his subjects.

Visual artists too, used their creativity in defiance of the Nazis. Many of them worked daily in the official drafting office, where they were required to produce charts, maps, and graphs. In secret, however, they recorded the paradox of the horrors of starvation, disease, and executions set against the backdrop of a pastoral countryside. The Nazis discovered some of these works and

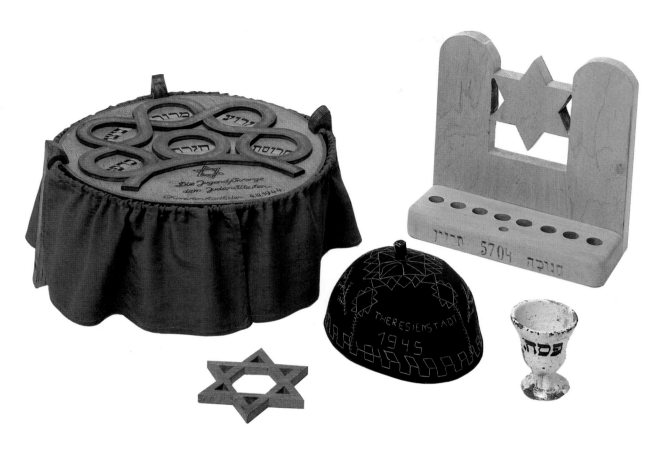

Fig. 218. *Ceremonial objects made at Terezín.*
From left: tiered Passover plate (cat. 288), Star of David (cat. 290), skullcap (cat. 286),
Ḥanukkah menorah (cat. 287), Passover cup (cat. 289).

the artists and their families were sent to be tortured in the Small Fortress; those who survived were sent east.

The ghetto community placed special emphasis on the education of children. Classes were conducted in the barracks, and the curriculum included religious and Zionist courses as well as the whole gamut of secular subjects such as reading, mathematics, sciences, history, music and art. Today the State Jewish Museum in Prague houses some 4,000 drawings made by the inmate children of Terezín (fig. 219). The earliest surviving drawings are from 1943, although the children were creating pictures before

this time. The subject matter varies, and it is impossible to ascertain whether the themes were suggested by teachers or spontaneously recalled and observed outside of classes. Many depict family scenes, others are studies copied from reproductions of Old Master paintings. Still others show the countryside, butterflies and flowers. The harsh reality of the ghetto appears as well—SS officers, guards, and executions. All available paper was salvaged and used. Children's classes also encouraged poetic expression. Surviving poems echo many of the themes of the drawings—the recognition of a brutal environment, a longing for the past, a hope for the future.

221

The poetic and pictorial works of the children of Terezín reflect the same reverence for life that inspired the centuries of Jewish artisans who created the objects now preserved in the Czechoslovak State Collections. Approximately fifteen thousand young people under the age of fifteen were among the deportees to Terezín. Only one hundred of these children survived. Today, their humble works of art are remnants of a precious legacy. They speak to the human spirit in a language that commemorates tragedy and yet transcends it.

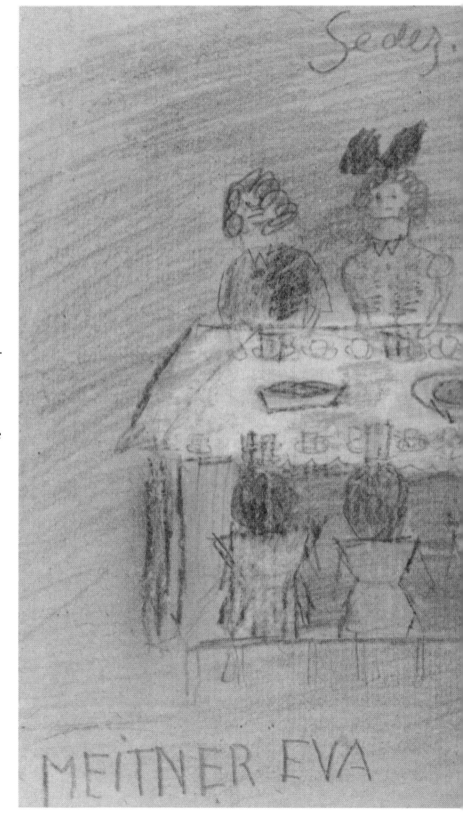

Fig. 219. *"Seder,"*
drawing by Eva Meitner, age 11,
Terezín, ca. 1943–45.

Overleaf
Fig. 220. *Detail of*
drawing by Tomáš Kauders,
who died at Auschwitz
at age 9.

222

skup IV. kum 11

CATALOGUE OF THE EXHIBITION

Exhibition curators Vivian B. Mann and Emily
D. Bilski prepared this catalogue with Jana Čermáková,
Jana Doleželová, Vlastimila Hamáčková,
Yvetta Michálková, Bedřich Nosek, Arno Pařík,
Markéta Petrášová, Vladimír Sadek, Jiřina Šedinová,
Michael Shudrich, Jarmila Škochová, and Jana Zachová.

In the entries, maximum dimensions are given, in the following order: height or length, width, depth. For circular objects, height is followed by diameter, designated dm. Manuscript dimensions are for single folios only.

Silver and pewter marks help to establish date and authorship. They are designated here by numbers in standard reference works; the abbreviated titles of these and other publications appear in the bibliography on p. 280. Some of the marks do not indicate manufacture, but are restampings required by the Austro-Hungarian government in the 19th century. Such marks provide both a *terminus ante quem* for the object and indicate where it was used at the time of restamping.

Due to space limitations, references are selected. For the same reason we have eliminated the transcription of biblical verses and standard liturgical passages. In addition, the Hebrew inscriptions on the Burial Society beakers and pitchers, which have been published elsewhere, are omitted, as are standard honorifics with the single exception of the phrase "of blessed memory," since it significantly affects the meaning. Another interesting feature of Hebrew inscriptions is the use of chronograms, based on the numerical value traditionally assigned to each letter. The chronograms that appear on objects included in this exhibition generally omit the first digit of the year. The remaining numbers are sometimes incorporated into quotations from Scriptures or the liturgy, with relevant letters marked by accents. Because of printing limitations, the range of diacritical marks used in the inscriptions could not be reproduced exactly. Since the Jewish lunar year does not exactly correspond to the Gregorian year, for Hebrew dates where the month is not specified both possible Gregorian equivalents are given.

Translations of biblical verses are from the latest Jewish Publication Society of America editions. The transliteration of Hebrew terms is according to the system set forth in the *Encyclopaedia Judaica*, except for names and terms that have entered English usage, which have been given their most common spellings.

We gratefully acknowledge our colleagues at the State Jewish Museum in Prague, whose names are listed on the catalogue title page, for their sustained and enthusiastic assistance in the selection of objects and the subsequent research. Their generosity of spirit and friendship were, at all times, inspiring. We also wish to thank Dr. Menachem Schmelzer, Librarian of the Jewish Theological Seminary of America, who chose the manuscripts and printed books on exhibition and who aided in the translations of inscriptions. Translation of Czech material was ably handled by Gertrude Adler, Hannah Kafka, Dr. Zdenka Munzer, Zdenka Sommer, and Frederick Terna.

Because of the brief time allotted for the writing and production of this catalogue, heroic efforts were required of the Judaica Department Staff at The Jewish Museum, New York. Our deepest thanks go to Sharon Makover, Administrative Assistant and to Gabriel Goldstein, Intern, for their tireless help in research, editing and production, and to Susan Braunstein, Assistant Curator, for relieving us of other responsibilities. Our efforts were made possible by the understanding of the staff of The Jewish Museum, in particular its Director, Joan Rosenbaum, who recognized the historical importance and significance of this project.

V.B.M.
E.D.B.

1 (Fig. 102)
Torah (Pentateuch) Scroll 5.369
Bohemia or Moravia, 1863/4
Ink on parchment; stained wood with engraved silver fittings
80 × 26.5 (closed dimensions)

A Torah scroll contains the first five books of the Hebrew Bible, written according to precise rules governing the preparation of the materials and the arrangement and transcription of the text. Each wooden roller is known as an *etz ḥayyim* (Tree of Life), a symbolic name also given to the Torah itself. These rollers are fitted with silver strips engraved with the following dedicatory inscription:

זן מ״ו״ה נתן לעוובעער ני בן מ״וה אהרן ז״ל לכבוד
אשתו הראשונה הצנועה מ׳ חיילה׳ נ״ע בשנת תרכד
לפ״ק/ולטוב יזכר שם אמו הגבירה הצנועה מ׳ לאה
רבקה ת׳ ושם אשתו שנית הצנועה מ׳ צארטל ת׳ בת
רבקה באכראך ת׳.

"This was donated by Nathan Levbe'er, the son of Aaron of blessed memory, in honor of his first wife Ḥayele, may she rest in peace, in the year [5]424 [= 1863/4]/ and may the name of his mother be remembered for good, Leah Rebecca, and the name of his second wife Tsartl, the daughter of Rebecca Bachrach."

Provenance: Boskovie na Moravě

2 (Fig. 111)
Torah Curtain 27.391
Prague, 1601/2
Silk velvet appliquéd with silk and embroidered with metallic threads, seed pearls, sequins, glass stones and metal foil; silk damask (later replacement); metallic ribbons
215 × 132

This work, one of the earliest Torah curtains in existence, is one of a group of four donated to the Altneuschul in the 16th and 17th centuries that were embroidered with a portal composition incorporating floral and Renaissance motifs largely executed in appliqué.[1] At top is a medallion enclosing three crossed carps, the coat of arms of the donor who is mentioned in the inscription below:

נתן בר יששכר הנקרא קרפל זקס /הדסי בת הרר משה
זצ״ל שנת שס״ב לפ״ק

"Nathan ben Isacchar who is called Karpel Zaks, Hadassi daughter of Moses of blessed memory, the year [5]362" (= 1601/2).

Note: [1]For the others see Volavková, *Story*, 38, 81, 132; Volavková, *Synagogue Treasures*, pls. 8, 12.
References: Čermáková, "Synagogue Textiles," 55, n. 5; Čermáková, "Rideaux," 28, n. 25; Muneles, *Prague Ghetto*, p. 108, pls. 59–61; Polák, "Peroches," 30–1; Volavková, *Story*, fig. 40.

3 (Figs. 10, 64)
Torah Curtain 16.703
Prague, 1685/6
Silk velvet and silk embroidered with metallic threads, sequins, and metallic ribbon; silk fringe and ribbon; damask linen lining
234 × 147

The portal composition on this curtain is highly stylized, with decorative and symbolic forms completely overlaying the surface and an avoidance of architectural details. For example, the blessing hands of *kohanim* (priests) replace column capitals in an allusion to the donor's lineage. The rich embroidery design, horizontal rows of flowers enclosed by lyre shapes, may be based on Italian silk weaves of the first quarter of the 17th century[1]. The techniques used to represent the flowers, the vertical symmetry of compositional elements and the framing of larger forms with borders of smaller floral motifs have close parallels in a Bohemian mitre dated 1696[2], one indication of artistic interchange between the producers of liturgical textiles for Christian patrons and for Jews. The inscription indicates that the donor was the daughter of an embroiderer[3]; the choice of the chronogram implies that she actually worked on the fabrication of this curtain.

נ״י הנעלה כ״הרר יצחק בן האלוף מהור״ר/ליפמן חזן
כהן פאפרש ז״ל וזוגתו מרת/טעמרל בת הרר הירש
פערל העפטיר זצ״ל/להתפאר בְּמַעֲשֵׂה יָדֶיהָ לפ״ק

"The donation of Isaac ben Lipman Ḥazzan Kohen Poppers of blessed memory and his wife Temerl, daughter of Hirsch Perlhefter, 'to glory in the work of her hands'" (variation on Is. 60:21 = [5]446 = 1685/6).

Notes:
[1]Cf. *Seidengewebe*, no. 441.
[2]Zeminová, *Barokní textílí*, no. 22.
[3]See above, ch. III, p. 126–28.

4
Torah Curtain 27.360
Prague, 1686/7
Silk velvet embroidered with metallic threads, sequins,
glass stones; metallic braid, lace and fringe
222 × 158

In contrast with the nearly contemporaneous curtain
donated by Isaac Poppers (cat. 3), this Torah curtain,
given to the Altneuschul, bears flatter embroidery that
is similar in feeling to the appliqué technique popular
earlier in the century.[1] The center is overlaid with a
dense, rich pattern of flowers, while the flanking
"columns" are filled with two alternating lyre shapes.
According to the inscription, this curtain was donated
by members of the prominent Mirels family, who came
to Prague from Vienna, presumably after the expulsion
of all Jews in 1670. Moses Mirels' grandson, who
restored the curtain, was also descended from Rabbi
Aaron Simon Spira Wedeles who was chief rabbi of
Prague in the 17th century.[2]

מ״הורר משה/מירלש/ואשתו מ״ר עלקלי מווין/ונתחדש
ע״י נכדם כ״הרר וואלף בן האלוף/מ״הורר אנשיל בן
הגאון מ״הרש ז״ל וזוגתו/אסתר בת כ״הרר קאפל מווין
תמ״ז לפ״ק

*"Moses Mirels and his wife Elkele from Vienna and
renewed by their grandson Wolf son of Anshel son of
the renowned Rabbi S[pira] of blessed memory and his
wife Esther daughter of Koppel from Vienna [5]447"*
(=1686/7).

Provenance: Altneuschul, Prague
Notes:
[1]J. Polák was of the opinion that the curtain should be dated ca. 1630
and that the inscription refers to repair. (Polák, "Peroches," 32.)
[2]For the Spira-Mirels families see *The Jewish Encyclopedia*, vol. XI,
520–1.
References: Čermáková, "Synagogue Textiles," 56; Polák, "Peroches,"
32; Manchester, *Treasures*, no. T6.

5
Torah Curtain 2.239
Prague, 1724
Silk brocade; silk velvet embroidered with metallic
threads and sequins; silk embroidered with metallic and
silk threads; metallic braid; silk fringe
227 × 160

On this example, the central field or mirror is a length
of French silk brocade of the first quarter of the 18th
century.[1] The lyre shapes which fill the very stylized
columns are based on one of the patterns used for the
earlier 1686/7 curtain from the Altneuschul, Prague
(cat. 4). Thus, this curtain was also made in Prague,
though donated to a rural synagogue, in or near Mladá
Boleslav, by a group of men who gathered every week
to study.

נ״י החבורה קדישא נאספים בכל שבת/ושבתא בספר
מנורת המאור ובמשנה/ובאגדתא אצל האלוף הר״ר
פישל גראטי/ג״ד ונגמר טוב אדר בהאשתא פ׳דֹת לפ״ק

*"The donation of the holy society who gather every
Sabbath [to study] the book Menorat ha-Ma'or and
Mishnah and Aggadah[2] with Fischel Grati and it was
finished the 17th of Adar in this year of [5]484"*
(=1724).

Provenance: Mladá Boleslav (Jung Bunzlau), Bohemia.
Notes:
[1]Cf. Thornton, *Silks*, no. 11A; *Seidengewebe*, no. 509 ff.
[2]The work *Menorat ha-Ma'or* referred to in the inscription is probably
the 14th–century ethical and religious treatise by Isaac Aboab. The
Mishnah is the oral law (as opposed to the Torah or written law)
redacted by Rabbi Judah the Prince at the beginning of the 3rd century.
Aggadah is the non-legal portions of rabbinic teaching, e.g., ethical
maxims.
Reference: Volavková, *Průvdoce*, 23.

6 (Fig. 47)
Torah Curtain 5.155
Austrian Empire, 1730/1
Silk velvet embroidered with silk and metallic threads,
metallic ribbon, glass stones and silk appliqués; linen
lining
221.5 × 150.5

The major iconographic elements of this curtain
commonly appear on Torah shields: two columns
surmounted by facing rampant lions holding a crown
that symbolizes the Torah (cf. cat. 46). Here the center
is filled with a bold design of strapwork and acanthus
leaves, motifs which also appear on the columns, crown,
and matching valance (cat. 12). The curtain bears
inscriptions of two different dates. The original one, of
appliquéd letters, reads:

כתר תורה/דע לפני מי אתה עומד/לפני מ' מ' ה'
הקב״ה/תצאל/מן הרר אליהו עסא/בן ה״ה כהרר
אברהם סגל/ואשתו מ' חנה בת/הרב מהורר משה ז״צל

"Crown of Torah. [Ethics of the Fathers 4:17] Know before whom you stand, before the King of Kings the Holy One, blessed be His name. [Babylonian Talmud: Berakhot 28b] [5]491 [=1730/1]. From Elijah Asa ben Abraham Segal and his wife Hannah daughter of Moses of blessed memory."

The second inscription is sewn directly to the velvet at the level of the top of the column shafts:

שייך להחברא/קדישא יצ״ו/ובא לידיהם/שנת [ת]קכב ל׳

"Belongs to the Burial Society and came into their hands in the year [5]522" (=1761/2). The Burial Society may have been that of Mikulov (Nikolsburg), the last known provenance of this curtain.

Provenance: Mikulov (Nikolsburg), Moravia
Reference: Volavková, *Průvodce*, 26.

7 (Fig. 112)
Torah Curtain 2900
Moravia, 1813/4
Silk embroidered with metallic threads; silk brocade; silk fringe; metallic appliqués and braid; linen lining
118 × 105

The combination of antique fabrics, crude embroidery, and simplified composition is characteristic of curtains produced in rural areas. The background fabric is Italian ca. 1620-40[1]; the brocade of the mirror is French and dates to the third quarter of the 18th century.[2] On it are embroidered appliqués from military uniforms of the reign of the Austrian Emperor Franz I and a dedicatory inscription:

א פ/ז״נ/ה׳ אברהם ב״ש/וזוגתו ה״ח מ׳ פראדל/בשנת תקע״ד

"A.(?) P.[3] This work was donated by Abraham ben S. and his wife Freidal in the year [5]574" (=1813/4).

Provenance: Boskovice, Moravia
Notes:
[1]Cf. *Seidengewebe*, no. 330.
[2]Cf. *Seidengewebe*, no. 660 or 661.
[3]The first letter is garbled but may be an *aleph*, in which case the two letters might be an abbreviation for *aluf parnas*, Hebrew titles which mean chief, leader.

8
Torah Curtain 7.596
Moravia, 1824/5
Silk embroidered with silk and metallic threads, glass stones and sequins; silk damask embroidered with silk threads; silk fringe; velvet and silk ribbon; metal bells; cotton lining
185.5 × 127

The iconography and composition of this curtain, two lions atop framing columns or pilasters who support a "Crown of Torah" below which is a large lit menorah, first appear on German Torah shields of the second half of the 18th century.[1] Such a shield may have served as

the model for this curtain whose embroiderer translated its forms into the flat, colorful idiom of local Moravian folk art.[2] The decorative treatment of forms extends even to the letters and diacritical marks of the inscription:

כתר תורה/ז״נ/לכבוד המקום ב״ה האלוף ה׳/בער ב״ר י״ס וויינר ע״ז המהוללת/והמשכלת א״ח מ׳ חיי׳ לאה/ב״ה מענדל אולמא ז״ל/שנת [ת]קפ״ה ל׳

"Crown of Torah. [Ethics of the Fathers 4:17] This was given in honor of Gad by the leader Ber, son of Y. S. Wiener with his wife Ḥaya[h] Leah, daughter of Mendel Ulma of blessed memory, the year [5]585" (= 1824/5).

Provenance: Dolni Kounice, Moravia
Notes:
[1]Y. Cohen, "Torah Breastplates from Augsburg in the Israel Museum," *The Israel Museum News* 14(1978), 82–4, especially figs. 19–20.
[2]Cf. a stylistically similar curtain whose inscription indicates it was dedicated to the synagogue of Trest (Triesch). (Volavková, *Story*, pl. 141.)

References: Volavková, *Průvodce*, 30; Volavková, *Story*, pl. 83.

9
Torah Curtain 175.815
Bohemia, 1828/9
Silk velvet embroidered with metallic threads, sequins and glass stones; metallic braid; silk fringe
207.5 × 157.5

On this type, a treasured fabric[1] is used for most of the curtain, except for the space reserved for the inscription:

ז״נ הנעלה הר״ר מאיר בכ״מר משה פישער/ז״ל וזוגתו מ׳ בילה בת הר״ר אלי׳ פליישנר ז״ל/עבור בנם הבח׳ אלי׳ שי לעת הגיעו לבר/מצוה ה׳ יזכם לגדלו לתורה ולחופה ולמ״ט/ש׳ תקפ״ט ל׳

"This was given by Meir son of Moses Fischer of blessed memory and his wife Beila daughter of Eli[jah] Fleischner of blessed memory for their son Eli[jah], a gift at the time of his attainment of bar-mitzvah. May God favor them to raise him 'to Torah, to the marriage canopy and to g[ood] d[eeds]'[2], the year [5]589" (= 1828/9).

Provenance: Kolín, Bohemia
Notes:
[1]The fabric is a French silk ca. 1770–80 (cf. *Seidengewebe*, no. 633).
[2]The text is drawn from the circumcision service (see ch. III, n. 42).

10 (Fig. 2)
Torah Curtain 7.228
Salzburg, 1894/5
Silk embroidered with metallic and silk threads; silk and
metallic fringes and tassels; metallic ribbon
296 × 202.5

Bands of metallic ribbon divide the curtain into major
and minor fields and a continuous border, whose lush
floral embroidery is enframed by quatrefoils alternating
with hexagrams. Griffins as guardian figures appear less
frequently on Judaica than do lions, but they are not
uncommon. The inscriptions read:

כבד את אביך ואת אמך למען יאריכון ימיך/כ׳
ת/לזכרון/בהיכל ה/ולכבוד אבותינו אשר בארץ
המה/ה״ה/כ׳ יצחק בן שלמה יהודה ווינקלער/ואשתו/מ׳
צארטל בת שלמה גרינבוים ע״ה/מאת בניהם גרשון יוסף
משה יהודה ליפמן/לתודה בעד הטובות שעשו
עמהם/בשנת תרנ״ה לפ״ק/ברכה מרבה לנו סלה
שמע בני מוסר אביך ואל תטש תורת אמך

*"Honor your father and your mother that you may
long endure on the land. [Ex. 20:12] C[rown] of
T[orah]. [Ethics of the Fathers 4:17] For a remembrance
in the Temple of the Lord and in honor of our parents
'who are in the land,' [Pss. 16:3] Isaac son of Solomon
Judah Winkler and his wife Zartel daughter of Solomon
Grunbaum, may they rest in peace, from their sons
Gerson, Joseph, Moses, Judah, Lipman in thankfulness
for the good that they did with them in the year [5]655
[= 1894/5]. May this be for a manifold blessing for us,
Selah.
My son, heed the discipline of your father, and do not
forsake the instruction of your mother."* (Proverbs 1:8)

On the reverse is a German inscription describing the
making of the curtain:

*Nach dem Entwurfe von Prof. J. Salb und unter
Leitung von Prof. G. Winkler und Industrielehrerin Frl.
G. Felgel, ausgeführt von Frau H. Winkler und den
Kunststickerinnen Frl. H. Franzky, M. Franzky, M.
Grundei, M. Henoch, M. Pomezny, M. Zinnober,
Salzburg 1895.*
*"After the design of Prof. J. Salb and under the
direction of Prof. G. Winkler and industrial teacher
Miss G. Felgel executed by Mrs. H. Winkler and the
embroiderers Misses H. Franzky, M. Franzky, M.
Grundei, M. Henoch, M. Pomezny, M. Zinnober,
Salzburg 1895."*

Provenance: Miroslav, Moravia
References: Berlin, *Historica Hebraica*, no. A118, pl. 15; Vienna,
Kunstschätze, no. 14.

11 (Fig. 113)
Torah Valance 2.243
Prague, 1718/9
Silk velvet embroidered with silk and metallic threads,
glass stones and semi-precious stones; metallic fringe;
linen backing
76.5 x 93.5

According to its inscription, this valance was commis-
sioned for a synagogue in Mladá Boleslav (Jung
Bunzlau), Bohemia.

נ״י ח״ק ג״ח דק״ק בומסלא/שנת תֻגֹמֹול חסד לפ״ק

ציץ הזהב/לחם פנים/כיור נחושת/שני
לוחות/מזבח/מנור[ת] זהב/אפד

*"[This is] a donation of the Burial and Benevolent
Society of the holy congregation of [Jung] Bunzlau in
the year 'You shall act benevolently'"* (variation on
Kohelet Rabba 7:9 = [5]479 = 1718/9).

The remaining inscriptions are tituli referring to the
ritual objects embroidered on the valance. These and the
crowns are executed in high relief stumpwork embroi-
dery. Variations in the type and direction of the stitches
and in the color of the silk support threads create rich
textural and coloristic effects.
A Prague origin is indicated by comparison with other
similar valances executed for synagogues in the capital,
for example, a nearly identical piece made in the same
year for the High Synagogue.[1] All of the valances of
this group have seven scallops with the central one
bearing the ten commandments above which hover
cherubim represented as eagles. This motif bisects the
inscription which is enclosed by wreaths.

Provenance: Mikulov (Nikolsburg), Moravia
Note: [1]New York, The Jewish Museum, *Fabric of Jewish Life*, no. 27
(ill.). Another related example is presently in use in the Altneuschul,
Prague. A fourth example from the Pinkas Synagogue dated 1786 is on
exhibition in the State Jewish Museum (59.729) and a fifth is in The
Jewish Museum, New York (F 2392).

12 (Fig. 47)
Torah Valance 5.166
Austrian Empire, 1730/1
Silk velvet embroidered with metallic threads; metallic
braid, fringe and tassels; linen lining; metal suspension
rings
49 × 153

This valance was made together with a curtain, whose
original inscription dates 1730/1 (cat. 6). Three stylized
bunches of flowers dominate the valance; they are
framed by acanthus leaves. These motifs are executed in
varicolored and variously stitched metallic threads which
create rich textural effects.

Provenance: Mikulov (Nikolsburg), Moravia

13
Torah Valance 5.167
Bohemia or Moravia (?), 18th century
Velvet embroidered with metallic and silk threads;
metallic fringe and ribbon; linen lining
34 × 145

Valances that are elaborately embroidered with representations of vessels of the desert Tabernacle begin to appear in German communities at the end of the 17th century and in Prague in the first decades of the 18th century. The depictions of the Tabernacle vessels are closest to those on valances executed by Elkone of Naumburg and Jacob Koppel Gans, well-known Bavarian embroiderers.[1] The overlapping and density of the bands of metallic ribbon resemble these aspects of a curtain and valance in the Prague Jewish Museum dated 1730/1 (cats. 6 and 12).

Provenance: Brno, Moravia

Note:
[1]Cf. F. Landsberger, "Old Time Torah Curtains," *Beauty in Holiness,* ed. J. Gutmann (New York: Ktav, 1970), figs. 7–10.

14
Torah Valance 59.890
Bohemia, 1811/2
Linen overlaid with sections of metallic embroidery and sections of silk velvet embroidered with metallic threads; metallic ribbon and fringe
43.5 × 125

The sections of embroidered velvet and metallic embroidery give a patchwork effect. A similar, but not identical, composite cloth formed the mirror and valance of a Torah curtain from Bolzano, Italy, dated 1800.[1] The valance now in Prague was made twelve years later according to its inscription:

קדש לה' ז"נ הנעלה כ' נטל ב"כה וואלף/ז"ל
מקאסאוויטץ וזוגתו הצנוע' מ' יהודית/בת כ"ה אברהם
סאיוויטץ ז"ל ש' תקע"ב ל'

"Holy to the Lord. This was given by Nettel son of Wolf of blessed memory from Kasejovice, Bohemia, and his wife, Judith daughter of Abraham Saivitz of blessed memory. The year [5]572" (=1811/2).

Provenance: Breznice, Bohemia
Note: [1] JL, IV/1, pl. CXXIV.
Reference: Manchester, *Treasures,* no. T3.

15 (Figs. 1, 114)
Torah Valance 102.010
Austrian Empire, early 19th century
Silk velvet embroidered with cotton and metallic threads; metallic fringe; linen lining; metal suspension rings
32 × 135

This Torah valance is composed of a pre-existing valance, embroidered with flowers, strapwork and an imperial insignia with military emblems, to which end pieces and a Hebrew inscription were added. The Hebrew inscription is crudely embroidered and its metallic threads are of poor quality, while the remaining decoration is skillfully executed in metallic threads wound about varicolored silk threads, with rich coloristic and textural effects.

זאת נדבה האשה מרת עלקא בת הרבני מהורר יונה ז"ל

"This was donated by the woman Elke, a daughter of Jonah of blessed memory."

16
Torah Valance 12.027
Bohemia, 19th century
Silk velvet printed with flowers and woven with metallic floral design; velvet appliquéd with metallic ribbon letters and sequins; linen linings
33.5 × 156

To form this Torah valance, an existing valance was cut horizontally and a different piece of velvet with appliquéd inscription was inserted. The inscription reads:

ז"נ. הקצין.ה'. ליב ברענר. זל.ואשתו.מ'. דבורה תי'

"This was donated by Leib Brenner of blessed memory and his wife Deborah." The initials L. B. appear on the matching curtain. (See Volavková, *Synagogue Treasures,* no. XLVI, pls. 86–8.)

17 (Fig. 129)
Torah Curtain Hook 54.536/3
Bohemia, 1828/9
Engraved and painted wood, traces of gilding; iron hook and ring
25 × 15

Inscription:

זאת נדבת האשה החשובה והצנועה מרת פערל
קויפלער/גבבאת [כך!] בית הכנסת ונשים הצדקניות
בשנת תקפ"ט לפ"ק

"This is the donation of Perl Käuffler/treasurer (?) of the synagogue and of the righteous women in the year [5]589" (=1828/9).

The Hebrew inscription, executed in white against a pale green ground, still bears traces of its original gilding and covers both sides of the wooden shield. An iron hook and ring pass through the center of the shield to attach and hang the Torah curtain.

Provenance: Loštice, Bohemia

18 (Fig. 130)
Torah Curtain Hook 54.536/2
Bohemia, 1840/1
Engraved and painted wood, traces of gilding; iron hook and ring
25 × 12

Hebrew inscription in white (originally gilt) letters on a blue ground:

נדבת לב הנשים/שנת הׄתׄרׄאׄ לפ"ק

"*The generous donation of the women/ [in the] year [5]601*" (=1840/1).

Provenance: Loštice, Bohemia

19 (Fig. 115)
Torah Mantle 52.527
Prague, 1670/1
Silk velvet embroidered with metallic threads; ribbed silk woven with chenille; silk fringe
92 × 49

This mantle, which belonged to the Pinkas Synagogue, bears a dedicatory inscription beginning on the front and continuing on the back:

נ"י הנעלה/כהרר אליקם בן הנעלה/כהרר בנימין
ז"ל/וזוגתו מרת אסתר בת/יושע אלם ז"ל עבור
בנם/בנימין שי' תל"א לפ"ק

"*The gift of Eliakim son of Benjamin of blessed memory and his wife Esther daughter of Joshua Elm of blessed memory for their son Benjamin, [5]431*" (=1670/1).

Below is a later replacement panel of mid 18th–century French ribbed silk woven with chenille.

Provenance: Pinkas Synagogue, Prague
References: Volavková, *Synagogue Treasures,* no. XXXIII, 16, pls. 61–2; Manchester, *Treasures,* no. T18.

20 (Fig. 66)
Torah Mantle 12.666
Prague, 1701/2
Silk velvet embroidered with metallic threads; silk fringe
98 × 49

The composition of this mantle from the Pinkas Synagogue resembles that of Torah curtains. Spiral columns overlaid with vines and topped by crowns flank the central panel whose dense embroidery of leaves and strapwork is symmetrical about the vertical axis.[1] A Hebrew inscription enclosed in oval cartouches appears on both sides:

נדבת יד/האלוף הקצין מהורר/זלמן י"ץ בן הקצין
הרר/משולם י"ט זצ"ל/וזוגתו מרת/חיילה בת ה"ה
הרב/מהרר' קלמן טויסק/זצ"ל תס"ב לפ"ק

"*The donation of Zalman ben Meshullam Yomtov of blessed memory and of his wife Hayele daughter of Kalman Toisek [5]462*" (=1701/2).

Provenance: Pinkas Synagogue, Prague
Note: [1]For a very similar mantle dated 1711, see The Hague, *Praag,* no. 42, pl. 4.
References: The Hague, *Praag,* no. 40; Vienna, *Kunstschätze,* no. 28.

21 (Fig. 67)
Torah Mantle 12.664
Prague, 1725/6
Silk velvet embroidered with metallic threads; silk brocade; metallic braid and tassels; linen lining
93.5 × 51

This mantle is one of two dedicated to the Pinkas Synagogue in 1725/6[1] that were fashioned of the same costly French brocade produced ca. 1725.[2] The beginning of the inscription on this example is marked by blessing hands, an allusion to the donor who stemmed from a priestly family.

הניח אחריו ה'/כ"הרר דוד בן הנעלה/כ"הרר יוסף כ"ץ
זצ"ל/וועלטש/ואשתו מרת/חיי' בת מ"הורר ליב
י"ץ/ייטלש רֹוֹוֹח וֹהֹצֹלֹהֹ/יׄעׄמׄוׄדׄ לפ"ק

"*Bequeathed by David, son of Joseph Katz of blessed memory, Waltash and his wife Ḥaya, daughter of Leib Yatlash, '. . . relief and deliverance will arise'*" (*Book of Esther 4:14 = [5]486*) (= 1725/6).

Provenance: Pinkas Synagogue, Prague
Notes:
[1]The second is no. 12.656, published in Volavková, *Synagogue Treasures,* no. XXII, pl. 48.
[2]Cf. *Seidengewebe,* no. 515; and Zeminová, *Barokní textilie,* no. 63.
Reference: Vienna, *Kunstschätze,* no. 27.

22
Torah Mantle 57.270
Prague, 1734/5
Silk velvet embroidered with metallic threads; silk brocade; metallic ribbon; silk fringe; linen lining
91 × 53

The brocade is a so-called "bizarre silk," a fabric incorporating both naturalistic and fantastic forms that was popular in France in the first two decades of the 18th century. According to the inscription, it was donated by a group of women to the synagogue of Turnov.

נ"י נשים צדקניות/פה ק"ק טורני תורת/ה' תֹמֹיֹמֹהֹ
לפ"ק:

"*The gift of righteous women here in the h[oly] c[ongregation] Turnov. 'The teaching of the Lord is pure*'" (*Ps. 19:8*) =[5]495) (= 1734/5).

Provenance: Turnov, Bohemia
References: Kybalová, "Thoramäntel," 38–9; Manchester, *Treasures,* no. T20; Vienna, *Kunstschätze,* no. 36.

23
Torah Mantle 122/74
Prague, 1737/8
Silk velvet embroidered with metallic threads; silk and
metallic brocade; metallic fringe and lace; linen lining
92.5 × 51

Compositionally, this mantle is similar to cat. 21, and
like it, is partly composed of a French brocade ca. 1725,
of a type also used in Prague for fashioning church
textiles in the early 18th century.[1] At top is an
inscription:

נ"י הנעלה כהר"ר פייבל בן הראש/והקצין כהר"ר יעקב
י"ץ/ירושלמי ז"ל/וזוגתו מר' שילא בת האנ[ל] וף
והקצין/הר"ר דוד אולמא ז"ל י"ץ/תצ"ח לפ"ק

*"The donation of Feivel son of Jacob Yerushalmi and his
wife Sheila, daughter of David Ulma of blessed
memory, [5]498"* (=1737/8).

Note: [1]Cf. two chasubles in Zeminová, *Barokní textilie*, nos. 60 and 63.

24 (Fig. 110)
Torah Mantle 32.105
Bohemia or Moravia, ca. 1750
Silk embroidered with polychrome silk and metallic
threads; silk fringe; linen lining
90 × 50

A pre-existing textile was used to form this mantle. The
original cloth was embroidered in the so-called "needle
painting" technique, in which silk and metallic threads
are used to form illusionistic floral forms derived from
Dutch still-life painting of the 17th century. Such
embroidery was popular in the late 17th and early 18th
centuries and can be found on vestments dated 1700-30
that were donated to the S. Maria in Loretto monastery
in Prague and other Austrian monasteries,[1] and on
other synagogue textiles in the State Jewish Museum,
for example, a mantle from the Pinkas Synagogue dated
1771.[2]

Provenance: Kyjov, Moravia

Notes:
[1]Zeminová, *Barokní textilie*, nos. 48 and 78.
[2]J. Doležal and E. Veselý, *Památky pražského ghetta* (Prague: Olympia,
1969), no. 138.

25
Torah Mantle 65.583
Prague, 1757/8
Silk damask woven with metallic threads[1] and
embroidered with metallic threads; metallic lace; silk
fringe; silk tassels (new); linen lining
84 × 52

The donor was the deceased wife of Wolf Poppers, head
of the Bohemian Landesjudenschaft (1749–67), the
organization of rural Bohemian Jewry. The mantle came
to the Prague Museum from Březnice, home of the

Poppers family. In 1761, Wolf Poppers and his wife
Malka, presumably his second wife, donated a mantle
now in the State Jewish Museum.[2]

קדש לה' הניח' אחריה/האשה החשובה הצנו/מרת
רעלא עח"ה ונגמר/ע"י בעלה האלוף/הראש והקצין
כהר"ר/ואנ[ל]וף פאפרש פרימוס/דמדינ' פיהם נרו'
שנת/תקי"ח לפ"ק

*"'Holy to the Lord' [Ex. 28:36; 39:30] bequeathed by
Rella, may she rest in peace, and finished by her
husband Wolf Poppers, 'primator' of the Bohemian
Landesjudenschaft, the year [5]518"* (=1757/8).

Provenance: Březnice, Bohemia

Notes:
[1]The damask is a French fabric ca. 1700. (Cf. Thornton, *Silks*, fig. 29a.)
[2]Čermáková, "Synagogue Textiles," 57.
References: Kybalová, "Thoramäntel," 83; Volavková, *Synagogue Trea-
sures*, no. XXV, pls. 65, 66; Volavková, *Průvodce*, 28.

26
Torah Mantle 2.778
Moravia (?), 18th-19th century
Silk; silk velvet embroidered with silk threads, metallic
threads, and sequins and appliquéd with silk; silk
fringe; metallic lace
54.5 × 29.5

The original 18th-century textile (perhaps a cushion
cover) that is the base of this mantle was embroidered
with floral designs enclosed by a running border. To
convert it into a mantle, silk strips were later added and
floral designs were appliquéd over the top portion of the
front, linking the old and new. Hebrew inscriptions
were also added:

"C[rown of] T[orah]" כ ת
"B L" (perhaps the donor's initials) ב ל

Provenance: Boskovice, Moravia

27 (Fig. 103)
Torah Mantle 52.713
Bohemia, 1819/20
Silk embroidered with silk threads and sequins
81 × 45.5

The shaded floral motifs on this mantle resemble those
on Bohemian folk embroideries. The inscription reads:

כ"ת/ז"נ הקצין ר' שלמה/יצ"ו וזוגתו גנענדל ת"ת/ממטייניץ
תק"פ ל"ו

*"'C[rown of] T[orah]' [Ethics of the Fathers 4:17]. This
was donated by Solomon and his wife Grendel from
Týnec. [5]580"* (=1819/20).

Provenance: Louny, Bohemia

28 (Fig. 116)
Torah Mantle 5.699
Bohemia, 1842
Linen embroidered with cotton
98 × 51.5

The materials and embroidery techniques used to make
this mantle resemble those of other Bohemian textiles
that were likewise donated to synagogues on the birth
of a male child (see cats. 35, 39, 40). The inscription
reads:

כ"ת ז"נ/אהרן מינץ/בשביל בנו/יוסף שי' הנלד [כר!]/ט'
טבת/בש/נת/תר/"ג/לפ"ק

"Crown of Torah. This was donated by Aaron Mintz for
his son Joseph who was born on the 9th of Teveth in
the year [5]603" (=1842).

Provenance: Hořovice, Bohemia
References: Čermáková, "Synagogue Textiles," 59; Manchester, *Treasures,* no. T25.

29
Torah Mantle 2.783
Moravia, 1867/8
Silk damask; silk brocade embroidered with silk and
metallic threads, metallic appliqués and beads, glass
stones; metallic braid and lace; linen lining
81 × 46.5

The base fabric is a French damask of the middle of the
18th century, while the brocade appears to be
19th–century and of German origin.[1] The double-
headed eagle is an Austrian imperial symbol. Above and
below it are the inscriptions:

לכבוד התורה
שנת/וברית/וחסדי מאתך/לא תמוט/לפ"ק

"In honor of the Torah, the year 'But My covenant and
My loyalty shall never move from you'" (variation on
Is. 54:10 = [5]628) (=1867/8).

White mantles whose color is symbolic of purity were
used on Rosh Ha-Shanah and Yom Kippur.

Provenance: Boskovice, Moravia
Note: [1]For the damask, cf. *Seidengewebe,* no. 698; for the brocade, Volavková, *Synagogue Treasures,* pl. 86.

30 (Fig. 109)
Torah Mantle 71.211
Bohemia, late 19th century
Wool embroidered with silk and appliquéd in silk;
metallic lace; silk fringe and ribbons
63 × 47

Inscription:

ק' ל'ה'

"H[oly] to the Lord" (Ex. 28:30; 39:30)

Provenance: Kolín, Bohemia
Reference: Manchester, *Treasures,* no. T28.

31
Torah Mantle 71.006
Bohemia, 19th century
Silk embroidered with silk threads and sequins; silk
fringe; linen lining
85 × 45.5

The inscription indicates the mantle was donated by a
boy.

ז"נ הילד אליעזר/יחי' בן מרת קילה/תחי'

"This was donated by the boy Eliezer son of Kilah(?)."

Provenance: Kostelec nad Orlicí, Bohemia

32
Torah Mantle 40.271
Bohemia, late 19th-early 20th century
Silk embroidered with metallic and silk threads; silk
braid
76.8 × 43.5

The oriental character of the motifs—an arch enclosing
a tree of life—is perhaps a reflection of the vogue for
Moorish design also seen in the decoration of the
Spanish Synagogue in Prague built in 1867. The
inscription reads:

"C[rown of] T[orah]." כ'ת'

Provenance: České Budějovice (Budweis), Bohemia

33 (Fig. 7)
Torah Binder 66.077
Bohemia, 1734
Printed linen
293 × 15

All of the decoration on this binder is printed, the
upper and lower floral borders and the inscription:

נ"י אברהם בן כמר ברוך כץ י"ץ נולד במ"ט ר"ח שבת
שנת תצ"ד לפ"ק השם יגדל לתורה לחופה ולמעשים
טובים א"ס

"The gift of Abraham son of Barukh Katz, born under
a good sign [on] the New Moon of Shvat, the year
[5]494 [=1734]. May God raise him to the Torah, to
the nuptial canopy and to good deeds. Amen Selah."

Printed fabrics were generally used to line synagogue
textiles, but relatively few were given a primary
function.[1] The exceptions stem from Germany or
contiguous areas: a Torah curtain from Fredericia, now
in Copenhagen, dated 1709, a mantle in New York, and
the small group of binders to which this example
belongs.[2]

Notes:
[1]See Volavková, *Synagogue Treasures,* pls. 90–5.
[2]The Torah curtain is no. 206 in the collection of the Mosaiske
Troessamfund, Copenhagen. (See New York, The Jewish Museum,
Kings and Citizens, cat. 4.) Related binders in the New York Jewish
Museum's collection are M 97, dated 1778 and F 2026, dated 1744; the
mantle is F 6077. (New York, The Jewish Museum, *Fabric of Jewish
Life,* nos. 43 and 146).

34 (Fig. 117)
Torah Binder 10.130
Bohemia or Moravia, 1749/50
Silk embroidered with silk threads; metallic lace;
printed linen lining
317 × 16.5

Binders with figured scenes are relatively rare in the
collection of the State Jewish Museum. This binder
bears a man holding aloft a Torah on which is inscribed
a statement from the liturgy,[1] a crowned lion and a
wedding scene, in addition to continuous borders of
flowering vines, all executed in extremely fine embroi-
dery. The unusual inscription records its dedication by a
woman in honor of her nephew.

ז״נ האשה חשובה הצנועה מ׳ גיטל בת ה׳ שמוא[ל] ז״ל
עבור בן אחה הילד שמוא[ל] בן האן[ל]וף התו׳ מ׳ ליב
נדו׳ מרעכניץ ה׳ יזכה לגדלו לתורה ולחופה ולמעש׳
טובים אמן והמלאכה היתה דים לפ״ק

"This was donated by Gittel daughter of Samue[l] of
blessed memory for her nephew Samue[l] the son of
Leib Nado[?] from Rehnice.[2] 'May God grant to raise
him to the Torah to the marriage canopy and to good
dee[ds] Amen.'[3] And their efforts had been enough"
(Ex. 36:7 = [5]510 = 1749/50).

Provenance: Loštice (Loschitz), Moravia

Notes:
[1]"It is a tree of life to those who take hold of it and happy are those
who support it." (*Daily Prayer Book*, trans. by P. Birnbaum (New York:
Hebrew Publishing Company, 1949), p. 390.)
[2]Rehnice is near Mladá Boleslav, Bohemia.
[3]From the circumcision service. (See ch. III, n. 32.)
References: Doleželová, "Torah Binders," 55; Manchester, *Treásures*, no.
T37.

35 (Fig. 195)
Torah Binder 66.055
Sušice (Schüttenhofen), Bohemia, 1784
Linen embroidered with cotton yarn
296 × 15.5

This binder is an example of the most common type
found in the Prague collection, a plain linen wrapper
embroidered with an inscription in red or blue cotton
yarn. Its inscription is unusual for the mention of a
place of origin.

הקטן לגדול יהיה יוסף בן כמר וואלף קובי׳ משיטנהובן
נולד למז״ט ביום ב׳ רד תשרי תקמה לפ״ק יגדל בתורה
ומ״ט א״ס

" 'May the infant become an adult,'[1] Joseph son of
Wolff Kovi[?] from Schüttenhofen born to a
g[ood] s[ign] on Monday the 24th of Tishri [5]545
(=1784). May he grow in Torah and g[ood] d[eeds]
A[men] S[elah]."[2]

Notes:
[1]From the circumcision service. (See ch. III, n. 32.)
[2]Variant on circumcision liturgy. (See n. 1.)

36 (Fig. 105)
Torah Binder 12.687
Moravia, 1857/8
Linen embroidered with cotton yarn
213 × 9.5

One side of the binder is embroidered with repeated,
geometricized floral motifs, finely executed in cross
stitch. The Hebrew inscription on the reverse is much
cruder and sewn of different colored yarn. These
differences and the similarity of the front to Moravian
belts suggests that a pre-existing sash was adapted for
use as a binder. The inscription reads:

ז״נ האשה מרת אסתר אשת כ״ה ישראל קוה שנת
תרי״ח לפ״ק

"This was donated by Esther the wife of Israel Kuh the
year [5]618" (=1857/8).
Provenance: The Pinkas Synagogue, Prague

37 (Fig. 118)
Torah Binder 687/72
Probably Frankfurt, 1876
Painted linen
357 × 20.5

Though embroidered binders are known from the 16th
century, painted binders with scenes first appear in the
18th century. This example is nearly identical to a
binder made for Judah Aryeh (Leo) Seligmann, the son
of Judah Seligmann Goldschmidt who was born in
Frankfurt in 1879.[1] Its origin outside Bohemia or
Moravia would explain why this type of painted binder
is rarely found in the Prague collection.

יששכר המכונה בערנהארד יוליוס ב״כ שלמה המכונה
זלמן גאלדשמידט הלוי שליט״א נולד במז״ט יום ד׳ כ״ב
טבת (מזל גדי) תרל״ו לפ״ק יגדל בתורה ולחופה
ולמעשים טובים אמן סלה.

"Issachar called Bernhard Julius son of Solomon called
Zalman Goldschmidt, the Levite, born in a good sign
Wednesday, the 22nd of Teveth (sign of Capricorn)
[5]636 [= 1876]. May he be raised in the Torah and to
the marriage canopy and to good deeds Amen Selah."[2]

Notes:
[1]Collection of Mrs. Elsbeth Goldschmidt Schloessinger, Great Neck,
New York.
[2]From the circumcision service. (See ch. III, n. 32.)

38
Torah Binder 56.912
Bohemia, 1888/9
Needlepoint with silk yarn on canvas; silk
39 × 22

One fifth of the binders in the State Jewish Museum
are of this type—rectangular cloths with ribbons for
attachment.[1] The inscription reads:

ריזל גלאוער/5649 "Reizal Glazer 5649."

Provenance: Soběslav, Bohemia
Note: [1]Doleželová, "Thorawickel," 1.

39 (Fig. 104)
Torah Cover 119/73
Šaratice (Scharatitz), Moravia, 1819
Embroidered linen
66 × 76

In material and decoration (an inscription whose letters
are filled with abstract and floral designs), this cover
reflects traditional Torah binders and, like them, was
dedicated on the birth of a male child.

נ״י הנעלה כמר ליב פוקס/מק״ק שעראטיץ עבור בנו
הילד/חיים הנולד לו במז״ט ביום ד׳ כ״ו ניסן/תקע״ט
השם יזכהו לגדלו לתו׳/ולחופה ולמעשים טובים/אמן
סלה

*"The donation of Leib Fuchs from the h[oly] congrega-
tion Scharatitz, for his son Hayyim who was born to
him with a good sign on Wednesday, the 26th of Nisan
[5]569 [=1819]. May God grant him to raise him to
Torah, to the marriage canopy and to good deeds.
Amen Selah."*[1]

Note: [1]From the circumcision ceremony. (See ch. III, n. 32.)

40
Torah Cover 59.893
Bohemia, 1858
Linen embroidered with cotton threads
81 × 84

The centralized composition of this cover reflects the
organization of more sophisticated metallic embroideries
produced in professional workshops, for example, a
Bohemian Torah curtain dated 1763, (no. 59.616) or
contemporaneous Ottoman textiles.[1] The inscription
runs around the perimeter, while the center is
emphasized by a rosette and by the direction of the
arabesques which fill the corners.

ז״נ האשה חשובה מרת פראדל אחרי מות בעלה מורנו
רב מנחם צבי פעלדמאן עבור בנם הילד·מאיר הנולד
במז״ט בשבת קדש י״ג אב תריח לפ״ק ה׳ יתן לגדל אותו
למ״ט

*"This was donated by Fraidel after the death of her
husband Menahem Zvi Feldman for their son Meir who
was born under a good sign on the Sabbath, the 13th
day of Av [5]618 [= 1858]. May God allow him to be
raised to g[ood] d[eeds]."*[2]

Provenance: Březnice, Bohemia
Notes:
[1]Cf. New York, The Jewish Museum, *A Tale of Two Cities*, no. 185.
[2]Variant on circumcision liturgy.

41 (Fig. 125)
Torah Shield 37.399
Maker: FK
Brno (Brünn), 1813
Repoussé, hammered and engraved silver
Marks: R[39243]; FK
33 × 26.3

The sinuous vines, lush foliage and graceful animals
that appear on this shield were used by Maker F.K. on
different types of Judaica, for example on the backplate
of a Hanukkah lamp now in a Viennese collection.[1] The
lions with two tails signifying superior strength are
symbols of both Prague and Bohemia. (For the crown
with ribbons see cat. 44.) The inscriptions read:

כ״ת/ז״נ הרר יוסף שלעזינגר/עם זוגתו א״ח מרת פעסל

*"Crown of Torah (Ethics of the Fathers 4:17). This was
donated by Joseph Schloessinger with his wife Pesel."*

Note: [1]Berger, *Judaica*, no. 436, pl. 101. For a similar Brno shield made
later in the century see loc. cit. no. 103.

Reference: Berlin, *Historica Hebraica*, no. A 24.

42 (Fig. 124)
Torah Shield 7.128
Maker: C. Rupka (?)
Vienna, 1813
Repoussé, hammered, and engraved silver
Marks: CR(?); Neuwirth, pl. 3, 3 and 16
37.1 × 28.4

A sense of whimsy transforms the traditional ico-
nographic motifs on this shield. The two flanking
columns terminate in a pair of blessing hands, and
leaves sprout forth from the top of the decalogue to
support a crown. The smooth surface of all these
elements contrasts with the hammered texture of the
background plane. Below the inscribed tablets are
additional inscriptions:

שנת ה׳ תקצ״א לפ״ק/נעשה מהחברה דנר של שבת
ב״הכי/ע״י הגבאים הר״ר יאקב הרש ה״ב נ״י והר״ר/נטע
אבליס נ״י

*"The year [5]591 [=1830/1]. Made from (i.e. by) the
Society for the Sabbath light of the Old Syn[agogue]
by the Treasurers Yaakov Hersh H. B. (Halberstam?),
and Nette Abeles."*

Provenance: Brno (Brünn), Moravia
Reference: The Hague, *Praag*, no. 98.

43
Torah Shield 37.603
Maker: Thomas Höpfel (1793–1847)
Prague, 1816
Repoussé and engraved silver
Marks: Hráský 160/3.5; R[39324]; Beuque 2706
22 × 20.4

The contrasting textures, lively animal forms and
unusual iconography of this shield are characteristic of
the work of Thomas Höpfel. (See cats. 44, 47.) Several
examples of this type are in the collection of the State
Jewish Museum.

Reference: Doleželová, "Thoraschilde," 29–30, 33, fig. 2.

44 (Fig. 122)
Torah Shield 44.162
Maker: Thomas Höpfel (1793–1847)
Prague, 1816
Repoussé, stippled and engraved silver
Marks: Hráský 160; R[39328]
31.3 × 30

In Bohemian heraldry, the imperial crown with ribbons
refers to the role of the emperor as head of the Church,
the ribbons deriving from a bishop's mitre.[1] This form
is often found on Bohemian Judaica like this shield
where it symbolizes the Crown of Torah. (See also cat.
41). The inscription reads:

נעשה ממעות צדקה

"Made from charitable funds."

Note: [1]Z. Zinger, *Česká heraldika* (Prague: Nakladatelství Vyšehrad,
1978), p. 81.

45
Torah Shield 104.795
Maker: Carl Skřemenec (d. 1828)
Prague, 1816
Repoussé, hammered and engraved silver
Marks: Hráský 422; R[39324]
17.5 × 15.5

According to its inscription, this shield was given to the
Cikánova (Gypsy) Synagogue which stood until the
urban renewal of the Prague ghetto early in the 20th
century.

נדבת יד הקצין הנעלה כה איצק שי' גבאי דבה"כן
ציגיינר בן הקצין/הנעלה כ"ה מאיר אשער ז"ל לס"ת
שלו עם זוגתו הא"ח מרת ציפרל/תי' בת הראש והקצין
פו"מ הנעלה כ"ה מרדכי איידליץ ז"ל שנת תקע"ו
לפ[נ]"ק

*"The donation of Itzig, treasurer in the Cikánova
Synagogue son of Meir Asher of blessed memory for
his T[orah] S[croll], with his wife Zipperl daughter of
Mordecai Eidlitz of blessed memory, the year [5]576"*
(= 1816).

The iconography of this shield is unusual. A flowering
and fruited tree growing from an urn is given central
place and should probably be interpreted as the Tree of
Life to which the Torah is often compared. (Cf. cat. 80).

Reference: Doleželová, "Thoraschilde," 29, 33.

46 (Fig. 106)
Torah Shield 37.616
Maker: Carl Skřemenec (d. 1828)
Prague, 1816
Repoussé, hammered and engraved silver
Marks: Hráský 422; R[39324], 7887, 7888
28 × 25

A sense of whimsy pervades this shield design. The
rampant lions each straddle two columns as they hold
aloft a crown. Below a third lion, jauntily waving his

tail, lies recumbent before a door or a schematic
rendering of the Tablets of the Law. Below the third
lion hangs a shield engraved with the dedicatory
inscription:

זכרון לטבת [כך!] נדיבה של האשה/גאלדה/ז"ל

"A remembrance for the generous goodness of Golda."

Note: For a nearly identical shield by Skřemenec see Doleželová,
"Thoraschilde," 29, fig. 1.
Reference: Doleželová, "Thoraschilde," 33.

47 (Fig. 123)
Torah Shield 174.189
Maker: Thomas Höpfel (1793–1847)
Prague, 1831
Repoussé, hammered and engraved silver
Marks: Hráský 160/3; R[39324]
21.2 × 16.7

This shield is noteworthy for its unusual iconography,
the lively contrasts in textures and the sense of vitality
resulting from the posture and compression of the
dragons' bodies. The dedicatory inscription appears on
the suspended shields:

ז"נ בצואה ר' חיים בער/ליכטענשטערן

*"This was donated in the will of Ḥayyim Ber
Lichtenstern."*

48
Torah Shield 10.632
Vienna (?), 1867–80
Repoussé, hammered, engraved and gilt silver
Mark: R[37863]
32 × 23.5

The shield is in the shape of a cartouche banded by
scrolls which end in winged grotesques. An unusual
feature is the size and prominence given these
decorative endings which dwarf the Jewish symbols
(lions, decalogue, and crown) and the inscription
engraved along the lower curves of the scrolls.

ז"נ הנ' כה' ישעי' גראף/מנייסטראשישיטץ בשנת תר"ם
לפ"ק

*"This was donated by Isai[ah] Graf von Neu-Straschitz
(Nové Strašecí) in the year [5]640"* (= 1879/80).

Provenance: Kladno, Bohemia

49 (Fig. 127)
Torah Finials *(Rimmonim)* 37.572 a,b
Maker: M. Entzinger
Prague, Staré Město, 1707
Repoussé, gilt, cut-out, and engraved silver
Marks: ME; Diviš 1562; restamping Prague 1806–07
(R[37]885) and Prague 1809–10 (Beuque 3024)
43.5 × 17.6 dm.

The baluster forms of these *rimmonim* are overlaid with
repoussé baroque forms: scrolls, shells and flowers.
They are surmounted by crowns. The dedicatory
inscriptions along the bases are later additions:

ז"נ הנעלה כהרר אברהם בן כהרר אפרים אובנר
ז"ל/וזוגתו מרת דבורה בת מהור' הקדוש עקיבא זצ"ל
בשנת תקכ"ח לפ"ק

*"This was donated by Abraham, son of Ephraim Ofner
of blessed memory/and his wife Deborah, daughter of
Akiba of blessed memory in the year [5]528"*
(= 1767/8).

Reference: Manchester, *Treasures*, no. M45.

50 (Fig. 107)
Torah Finials *(Rimmonim)* 46.002 a,b
Maker: Richard Fleischmann (1741–1822)
Prague, Malá Strana, 1776–84
Repoussé, parcel-gilt, cast and engraved silver
Marks: RF, Diviš 949; restamping 1806–1810 (R[37]885;
Beuque 3.024)
44 × 17.9 dm.

These *rimmonim* are executed in a restrained Empire
neo-classical style, and are noteworthy for the absence
of any Jewish iconographic elements. The inscription is
engraved along the bases:

זאת נדב הנעלה כהרר וואלף בן כהרר עזריאל גדלש
גבאי ד"ב/ב"הכ פינחס שנת תקמ"ד ל'/וזוגתו האשה
החשובה מרת פאטשי בת כהרר יאקב ווין ז"ל סגל

*"This was donated by Wolff son of Azriel Gedels
treasurer of the Pinkas Synagogue in the year [5]544
[= 1783/4]/ and his wife Petshi daughter of Yaakov
Wien of blessed memory Segal."*

Richard Fleischmann also made two Torah shields in the
Prague Museum's collection (nos. 46.075 and 4.391),[1]
the first of which is Empire in style and bears urns
similar to those on these *rimmonim*.

Provenance: Pinkas Synagogue, Prague
Note: [1]J. Doleželová, "Thoraschilde," 26–7, 31–2.
References: Manchester, *Treasures*, no. M33; Volavková, *Pinkas Synagogue*, pl. 47.

51
Torah Finials *(Rimmonim)* 10.387 a,b
Maker: FM(?)
Brno (Brünn), 1813
Repoussé, parcel-gilt and chased silver
Marks: FM(?), R[39]238, 9243
37 × 18 dm.

Various leaf decorations overlay the various parts of
these finials, the bases, shafts, and openwork crowns,
and serve to unify them. Atop the crowns are sculptural
forms rarely found on Judaica—mourning putti.

52
Torah Finials *(Rimmonim)* 23.006 a,b
Maker: Vincenz Carl Dub (d. ca. 1922)
Vienna, 1886–92
Cast, cut-out, hammered and engraved silver
Marks: Neuwirth, pl. 7, 2 or 3 and 2212
34 × 14 dm.

The cut-out bulbous shapes supported by baluster stems
and surmounted by crowns are typical of *rimmonim*
fashioned in the Austrian Empire in the late 19th
century.[1] German inscriptions appear frequently on
Judaica from this period.

Gespendet von Moriz [sic] & Mathilde Bauer
"Donated by Moriz [sic] & Mathilde Bauer."

אתי שדי תרנ"ב

"The Almighty is with me [5]652" (= 1891/2).

Note: [1]A similar pair is in the collection of the National Museum of
American History (1978.2106.3,a,b.) (See Washington, D.C., Smithsonian Office of Folklife Programs and Renwick Gallery, *Celebration: A
World of Art and Ritual*, exhibition catalogue, 1982, no. 204c.)

53 (Fig. 126)
Torah Crown 19/82
Maker: Wenzel Mendřický (Václav Leopold)
(1771–1839)
Prague, 1839
Repoussé, cast, hammered, engraved and gilt silver;
velvet
Marks: R[39]324; Hráský 275/4
54.5 × 37.5

The large size of this crown is accentuated by the
dimensions of the miniature crown it supports.
Retardataire rococo motifs enliven the spans of both
crowns as well as the base of the larger one, which also
bears a dedicatory inscription:

נעשה ממעות דח"ק/ת"ת ב"ש/וש"ק דב"הכן/קלויזן ע"י
הגבאים האלוף מו"ה/דוד טעבלס כ"ץ/ותה' יוסף
ליעבן/ותה' ר' מתתי' שניידער/על תנאי כמבואר/בפנקס
דב"הכן/בשנת תר"ג לפ"ק

*"Made from the funds of the Holy Society for the
S[tudy] of T[orah], B[arukh] s[he-Amar] and h[ymns]
of the Klausen Synagogue by the treasurer David Tevels
Katz and the scholar Joseph Lieben and the scholar
Mattitya[hu] Schneider according to the condition
explained in the record book of the synagogue in the
year [5]603"* (= 1842/3).

The *Barukh she-Amar*[1] Society of Prague was founded in the 16th century and existed until World War II. Its members rose early to be in the synagogue before the recitation of the *Barukh she-Amar* prayer.

Provenance: Klaus Synagogue, Prague

Note: [1]For the *Barukh she-Amar* see cat. 87.

54
Torah Crown 37.443
Maker: Abraham Daniel Kuh (1830–1882)
Prague, 1872–1882
Cast, repoussé, hammered, cut-out and engraved silver
Marks: Diviš 832, Hráský 231
29 × 24.5

Inscribed on both tiers of the two-tiered circlet:

ANLÄSSLICH DES 70TEN GEBURTSFESTES SEINES LANGJAHRIGEN [sic] SCHRIFTFUHRERS [sic] DES HERRN LOWY HAMMERSCHLAG GEWIDMET VOM JSR. FRAUEN VEREIN AUSSIG 3 FEBRUAR 1905.

"[Dedicated by] the Israelite Women's Association [of] Aussig February 3rd 1905 on the occasion of the 70th birthday of its secretary of long standing Mr. Lowy Hammerschlag."

The body, formed of eight acanthus leaves, contains many open areas imparting an airy and graceful quality to this crown, fashioned by a member of the Jewish gold and silversmith guild of Prague. Aussig (Ústí nad Labem), an industrial town in Northern Bohemia, did not have an established Jewish community until 1866.

Reference: Manchester, *Treasures*, no. M25.

55
Torah Crown 17.561
Maker: František Hladík
Prague, 1913
Parcel-gilt, engraved, chased and repoussé silver; semi-precious stones
Marks: Diviš 832, R[39]326, F.H.
29 × 23

German inscription (on bottom):

ZUR ERINNERUNG AN DIE VOLLENDUNG DES 80. LEBENSJAHRES DES VERDIENSTVOLLEN VORSTEHERS HERRN MORITZ AUSTERLITZ. GEWIDMET VON SEINEM AUFRICHTIG ERGEBENEN FREUNDE. PRAG AM 2. FEBRUAR 1913 / FRITZ WINTERBEBG [sic]/Entw. UND AUS-GEFÜHRT FR. HLADÍK

"In remembrance of the completion of the 80th year of the life of the meritorious director Mr. Moritz Austerlitz. Dedicated by his sincere and devoted friends. Prague on February 2, 1913/Fritz Winterbebg [sic]. Des[igned] and executed [by] Fr. Hladík."

This Torah crown is fashioned in the form of an Imperial Habsburg crown, a motif found on many pieces of Judaica produced within the Empire. (See, for example Torah shields, nos. 41, 43, 44, 46, 47.)

Provenance: Klaus Synagogue, Prague
Reference: Manchester, *Treasures*, no. M31, pl. VII.

56 (Fig. 108)
Torah Pointer 4.105
Moravia, ca. 1800
Cast and engraved silver
Marks: restamping Brno 1806–1809 (Diviš 84) and 1809–10 (R[37886])
19 l.

Three knops divide the spiral shaft of this pointer. The largest knop at the top bears the crudely engraved Hebrew initials:

"M.M." מ מ

Provenance: Chotěboř, Bohemia

57
Torah Pointer 9.551
Bohemia, ca. 1800
Cast and engraved silver
Marks: restamping Prague 1806–1809 (Diviš 84) and Prague 1810–1824 (Diviš 564)
32 l.

The design is distinguished by a spiral shaft, the engraved fluting on the three knops which articulate the pointer's segments, and by the rendering of the sleeve below the hand in the form of a starched cuff with a full scalloped ruffle. The extended index finger is damaged.

Provenance: Kounice, Bohemia
Reference: Bratislava, *Ars Judaica*, no. 107.

58 (Fig. 108)
Torah Pointer 48.260
Prague(?), ca. 1810/11
Cast and engraved silver
Mark: restamping Prague 1810–24 (Diviš 564)
30 l.

Inscribed on lower portion of the shaft:

ז"נ האלוף התו' מהו יוסף בה/שמחה ווינר ז"ל
וזוגתו/א"ח מ' רייכל בת כ"ה דוד/פערלש ז"ל תקע"א
ל/"

"T[his was] d[onated] by Joseph s[on of] Simhah Wiener of blessed memory and his spouse Reichel daughter of David Perls of blessed memory [5]571" (=1810/11).

Ten years after the original dedication, Joseph's son had the pointer restored, whereupon a second inscription was engraved on the upper part of the pointer:

נתחדש ע"י בנו/כ"ה שמחה ש"י/וזוגתו.א"ח מ/מינדל
תי' תקפ"א ל"פק

"Renovated by his son Simhah and his spouse Mindel [5]581" (=1820/21).

239

59
Torah Pointer 4.381
Maker: probably Carl Skřemenec (1769–1828)
Prague, 1818
Cast and engraved silver
Marks: R^{39}324, Hráský 422, restamping Prague
1810–1824 (Diviš 564)
24 l.

This pointer consists of a rectangular handle with
beveled edges leading to a spiral shaft which terminates
in a hand with curved index finger. Two round knops
and a cuff above the hand articulate the different
segments. This design harks back to 18th-century
German examples.[1] The handle bears the dedicatory
inscription:

לקהל דק״ק שאמבורג/י״צ בשנת/תקע״ט לפ״ק

*"To the community of the h[oly] c[ongregation of]
Zamberg g[uard their] l[ives] in the year [5]579"*
(=1818/9).

Jewish settlement in Zamberg (today Žamberk) in
northeastern Bohemia dates from before 1654.

Note: [1]See, for example, New York, The Jewish Museum, *Danzig 1939*,
nos. 87–89.

60 (Fig. 108)
Torah Pointer 104.790
Eastern Europe, first half of the 19th century
Brass; filigreed, silvered copper
34 l.

The use of three metals in the design of this pointer
produces a coloristically rich and varied effect. The brass
hand appears to be a somewhat later addition.

References: Berlin, *Historica Hebraica*, no. A79; Bratislava, *Ars
Judaica*, no. 138, ill.; The Hague, *Praag*, no. 153; Vienna,
Kunstschätze, no. 218.

61 (Fig. 108)
Torah Pointer 2.281
Maker: JE
Vienna, 1867–70
Cast, chased, engraved and hammered silver
Marks: Beuque 191; JE
34.5 l.

Inscribed (on lower portion of shaft):

הקצין כ״ה יונה נ״י עם זוגתו הקצינה/מרת מרים
וואססערמאן תחי׳/החונה בק״ק פעסט/נדב זאת
היד/לחנוכת/בית הכנסת/דק״ק
גראס/מעזעריטש/ביום/י״ג תמוז/תר״ל לפ״ק

*"Yonah with his spouse Miriam Wasserman who dwells
in the h[oly] c[ongregation of] Pest donated this Torah
pointer for the dedication of the synagogue of the
h[oly] c[ongregation of] Gross Meseritch on the 13th
day of Tammuz [5]630"* (=1870).

The bulbous upper portion and the floral and scroll
decoration are characteristic of 19th-century pointers of
Viennese manufacture.

Provenance: Velké Meziříčí (Gross Meseritch), Moravia
References: Bratislava, *Ars Judaica*, no. 89; The Hague, *Praag*, no. 139;
Vienna, *Kunstschätze*, no. 151.

62 (Fig. 108)
Torah Pointer 10.965
Maker: VC, possibly Vincenz Czokally
Vienna, 1867–72
Cast and machine engraved silver
Marks: Beuque 191; VC
24.5 l.

The combination of regular machine engraved motifs,
simple geometric forms and naturalistic detail found on
this pointer is also characteristic of other works by
Vincenz Czokally.[1]

Provenance: Strážnice, Moravia
Note: [1]Neuwirth, I, p. 138, pl. 75, fig. 2.
References: Bratislava, *Ars Judaica*, no. 117; The Hague, *Praag*, no.
141; Vienna, *Kunstschätze*, p. 49, no. 184.

63 (Fig. 108)
Torah Pointer 9.727
Possibly Russia, 19th century
Parcel-gilt and hammered silver; coral
15.5 l.

Separating the shaft of this pointer from the coral hand
is a thin band of gilt silver fashioned to simulate a lace
cuff. A Russian origin is suggested by the use of coral
and the rendering of the hand.[1]

Provenance: Březnice-Kasejovice, Bohemia
Note: [1]See, for example, New York, The Jewish Museum, *Danzig 1939*,
nos. 97 and 241.

64
Torah Pointer 4.449
Moravia, 1902
Partially silvered and engraved brass
30 l.

The color contrast between brass and silver enlivens the
decoration of this pointer and articulates its different
segments. A German inscription on the upper part of
the shaft reads:

*Gewidmet von Leopold und Antonie Goldberger in
Poln[isch] Ostrau anlässlich ihrer silbernen Hochzeit
am 24/5. 1902.*
*"Dedicated by Leopold and Antonie Goldberger in
Poln[isch] Ostrau on the occasion of their silver
wedding anniversary on May 24, 1902."*

At the time this pointer was dedicated, the town of
Moravska Ostrava in Moravia included a section called
Polnisch Ostrau (after 1918, Slezska Ostrava) which was
under Silesian rather than Moravian administration.

Reference: Berlin, *Historica Hebraica*, no. A73.

65 (Fig. 128)
Torah Pointer 101.999
Bohemia, 1806/7
Carved wood; cotton cord
17.5 l.

The date is carved just below the suspension hole:

"The year [5]567" (=1806/7). שנת תקס״ז ל׳

A similar piece of Alsacian origin is now in the Musée
Lorrain, Nancy.[1]

Note: [1]*Monumenta Judaica*, no. E 392; cf. also no. E 470.

66 (Fig. 128)
Torah Pointer 37.536
Prague(?), beginning of the 19th century
Carved and engraved wood
32.4 l.

The hand on this example is distorted in an expressive manner. The forefinger is elongated and the remaining fingers are bent to the side. The bottom is planed flat.

67 (Fig. 128)
Torah Pointer 23.130
Bohemia, beginning of the 19th century
Carved wood
25 l.

The hand of this pointer is very mannered in appearance, and has an elongated forefinger. A hole was drilled at the opposite end for a chain (now missing).

Provenance: Mělník, Bohemia
Reference: The Hague, *Praag,* no. 160.

68 (Fig. 128)
Torah Pointer 2.147
Bohemia, first half of the 19th century
Carved wood; walrus inlaid with glass stone
24.5 l.

The thumb bears a ring inlaid with a small glass stone.

Provenance: Mladá Boleslav (Jung Bunzlau), Bohemia

69 (Figs. 3, 128)
Torah Pointer 37.795
Prague, first half of the 19th century
Carved, varnished and painted wood
26.51

The bentwood handle of this pointer terminates in a ruffled cuff and a hand that is painted white. This piece stems from the Pinkas Synagogue.

Provenance: Pinkas Synagogue, Prague.
Reference: The Hague, *Praag,* no. 164.

70 (Fig. 128)
Torah Pointer 32.394
Bohemia, second half of the 19th century
Carved wood
32 l.

In form, this pointer imitates silver examples.

Provenance: Kolín-Zruč, Bohemia

71 (Fig. 128)
Torah Pointer 23.503
Bohemia, 19th century
Carved, engraved and inlaid wood; metal ring and chain
31 l.

The same inscription appears on all four sides of the handle:

"Holy to the Lord" (Ex. 28:36; 39:30) קדוש לה'

This pointer's shape imitates silver examples.

Provenance: Domažlice, Bohemia

72 (Fig. 128)
Torah Pointer 1.807
Bohemia, 19th century
Carved and stained horn
29.3 l.

The curving shape of this pointer results from the natural bend of the horn.

Provenance: Klatovy, Bohemia

73 (Fig. 46)
Pair of Lions from a Torah Ark 21/82 a, b
Bohemia, ca. 1820
Carved, polychrome and gilt wood
51 × 36

Recent archaeological excavations have shown that carved lions were used to decorate Torah arks as early as the 3rd century.[1] From the posture and finish of these wooden figures, it would appear that they were meant to be seen in three-quarter pose facing one another and holding aloft a common object. They may have supported a crown, as on numerous Torah shields (e.g., cat. 46) or the Tablets of the Law.[2]

Restored: 1983
Provenance: Bechyně, Bohemia
Notes: [1]E. M. Meyers, J. F. Strange, and C. L. Meyers, "The Ark of Nabratein—A First Glance," *Biblical Archaeologist* 44 (Fall, 1981), 237–43.
[2]Cf. the decoration from a German ark dated to the early 19th century (*Monumenta Judaica,* no. E281, fig. 75).

74 (Fig. 96)
Sections of a Grill for the *Bimah* (Reader's Desk) 23/82, 24/82, 25/82
Prague, second half of the 18th century
Wrought iron
23/82: 116.5 × 59; 24/82: 123 × 66.8; 25/82: 113.5 × 86

These sections were mounted on short, turned columns placed along the top of the *bimah* in the Cikánova Synagogue. They are similar in form to the grillwork donated to the Pinkas Synagogue in the late 18th century and, like it, incorporate the symbol of the Jewish community within flowering vines and fretwork.[1] The use of decorative ironwork is a hallmark of Prague architecture.

Provenance: Cikánova Synagogue, Prague
Note: [1]For the Pinkas grillwork see Volavková, *Pinkas Synagogue,* pls. 43, 49–50.
Reference: Lieben, *Jüdische Museum,* 6.

75 (Fig. 98)
Eternal Light 10.931
Maker: possibly Johann Honzák (1809–1890)
Prague, 1850s
Repoussé, engraved and cast silver; brass
Marks: R[39324]; Hráský 158(?)
75 h.

Between the consoles that hold the chain are three empty slots, an indication that portions of the lamp are now missing.

76 (Fig. 99)
Eternal Light 37.529
Prague(?), 1892
Cast, repoussé, hammered and engraved silver
103.5 h.

Various motifs on this lamp, such as the cut-out
trefoils, indicate the influence of the late 19th-century
neo-Gothic movement. According to its inscription, this
lamp was dedicated by an officer of the Great Court
Synagogue[1] in honor of Feivel Bondi.

נ"י הקצין המרומם כ"ה יעקב כ"ץ קאהן אחד מפרנסי
דב"הכנ/חצר הגדולה ע"ז מרת טריינדל תחי'
לכבוד הק"בה לכבוד הגבאי האלוף מהו' פייבל באנדי נ"י
לעת מלאת חמש ועשרים שנה מאז נבחר לראש קרואי
העדה בב"הכנ הנ"ל יום ד' כסלו תרנ"ג לפ"ק

*"The donation of Jacob Katz Kahn, one of the leaders of
the Great Court Synagogue w[ith his] w[ife] Treindel,
in honor of God [and] in honor of the treasurer
(gabbai) Feivel Bondi at the time of the completion of
twenty-five years since he was chosen to head the 'elect
of the congregation' [Nu. 1:16] in the above-mentioned
synagogue 4 Kislev [5]653"* (=1892).

Note: [1]The Great Court Synagogue in Prague was torn down at the
beginning of the 20th century at the time of the "urban renewal" of the
Jewish quarter.

77 (Fig. 100)
Eternal Light 32.916
Maker (of canopy): Salomoun Rosenberg (b. 1813)
Prague, last quarter of the 19th century
Colored and translucent (etched) glass; wood; brass;
hammered and engraved silver
Marks (on silver canopy): Diviš 832; Hráský 363
90 h.

Glass lights for the synagogue are rare. A Viennese
example, also having a red and white globe and silver
fittings, is dated 1846.[1] Salomoun Rosenberg, who
fashioned the canopy of the Prague lamp, became a
master in 1840; the Prague mark on the canopy dates
after 1872, suggesting a date in the last quarter of the
19th century. This dating is harmonious with the style
of the floral and strapwork designs etched on the
translucent cartouches of the globe which are similar to
those adorning the museum for decorative arts in
Prague, Uměleckoprůmyslové museum, erected in the
late 1880s.

Note: [1]Berger, Judaica, Inv. Nr. 439.

78 (Fig. 121)
Laver and Basin 46.036 a,b
Maker: Johann Georg Lux (1664–1724)
Prague, Malá Strana, 1702
Repoussé, hammered, chased, basket weave and
engraved silver
Marks: Diviš 1578 (R[39317]), R[39337]; restamping
Prague 1806–09 (Beuque 3024) and 1809–10 (R[37885])
Laver: 25.5 × 19.5; Basin: 46 dm. × 5

The highly ornate laver contrasts with the elegant
simplicity of the basin. In this contrast as well as in its
shape, decoration, and proportions, Lux's work is very
similar to a laver and basin set of ca. 1690–1700 by the
Augsburg master Philipp Küssel.[1]
 An example of the finest in Prague silver production,
this laver and basin were restamped ca. 1810, where-
upon a dedicatory inscription in Judeo-German was
engraved on the rim of the basin:

רעפונצירט בפקודת הקיסר יר"ה משלשה אחים הלא
המה הנעלה ר' קפמן ור' אפרים ור' חיים בני הנעלה
כ"ה יצחק עפשטיין סג"ל ז"ל גבאי דב"הכ"נ פינחס
בשנת תק"ע לפ"ק

*"Restamped in accord with the command of the
Emperor ma[y his] g[lory be exalted] from three
brothers, they are the distinguished Kufman and
Ephraim and Ḥayyim sons of Isaac Epstein Segal of
blessed memory, Treasurer of the synag[ogue] Pinkas in
the year [5]570"* (=1809/10).

Provenance: Pinkas Synagogue, Prague

Note: [1]Leningrad, the Hermitage, Inv. Nos. 8720, 8744, ill. in Seling,
II, fig. 358. Seling (I, p. 105) remarks that the sparse decoration of the
Augsburg basin indicates that it was not merely an ornamental piece,
but was made to be functional.

References: Krüger, Kunst der Synagoge, p. 180, figs. 50–51; Sadek,
"Argenterie," 70; Volavková, Pinkas Synagogue, ill., pp. 99–101.

79 (Fig. 5)
Laver 20/82
Maker: DH, probably Daniel Herold (ca. 1665–1745)
Augsburg, 1708–1710
Cast, repoussé, parcel-gilt, chased, hammered and
engraved silver
Marks: Seling, III, 167 and probably 1948; restamping
Prague 1810–24 (Diviš 564)
29 × 25

Scalloped shells executed in a variety of techniques—
intaglio, repoussé, and engraved—constitute the major
decorative motif of this finely-fashioned laver. Gilt areas
articulate transitions in form and decoration. The
bulbous lower portion, flaring neck, undulating rim,
and fanciful handle of intertwining snakes create a
lively and graceful silhouette. This laver has features in
common with contemporary works by other Augsburg
silversmiths. The foot and lower portion are close to a
laver made ca. 1705 by Daniel I. Schäffler[1] and the
entire upper section and handle strongly resemble a
laver of the same height by Michael Hueter dated ca.
1698.[2] Engraved on the base are the letters *FE u[nd]
GM* ("FE a[nd] GM"), most likely the initials of former
owners of the laver.

Notes:
[1]Vienna, Österreichisches Museum für angewandte Kunst, Inv. no. Go
1799, Seling, II, fig. 844.
[2]Private Collection, Seling, II, fig. 846.

80 (Fig. 45)
Synagogue Lavabo III-915
Slovakia, 1800/1
Cast, repoussé, engraved, gilt and polychromed brass
46 × 26 × 20

This lavabo is unusual for its rich scenic decoration, and for the manner in which the maker utilized the curvature of the form to enhance the perspective rendering of the setting. Beneath the arch is a flowering tree on which a bird is perched; the tree is set behind a balustrade. Two rampant griffins face inward toward this central motif. Similar compositions decorate the backplates of 19th-century Eastern European Hanukkah lamps[1], and this Slovakian lavabo may have been based on a similar model. At bottom is the date:

"The year [5]561" (=1800/1). שנת תקס"א לפ"ק

Note: [1]E.g. New York, The Jewish Museum, *Danzig 1939*, no. 43.

81
Basin for a Lavabo 27/82
Bohemia, beginning of the 19th century
Cast and hammered copper
18.7 × 32.8 × 25

On the back is a socket for attachment to the wall.

82 (Fig. 71)
Alms Box 10.355
Possibly Brno (Brünn), Moravia, 1763/4
Hammered and engraved silver
Marks: Restamping Brno 1806–7 (Beuque 3028)
16 × 11

Alms boxes like this one are depicted in the cycle of paintings commissioned by the Prague Burial Society (cats. 182 and 191). The inscription reads:

שייר/לגבאי צדקה/דק"ק מיזלב/נעשה ע"י ה'/וואלף
אירץ וה" דוד טריבטש וכמר פתח' בג ושבי"ה בִּצְדָקָה

"[This] belongs to the treasurers of charity of the h[oly] c[ongregation] Mislov [Miroslav], commissioned by Wolff Ertz and David Trebitsch and Petah[iah] Bag[?], 'her repentant ones [shall be redeemed] with righteousness'" (Is. 1:27) (=[5]524 = 1763/4).

References: Bratislava, *Ars Judaica*, no. 191; The Hague, *Praag*, no. 290; Vienna, *Kunstschätze*, no. 300.

83 (Fig. 132)
Alms Box 66.125
Bohemia, beginning of the 19th century
Painted and stained wood; hammered and gilt brass
36 × 30 × 20

Several alms boxes with outstretched arms are part of the State Jewish Museum's collection; they are also known outside of Bohemia.[1] Their form may reflect the influence of medieval arm reliquaries, treasured church objects in both Germany and Bohemia. The inscription reads:

"A gift in secret pacifies anger." (Prov. 21:14)

Provenance: Sušice, Bohemia.

Note: [1]Frauberger, "Über Alte Kultusgegenstände," figs. 91–2.

84 (Fig. 131)
Alms Box 9.720
Kasejovice, Bohemia, early 19th century
Carved and stained wood; hammered iron
44 × 29.2 × 19.5

The box is formed of a cubic piece of wood, planed on three sides with the front beveled and decorated by a pattern of rough tool marks.

Reference: The Hague, *Praag*, no. 283.

85 (Fig. 119)
Alms Box 1.609
Eastern Europe(?), 1876/7 (inscription date)
Silver-plated, chased and engraved copper
Marks: unidentifiable double-headed eagle with orb and scepter, 20.
19.5 × 13

The Hebrew inscription is engraved on both sides of the slot for depositing money:

צדקה תציל ממות/שנת תרל"ז לפ"ק

"Righteousness saves from death (Prov. 10:2; 11:4) */[in the] year [5]637"* (=1876/7).

Chased motifs of flowers, leaves and grapes decorate the entire surface of this pear-shaped container.

Provenance: Hradec Králové (Königgratz), Bohemia

86
Sconce 12.942
Prague, 18th century
Repoussé and hammered brass
46 × 32

Provenance: Pinkas Synagogue, Prague

87
Prayer Plaque 13/76
Bohemia, 1722/3
Painted brass, wood frame and backing
75.2 × 71.9

The main text on this plaque is the *Barukh she-Amar* (lit. "Blessed be He who spoke"), the benediction opening one portion of the morning service known as the "passages of song." Below is a dedication:

נ"י ר' הירש בן ר' ליב כ"ץ/פנטא ז"ל שהוא היה/מזמרי
ברוך שאמר ופסוקי דזמרי [כך!]/עבור נכדו ליב בן ר'
מאיר כ"ץ ז"ל/למלא מְקוֹם אֲבֹתיו לפ"ק

"The donation of Hirsch son of Lieb Katz Pinta of blessed memory who was one of the singers of 'Blessed be he who spoke' and 'passages of song' for his grandson Leib son of Meir Katz of blessed memory 'to fill the place of his fathers'" (=[5]483 = 1722/3).

Below is a second dedicatory inscription, most of which is illegible, referring to the restoration of the plaque.
 The double portal frame that is surmounted by pairs of facing figures was probably modeled on similar

compositions in both printed and manuscript Scrolls of Esther.[1] The motifs at bottom, the blessing hands of a *kohen* (priest) and the running deer refer to the name of the donor.

Note: [1] Cf. New York, The Jewish Museum, *Danzig 1939*, no. 48.

88 (Fig. 134)
Shiviti Plaque 1.797
Moravia, 1879/80; additions, 1913
Silvered, repoussé and stippled brass; wood mount
124.5 × 60.5

The composition, medium, style and iconography of this plaque bearing prayers invoking piety demonstrate the influence of Eastern European Judaica on the cermonial art of Bohemia and Moravia.[1] The original lower portion was enlarged in 1913 by the addition of the section above the entablature: a silvered brass plaque bearing both 20th-century and earlier appliqués. In its final form this plaque once served as the door of a Torah ark in the Synagogue of Frýdek-Místek, Moravia. Inscriptions:

ושמו את שמי על בני ישראל ואני אברכם

שויתי ה' לנגדי תמיד

דע/לפני מי אתה עומד לפני מ'מ'ה' ה'ק'ב'ה'

מה למעלה ממך/עין ראה ואזן שומעת וכל מעשיך/בספר נכתבים

מאין באת ולאן אתה הולך ולפני מי אתה עתיד לתן דין וחשבון

הוי עז כנמר וקל כנשר רץ כצבי וגבור כארי לעשות רצון אביך שבשמים

בשנת תרם לפק

"Thus they shall link My name with the people of Israel, and I will bless them. (Nu. 6:27)

I am ever aware of the Lord's presence. (Ps. 16:8)

Know before whom you stand, before the King of Kings, the Holy One, Blessed be He. (Babylonian Talmud, Berakhot 28b)

What is above you—an [all-] seeing eye and an [all-] hearing ear, and all your deeds recorded in a book. (Avoth 2:1, Midrash Shmuel 5:21)

Whence you are come—and where you are going, and before whom you will in future render account and reckoning. (Avoth 3:1)

Be strong as the leopard (and) light as the eagle (and) fleet as the hart, and mighty as the lion to do the will of your Father who is in Heaven (Ethics of the Fathers 5:23).

In the year[5]640" (= 1879/80).

Provenance: Frýdek-Místek, Moravia

Note: [1] Cf. A *shiviti* from Poland published in New York, The Jewish Museum, *Danzig 1939*, no. 116.

89 (Fig. 93)
Synagogue Clock 23.412
Maker: Joseph Vogel
Písek, Bohemia, ca. 1870
Carved, painted and parcel-gilt wood; seven clock faces; glass
Marked on back: Herrn Jos. Vogel Uhrmacher Pisek
71 × 46 × 11.5

This richly-embellished synagogue clock contains seven faces: the large central one is an actual clock, while the six smaller dials are set by hand each week to indicate the time to begin the recitation of the different prayers. A wooden plaque in the form of a swag over the central clock bears the painted Hebrew inscription:

זמני התפלות *"Times of Prayers"*

Inscriptions indicate the significance of the other six dials: in the right column:

בימי החול/שחרית/מנחה/קבלת שבת

"On weekdays; morning service; afternoon service; welcoming the Sabbath"

and in the left column:

בשבת וביוט/שחרית/מנחה/מעריב

"On Sabbath and Festi[vals]; morning service; afternoon service; evening service"

A rich decorative effect is produced by the brown, gold, and teal blue color scheme, and by the carved frame.

90 (Fig. 120)
Tankard for Wine 2.704
Maker: IK
Vienna, middle of the 16th century; lid: 19th century
Cast, hammered, cut-out, gilt and engraved silver
Marks: R[3]7850; IK
28 × 14.5 dm.

The main body of the tankard was made in Vienna in the middle of the 16th century. According to the inscription, it was purchased and donated to a synagogue in 1813/14, at which time the lid may have been added.

כלי זה נקנה מקופת הצדקה בשנת (ת)קע"ד בהתמניות ה"אל"ק גבאי צדקה/ה"ה ה' מענדל טעכוי ה' בער בר"ח שווארץ וה' דוד ברד"ס יצ"ו

"This vessel was bought from the charitable fund in the year [5]574 [= 1813/14] by the nominations of the h[ead] of the c[ongregation], treasurer of charity Mendel Tachau (?), Ber son of H. Schwartz and David Bardeis."

Reference: Vienna, *Kunstschätze*, no. 376.

91
Ceremonial Beaker 3.701
Maker: Carl Schuch (1652–1731)
Augsburg, 1695–1700
Hammered and engraved silver
Marks: Seling 151, 1793
8 × 6.7 dm.

In 1804, this late 17th-century beaker was donated to a
Bohemian synagogue.

ז"נ ה"ה שמעון פוליץ עם זוגתו מ' מינדל עבור בנם הילד
אייזק להצדקה ד"בהכ"נ דק"ק א"ג בתקס"ד ל'

*"This was donated by Simon Politz with his wife
Mindel for their son Isaac to the charity of the
synagogue of the holy community A.G. in [5]564"*
(=1803/4).

Provenance: Jewish Museum, Mikulov (Nikolsburg), Moravia

92 (Fig. 173)
Ceremonial Beaker 44.410
Maker: probably Gottfried Kittel (1697–1717)
Ohlau, Silesia, 1697–1700
Cast, chased, hammered and engraved silver
Marks: R³4327 and probably 4333; restamping Prague
1806–07 (Beuque 3024) and 1809–10 (R³7886)
12 × 9

Later inscription on rim:

נעשה ממעות הצדקה ע"י הגבאת האשה מ' אסתרל אל
המנוח כ"ה איצק ועהלי ז"ל שנת תקע"ד ל'

*"Made from charitable funds b[y] the treasurer the
lady Estherel for the late Itzig Wehle o[f] b[lessed]
m[emory] . . . [in the] year [5]574"* (=1813/4).

The initials M.G.H. also appear on the rim.
This beaker with a false bottom is richly decorated with
chased quatrefoils set within circular frames, leaves, and
crowned flaming hearts.

Provenance: Maisel Synagogue, Prague
References: The Hague, *Praag,* no. 240, fig. 34; Vienna, *Kunstschätze,*
no. 369, fig. 28.

93 (Fig. 136)
Hanukkah Lamp for the Synagogue 22/82
Bohemia, middle of the 19th century
Cast, cut-out and engraved pewter
157 × 70 × 43

The custom of lighting Hanukkah lamps in the
synagogue for the benefit of wayfarers dates back to the
13th century. Moses and Aaron are not connected with
Hannukah lore. Their presence on this lamp appears
due to the influence of printed books. (See above ch.II.)

94 (Fig. 133)
***Eruv* Holder for the Synagogue** 12.851
Moravia, 1837/8
Repoussé and cut-out brass with copper inlays
36 dm.

An *eruv* is a common boundary that residents of a
Jewish community (or of a building with a common
court) establish so that the area within is considered
private property for the purpose of carrying on the
Sabbath. Normally, carrying is one of those categories
of work forbidden on the day of rest. To symbolize
their union within the *eruv*, members of the communi-
ty or house contribute to a common dish. A similar
container still hangs in the Altneuschul.[1] The appliquéd
Aramaic and Hebrew inscription, drawn from the
ceremony establishing an *eruv* reads:

ע"ח
יהא שרא לנא לפק

*"An amalgamation of courtyards. May it be permitted
to us, [5]598"* (=1837/8).

The rosettes which decorate this container and the one
in the Altneuschul are a motif common in Moravian
folk art.

Provenance: Ivanovice u Brna, Moravia
Note: ¹Other published *eruv* holders are very different in form. See F.
Landsberger, *A History of Jewish Art* (Cincinnati: The Union of
American Hebrew Congregations, 1946), p. 62, fig. 42; *Monumenta
Judaica,* no. 267; Frauberger, "Über Alte Kultusgegenstände," 63–4, fig.
94.
References: The Hague, *Praag,* no. 350; Volavková, *Guide,* 1948, 28.

95
Lectern *(Stende)* 173.332
Bohemia, 19th century
Stained wood
113.7 × 40.2 × 40.5

Such lecterns were commonly used by Jews in various
European countries. (Cf. *Monumenta Judaica,* no.
E404, fig. 84, a 19th-century lectern from Alsace.)

96
Lectern Cover 40.968
Prague(?), 1936/7
Cut-out and appliquéd leather; metal tabs and rings
50.5 × 73

From the metal attachments, this cover appears to have
been used on a lectern. The inscription reads:

זאת נדבו החשובים והנכבדים/כהר עזריאל בן מרדכי
הארץ נ"י/ובניו יעקוב מרדכי וצבי נ"י/לזכרון נשמת
אשתו ואמם/החשובה והצנועה מרת/שרה בת שינדל
ז"ל בשנת תרצ"ז לפ"ק

*"This was donated by Azriel, son of Mordecai Hertz
and his sons Jacob, Mordecai and Zvi, in memory of
the soul of his wife and their mother Sarah, daughter
of Sheindel o[f] b[lessed] m[emory] in the year [5]697"*
(=1936/7).

In the collection of the State Jewish Museum are other earlier coverings executed in the same technique. The presence of cut-out and appliquéd leather garments and coverings in Hungary and neighboring areas has been attributed to Ottoman influence.[1]

Provenance: Pinkas Synagogue, Prague

Note: [1]Gervers, *The Influence of Ottoman Turkish Textiles and Costume*, 13, figs. 18–21.

97 (Fig. 95)
Synagogue Key 37.534
Prague(?), end of the 19th century
Cast steel
24.5 × 7

Each of the circles of the trefoil handle is filled with a Star of David.

Provenance: Prague
Reference: Berlin, *Historica Hebraica*, no. A161.

98 (Fig. 164)
Tefillin **Bag** 363/72
Bohemia, second half of the 19th century
Crocheted cotton, silk embroidered with cotton thread; cotton cord
19 × 14.5

The bag is crocheted as a series of petalled flowers whose openwork design allows for effective contrast with the colored lining. Crocheting is a traditional Bohemian folk art.

99 (Fig. 165)
Tefillin **Bag** 401/72
Bohemia, 1893
Velvet embroidered with colored cotton; linen lining
20 × 18

Inscription:(at top) ("Fischel Bard"?) (?) פישל באדר
(below) *1893*

The geometricized forms of the embroidered decoration, birds, flowers, and bushes, are similar to those found on Bohemian folk embroideries. (See cat. 130, n. 1 for reference.)

100 (Fig. 163)
Tefillin **Bag** 339/72
Bohemia, early 20th century
Crocheted cotton, cotton cord (new lining)
20 × 18

The bottom of the bag is crocheted as a rosette whose interstices are filled with openwork and the top consists of rows of opaque and openwork diamonds, resulting in a decorative contrast between the neutral cotton and the colored lining.

101 (Fig. 166)
Prayer Shawl (*Tallit*) 19.344
Germany, second half of the 18th century
Silk damask; silk brocade; metallic ribbon; wool fringes
278 × 220

Ten of these deluxe prayer shawls are extant.[1] All stem from Germany proper or contiguous areas and are formed of 18th-century fabrics: white silk damask and an overlaid panel of flowered brocade. The damask of this example is probably German and dates to the middle of the 18th century; the brocade is French from the third quarter of the 18th century.[2]

Notes:
[1]See listing in New York, The Jewish Museum, *A Tale of Two Cities*, no. 77. Another is published in R. D. Barnett, ed., *Catalogue of the Permanent and Loan Collections of the Jewish Museum, London* (London: Harvey Miller, 1974), no. 180. Two additional examples are in the collection of the Mosaiske Troessamfund, Copenhagen, nos. 242 and 243, whose holdings include items from Hamburg, part of the Kingdom of Denmark from 1640 to 1864. (New York, The Jewish Museum, *Kings and Citizens*, cat. 16.)
[2]For the damask, cf. Thornton, *Silks*, pl. 87A and *Seidengewebe*, nos. 573-5; for the brocade, cf. Thornton, *Silks*, pl. 98B.

102
Prayer Shawl (*Tallit*) 24.061
Prague(?), late 19th century
Wool, silk, metallic ribbon, and wool fringes
64 × 184

White wool prayer shawls woven with black stripes of varying width are the most common type, and some one hundred and fifty similar examples are part of the State Jewish Museum's collection. This one is embellished by a metallic neckband, known as an *atarah* (lit. crown). It stems from the holdings of the Prague Burial Society.

103
Prayer Shawl Bag 255/72
Bohemia(?), second half of the 19th century
Velvet embroidered with metallic threads; metallic braid; brass buttons; cotton and linen lining
34 × 36

On the front of the bag, a wreath of oak leaves encloses the inscription, the name of the owner:

הרב/שלמה ליב/פריעדלענדער

"Rabbi Solomon Leib Friedlander."

The lining within has multiple, overlapping patches attesting to long use.

104
Prayer Shawl Bag 241/71
Germany or Austrian Empire, late 19th-early 20th century
Velvet embroidered with cotton threads
35.5 × 38

Prayer Shawl bags embroidered with the owner's monogram and, sometimes, other decorative motifs were popular in Germany and the Austrian Empire in the late 19th and early 20th centuries.[1] The monogram on this bag is indecipherable.

Note: [1]A similar German bag in The Jewish Museum, New York (1982–50) dates 1925.

105
Skullcap 53/73
Bohemia(?), 18th–19th century
Silk damask; metallic ribbon, linen lining
16 × 17 dm.

The silk damask dates to the middle of the 18th
century.[1]

Note: [1]Cf. *Seidengewebe*, no. 579.

106 (Fig. 167)
Skullcap 5.158
Moravia(?), early 19th century
Velvet appliquéd with silk and embroidered with
metallic and silk threads, spangles and sequins; leather
reinforcement band
19 × 15 dm.

The appliqués are used to form the flowers and leaves of
a vine scroll running around the circumference.

107 (Fig. 168)
Skullcap 20/73
Bohemia(?), middle of the 19th century
Velvet embroidered with metallic threads and sequins;
silk and cardboard lining; metallic tassel
10.5 × 21 dm.

The embroidery is in the form of leafy twigs and vines,
with sequins used to represent the veining on leaves.
These motifs and their depiction by means of metallic
embroidery and sequins are commonly found on the
textiles of the Ottomon Empire and may represent
Turkish influence.[1] A similar skullcap appears in the
19th–century portrait of a man, cat. 233.

Note: [1]For a discussion of Turkish influence on European textiles, see
Gervers, *The Influence of Ottoman Turkish Textiles and Costume.* For
similar motifs and techniques, see New York, The Jewish Museum, *A
Tale of Two Cities*, nos. 153 and 192.

108 (Fig. 169)
Skullcap 27.053b
Bohemia, 19th century
Velvet embroidered with cotton threads; linen lining
with leather band
7.5 × 18 dm.

109
Judenstern **(Hanging Sabbath Lamp)** 23.197
Bohemia(?), first half of the 19th century
Cast and engraved brass
127 × 23

After the Middle Ages, hanging star-shaped lamps fell out
of use by the general European population. Yet they re-
mained popular among Jews as Sabbath lamps, which is
why these lamps acquired the name *Judenstern* or Jewish
star. The end of the ratchet hook on this example termi-
nates in a bird's head.

110 (Fig. 171)
Pair of Candlesticks 23.728 a,b
Austrian Empire, late 19th century
Cast, mechanically engraved and gilt silver
Marks: O in diamond; N in rectangle; helmet and lance(?)
in diamond
28.3 × 14

Various characteristics of these candlesticks, the mechanical
ornament, strongly profiled borders (around the knop), an-
imal motifs and sculptural feet appear in Viennese works of
the late 19th century.[1]

Note: [1]Cf. cat. 62 and Neuwirth, pl. 75, fig. 2.

111 (Fig. 172)
Ceremonial Goblet 173.386
Bohemia, mid 19th century
Glazed, gilt and cut glass
15 × 8.5

A German inscription on the foot of the cup identifies the
scene:

Rükkehr [sic] der Israeliten aus Babylon V.C.G. 536
"Return of the Israelites from Babylonia 536 B.C.E."

The artist's interest in naturalism is revealed in the ana-
tomical details of the animals, for example the oxen's rib
cage, the mounted leader who leans forward in the saddle
to urge on a tired horse and the palm trees to evoke the
terrain of the Middle East.

112
Ceremonial Beaker 32.121
Bohemia, second half of the 19th century
Cut and painted glass
14 × 8.6

The glass is of fine quality, but the painted inscription (the
benediction over wine) was poorly executed by someone
ignorant of Hebrew.

*"Blessed be Thou, O Lord our God, King of the universe,
who creates the fruit of the vine."*

Provenance: Old Jewish Museum, Prague
Reference: Berlin *Historica Hebraica*, no. A365.

113
Hallah **Cover** 105/74
Bohemia, early 20th century
Machine–embroidered linen, with cotton threads
34 × 44

It is customary for married men to recite a selection from
Proverbs 31 on Friday evening prior to the recitation of
kiddush, the sanctification over wine. The opening verse is
embroidered on this cloth:

*"A woman of valor who can find, her worth is far beyond
that of rubies"* (Prov. 31:10).

A *hallah*, the braided bread traditionally eaten on Sab-
baths, is framed by the quotation. This cloth and cat. 114
were used to cover the *hallah* during *kiddush*; thereafter,
the cloth was removed and the benediction for bread was
recited. This cover, white linen embroidered with colored
thread, represents the most common type in the State Jew-
ish Museum's collection.[1]

Note: [1]Cf. New York, The Jewish Museum, *Fabric of Jewish Life*, no. 185.

114 (Fig. 6)
Ḥallah **Cover** 65.418
Moravia, early 20th century
Silk, cotton, wool, metallic ribbon, silk fringe and linen
backing
45.5 × 44.5

This patchwork cover is formed of pieces of silk of the type
used for neckties. The center is marked by a red diamond
outlined in metallic ribbon.

Provenance: Mikulov (Nikolsburg), Moravia

115 (Fig. 176)
Spice Box 173.696
Brno (?) (Brünn?), Moravia, second half of the 18th
century
Filigree, parcel-gilt and cut-out silver
Mark: restamping Brno before 1824
27.6 × 9

Spice boxes in the shape of towers appear as early as the
13th century.[1] Their form probably derives from the archi-
tectural shapes of church vessels such as censers, whose
function is similar. Fine filigree was produced in Bohemia
and Moravia, and this piece may have been made there.
An identical spice box in the collection of the New York
Jewish Museum bears no marks (F 2655).

Note: [1]M. Narkiss, "Origins of the Spice Box,", *Journal of Jewish Art* 8
(1981), 29, fig. 1.
Reference: Manchester, *Treasures*, no. M70.

116 (Fig. 175)
Spice Box
Slovakia or Eastern Europe, 19th century 173.916
Cast, hammered, engraved, cut-out and parcel–gilt silver
15.3 × 12

For a discussion of the form of this box see ch. IV, p. 179.

Provenance: Slovakia(?)

117 (Fig. 174)
Spice Box
Palestine, ca. 1900 27.796
Carved and stained wood; glass
8 × 4.5

This egg-shaped container is covered with geometric orna-
ment, some of which is pierced to allow the smell of the
spices to escape. At one end is a small glass globe contain-
ing a miniature picture of Safed with the title:

עה"ק צפת קבר רשב"י

*"The h[oly] city Safed, the grave of R[abbi] S[imon] s[on
of] Y[oḥai]."*

118 (Fig. 177)
Havdalah **Candle** 28/82
Bohemia, 20th century
Braided and colored wax
42.4 × 2.7

119 (Fig. 177)
Havdalah **Candle** 29/82
Bohemia, 20th century
Braided and colored wax
25 × 3.8

120 (Fig. 9)
Sabbath and Festival Ring 173.351
Poland(?), 18th century
Gold set with carnelian (gilt) and semi-precious stones
Mark: restamping Prague 1806–07 (R[3]9327 (7877))
2.1

The carnelian face of this ring bears a gilt depiction
of a three branched candelabrum and the Hebrew
inscription:

להדליק נר של שבת וי"ט

"To kindle lights of the Sabbath and f[est]i[val],"

a portion of the blessing recited over the lighting of
candles. Similar carnelian and gold rings inscribed with
the blessing over the Sabbath lights and decorated with
depictions of lampstands are in the collections of The
Jewish Museum, New York,[1] the Sir Isaac and Lady
Edith Wolfson Museum, Hechal Shlomo, Jerusalem,[2]
The Schmuckmuseum in Pforzheim,[3] the former
Maximilian Goldstein Collection in Lwow (Lemberg),
Poland,[4] The Israel Museum, Jerusalem, The Michael
Kaniel Collection, Jerusalem,[5] and the Moldovan Family
Collection, New York.[6] The Polish provenance of many
of the rings in this group suggests a similar origin for
the ring in the Prague collection.

Notes:
[1]M 247; marked with restamping Cracow 1806-07, Beuque 3079.
[2]Yehuda L. Bialer, *Jewish Life in Art and Tradition* (New York: G.P.
Putnam's Sons, 1976), p. 55, ill.
[3]Inv. no. 2009/416; *Monumenta Judaica*, no. E171, fig. 49.
[4]Maksymiljan Goldstein and Karol Dresdner, *Kultura i Sztuka hudu
Żydowskiego na Ziemiach Polskich Zbiory Maksymiljana Goldsteina*
(Lwow: Drukarni Polskiej, 1935), p. 35, ill. p. 34.
[5]Michael Kaniel, *Judaism, The Art of World Religions* (Poole, Dorset:
Blanford Press, 1979) ill. pl. following p. 14.
[6]Marked with restamping Cracow 1806–07, Beuque 1959. We would
like to thank Dr. Alfred Moldovan for providing information on the last
four rings.
Reference: Berlin, *Historica Hebraica*, no. A270.

121 (Fig. 178)
Shofar 32.854
Moravia, 19th century
Carved horn
31.5 l.

The only decoration on this *shofar* is the zigzag edging
of the wide end.

Provenance: Moravské Budějovice, Moravia

122 (Fig. 179)
Belt Buckle for Yom Kippur 104.785
Maker: M. K.
Lwow (Lemberg), 1847
Hammered and repoussé silver
Mark: R[3]7987, MK
6.5 × 11.5

For the inscription, see cat. 123.

123 (Fig. 180)
Belt Buckle for Yom Kippur 3.992
Probably Eastern Europe, first half of the 19th century
Hammered and engraved silver
6.1 × 10.2

The shape of the lions on this buckle and the manner in which their forms are reserved against a patterned ground have parallels in works stemming from Eastern Europe.[1] The inscription reads:

"For on this day atonement shall be made to you to cleanse you from all your sins; you shall be clean before the Lord" (Lev. 16:30).

Provenance: Jewish Museum, Mikulov (Nikolsburg), Moravia
Note: [1]New York, The Jewish Museum, *Danzig 1939*, no. 106

124 (Fig. 182)
Etrog **Container (?)** 2.932
Maker: L. W.
Vienna, 1807
Cut-out and engraved silver
Marks: R[3]7859, 7877, 7881, 7886; LW
23.1 × 10.1 × 6.7

The walls of this dish feature a cut-out design of a repeating vase and flower motif which produces an effect resembling trellis work. A variation on this motif—a central blossom amid scrolling leaves—is found on the two handles. A Hebrew inscription engraved along the base:

ז״ז האשה חשובה מ׳ פערל וויס/תר״ד לפ״ק

"T[his was] d[onated by] the woman Perl Weiss [in the year 5]604" (=1843/4).

indicates that it was given to a Jewish communal organization nearly forty years after its manufacture. According to the records of the State Jewish Museum in Prague it was used as an *etrog* container.

Provenance: Lipník, Bohemia
References: Berlin, *Historica Hebraica*, no. A473; The Hague, *Praag*, no. 231; Vienna, *Kunstschätze*, no. 265, fig. 21.

125 (Fig. 181)
Etrog **Container** 897
Vienna, ca. 1840
Parcel-gilt, repoussé, hammered, chased and engraved silver
Marks: Viennese mark with illegible date (in use 1826–1866) Diviš 1901 and an illegible maker's mark
13 × 16 × 11

Originally fashioned as a sugar box, this container was transformed into an *etrog* holder according to a Hebrew inscription engraved on the underside in 1878/9:

לזכרון עולם יהיה זאת הכלי/של מצות אתרוג מה
שנדבה/את האשה החשובה והצנועה/מרת חנה אשת
כהר לופמן/יאנאוויטץ ז״ל מ״ב פריטשאן יע״א בשנת
תרל״ט לפ״ק

"May this be in everlasting memory this vessel for the commandment of etrog which was donated by Hannah wife of R. Lipman (?) Yanovitz o[f] b[lessed] m[emory] . . . Pritschen in the year [5]639" (=1878/9).

In its traditional baroque form, gilt interior, melon finial, and chased floral decoration, this container is extremely similar to Viennese sugar boxes produced around 1840.[1]

Provenance: Plzeň-Poříčany (Pritschen), Bohemia
Note: [1]See, for example, London, The Victoria and Albert Museum, *Vienna in the Age of Schubert: The Biedermeier Interior 1815–1848* (1979), fig. 30.
Reference: Berlin, *Historica Hebraica*, no. A474.

126 (Fig. 185)
Passover Plate 37.690
Maker: PD; engraver: Zanwill from Lissa
Probably Bohemia, early 18th century
Engraved pewter
Mark: single tower with three crenellations and initials PD (unidentified)
36.3 dm.

The earliest inscription on the back of this plate "RAK 1720" provides a *terminus ante quem* for its manufacture. Subsequently, the plate was transformed for use at Passover by the addition of a Hebrew inscription on the rim listing the order of the *seder* service and an engraved decoration in the center. Depicted here are three men, each holding one of the central symbols of the Passover meal, *pesah* (paschal lamb), *matzah* (unleavened bread) and *maror* (bitter herbs). The artist is identified in an inscription engraved in a banner above:

מעשה ידי הקטן זנוויל מליסה ולע״ע פה ק״ק זאבארטן
לפרט למשפחותיכם ושחטו הפסח לפ״ק

"Made by the child Zanwill from Lissa and for the p[oor of your] c[ity] here [in the] h[oly] c[ongregation of] Soborten[1] 'for your families, and slaughter the Passover offering,' " (Ex. 12:21)(=[5]552 = 1791/2).

Zanwill's engraving style is distinguished by large, graceful, neatly executed letters, and the naturalistic treatment of the lamb's fluffy wool. A later, cruder engraving by another hand of flowers and leaves appears on the rim and above Zanwill's inscription, a vase with flowers and the Hebrew initials:

"N. B. [or V.]" נב

Another unintelligible Hebrew inscription of indeterminate date is crudely scratched into the back of the plate:

יעחיקל שדל ראססעש חי׳י

"Yehiekel Shadel Rossesh [?]."

Provenance: Old Jewish Museum, Prague
Note: [1]Soběḑwhy (Soborten) in North Bohemia
Reference: Volavková, *Story*, fig. 96.

127 (Fig. 158)
Passover Plate 174.838
Maker: Josef Vater[1]
Vienna, ca. 1900
Porcelain
36.5 × 35.5

Chinese porcelain served as the inspiration for both the decorative motifs and color scheme on this plate: vines, blossoms, and birds perched in branches all executed in blue on a white ground. A six-pointed star of David fills the center of the plate, around which are arranged six little heart-shaped dishes to hold the symbolic foods eaten during the Passover meal.

Note: [1]Waltraud Neuwirth, *Wiener Keramik: Historismus—Jugendstil—Art Déco*, (Braunschweig: Klinkhardt and Biemann, 1974), p. 23, mark no. 7.

128 (Fig. 184)
***Matzah* Roller** 7.580
Bohemia, early 19th century
Carved wood, iron
66.3 × 11

The roller form of this tool has a parallel in a smaller roller with handle in the collection of The Jewish Museum, New York (JM 10-52).

Reference: Berlin, *Historica Hebraica*, no. A46.

129 (Fig. 183)
***Matzah* Bag** 3.466
Moravia, 1903/4
Velvet embroidered with cotton; cotton and metallic fringe; cotton cord; linen damask lining
44.5 × 31.5

On the front of this bag, two flowering vines rise to form an amphora–shaped field within which is a wine cup, a tree and the name of the owner:

"Zvi Vinoker(?)" (?) צבי וינעקאר

Just above the cup is the Hebrew date, תרס״ד,*"[5]664"* (=1903/4). The order of the *seder* service is embroidered along the edge, and the traditional designations of the three *matzot* placed within are sewn on tabs at the bottom.

Provenance: Jewish Museum, Mikulov (Nikolsburg), Moravia

130 (Fig. 186)
***Matzah* Cloth** 3.408
Bohemia, early 20th century
Linen embroidered with cotton yarn; cotton lace
139 × 34.5

One end of this cloth bears an embroidered representation of a *seder* table. Surrounding it is the blessing over *matzah* (unleavened bread):

"Blessed art Thou, O Lord our God, King of the universe, who has sanctified us with his commandments and commanded us to eat unleavened bread."

The border design of a leafy vine is commonly found on Bohemian embroideries.[1]

Note: [1]For example, cf. cat. 99, and D. Stránská, *Lidové kroje v Československu, I. Čechy* (Prague: J. Otto, Společnost S.R.O., n.d.), fig. 85.

131 (Fig. 191)
Hanukkah Lamp 12.457
Probably Moravia, early 19th century
Cast and repoussé brass
25.5 × 28.9

Repoussé beaded borders commonly occur on locally made brass sconces. The restrained decoration and clear forms of the backplate and superimposed pitcher reflect neo-classical sensibilities and suggest a date in the early 19th century.

Provenance: Brno (Brünn)

132 (Fig. 188)
Hanukkah Lamp 37.327
Bohemia, 19th century
Cast brass
41.8 × 21.6

This type of lamp, a baluster stem and lyre-shaped support holding aloft the oil pans, appears in Bohemia as early as the 18th century,[1] however, the ribbed decoration along the base suggests a later date.

Provenance: Burial Society, Prague

Note: [1]Cf. M. Narkiss, *The Hanukkah Lamp* (Jerusalem: Bney Bezalel Publishing Co., 1939), no. 188 (Hebrew).

Reference: Manchester, *Treasures*, no. M137.

133 (Fig. 189)
Hanukkah Lamp 173.778
Austrian Empire, 19th century
Cast, engraved and cut-out pewter
13.5 × 27.3 × 7.2

The fluted pilasters and low pedestals decorated with festoons and oval cartouches are neo-classical motifs. Below the double-headed eagle, symbolic of the Austrian Empire, is a Hebrew inscription:

זכר לנס חנוכה

"A remembrance of the miracle of Hanukkah."

134 (Fig. 190)
**Two *Dreidlach* (Spinning Tops)
for Hanukkah** 173.818/5-6
Bohemia, 19th–20th century
Cast lead
2.6 × 1

Both of these tops appear to have been made from the same mold and are decorated on each of their four faces with a Jewish star enclosing a single letter:

נ ג ה ש

"A g[reat] m[iracle] h[appened] t[here]."

These *dreidlach* are similar in decoration to wooden examples dated to the early 19th century.[1]

Note: [1]Cf. *Monumenta Judaica*, no. E661.

135 (Fig. 190)
Dreidel (Spinning Top) for Hannukah 173.818/1
Bohemia, 19th–20th century
Cast lead
9 × 2.7

On this top, each of the four cast letters is set within a square frame. (See cat. 134.)

136 (Fig. 190)
**Three *Dreidlach* (Spinning Tops)
for Hanukkah** 173.818/2, 3, 4
Bohemia, 19th–20th century
Cast lead
9 × 2.7

A single letter appears on each face of the cubic bodies of these tops (cf. cat. 134). All appear made from the same mold.

137
Seal of the Mikulov Jewish Community Sign. 4884/e
Mikulov (Nikolsburg), Moravia, 19th century
Engraved brass and wood
9.5 × 3.0

At the center of the ring are two knives for cutting vines. Mikulov (Nikolsburg) is a wine-growing area and the same tools appear on the coat of arms of the Duke of Ditrichstein whose seat was in the Moravian capital. The inscriptions read:

Nicolsburger Iudengemeinde
"Jewish Community of Nikolsburg"

"N[ikol]s[burg] Community" קהל נ״ש

138 (Fig. 78)
**Seal of the Jewish Society for the Poor
and Hospital Director(s) in Nikolsburg** Sign. 4884 d/
Mikulov (Nikolsburg), Moravia, 19th-20th century
Wood and brass
10.2 × 2.2

Inscription:

Israelitische Armenverein—u. Spitalvorsteher in Nicolsburg.
"Jewish Society for the Poor a[nd] Hospital Director(s) in Nikolsburg."

139 (Fig. 77)
**Seal of the Nikolsburg High School
Directorate** Sign. 4980/c
Mikulov (Nikolsburg), Moravia, 19th-20th century
Engraved brass
4.5 × 3.4

Inscriptions:

Directorat der Hauptschule zu Nikolsburg
"Directorate of the Nikolsburg (Mikulov) High School"

"Remember the Torah of Moses my servant"
(Malachi 3:22).

The establishment of German–speaking schools for Jewish children was mandated by Emperor Joseph II in 1790. In Mikulov, the German school opened in 1839 and was connected with a textile workshop.

140
**Seal of the Board of Trustees of the
Prague Jewish Community** Sign. 63612
Prague, 19th-20th century
Engraved brass and wood
9.6 × 2.6

Inscription:

Prager Israeliten Gemeinde Vorsteher Amt
"Board of Trustees of the Prague Jewish Community."

141
Seal of the Přibram Community 16/81
Přibram, Bohemia, ca. 1880
Carved wood and brass
11.5 × 3

The inscription reads:

Israelit: Kultus Gemeinde der K: Bergstadt Przibram

"The Jewish Community of the royal city of Przibram (Přibram)."

142 (Fig. 79)
Seal of the Rousínov Community Sign. 4980/a
Rousínov, Moravia, 19th-20th century
Engraved brass
4.4 × 3.1

At the center of the seal are a palm tree and a shield decorated with a bucranium. Surrounding these images is the inscription:

Gemeinde Neuraussnitz

"Neuraussnitz (Rousinov) Community."

143 (Fig. 15)
Emblem of the Jewish Butcher's Guild 37.850
Prague, 1620; restored 1841 and 1866
Cast and engraved pewter
113.5 × 35

In its present state, this emblem of the Jewish butcher's guild of Prague incorporates the original key and later additions, the last dated 1866. The key was carried in procession at the birth of Archduke Joseph in 1741 and is depicted in an engraving recording that event.[1] The lion now on top is not visible in the engraving, suggesting that major alterations of form may have taken place. Below the lion is the first inscription:

שנת ש״פ לפ״ק

Im Verleihungsjahre MDCXX

"In the year [5]380. In the dedication year 1620."

Along the post is engraved:

Im Jahre 1841 wurde dieser Ehren-Zunft-Schlüssel erneuert. In eben diesem Jahre sind Salomon Wilhartitz u. Elias Nefeles Zunftsvorsteher und als Mittglieder derselben Marcus Wilhartitz, Salomon Nefeles, Salomon Thias, Jakob Lieberles, Löwy Nefeles, Jacob Nefeles, Lazar Wilhartitz, Simon Lieberles, Moses Kauders, Moses Radnitz, Jacob Taussig, Adam Wilhartitz, Moses Weil.

Jindřich Štein, starosta od roku 1866.

"In the year 1841, this honorary guild key was renewed. In this same year Salomon Wilhartitz a[nd] Elias Nefeles were chairmen of the guild and members of the same [guild] were Marcus Wilhartitz, Salomon Nefeles, Salomon Thias, Jakob Lieberles, Löwy Nefeles, Jacob Nefeles, Lazar Wilhartitz, Simon Lieberles, Moses Kauders, Moses Radnitz, Jacob Taussig, Adam Wilhartitz, Moses Weil. Jindrich Stein, master of the year 1866."

Provenance: Old Jewish Museum, Prague

Note: [1]See fig. 70.

References: EJ, XII, col. 546, fig. 7; *JL,* II, col. 1407; Lieben, *Jüdische Museum,* 8-9; Volavková, *Story,* pl. 70.

144 (Fig. 162)
Slaughtering Knife 12.479
Brno(?) (Brünn ?), Moravia, 19th century
Steel blade; walrus handle with brass mounts
Mark (on blade): MK surmounted by five-pointed
crown
37 × 4

145 (Fig. 162)
Koshering Board 91.922
Prague, second half of the 19th century
Carved wood
57.6 × 31.4 × 4.8

After ritual slaughtering, kosher meat must be soaked
and salted to remove excess blood, if it is not to be
broiled. While salting, the meat rests on a slotted board
like this one, which is tilted to facilitate drainage.

146
Community Seal 37.472
Prague, middle of the 19th century
Carved wood and engraved brass
5.5 c 1.7

The seal is inscribed:

"Kosher" כשר

that is, fit for ritual use; it may have been used to
stamp food.

147
Butcher's Seal 28/81
Prague, second half of the 19th century
Engraved brass
7.3 × 3.5

Inscribed: *Selcherei M. Metzeles, Prag NO 94/V*

*"Cured meats shop M. Metzeles, Prague No. 94/V
[address of shop]"*

and *"Kosher."* כשר

148
Guild Tankard 27.680
Česká Lípa? (Böhmisch Leipa?), Bohemia, 1842 (date of
inscription)
Cast and engraved pewter
22 × 18

Two addorsed rampant lions hold a triangular object
which appears to be a stylized depiction of a weaving
loom. A German inscription appears on either side of
the engraving and on the lid of the tankard:

(to the left):

*Wenzel Weishaupt /Peter Homan /Beisitzmeister, /
Wenzel Hanisch Altgesell, /Bernard Gratz /Herr Vater*

(to the right):

*Leopold Zinner /aus Böhm[isch] Leippa[sic] /Isra-
elitischer /Junggesell ge/widmet der Ehr/samen Brü-
derschaft*

(on lid):

Ferd. Weisman /Wenzel Bacher /Vorsteher /1842

*"Wenzel Weishaupt, Peter Homan, master assessor,
Wenzel Hanisch, senior journeyman, Bernard Gratz,
paternal head, Leopold Zinner from Böhm[isch] Leippa
[sic] Israelite junior journeyman dedicated to the
honorable Brotherhood. Ferd. Weisman, Wenzel Bacher,
chairman [of the brotherhood] 1842."*

Leopold Zinner, a Jewish junior journeyman, dedicat-
ed this tankard to his guild.

The central pictorial motif is one found on other
drinking vessels made for guilds, for example a
porcelain beer mug made in Klašterec (Klösterle), ca.
1815, with two rampant lions supporting a rectangular
object filled with cross-hatching, which may also
represent a loom.[1] Stylistically, the lions on this
tankard resemble the two standing lions depicted on a
page of the Statutes of Moravian Jewry in stance,
expression and the rendering of long, shaggy manes.[2]
A pewter tankard donated to the pewter pourers guild
in Elbing, (Germany) by a Jewish member in 1793 is in
The Jewish Museum, New York.[3]

Notes: [1]Meyer, *Böhmisches Porzellan*, pl. XXXIII, fig. 5.
[2]Cat. 261 in this exhibition.
[3]New York, The Jewish Museum, *Danzig 1939*, no. 284.

149 (Fig. 68)
Ballot Box for Burial and Benevolent Society 4.526
Mikulov (Nikolsburg), Moravia, middle of the 18th
century
Cast, openwork and engraved silver; wood; velvet
17.8 × 15.5

Presumably this box was used in the annual elections of
officers and members. The openwork silver frame
consists of a series of framed cartouches engraved:

זה קפפי שייך לההחברה קדישא דגמילות חסדים ונעשה
ע"י האלופים הנקובים בשמותם על השילטין לפרט
צדקה תציל ממות/ע"י/ה"ה זעלקי ב'/ה"מ הרש/אבליז
ע"י/ה"ה הרר/ליב פ"ל/רפטירט'
ע"י/ה"ה הרר/מאיר בלא ממו'
ע"י/ה"ה הרר/אהרן מ"ש/סגל בורר
ונגמר/ע"י ה' משה/דייטש ור'/ליב ב"ר יונה/שמש ור'
הרש ב"ר/דוד פיס'

*"This is the box that belongs to the Burial and
Benevolent Society and it was commissioned by the
leaders 'who are pointed out by name' [Nu. 1:17] on
the plates in accordance with 'Charity redeems from
death.' by Zelke son of Hersh Abeles, by Leib F. L.
Rappatirt (?), by Meir. . . , by Aaron M. S. Segal,
head, and it was completed by Moses Deutsch and Leib
son of Jonah, the sexton, and Hirsch son of David
Pis[e?]k]."*[1]

A similar container made of leather and wood
originating in Alsace bears a date of 1748.[2] This date is
in accord with the style of the engraved decoration on
the top of the Prague example.[3]

Provenance: Mikulov (Nikolsburg), Moravia
Notes: [1]The same family name appears on the silver lid for a pitcher,
cat. 162.
[2]*Monumenta Judaica*, no. E183.
[3]Cf. the decoration of 18th–century circumcision knives eg. New York,
The Jewish Museum, *Danzig 1939*, nos. 2, 3.
Reference: Manchester, *Treasures*, no. M125.

150 (Fig. 69)
Banner of the Society for Visiting the Sick 2.079
Bohemia, 1817/8
Silk appliquéd with silk, metallic ribbon and damask; silk fringe; iron bar and metallic cord
88 × 60

The purpose of the flag is set forth in the Hebrew inscription on one side:

דגל מחנה דן/מדניאל שנדר/לחברא דביקור/חולים
עבור בנ/אנשיל תקע/לפ״ק

"A flag for the Camp of Dan from Daniel Schneider to the Society for Visiting the Sick for his son Anshel [5]578" (= 1817/8).

On the other side is a stumpwork crown of damask and four Roman letters of indeterminate meaning: A, L, W, B.

Provenance: Budyně nad Ohří, Bohemia

151 (Fig. 154)
Comb for a Burial Society 173.350
Bohemia, 1660 (inscription date)
Horn and engraved silver
12 × 11.7 (including chains)

The comb is fashioned of horn and set into a three-sided flat silver frame with a decorated rim and an engraved Hebrew inscription:

זה שייך לחבורא קדישא דג״ח יצ״ו ותשלם המלאכה יום
ו׳ אחר שבוע׳ ת״כ ל׳

"This belongs to the Holy (Burial) and B[enevolence] Society and the work was completed [the] Friday after Shavuo[t 5]420" (= 1660).

The crude working of the silver suggests a rural provenance.

Reference: Berlin, *Historica Hebraica*, no. A295.

152 (Fig. 154)
Comb and Nail Cleaner Pick for a Burial Society 32.328 a,b
Meziříčí (Meseritsch), Moravia, 1742/3
Engraved, cut-out and silvered copper
Comb: 11 × 15.1; Pick: 8

The upper edge of the comb is cut-out, creating a wavy decorative outline. An engraved Hebrew inscription appears on both sides:

ש׳ לחג״ח דק׳ מעזריטש נ׳ ע״י האלופים גבאים יי״צ
ה״ה/מוה׳ אברם בה״צ ה׳ יידל במ״א ה׳ נתן בר״מ תק״ג
ל׳

"[This] b[elongs to the] B[enevolence] S[ociety] of the C[ongregation of] Meseritsch d[onated] b[y] t[he] distinguished treasurers /Avram s[on of] Z. Yidel s[on of] A. [and] Nathan [son of] M. [5]503" (= 1742/3).

Three holes along this edge once held chains; now there is only one which attaches a narrow pick to the comb.

References: Berlin, *Historica Hebraica*, no. A299; The Hague, *Praag*, no. 272.

153 (Fig. 154)
Double-edged Comb from the Prague Burial Society 49.444
Maker: I. K.
Prague, 1794/5
Cast, cut-out and engraved silver
Marks: R³9321, I. K., 13; restamping Prague 1806-09 (Beuque 3024) and 1809-10 (R³7886)
24.2 × 9 (including chains)

Hebrew inscription:

זאת נדיב [כך!] הנעלה כהר״ר משה בן האלוף והקצין
כהר״ר יעקב ירושלמי ז״ל מבורר אצל ח״ק דג״ח/וזוגתו
הצנועה מרת פרומטל ת״י בת הקצין כהר״ר שלמה
פשיבראם יצ״ו שנת תקנ״ה לפ״ק

"This is the donation of Moses son of Jacob Yerushalmi o[f] b[lessed] m[emory] chosen by [the] H[oly] (Burial) and B[enevolence] S[ociety] /and his spouse Frumtil daughter of Solomon Przibram (Přibram) [the] year [5]555" (= 1794/5).

On one of the short sides, three holes have been bored into the comb, attaching it to three chains which lead to a ring. This ring would have slipped over the finger of a Burial Society member, who could have thus easily held the comb while engaging in another activity with his free hand, as can be seen in the painting showing the washing of a corpse from the cycle of the Prague Burial Brotherhood (cat. 181) where a similar double-edged comb is depicted.

Provenance: Burial Society, Prague

154 (Fig. 154)
Nail Cleaner and Case for a Burial Society 3.793 a, b, c, d
Moravia, beginning of the 19th century
Copper and engraved silver case; engraved and cut-out silver picks
Case: 10.6 × 1.8; Picks: 9 × 0.7

Silver fittings adorn the top, bottom, and opening of the copper case, creating a lively color contrast. Three flat, narrow nail cleaners with scalloped handles are engraved with Hebrew inscriptions which, read together, contain the dedication:

ז״נ ה׳ חיים ט/ב״ה גרשון/בתקע״ח ל׳

"T[his was] d[onated by] Ḥayyim. T. s[on of] Gershon in [5]578" (= 1817/8).

Provenance: Jewish Museum, Mikulov (Nikolsburg), Moravia
References: Berlin, *Historica Hebraica*, no. A302; Vienna, *Kunstschätze*, no. 287.

155 (Fig. 154)
Nail Cleaner for a Burial Society 23.339 a
Maker: A.(?)
Vienna, 1866
Cast and engraved silver
Marks: R37861 for 1866 and a blurred maker's mark
11.9 × 2

A Hebrew inscription of small, neat letters is engraved on one side of the hollow handle:

ז"נ כה"ר יואל ר"ב לח"ק כ"ז אדר תרכ"ז לפ"ק

"T[his was] d[onated by] Yoel RB to the H[oly] (Burial) S[ociety on the] 27th of Adar [5]627" (=1867).

The other side of the handle bears the continuation of the inscription, executed in large double-outlined letters filled with zigzags:

"With his spouse Pesl." עם זוגתו מ' פעסל תי'

Provenance: Podivín, Moravia

References: Berlin, *Historica Hebraica,* no. A296, fig. 24b; Vienna, *Kunstschätze,* no. 289.

156
Burial Society Uniform 48.528
Moravia, early 20th century
Wool; metallic ribbon; silk; metal buttons; leather
Coat: 120 × 60; Hat: 14 × 25

On the right sleeve is a badge with a Jewish star and the abbreviation CHKT = CH[evrah] K[addisha] T[řebíč].

Provenance: Třebíč (Trebitsch), Moravia

157 (Fig. 156)
Burial Society Beaker 63.620
Prague, 1783/4
Enameled glass
19 × 14

Hebrew inscription:

"Cup of Benediction for feasting and rejoicing, for drinking our fill of love. Lovers of friends, elders signed on the form of the H[oly] (Burial) S[ociety of] B[enefactors] and the new visitors and friends for the care of the sick; for the gathering of the scattered and the dispersed: Beauty and Bands shall be in his hand to unite them. [in the] year [5]544" (=1783/4).

A cartouche to the right of the handle containing depictions of a cemetery most likely derives from similar cartouches on Bohemian beakers belonging to Christian guilds where the emblems of the trade were displayed.[1] (See ch. III, p. 156.)

Provenance: Burial Society, Prague

Note: [1]See, for example a beaker dated 1696 with emblem of the Hosiers' Guild Prague, Uměleckoprůmyslové Museum v Praze, *České sklo 17. a 18. století* (Prague: Obelisk, 1970), cat. no. 83.

References: Manchester, *Treasures,* no. M122, pl. VIIIa; Sadek, "Goblets and Jugs," 79, pl. 25; Shachar, "Feast and Rejoice," 26–27, 29, no. 3; Volavková, *Story,* pl. 158.

158 (Fig. 200)
Burial Society Beaker 63.621
Prague, 1798/9
Faience, painted under glaze
Signed on bench in house: FH
14 × 22

Hebrew inscription:

"The T[reasurers] and O[fficers] of the H[oly] (Burial) S[ociety] h[ere in] P[rague] and these are they by their names: Wolf Gedeles, first treasurer; Pinkas Segal RMD[1], h[ead of the] c[ommunity], second treasurer; Wolf Segal Moscheles[2], h[ead of the] c[ommunity], third treasurer; Gershon Segal Austerlitz, officer; Shlomo Hock, officer; Noah Karpeles, officer; T[his was] d[onated by] Hirsch S. Brandes, [5]559" (=1798/9).

Between the eighth and ninth line of this inscription is a prancing stag, a reference to Hirsch (stag in German), the name of the donor.

The sophistication of the painting with its careful perspective, atmospheric treatment of landscape, and attention to details, suggests that this is the work of a professional painter. A faience factory was founded in Prague in 1793 and until 1810 many of its products were unmarked.[3] Franz Heidrich, one of the principal painters employed by the factory, may be the decorator of the Prague beaker. The treatment of the landscape and figures on this beaker is extremely close to works produced in the Prague faience factory.[4]

Provenance: Burial Society, Prague

Notes: [1]For his portrait, see cat. 176, part of set of eight Burial Society members.
[2]For portraits of him and his wife, see cats. 225 and 224.
[3]Meyer, *Böhmisches Porzellan,* p. 169.
[4]Compare a beer mug, ca. 1800, Meyer, *Böhmisches Porzellan,* pl. XXXVI, fig. 3 and a soup tureen, ibid., pl. XXXVII, fig. 2a & b.

References: Berlin, *Historica Hebraica,* no. A305; Sadek, "Goblets and Jugs," 79; Shachar, "Feast and Rejoice," 30–31, no. 5.

159
Burial Society Beaker 57.309
Turnov (Turnau), Bohemia, 1819/20
Painted glass
13.7 × 12.2

Hebrew inscription below rim:

"He will destroy death forever. My Lord God will wipe the tears away from all faces and will put an end to the reproach of His people over all the earth—For it is the Lord who has spoken (Is. 25:8)."

A funeral procession of men walking two abreast runs, unbroken, around the glass. An attempt has been made to differentiate their ages. Below, another Hebrew inscription:

"And let men sprout up in towns like country grass (Ps. 72:16); He is mindful that we are dust. Made anew in the year 'and will put an end to the reproach of His people' (Is. 25:8)" (=[5]580 =1819/20),

indicates that this glass was a replacement for an earlier, broken example.

Provenance: Burial Society, Turnov (Turnau), Bohemia
References: Shachar, "Feast and Rejoice," 32–33, no. 6; Volavková, *Story,* p. 64, fig. 30.

160 (Fig. 40)
Burial Society Beaker 2124
Mladá Boleslav (Jung-Bunzlau), Bohemia, 1837/8
Etched and colored glass
22 × 15

German inscription (to left of handle):

Aus dem Tode sprist [sic] das Leben
Muthig schaut darum den Tod!
Seht ein Morgenroth sich heben
Wo ein nächtlich dunkel droht.

"From death springs life,
Therefore regard death courageously!
Behold dawn rising
Where nocturnal darkness threatens."

To left of this, Hebrew inscription:

"Drink, my Brother! Drink and you shall suppress your
grief. If you behold in the pictures of the cup before us,
That our life is scattered vanity And to dust shall our
bodies return. Do not fear! Upward shall your spirit
fly, And in the End of Days shall you rise from your
sleep, If you attended to the commandments and your
deeds were good. Thus, Drink, my Brother! Drink and
look to the cup."

and further to the left:

"Donation for the H[oly] (Burial) S[ociety] of B[enefac-
tors] of the h[oly] c[ongregation] of Bunzlau from Jacob
Weinberg in the year 'his dead will arise' " (= [5]598
= 1837/8).

The artist has varied the scale of the figures in the
funeral procession without regard to naturalism, but
rather to reflect the status of the different personages.
Whereas the people are seen in profile, the cemetery is
depicted in aerial perspective.

Provenance: Burial Society, Mladá Boleslav (Jung-Bunzlav), Bohemia.
References: EJ, XII, col. 185; Sadek, "Goblets and Jugs," 79; Shachar,
"Feast and Rejoice," 34–35, no. 7; Volavková, *Story,* p. 80, pls. 148,
150.

161 (Fig. 153)
Burial Society Pitcher 8048
Mikulov (Nikolsburg), Moravia, 1836
Painted and gilt pottery
39 × 26

The antiquated costume as well as the existence of a
similar pitcher dated 1723/4 and 1801[1] suggest that this
pitcher is a copy of an example from the early 18th
century. A prayer book from Miroslav 1813/14 (cat.
270) contains an illustration of men in a synagogue
with similar antiquated dress. By arranging the figures
in order of decreasing size, the decorator of the pitcher
was attempting to show movement into depth. Similar-
ly, the angled walls of the cemetery are meant to
suggest a three-dimensional plot of land.

Beneath the rim, the monogram: MR. Below,
Hebrew inscription:

"Righteousness saves from death (Prov. 10:2; 11:4).
This jug belongs to the Holy Society of Benevolence
and was made by the Treasurers Mendel Yedles,
Abraham Isaac Pöhm, Moses Leib Bisentz [and] Ezekiel
Mas 1836 in the year [5]696" (= 1836).

Provenance: Burial Society, Mikulov and Jewish Museum, Mikulov
(Nikolsburg), Moravia.

Notes: [1]Inv. no. 8049. See cat. 162 for discussion of this point and
other issues relevant to this pitcher.
References: Berlin, *Historica Hebraica,* no. A303; Manchester, *Trea-
sures,* no. M121, pl. VIIIb; Sadek, "Goblets and Jugs," 79; Shachar,
"Feast and Rejoice," 42–43, no. 11; Volavková, *Story,* pp. 75, 296 and
pls. 117 and 147.

162 (Fig. 155)
Lid for a Burial Society Pitcher 3.941
Probably Prague and Mikulov (Nikolsburg), 1724/5
(inscription date)
Repoussé, cast, engraved and chased silver
Marks: restamping Vienna 1806–09 (Diviš 1493) and
1809–10 (Diviš 561)
19.5 × 19

The repoussé gadrooned edging and chased floral and
leaf motifs in the center of this lid are very close in
technique and decoration to the laver by J. G. Lux
fashioned in Prague in 1702 (cat. 78), suggesting a
Bohemian origin ca. 1700 for its manufacture. A group
of cast figures standing on a lyre-shaped silver base
which resembles a circumcision shield was affixed to the
top of the lid and a Hebrew inscription was engraved
along the rim:

"[This] belongs to the H[oly] (Burial) S[ociety] of
B[enevolence] and was made b[y the] Treasurer[s]
Moses Deutsch, Meir Bloch, Leib P. L., Hirsch Pis[e?]k[1]
[in the] year [5]475" (= 1724/5).

The cast figural group consists of four pallbearers
carrying a stretcher on which lies a fully dressed corpse,
without the traditional shrouds.[2] This discrepancy
between Jewish burial customs and the appearance of
the deceased on this lid is probably due to the use of
stock molds in the casting of the figures by a workshop
which lacked a mold for a Jewish cadaver. Despite the
use of molds, however, the pallbearers are differentiated
in details of pose and costume. Dressed in flat berets,
long coats, ruffs, tunics with wide bands down the
center, knickers, and high boots, the pallbearers' attire is
very similar to that of men in an engraving of 1714–18
of a Jewish wedding procession in Frankfurt.[3]

This trefoil lid roughly fits two of the Moravian
faience Burial Society pitchers in the Prague Museum:
the first, most likely from Mikulov, is inscribed with
the Hebrew date [5]484 (= 1723/4) and the date "1801"
(Inv. no. 8049),[4] and the second (cat. 161) has a
Mikulov provenance and the date 1836. The similarity
of shape and decoration, the *retardataire* pictorial
treatment and costumes of the figures on the two
pitchers, and the incorporation of the 1723/4 date into
the first pitcher, indicate that this one, and perhaps the
later one as well, were copies of an earlier example of
ca. 1724 which had broken and needed replacing. The
inscription date of 1724/5 on the lid suggests that it
may have belonged to this original faience beaker.[5]

Notes: [1]The name Hirsch Pis[e?]k appears on the dedicatory inscription
of a ballot box for a Burial and Benevolent Society from Mikulov,
Moravia (cat. 149). This, together with the fact that the lid fits two
pitchers with Mikulov provenances, suggests a similar provenance for
the lid.
[2]Compare appearance of corpse in the cycle of paintings from the
Prague Burial Society, especially cats. 182, 184, 186.
[3]Illustration by Peter Fehr in Johann Jakob Schudt, *Jüdische Merkwür-
digkeiten* (Frankfurt and Leipzig, 1714–18), p. 74 of third book of Part
IV. Ill. in New York, The Jewish Museum, *Tale of Two Cities,* no. 53.
[4]Shachar, "Feast and Rejoice," no. 9.
[5]See Shachar, *Ibid,* p. 51, n. 65 and Volavková, *Story,* p. 296.

References: Berlin, *Historica Hebraica,* no. A304, fig. 26; *EJ,* IV, col.1519;
JL, III, pl. CXVI; Shachar, "Feast and Rejoice," 38, 43, 51, nos. 65, 72.

163
Silverware of the Prague Burial Society 46.099
Makers: Anton Neubert (1776–1853) and Anton Kaba
(1787–1832)
Prague, 1821
Cast and engraved silver; wooden box covered in tooled
leather with brass handles
Marks: R^{39324}, Hráský nos. 295, 186; restamping
Prague 1810-24 (R^{39328})
Box: 12 × 38.4 × 27

The set consists of service for twelve (knives, forks,
soup spoons), plus two serving spoons, two salt cellars
and a soup ladle. Each piece is inscribed:

לח״ק דג״ח

*"[Belongs] to the H[oly] (Burial) and B[enevolence]
S[ociety]."*

Provenance: Burial Society, Prague
Reference: Doleželová, et al, "Acquisitions to the Collections," 33.

164
Burial Society Dishes 4 plates: 174.789–790,
 73.048/2,26
 4 bowls: 73.048/3,4,20,25
Všeruby (Neumark), Bohemia, ca. 1838/9
Porcelain
Mark: Neumark (Danckert p. 297)
25 dm. each

Inscription (around rim):

שייך לחברה קדישא גומלי חסדים בשנת תקצ״ט לפק

*"[This] belongs to the Holy (Burial) Society of
Benefactors in the year [5]599"* (=1838/9).

The porcelain factory in Všeruby was founded in 1832
by Anton Fischer. A plate which appears to have been
part of this same dinner service was recently auctioned
at New York, Sotheby Parke-Bernet ("Good Judaica and
Related Works of Art," May 13, 1981, lot no. 89).

165
Soup Tureen for a Burial Society 23.912B/3
Makers: Haas and Czjizek
Horní Slavkov (Schlaggenwald), Bohemia, after 1867
Porcelain
16 × 31.5 × 24

Inscription:

H[oly] (Burial) S[ociety]. ח״ק

Part of the same service as the fish platter and gravy
boat (cats. 166 and 167).

166
Fish Platter for a Burial Society 23.912/2
Makers: Haas and Czjizek
Horní Slavkov (Schlaggenwald), Bohemia, after 1867
Porcelain
Mark: Danckert 401, no. 12
63 × 24.2

Inscription:

H[oly] (Burial) S[ociety]. ח״ק

The porcelain factory in Schlaggenwald, Bohemia (today
Horní Slavkov), founded in 1793, was run by Georg
Haas from 1847 to 1867. In 1867 Johann Czjizek
became a partner and the firm expanded to become one
of the largest porcelain factories in Bohemia, producing
a great variety of wares from simple household dishes
to elaborate luxury items. Part of the same service as
the soup tureen and gravy boat (cats. 165 and 167).

167
Gravy Boat for a Burial Society 23.905/2
Makers: Haas and Czjizek
Horní Slavkov (Schlaggenwald), Bohemia, after 1867
Porcelain
11 × 26.5 × 15

Inscription:

H[oly] (Burial) S[ociety] ח״ק

Part of the same service as the soup tureen and fish
platter (cats. 165 and 166).

168
Tablecloth 5.717
Bohemia, early 20th century
Linen damask
145 × 140

169–176
**Set of Portraits of Members of the Prague Burial
Society**

These are the earliest portraits in the Prague collection.
Painted from life, they were cut out of a larger piece of
board and pasted down on individual sheets of paper.
An inscription was added to the bottom of these sheets,
identifying the sitters and their roles within the Jewish
community. The straight edges of the portraits' support
and the fact that sections of the images and inscriptions
are obscured by the frames, indicate that the oval
frames were not part of the original design.

By comparing these eight portraits with the final
painting in the cycle of fifteen canvases depicting the
activities of the Prague Burial Society (cat. 191), we can
see that the portraits are actually a bit larger than the
figures in the painting. It seems likely that the portraits
were not intended as miniatures, and may have been cut
down from a larger group portrait similar to cat. 191.
The commissioning of the cycle of fifteen paintings to
replace a single group portrait may, in fact, have been
the reason for cutting down the larger work. Whether
the inscription date of 1772/3 reflects the date when the
portraits were painted or the date when they were cut
down and the inscriptions were added, has not as yet
been determined. Two of the sitters, Wolf Bumsla and
Israel Frankel, died in 1772.[1] Since the portraits were

clearly done from the model, we must assume they were at least begun in 1772 or earlier.

Note: [1]Simon Hock, *Die Familien Prags: Epitaphien des Alten jüdischen Friedhofs in Prag* (Pressburg: Druck von Adolf Alkalay, 1892), p. 35, no. 929 and p. 289, no. 4865.

169
Portrait of Isaac Austerlitz 17.820/1
Prague, 1772/3
Oil on cardboard
15 × 11; framed: 22.5 × 19

Hebrew inscription:

הו״ה האלוף מו״ה יצחק סג״ל אויסטרליץ ר״ה ד״ק
וגבאי דח״ק גו״ח תקל״ח לפ״ק

"Isaac Segal Austerlitz h[ead] of the c[ongregation] and Treasurer of the H[oly] (Burial) S[ociety] of B[enefactors 5]533" (=1772/3).

Provenance: Burial Society, Prague
References: Manchester, *Treasures,* no. P16, ill. p. 145; Pařík, "Bildersammlung," 77.

170 (Fig. 39)
Portrait of Lezer Zekeles 17.820/2
Prague, 1772/3
Oil on cardboard
15 × 11; framed: 22.5 × 19

Hebrew inscription:

הו״ה כ״ה ליזר זעקעליס שתדלן דתפוסים וגבאי דח״ק
גו״ח תקל״ג לפ״ק

"Lezer Zekeles, advocate of prisoners and Treasurer of the H[oly] (Burial) S[ociety] of B[enefactors 5]533" (=1772/3).

Zekeles acted as an intermediary between members of the Prague Jewish community and the gentile authorities.

Provenance: Burial Society, Prague
References: Manchester, *Treasures,* no. P17, ill. p. 145; Pařík, "Bildersammlung," 77.

171
Portrait of Wolf Bumsla 17.820/3
Prague, 1772/3
Oil on cardboard
14.5 × 11; framed: 23 × 19

Hebrew inscription:

האלוף המרומם כ״ה וואלף בומסלא גבאי דמתא
ומבורר דח״ק גו״ח תקל״ג לפ״ק

"Wolf Bumsla, the local treasurer and the selected one of the H[oly] (Burial) S[ociety] of B[enefactors 5]533" (=1772/3).

Provenance: Burial Society, Prague
References: Manchester, *Treasures,* no. P18; Pařík, "Bildersammlung," 77.

172
Portrait of Leib R. Feivel 17.820/4
Prague, 1772/3
Oil on cardboard
14.5 × 11; framed 23 × 19

Hebrew inscription:

הרב המפורסם מו״ה ליב ר׳ פייבל דיין מבורר דח״ק
גו״ח תקל״ג לפ״ק

"The famous Rabbi Leib R. Feivel, judge, selected one of the H[oly] (Burial) S[ociety] of B[enefactors 5]533" (=1772/3).

Provenance: Burial Society, Prague
References: Manchester, *Treasures,* no. P19; Pařík, "Bildersammlung," 77.

173
Portrait of Jonas Jeitteles 17.820/5
Prague, 1772/3
Oil on cardboard
14.5 × 11; framed: 23 × 19

Hebrew inscription:

הרבני האלוף מו״ה יונה ייטלס רופא נאמן דקהלתנו
תקל״ג לפ״ק

"The learned Jona[s] Jeitteles, faithful physician of our congregation [5]533" (=1772/3).

This portrait, painted from life, later served as the model for the image of Jeitteles in the first painting of the Prague Burial Society cycle (cat. 177) by the same artist. (For information on Jeitteles, see cat. 245). Jeitteles is the only beardless man in this set of eight portraits.

Provenance: Burial Society, Prague
References: Manchester, *Treasures,* no. P20; Pařík, "Bildersammlung," 77.

174
Portrait of Israel Frankel 17.820/6
Prague, 1772/3
Oil on cardboard
14.5 × 11; framed: 23 × 19

Hebrew inscription:

הו״ה פו״מ מו״ה ישראל פראנקל פרימאס דח״ק גו״ח
ופרימאס ד״ק תקל״ג לפ״ק

"Israel Frankel 'primus' (head) of the H[oly] (Burial) S[ociety] of B[enefactors] and 'primus' of the c[ongregation 5]533" (=1772/3).

Provenance: Burial Society, Prague
References: Manchester, *Treasures,* no. P21; Pařík, "Bildersammlung," 77.

175
Portrait of Abraham Riss　　　　　　　17.820/7
Prague, 1772/3
Oil on cardboard
14.5 × 11; framed: 23 × 19

Hebrew inscription:

המרומם הנדיב כ"ה אברהם ריס גבאי דמתא ומבורר
דח"ק גו"ח תקל"ג לפ"ק

*"Abraham Riss, local treasurer and selected one of the
H[oly] (Burial) S[ociety] of B[enefactors 5]533"*
(=1772/3).

Provenance: Burial Society, Prague
References: Manchester, *Treasures,* no. P22; Pařík, "Bildersammlung,"
77.

176
Portrait of Pinkas RMD　　　　　　　17.820/8
Prague, 1772/3
Oil on cardboard
14.5 × 11; framed: 23 × 19

Hebrew inscription:

מ המרומם כהר"ר פנחס רמ"ד ר"ה ד"ק ומבורר דח"ק
גו"ח תקל"ג לפ"ק

*"Pinkas RMD, h[ead] of the c[ongregation] and selected
one of the H[oly] (Burial) S[ociety] of B[enefactors
5]533"* (=1772/3).

His name also appears in the inscription on the faience
Prague Burial Society beaker dated 1798/9 (cat. 158).

Provenance: Burial Society, Prague
References: Manchester, *Treasures,* no. P23; Pařík, "Bildersammlung,"
77.

177–191 (Figs. 138–152)
Cycle of Burial Society Paintings
Prague, ca. 1780

These paintings depicting the activities of the Prague
Burial Society originally hung in the meeting room
where members gathered for their annual banquet.
Christian guilds commonly commissioned paintings of
their activities and portraits of their members to
decorate their guild houses, and the Prague cycle is the
only known Jewish counterpart to this tradition.[1]
Illustrations of burial society practices in Hebrew
manuscripts and on alms boxes established certain
motifs which set a precedent for this cycle in Jewish
art.[2] Depictions of burial processions also appear in folk
art from the regions comprising present day Czechoslo-
vakia.[3]

The artist of these fifteen canvases also painted the
eight portraits of Prague Burial Society members (cats.
169–176), ca. 1772/3. By comparing these individual
portraits with the group portrait which completes the
cycle (cat. 191), we can see that the latter is stiffer and
less spontaneous, indicating that the artist copied the
images in his earlier work for the cycle. A date of ca.
1780 is suggested by this internal evidence and by
developments in the community at that time. The
reforms of Joseph II beginning ca. 1780, were
threatening many Jewish customs and organizations:

the Old Jewish Cemetery was closed by his decree in
1787. Catholic orders which were strictly religious and
did not engage in good works were abolished as well.
The Prague cycle, with its emphasis on charitable acts
and on the importance of the burial society within the
Jewish community may have been commissioned by the
Society to assert its position in the face of these
reforms.

The repetitive nature of several of the paintings
indicates that fifteen canvases were required to fill the
hall. In the 19th century, four canvases were added
illustrating non-burial activities of the Society. In one
of these, depicting the annual banquet, the 18th–cen-
tury cycle can be seen hanging just below the ceiling.[4]

Provenance: Burial Society, Prague
Notes: [1]A famous example of a guild group portrait is Rembrandt van
Rijn's *The Sampling Officials of the Drapers' Guild,* 1662, Rijksmu-
seum, Amsterdam.
[2]See, for example title page of Prague Jewish Museum Ms. 244, (*Kitzur
Ma'avor Yabok,* Moravia, 18th century), showing visit to a sick man (ill.
in Sadek, "Mss Collections . . . Illuminated Manuscripts]," pl. IX); and
alms box from Třebíč, Moravia, ca. 1750 (Inv. no. 48.529) with four car-
touches of scenes of duties of burial society members, (ill. Krüger, *Syn-
agoge,* fig. 69).
[3]See S. Kovačevičová, *Lidové výtvarné umění Slovensko,* (Prague:
Slovensko Státní pedagogické nakladatelství, 1974), fig. 54 for example
in a book recording deaths in a parish in western Slovakia in 1711–12.
[4]Ill. in *JL,* I, pl. LII.

177 (Fig. 138)
Visiting the Sick Man　　　　　　　12.843/1
Prague, ca. 1780
Oil on canvas
55 × 110

Dr. Jonas Jeitteles (see cats. 173 and 245) is the central
figure. The less fluid treatment in the handling of his
portrait in comparison to cat. 173, indicates that the
artist copied his earlier portrait in creating this canvas.

References: Manchester, *Treasures,* no. P1; Pařík, "Bildersammlung,"
76; Volavková, *Guide II,* p. 13.

178 (Fig. 139)
Prayers at the Deathbed　　　　　　　12.843/2
Prague, ca. 1780
Oil on canvas
55 × 110

References: Georges, *Mort,* pp. 82–3; *JL,* III, pl. CXIII; Kedourie,
Jewish World, p. 204; Manchester, *Treasures,* no. P2; Pařík,
"Bildersammlung," 76 and fig. 22; Volavková, *Guide II,* p. 13.

179 (Fig. 140)
Taking Custody of the Dead Man　　　　　12.843/3
Prague, ca. 1780
Oil on canvas
55 × 110

References: Berlin, *Historica Hebraica,* no. A285; *JL,* III, pl. CXIII;
Manchester, *Treasures,* no. P3; Pařík, "Bildersammlung," 76; Volavková,
Guide II, p. 13.

180 (Fig. 141)
The Making of the Shroud　　　　　　12.843/4
Prague, ca. 1780
Oil on canvas
55 × 110

References: *JL,* III, pl. CXIII; Manchester, *Treasures,* no. P4; Pařík,
"Bildersammlung," 76; Volavková, *Guide II,* p. 13.

181 (Fig. 142)
The Washing of the Body 12.843/5
Prague, ca. 1780
Oil on canvas
55 × 110

References: Berlin, *Historica Hebraica*, no. A286; *JL*, III, pl. CXIV;
Manchester, *Treasures*, no. P5; Pařík, "Bildersammlung," 76; Volavková,
Guide II, p. 13.

182 (Fig. 143)
Carrying the Body out of the House 12.843/6
Prague, ca. 1780
Oil on canvas
55 × 110

References: *JL*, III, pl. CXIV; Kedourie, *Jewish World*, p. 208;
Manchester, *Treasures*, no. P6; Pařík, "Bildersammlung," 77; Volavková,
Guide II, p. 13.

183 (Fig. 144)
The Digging of the Grave 12.843/7
Prague, ca. 1780
Oil on canvas
55 × 110

References: *JL*, III, pl. CXIV; Manchester, *Treasures*, no. P8; Pařík,
"Bildersammlung," 76; Volavková, *Guide II*, p. 13.

184 (Fig. 145)
**The Entrance of the Burial Procession
into the Cemetery** 12.843/8
Prague, ca. 1780
Oil on canvas
55 × 110

References: *JL*, III, pl. CXV; Manchester, *Treasures*, no. P8; Pařík,
"Bildersammlung," 76; Volavková, *Guide II*, p. 13.

185 (Fig. 146)
The Oration Over the Dead Man 12.843/9
Prague, ca. 1780
Oil on canvas
55 × 110

References: Georges, *Mort*, pp. 82–3; *JL*, III, pl. CXV; Kedourie, *Jewish
World*, p. 204; Manchester, *Treasures*, no. P9; Pařík,
"Bildersammlung," 76; Volavková, *Guide II*, p. 13.

186 (Fig. 147)
Carrying the Body to the Grave 12.843/10
Prague, ca. 1780
Oil on canvas
55 × 110

References: Berlin, *Historica Hebraica*, no. A287; *JL*, III, pl. CXV;
Kedourie, *Jewish World*, p. 204; Manchester, *Treasures*, no. P10; Pařík,
"Bildersammlung," 76 and fig. 23; Volavková, *Guide II*, p. 13.

187 (Fig. 148)
The Making of the Coffin 12.843/11
Prague, ca. 1780
Oil on canvas
55 × 110

References: Manchester, *Treasures*, no. P11; Pařík, "Bildersammlung,"
76; Volavková, *Guide II*, p. 13.

188 (Fig. 149)
Lowering the Body into the Grave 12.843/12
Prague, ca. 1780
Oil on canvas
55 × 110

References: Georges, *Mort*, pp. 82–3; *JL*, III, pl. CXVI; Kedourie,
Jewish World, p. 205; Manchester, *Treasures*, no. P12; Pařík,
"Bildersammlung," 76; Volavková, *Guide II*, p. 14.

189 (Fig. 150)
After the Burial 12.843/13
Prague, ca. 1780
Oil on canvas
55 × 110

References: *JL*, III, pl. CXVI; Manchester, *Treasures*, no. P13; Pařík,
"Bildersammlung," 76; Volavková, *Guide II*, p. 14.

190 (Fig. 151)
**Washing Hands Upon
Leaving the Cemetery** 12.843/14
Prague, ca. 1780
Oil on canvas
55 × 110

References: Manchester, *Treasures*, no. P14; Pařík, "Bildersammlung,"
76; Volavková, *Guide II*, p. 14.

191 (Fig. 152)
**Group Portrait of Members of the
Prague Burial Society** 12.843/15
Prague, ca. 1780
Oil on canvas
55 × 110

References: *JL*, I, pl. LII; Kedourie, *Jewish World*, p. 204; Manchester,
Treasures, no. P15; Pařík, "Bildersammlung," 76; Volavková, *Guide II*,
p. 13.

192 (Fig. 16)
Cradle 32.141
Moravia, beginning of the 19th century
Carved, stained and inlaid wood; velvet embroidered
with metallic threads and glass stones
57 × 73.5 × 43.4

A quotation from the circumcision service is engraved
and painted along the sides of the cradle:

זה הקטן גדול יהיה

"*May this child [. . .] become adult.*"

Rosettes, a popular motif in Bohemian and Moravian
folk art, decorate the ends. The mattress is covered with
embroidered velvet.

Provenance: Mohelnice, Moravia; Old Jewish Museum, Prague

193 (Fig. 194)
Circumcision Bench 79.873
Údlice, Bohemia, ca. 1805
Carved, stained and painted wood; silk damask
131.3 × 120.3 × 63.2

Though several examples of double circumcision
benches exist from the 19th century, none is so
extensively painted and inscribed as is this one.[1] The
inscriptions on the right side read:

המוהל יאמר

ברוך אתה ה׳ אלקינו, מלך העולם, אשר קדשנו
במצותיו וצונו על המלה.

אבי הבן יאמר

ברוך אתה ה׳ אלקינו, מלך העולם, אשר קדשנו
במצותיו וצונו להכניסו בבריתו של אברהם אבינו.

הקהל משיבים

כשם שנכנס לברית, כן יכנס לתורה ולחפה ולמעשים
טובים.

ונמלתם את בשר ערלתכם והיה לכם לאות בריה [כך!]
ביני [וביניכם]

המול ימל לכם כל זכר

אחר דבריח ... ערלו עפר והיה זרעי [כ]עפר הארץ
כוס ישועת אשה [כך!] יעשם [כך!] ה׳ אקרא
כוס של מציצה
כוס של ברכה

נר ה׳/ליהודים היתה אורה

ברוך הבא בשם/ה׳/זה כסא של אליהו זכור לטוב: מזל
טוב:/זאת נדב/הרר יאקב ליב בן ר׳ שמעון
מאיידליץ/וזוגתו מרת פעסל בת ר׳ אברהם
מהאסטון:/לסדר ,,ובן שמונה ימים ימול בשר זכור ברית
אברהם ועקידת יצקק [יצחק]/השב שבות/אהלי
יעקב״/הושיעם למען שמך

The circumcisor will say:

*"Blessed art thou, Lord our God, King of the universe,
who has sanctified us with thy commandments, and
commanded us concerning circumcision."*

The father of the son will say:

*"Blessed art thou, Lord our God, King of the universe,
who has sanctified us with thy commandments, and
commanded us to introduce my son into the covenant
of Abraham our father."*

The congregation answers:

*"Even as he has been introduced into the covenant, so
may he be introduced to the Torah, to the marriage
canopy, and to a life of good deeds."*

Above and below the depiction of the knife:

*"You shall circumcise the flesh of your foreskin, and
that shall be the sign of the covenant between Me and
you . . . every male among you shall be circumcised"
(Gen. 17:11–12).*

Above and below the flagon:

*"After the circumcision . . . his foreskin [with] earth.
'And my seed shall be as the dust of the earth' "
(variation on Gen. 13:16).*

Above and below the first cup:

*"I raise the cup of deliverance and invoke the name of
the Lord" (Ps. 116:13).*

Below the second cup:

"The cup of blessing."

Above and below candles:

*"The candle of the Lord" (Prov. 20:27). "To the Jews
there was light" (Esther 8:16).*

The inscriptions on the left side read:

*"Blessed are those who come in the name of the Lord.
This is the throne of Elijah of blessed memory. Mazel
Tov. This was donated by Yaakov Leib son of Simon
from Udlice and his wife Pesl daughter of Abraham
from Hostín according to the order: 'Every male shall
be circumcised at the age of eight days' (variation on
Gen. 17:12; chronogram = at least 1805). Remember
the covenant of Abraham and the sacrifice of Isaac. 'I
will turn the captivity of Jacob's tents' (Jer. 30:18) and
save them for the sake of your name."*

Provenance: Old Jewish Museum, Prague

Note: [1]Cf., for example, *Monumenta Judaica*, no. E111, and Shachar,
Jewish Tradition in Art, no. 9, where other, similar pieces are listed.
References: B. Nosek, J. Šedinová, "Le fauteuil de circoncision," *JB* 16,
1 (1980), 80, fig. 26; Volavková, *Story*, p. 73.

194 (Fig. 192)
Circumcision Knife 9.969
Bohemia or Moravia, ca. 1800
Steel blade; agate; and silver filigree
17.5 × 2.5

The fan-shaped filigree mount on the blade and the
petal-shaped filigree mounts embellishing the agate
handle are features found in the design of a circumci-
sion knife from the Danzig collection[1] and on a nearly
identical knife in the State Jewish Museum in Prague.
Both Prague knives came from the pre-World War II
Jewish Museum in Mikulov.[2]

Provenance: Jewish Museum, Mikulov (Nikolsburg), Moravia
Notes: [1]New York, The Jewish Museum, *Danzig 1939*, no. 3.
[2]Inv. no. 4861. Krüger, *Synagoge*, fig. 61.
Reference: Berlin, *Historica Hebraica*, no. A242.

195 (Fig. 192)
Circumcision Shield 46.120/c
Bohemia, 19th century
White brass
6 × 3.2

The handle of this shield from a set of circumcision
instruments is in the form of a pointed leaf.

Provenance: Chief Rabbinate, Prague
References: Berlin, *Historica Hebraica*, no. A247; The Hague, *Praag*,
no. 256.

196 (Fig. 192)
Circumcision Shield 46.120/e
Bohemia, 19th century
Silver
6.5 × 4.5

This elongated shield has a five-lobed handle similar in
shape to a leaf of clover.

Provenance: Chief Rabbinate, Prague.

197
Circumcision Shield 46.120/d
Bohemia, ca. 1900
Chromed brass
9 × 5

Provenance: Chief Rabbinate, Prague.
References: Berlin, *Historica Hebraica*, no. A248; The Hague, *Praag*,
no. 255.

198 (Fig. 192)
Circumcision Vial 12.786
Prague(?), mid 19th century
Silver
12 × 4.8

This teardrop-shaped vial has a screw-on top with
ribbon edges and a small lentil-shaped finial.

Reference: The Hague, *Praag*, no. 260.

199 (Fig. 192)
Circumcision Vial 61.945
Prague(?), late 19th century
White metal
7.5 × 1.5

This vial for disinfectant resembles a knife handle.

200
Circumcision Vial 4.502
Moravia(?), 19th century
Engraved silver
8.5 × 1.5

Engraved parallel lines divide the body of this vial into
six vertical panels. Smooth, unadorned panels alternate
with panels decorated by an engraved diamond pattern.

References: Berlin, *Historica Hebraica*, no. A255; The Hague, *Praag*,
no. 262.

201
Wedding Ring 174.913
Maker: JB
Probably Vienna, 1891
Hammered and engraved gold set with semi-precious
stone
Mark: JB
2.5 dm.

The stone is set at the center of a Jewish star that is
flanked by two flowers. Inside the band is engraved:

*IP 18*24/5 *91 ("IP May 24, 1891").*

Reference: Doležilová, et al, "Acquisitions to the Collections," 34.

202 (Fig. 196)
Bridal Wreath and Veil in a Frame 173.648
Bohemia, 19th century
Waxed cloth and leaves; tulle; gilt wood frame
50.5 × 38

203 (Fig. 170)
Bonnet 12.577
Bohemia, early 19th century
Metallic thread, appliqués and lace; sequins; precious
stones and cardboard frame
20 × 25

The back portion of the bonnet is richly embroidered
with metallic threads and appliqués, sequins and stones
as a pattern of leaves and flowers. Metallic lace covers
the upper portion and forms the ruffle. Similar bonnets
were worn by women in various parts of Bohemia in
the early 19th century.[1] According to Jewish custom,
women cover their hair after marriage as a sign of
modesty.

Provenance: Pinkas Synagogue, Prague

Note: [1]Cf. D. Stránská, *Lidové kroje v Československu, I. Čechy*
(Prague: J. Otto, Společnost S.R.O., n.d.), fig. 85. The bonnet in the
State Jewish Museum is different in form and decoration from Polish
examples. (See G. Frankel, "Little Known Handicrafts of Polish Jews in
the Nineteenth and Twentieth Centuries," *JJA*, 2(1975), 43, fig. 3 or
A. Rubens, *A History of Jewish Costume* (New York: Crown
Publishers, Inc., 1973), figs. 151, 152.

204 (Fig. 170)
Apron 31/82
Bohemia, 19th century
Silk brocade; metallic lace and fringe
72.5 × 88 (without fringe)

The lace of this apron is of the same pattern as that of
the bonnet (cat. 203), but is far more worn, with many
of the underlying silk threads exposed. It is attached to
a piece of Italian brocade ca. 1700/10,[1] that has been
turned so that its pattern runs sideways. Aprons such as
this were part of the traditional Bohemian woman's
costume, and one is worn by the bride depicted on the
18th–century embroidered Torah binder in this exhibi-
tion (cat. 34).

Note: [1]Cf. *Seidengewebe*, no. 687.

205
Wedding Plate 174.491
Maker: Joseph Kunzel (b.1782)
Plzeň (Pilsen), Bohemia, 1802
Hammered and engraved pewter
Marks: Tischer 618d
29 dm.

On the center of the plate a series of floral motifs and
ribbons form a cartouche framing an abbreviation
meaning "good luck":

Around the rim is a lengthier inscription:

ד״ד מח״ק דעזר מעט להבח׳ החתן ייקל כהן פה ק״ק
יעניקויא שנת תק״צ לפ״ק
מזט

*"A wedding gift from the Holy Society for Minor Aid
to the groom Yikl Cohen here in the holy congregation
[Golčův] Jeníkov, the year [5]590" (=1829/30).*

Five of the twenty wedding dishes in the State Jewish
Museum came from the workshop of Joseph Kunzel.[1]
The lack of wear on these plates suggests their use was
primarily decorative.[2]

Notes: [1]Doležilová, "Wedding Dishes and Plates," 30.
[2]Ibid, 34.
Reference: Doležilová, "Wedding Dishes and Plates," 32, 40.

206 (Fig. 197)
Wedding Dish 46.133
Maker: Martin Extel
Prague, 1803
Hammered and engraved pewter
Marks: Tischer 796
27.5 dm.

This basin belongs to a series of twenty pewter plates in the collection of the State Jewish Museum that were given as wedding gifts. The inscription reads:

ד״ד לפאר הבחורים ה״ב החתן כ״ה בער ניישטאדרטל
סג״ל הובא לעת חתונתו יום אפריון שנת תקצ״ג ל'

"A wedding gift to the glory of the youths, the groom Ber Neustadel Segal, presented on the occasion of his marriage, the wedding day, the year [5]593" (= 1832/3).
At center, a laver and basin are depicted, a reference to the fact that the groom was a Levite, whose task it is to assist the *kohanim* (priests) in washing their hands prior to the recitation, on festival days, of the priestly benediction. The maker, Martin Extel, also produced a second pewter plate in the Prague collection (no. 170.752).[1] He became a master pewterer in 1802.

Note: [1]Doleželová, *"Wedding Dishes and Plates,"* 38.
Reference: Doleželová, "Wedding Dishes and Plates," 31, 38.

207
Tombstone of Wolf and Raizel Fischer 173.614
Liteň, Bohemia, 1838
Wood carved in sunk relief
115 × 62.5 × 9.0

There are two inscriptions on this unusual wooden tombstone, one for the wife (at right) and another for her husband (at left).

זאת מצבת/פט אשת יקרה/ אשת חיל/ צנועה מ' רייזל/
אשת ר' וואלף/ מכפר מ' פיה/ פתחה בחכמה/ עצלות
לא/ אכלה אשר הלכה/ לעולמה ביום ג' כ״ו/ שבט
ונקברה/ ביום כ״ז

איש חיד בפעלים/ הלך בדרך ישרה כל/ הימים זן וכלכל
בני/ביתו מיגיע כפיו/ומסעודת אחרים לא/נהנה הביא
בניו לבית/הספר וקבע עתים לתורה/עבד את ה' ביראה
כ״ה/וואלף פישער מכפר/מאלקאף הלך לחיי/ערב יום
א' י״ח תמוז/ונקבר בשם טוב כ״ג/בחדש
בשנת/תקצ״ח/ת״נצבה

"This is the monument
H[ere lie] b[uried]"
At right:

"A dear woman, a woman of valor, modest Raizel wife of Wolf from the village of M[olkov]. 'Her mouth is full of wisdom . . . [and she] never eats the bread of idleness' (Prov. 31:26-7) who went to her world on Tuesday the 26th of Shvat and was buried on the 27th."

At left:

"A man clever in deeds, he walked a straight path all the days; [he] fed and supported his household from the work of his hands and did not benefit from the feasts of others. [He] brought his sons to school and fixed times [for the study of] Torah. [He] worshipped the Lord in fear. Wolf Fischer from the village of Molkov went to the life, on Sunday evening, the 18th of Tammuz and was buried with a good name on the 23rd of the month in the year [5]598 [= 1838]. M[ay their] s[ouls be] b[ound up in the] b[onds of] l[ife]."

208 (Fig. 160)
Mezuzah 32.129
Bohemia, 18th–19th century
Carved and stained wood; parchment
15.4 × 3.2

This rare *mezuzah* is carved to look like braided leather strips.

Provenance: Old Jewish Museum, Prague
Reference: Berlin, *Historica Hebraica,* no. A163.

209 (Fig. 160)
Mezuzah 27.180
Bohemia or Moravia, 18th–19th century
Carved and stained wood
16 × 3.1

The composition and decoration of this *mezuzah* and the following example (cat. 210) are so similar as to suggest that both were made in the same workshop. The bottom zone is filled with an eight-pointed star; next is a zone of strips of geometric ornament running vertically; then the aperture for the parchment set within an architectural frame. In this case, the aperture fills the center of a facade with a high pitched roof. The backs of both *mezuzot* are similarly planed and left unstained. (For related pieces attributed to 18th–century Germany, see *Monumenta Judaica,* no. E4; Shachar, *Jewish Tradition in Art,* nos. 94 and 95.)

Provenance: Polná, Moravia
Reference: Berlin, *Historica Hebraica,* no. A168, pl. 19d.

210 (Fig. 160)
Mezuzah 66.483
Bohemia or Moravia, 18th–19th century
Carved and stained wood; parchment
18.4 × 2.7

For a discussion, see cat. 209.

Provenance: Klaus Synagogue, Prague
Reference: Berlin, *Historica Hebraica,* no. A167, pl. 19c.

211
Laver 46.134
Horní Slavkov (Schlaggenwald), 1878–1914
Cast pewter
Mark: Tischer 850
20.5 × 17

Joseph Scheller procured finished pewter from Schlaggenwald which he sold in Prague.[1]

Note: [1]Tischer, p. 205.

212
Towel for Ritual Handwashing 71.439
Bohemia, ca. 1900
Linen damask; linen fringe
114 × 60.5

The last words of the blessing on washing the hands
before eating are woven into the ends of this towel:

"on washing hands." על נטילת ידים

The blue letters contrast with framing bands of
decorative motifs executed in red threads. Similarly
colored and woven textiles were in general Bohemian
use early in this century.[1]

Note: [1]S. Kovačevičová, *Lidové výtvarné umění Slovensko* (Prague:
Statní pedagogické nakladatelství, 1974), ill. 95.

213
Plate 37.696
Maker: KC
Bohemia or Moravia, ca. 1815
Cast and engraved pewter
Mark: unidentified
33 dm.

Engraved in the center of this plate is a depiction of the
scene recounted in Genesis 39 of Potiphar's wife's
attempt to seduce Joseph. She is shown in bed, nude
from the waist up, pulling off Joseph's coat as he flees
from her advances.

Hebrew inscription around rim:

*"His master's wife cast her eyes upon Joseph and said,
'Lie with me.' But he refused. She caught hold of him
by his coat. But he left [his coat in her hand] (Gen.
39:7, 8, 12)."*

On the back are engraved the Hebrew initials יד *(Y.D.)*
and *"Josephus Adler Anno 1815."*
 A plate with nearly identical decoration and inscrip-
tion, but executed in a less lively and accomplished
engraving style is in the Berger collection, Vienna.[1]

Provenance: The Old Jewish Museum, Prague
Notes: [1]Berger, *Judaica*, fig. 24, Inv. no. 359. For a German plate
illustrating the same scene with a different composition, see Cologne,
Kölnisches Stadtmuseum, *Judaica*, text by Liesel Franzheim, 1980, no.
111.
Reference: Manchester, *Treasures*, no. M112.

214
Tablecloth 5716
Bohemia, early 20th century
Linen embroidered with cotton
84.6 × 95.4

Provenance: Hořovice(?), Bohemia

215 (Fig. 137)
Chair 173.830
Bohemia, late 19th century
Carved and stained wood
97.5 × 40 × 42.2

Neo-gothic motifs, like the cut-out tracery and
crocketed forms on this chair, appear on late 19th–cen-
tury Bohemian Judaica. (Cf. cat. 76, an eternal light
donated to the Great Court Synagogue in 1892.)

Provenance: Turnov(Turnau), Bohemia

216
Sconce 10.786/5
Bohemia, 19th century
Hammered and cast brass
30.5 dm.

217
Sconce 154/a
Bohemia, 19th century
Hammered and cast brass
30.5 dm.

Provenance: Budyně nad Ohří, Bohemia

218
Kitchen Items

These kitchen implements, on exhibition in the section,
Legacy of Family and Home: Daily Life, are from the
collection of the State Jewish Museum in Prague, and
date from the 19th and early 20th century. Many of
them stem from Kasejovice, Bohemia.

219
Ring 4.512
Moravia(?), 19th century
Cast and engraved brass
2.5 dm.

The owner's name is engraved around the circum-
ference:

"Isaac son of Asher Segal." יצחק בר אשר סגל

At center is a pitcher, a reference to the owner's
belonging to the tribe of Levi. (See cat. 206.)

Provenance: Moravia
Reference: Berlin, *Historica Hebraica*, no. A267.

220 (Fig. 8)
Ring 4.513
Moravia, 19th century
Cast and engraved brass
2.7 dm.

The owner's name reads:

"Judah son of Rabbi Meinster." יהודא בה מיינשטר

At the center is engraved the sign of Gemini, probably
a reference to the birthdate of the owner.

Provenance: Moravia
Reference: Berlin, *Historica Hebraica*, no. A274.

221
Ring 4.514
Moravia, 19th century
Cast and engraved brass
2.7 dm.

The owner's name reads:

"Joseph son of Leib." יוסף בר ליב

Below is the sign for Libra.

Provenance: Moravia
Reference: Berlin, *Historica Hebraica*, no. A275.

222
Seal 12.792
Bohemia, ca. 1800
Cut-out and engraved silver
Mark: 13
3.2 × 1.7

Hebrew inscription around rim:

ליפמן ב"ה וואלף מעסטיץ ז"ל מטאארנה

*"Lipman s[on of] Wolf Mestitz of blessed memory from
Turnau."* [1]

Two fish, the symbol of Pisces and the Hebrew month
Adar, decorate the center. The handle is in the form of a
lion.

Note: [1]Turnov, in northern Bohemia. For a Burial Society beaker from
this community, see cat. 159.

223
Seal of Rabbi Mordecai Banet 4.519
Moravia, 19th century
Carved agate and engraved silver
8.7 × 2.6

The inscription reads

מרדכי ב"ר אברהם בנעט

"Mordecai son of Abraham Banet."

Mordecai Banet (1753–1829) was district rabbi of
Moravia and head of the Mikulov (Nikolsburg)
yeshivah. He wrote several works, some published after
his death. [1]

Provenance: Moravia
Note:[1]*EJ,* I, 159.

224 (Fig. 72)
Portrait of Sara Moscheles (1745–1815) 12.432
Prague, ca. 1790
Oil on canvas
73 × 58

225 (Fig. 73)
Portrait of Wolf Moscheles (1744–1812)[1] 12.433
Prague, ca. 1790
Oil on canvas
73 × 58

The anonymous painter of this pair of pendants used
color, composition and iconography to link the images
of husband and wife to one another. Both works are
executed in tones of brown, grey and olive green,
enlivened by the orange of Sara's dress which is
repeated in the spines of the books in her husband's
library.

Their bodies are turned slightly towards one another,
but their eyes engage the viewer, and both images are
set in an oval. Wolf is shown seated in front of shelves
of books, an open volume at his side. The theme of
learning is reiterated in the book which Sara holds,
keeping her place in the volume with her second finger,
as if we have just interrupted her reading. Husband and
wife wear identical rings on the little fingers of their
right hands.

Wolf Moscheles is mentioned in the inscription on
the faience beaker of the Prague Burial Society dated
1798/9 (cat. 158). Both portraits were in the collection
of the pre-World War II Prague Jewish Museum.

Note: [1]The identities of both sitters and their birth and death dates
were inscribed on the backs of the paintings' frames when they entered
the collection during the War.

226
Portrait of an Older Man in a Black Hat 27.244
Prague, end of the 18th century
Oil on canvas
62.5 × 45

The pose, expression and dress of this man is similar to
these features of the Prague Burial Society portraits,
(especially cats. 172 and 174), with which it is roughly
contemporary, though this portrait is the work of a far
more sophisticated artist. The dark hat, clothing and
background focus our attention on the sitter's face with
its individualized physiognomy. An expression at once
strong and compassionate, and the effects of aging have
been sensitively rendered. This portrait entered the
collection with a pendant of the man's wife (Inv. no.
27.246).

227 (Fig. 44)
Portrait of a Scholar 60.715
Prague, 1817
Oil on canvas
67 × 53.5

The sitter wears a black skullcap, white shirt, and a blue
robe open at the neck, giving the impression of an
informal view of a scholar at home. With his right
hand, the man points to an open book, inscribed on one
side in Hebrew:

ר"ח ניסן תקע"ה *"N[ew] M[oon of] Nisan [5]577,"*

and on the other side with the German equivalent:

18. März 1817
"18th March 1817."

The face, with its fluid handling, fine features,
aristocratic demeanor, and expression of a scholar
absorbed in thought, is the strongest part of this
painting; the treatment of the hand and torso is
somewhat weak.

228
Portrait of a Child 27.262
Prague, ca. 1830
Oil on canvas
48.5 × 42.5

The special affinity between children, as yet uncor-
rupted by society, and the natural world is an idea
explored in the art and literature of Romanticism. This
portrait partakes of the same conceit, depicting the child
embedded within the landscape like one of the
wildflowers she clutches in her hands or which sprout
out of the earth around her. In its close-up view of a
child's world from her eye-level and its understanding

of the pudginess and occasional awkwardness of a child's anatomy, this portrait demonstrates a kinship with the works of Philipp Otto Runge, a master of German Romantic painting. In Czechoslovakia, such direct studies of children were pioneered in the works of František Tkadlík.[1]

Note: [1]In addition to Tkadlík's paintings and drawings of children, he did the illustrations for *Theater für Kinder* by Karl Payer (I, Vienna and Prague, 1818; II, Prague, 1821; III, Prague, 1822.) For comparable works by Tkadlík see Eva Petrová, *František Tkadlík* (Prague: Nakladatelství Československé akademie věd, 1960), figs. 18, 109–112.

Reference: Pařík, "Bildersammlung," 77.

229 (Fig. 199)
Portrait of Karl Andrée (1796–1876) 152.139
Probably Vienna, ca. 1835
Oil on canvas
76 × 63

230 (Fig. 198)
Portrait of Amálie Andrée (1814–1874) 152.140
Probably Vienna, ca. 1835
Oil on canvas
76 × 63

This pair of portraits of Karl Andrée, a bookseller in Prague, and his wife Amálie, née Weiss, may have been painted on the occasion of the couple's marriage. Amálie was the daughter of Anton Weiss (1782–1822) and Theresie née Foges. Weiss, Foges, and Andrée exemplify the prosperous Prague Jewish merchant families of the first half of the 19th century and numerous portraits of members of these families were recently acquired by the Prague Museum.[1]

The elegance of these portraits suggests that they were painted in Vienna and not in Prague.[2] Amálie's pose, the graceful disposition of her figure and the fluid handling recall works by the Viennese master Ferdinand Georg Waldmüller, and the fashions depicted in these works suggest a date of ca. 1835 for Amálie's portrait.[3] Similarly, Karl's expression, posture and dress bear an affinity to Viennese portraits of the period.[4]

Notes:
[1]Portraits of Amálie's sister and brother-in-law, Henrietta and Thomas Robert Beer are cats. 232 and 231 in this exhibition.
[2]For stylistic characteristics of Prague portraiture see cat. 235.
[3]Compare, for example the wife in Waldmüller's family portrait *Princess Esterhazy's Councellor Matthias Kerzmann with his wife and daughter,* 1835 (Vienna, Österreichisches Galerie, inv. 1521, ill. in London, Victoria and Albert Museum, *Vienna in the Age of Schubert: The Biedermeier Interior 1815–1848,* exhibition catalogue, 1979, fig. 4).
[4]See for example, *Portrait of Dominik Artaria,* 1836, by Wilhelm Heinrich Schlesinger (Vienna, Historisches Museum der Stadt Wien) ill. in Bruno Grimschitz, *The Old Vienna School of Painting* (Vienna: Kunstverlag Wolfrum, 1961), pl. 44, a. A Viennese provenance is further corroborated by the stamp on the back of Karl's portrait: "W. Coller & Co. in Wien. Vormals J. Hall."

Reference: Pařík, "Bildersammlung," 77.

231
Portrait of Thomas Robert Beer (1800–1856) 152.145
Ignaz Porges (1812–1890)
Prague, ca. 1836
Watercolor on paper
Signed, lower right: Ign. Porges
13 × 15; framed: 24.5 × 22.2

Thomas Robert Beer, husband of Henrietta née Weiss (cat. 232), came from a prominent Prague family: his father, Peter Beer (1758–1838) was a leading educator, author and advocate of religious reform in Prague.[1] Thomas was a physician and served as medical councillor in the municipal government of Cracow.

This Biedermeier watercolor is executed in a delicate miniaturist style. Details like the shirt buttons in the form of the sitter's initials "T" "B" and the individual strands of hair are finely rendered. Porges, a Jewish artist, enjoyed popularity as a portraitist in Prague, especially among Jews. Among his works is a lithograph of Rabbi Samuel Landau. In 1856 Porges converted to Catholicism and in 1873 changed his name to Boresch.

Notes: [1]See *EJ,* IV, cols. 379–80 and *JE, II,* p. 635.
Reference: Pařík, "Bildersammlung," 77.

232
Portrait of Henrietta Beer (1815–1891) 152.146
Josef Alexander Leopold Koruna (1807–1854)
Prague, ca. 1836
Watercolor on paper
Signed on base of column at right: Koruna
15.5 × 12; framed: 23 × 19.5

Henrietta Beer née Weiss, wife of Thomas Robert Beer (cat. 231), was the sister of Amálie Andrée (cat. 230). Koruna worked in Prague, specializing in portraits and genre paintings. Here he relied on many of the traditional devices of portraiture, depicting Henrietta holding a fan, seated in front of a column and billowing curtains, with a view of a distant landscape at the left. A date of ca. 1836 is suggested both by the appearance of the sitter's age and by her costume.[1]

Note: [1]Close parallels in terms of dress style, hairdo and pose can be found in two portraits by Antonín Machek, *Portrait of Eleanor Zeyer,* 1836 and *Portrait of Ludovíka Chmelenská,* 1838 or before (Novák, *Machek,* no. 335, fig. 171 and no. 362, fig. 176).
Reference: Pařík, "Bildersammlung," 77.

233
Portrait of an Older Man 89.245
Prague(?), ca. 1840
Oil on canvas
44.5 × 35

The man is seated at a small table on which he rests his right forearm, his hand placed over a small engraved silver snuff box. He wears a high skull cap of dark blue velvet with vine scrolls embroidered in gold thread and a gold tassel, similar to cat. 107 in the exhibition.

234 (Fig. 76)
Portrait of a Young Girl with a Butterfly 91.243
Theodor Blätterbauer (b. 1823)
Probably Legnica (Liegnitz), 1848
Oil on canvas
Signed lower left corner: Th. Blätterbauer 1848
47.5 × 40

The style of this portrait is influenced by the Nazarene
movement in German Romanticism, especially in its
emulation of Italian Renaissance painting. Whereas the
child in cat. 228 is embedded within nature, the
Italianate landscape in this portrait serves as a backdrop
against which the girl's figure is silhouetted. The
contrast between the castle ruins in the distance and the
fresh youthfulness of the girl and the fragility of the
butterfly she holds suggest an allegorical significance.
Traditionally, butterflies are symbols of the soul and of
fleeting time. Blätterbauer, a painter of landscapes,
portraits and architecture, worked primarily in Liegnitz
in Lower Silesia (today Legnica, Poland).

Reference: Pařík, "Bildersammlung," 77.

235 (Fig. 75)
**Portrait of an Older Woman in a Tulle Cap with
Roses** 27.150
Prague, ca. 1850
Oil on canvas
61 × 49

The anonymous painter of this work flattened the forms
of the figure against the picture plane, but rendered the
facial features with sculptural definition. These stylistic
features, coupled with a tendency towards an often
unflattering realism, are characteristic of much of
Prague portraiture in the first half of the 19th century,
exemplified by the work of Antonín Machek
(1775–1844). Machek, the leading portraitist of his
time, depicted several middle class older women
similarly attired in lace collar, dressy bonnet and six-
strand pearl choker.[1]

Notes: [1]See, for example, *Portrait of Anna Smolíková*, after 1840,
Novák, *Machek*, cat. no. 387. See also, *Portrait of Thekla Battková-
Podleská*, 1826, *ibid.*, cat. no. 146, which depicts an older woman in an
elaborate bonnet, where the figure is flattened but the facial features are
rendered with plasticity.

236
Portrait of a Student 82.636
Prague(?), mid 19th century
Oil on canvas
Signed, lower right edge of oval: Swoboda
52 × 42

This straightforward presentation of a serious young
scholar harks back to the iconography of Jewish
portraits found in the Prague Burial Society portraits
(cats. 169–176): sober dress, somber colors, and no
background details or attributes to distract from the
sitter's face.

237
**Portrait of a Woman
(Probably Eleonore Soudeck)** 27.461
Prague, ca. 1855
Hand-colored photograph and watercolor on paper
20 × 16.5; framed: 35.5 × 31

238
Portrait of a Man (Probably S. Soudeck) 27.462
Prague, ca. 1855
Hand-colored photograph and watercolor on paper
19 × 15.5; framed: 30 × 24.5

In both these works, the artist has taken the
photographic likeness of the sitter and placed it in a
traditional portraiture setting of ivy covered columns,
heavy drapery, and background vistas. Behind the
woman we see a panoramic view of Prague: the Vltava
(Moldau) river, the Charles Bridge and the southern
bank dominated by the Prague Castle. Her husband sits
in front of a landscape with lakes and mountains.
Precise details of dress and physiognomy have been
captured by the camera and then reinforced with the
brush using a miniaturist technique.

239
Portrait of a Young Boy 79.796
František Weidlich (b. 1811)
Prague, 1859
Oil on canvas
Signed, lower left (on table): 1859 Fr. We[i]dlich
69 × 51

The flat treatment of forms and smooth facture reflect a
primitivizing tendency on the part of the artist.
National folkways are evoked by the boy's costume, in
particular the embroidered suspenders. He holds three
cherries in his hand, which traditionally symbolize
sweetness of character.

240
Portrait of a Woman 82.193
Prague(?), ca. 1870
Oil on canvas
73 × 59.5

Set off by the rich brown tones of dress and
background, the woman's face seems to glow as it
emerges from the darkness. This contrast, as well as the
loose brushwork on the dress, Old Master resonances
and subtle sensuality suggest the influence of the Czech
painter Karel Purkyně (1834–1868). A kinship with the
work of the French painter Gustav Courbet is also
evident, and this could have been mediated through
Purkyně who worked in Paris and brought back with
him to Prague new developments in French art.

241
Portrait of a Young Man 97.152
Ignaz Perlsee (1823–1893)
Prague, 1889
Oil on canvas
Signed lower left: Perlsee 1889
92 × 58.5

Perlsee, a Jewish artist, studied at the Prague Academy
of Fine Arts (1838–1840) with František Tkadlík, the
leading Czech exponent of polished classicism. Specializ-
ing in portraits, Perlsee was particularly popular with
Jewish patrons. This portrait, most likely made with the
aid of photography, employs a walking stick and adoring
dog as studio props, creating a somewhat sentimental
image of a serious youth.

242 (Fig. 74)
Portrait of a Boy 97.371
Isidor Kaufmann (1853–1921)
Probably Vienna, end of the 19th century
Oil on panel
Signed along left edge at bottom: Isidor Kaufmann
37 × 29.4

For discussion, see cat. 243.

243
Portrait of an Old Jew 97.372
Isidor Kaufmann (1853–1921)
Probably Vienna, end of the 19th century
Oil on panel
Signed along right edge at bottom: Isidor Kaufmann
40 × 32

Isidor Kaufmann, born in Arad, Hungary, studied
painting in Budapest and Vienna. He settled in Vienna
in 1876 and pursued a successful career as a portraitist,
and as a genre painter specializing in Jewish subjects.

The two paintings in the Prague collection are based
on Kaufmann's travels in Galicia, Poland and the
Ukraine. He moved from village to village, document-
ing the life, customs and dress of Orthodox Eastern
European Jewry. These portraits and his genre scenes of
the humble and pious life of the *shtetl* were produced
for middle class urban Jews living in an environment of
increasing assimilation and the weakening of Jewish
tradition. Kaufmann's depictions awakened in this
audience a nostalgia for the customs and traditions of
their past, and his technical virtuosity won him many
admirers.

Using a pointed brush, and often working on panel,
Kaufmann created highly nuanced images which render
naturalistic detail with meticulous clarity. For example,
in the *Portrait of a Boy*, Kaufmann renders a variety of
textures with delicate, small brushstrokes, differentiat-
ing between the red fox fur and black velvet of the
shtreimel (hat), the soft flesh of the face, the shiny
veneer of the chair and the rough cloth of the black
coat. In the *Portrait of an Old Jew*, the aging lines of
the face, the fur hat and the texture of the beard which
thins out towards the bottom are painted with precision
and sensitivity. His depiction of these Jewish "types" is
an example of late 19th–century realism, in accord with
the materialistic spirit of the age. Nevertheless, Kauf-
mann expressed a profound tenderness and admiration
for his subjects, which is reflected in his statement:
"The strength of every artist is derived from his
nation."[1]

Note: [1]Alfred Werner, *Families and Feasts. Paintings by Oppenheim and
Kaufmann*, exhibition brochure (New York: Yeshiva University Muse-
um, 1977), p. 12.

244 (Fig. 65)
Portrait of David son of Abraham Oppenheimer
(1664–1736) 15/82
Jan Jiří Baltzer (1738–1799) after Jan (Johann)
Kleinhardt (1742–1794)
Prague, 1773
Engraving
Kleinhard. del., Baltzer fc.
16.5 × 10.9

Published in F. M. Pelzl's *Abbildungen Böhmisher und
Mährischer Gelehrten und Künstler* (Pictures of Bohe-
mian and Moravian Scholars and Artists), this print is a
posthumous depiction of Oppenheimer who served as
Chief Rabbi of Moravia and later of Bohemia. A
collector of rare books and manuscripts, Oppenheimer
amassed a fabulous library which was sold to Oxford
University in 1829, and now comprises the chief portion
of the Hebraica section of the Bodleian Library. A
document of Oppenheimer's appointment as rabbi in
Prague is cat. 254.

Baltzer, together with two of his brothers, ran a large
workshop and engraving press in Prague.

References: EJ, XII, col. 1420; *JE*, IX, p. 411; Pařík, "Bildersammlung,"
77; Rubens, *Iconography*, no. 1943; Volavková, "Grafické portrétní
dokumenty," 156.

245
Portrait of Jonas Jeitteles (1735–1806) 95.673
Johann (Jan) Berka (1759–1838)
Prague, 1806
Aquatint and etching
Jo. Berka fc.; L. del.
20.4 × 15.4

Jonas Jeitteles, a member of one of Prague's illustrious
Jewish families, earned a reputation as one of that city's
leading enlightenment figures through his medical
activities; in particular his efforts to promote innocula-
tion against smallpox. The Polish King Stanislas II
Augustus offered Jeitteles the post of court physician
(he declined) and after an audience in 1784, the
Austrian Emperor Joseph II granted him permission to
treat non-Jewish patients.

Jeitteles' high standing in the Jewish community is
indicated by his position of honor in the center of the
first painting of the Prague Burial Society cycle (cat.
177). Berka's print seems, in fact, to have been based on
the depiction of Jeitteles on this canvas, which, in turn,
was modeled on a portrait done from life, one of the set
of eight portraits of Burial Society members painted in
1772/3 (cat. 173). Berka had an engraving firm in
Prague and specialized in portraits of leading person-
alities, as well as aristocratic and bourgeois clients, and
provided title pages and illustrations for numerous
books.

References: EJ, IX, col. 1331; *JE*, VII, ill. p. 91; Rubens, *Iconography*,
no. 1702; Volavková, "Grafické portrétní dokumenty," 156.

246
Ezekiel son of Judah Landau (1713–1793) 17/82
František Šír (1804–1864) after M. Klauber
Prague, ca. 1840
Lithograph
22 × 13.5; framed: 28 × 19

Hebrew inscription:

נודע ביהודה ובישראל גדול שמו רבינו הגדול מו"ה
יחזקאל סג"ל לנדא זצ"ל רב בק"ק פראג

*"Known in Judah and Israel, great is his name . . .
Ezekiel Segal Landau of blessed memory Rabbi of the
h[oly] c[ongregation of] Prague."*

The honorific beginning the inscription is a play on the
title of one of Landau's works, *Noda bi-Yhudah*
(Prague, 1776, 1811), a collection of responsa. (See cat.
266, another work by Rabbi Landau.)
 František Šír ran a lithography workshop in Prague
and was a popular portraitist. He based his image of
Rabbi Landau on a widely-disseminated 18th–century
engraving by M. Klauber.[1]

Note: [1]Ill. *EJ*, X, col. 1389.
References: Pařík, "Bildersammlung," 77.

247
The Třebíč Maḥzor
(Prayer Book for Holidays) Ms. 250
Třebíč(?), ca. 1300
Ink, gouache and gold paint on parchment
43 × 30; 202 fols.

The Mahzor is fragmentary and badly damaged. Incipits
and tituli are written in gouache or gold paint and the
work is also ornamented by marginalia.

References: Ch. J. Polak, "Dovev sifte ješenim," *Ha-neser*, 3(1863),
10–11; I. Sommernitzová, "Der Trebitscher Machsor—eine Be-
schreibung und Analyse des Manuskripts mit Übersetzung von
Probepartien. Diplomarbeit, Prag 1969" *JB*, 9, 2(1973), 91–3.

248
Torat Kohanim and *Mishnat ha-middot* Ms. 259
Origin unknown, before 1590
Ink on parchment
34.5 × 28.8; 8 fols.

This composite manuscript contains sections of three
works: fragments of *Torat Kohanim*, a collection of
exegetical comments on the book of Leviticus; portions
of an unknown text; and the *Mishnat ha-middot*, the
oldest Hebrew mathematical treatise which was com-
posed in the classical or Arabic periods. The first five
chapters of *Mishnat ha-middot* describe methods of
determining the dimensions of plane and solid geo-
metric figures. Chapter VI, which is only known from
the Prague text, is devoted to the plan of the desert
Tabernacle.

References: Gad B. Sarfatti, "Some Remarks about the Prague
Manuscript of Mishnat ha-Middot," *Hebrew Union College Annual*,
45(1974), 197–204; A. Scheiber, "The Prague Manuscript of Mishnat
ha-Middot," *Hebrew Union College Annual*, 45(1974), 191–196.

249
Prayer Book and Memorial Book
for the Altneuschul Ms. 113
Prague, late 16th–18th centuries
Paint and ink on parchment; ink on paper
26.3 × 18.5; 24 fols.

Though the earliest portion of this manuscript dates
from the late 16th century, it includes copies of
memorial notices first written in the 15th century.
Initial words of paragraphs in the older section are
formed of large, painted letters often filled with
zoomorphic or foliate forms.

References: O. Muneles, "Die Rabbiner der Altneuschul," *JB*, 5,
2(1969), 92 ff.; Sadek—Šedinová, "From the MSS Collections," 85–86.

250
Scroll of the *Vorhang* Purim
(Curtain Purim) Ms. 254
Prague, 1623
Ink on parchment
76.2 × 25.9

Scrolls like this one were modeled on the Story of
Esther, and like it commemorate an averted disaster. The
scroll of the *Vorhang* Purim tells of two innocent Jews
who were jailed because of the theft of curtains from a
castle in Prague.

References: A. Kisch, "Megillat pure ha-qela'im (Firheng Purim),"
Jubelschrift zum siebzigsten Geburtstage des Prof. Dr. H. Graetz
(Breslau: S. Schottlaender, 1887), pp. 48–52 (Hebrew); Lieben,
"Megillat Samuel," 307; V. Sadek, "Die jüdische Version der
Familienmegilla 'Vorhangpurim' aus dem Jahre 1623," *JB*, 4, 1(1968),
73–78; M. Steinschneider, *Die Geschichtsliteratur der Juden*, I
(Frankfurt a. M.: J. Kaufmann, 1905), pp. 113–114.

251
Prayer Book Ms. 89
Prague, after 1689
Ink on parchment
30 × 22; 41 fols.

In addition to the usual texts, this manuscript contains
a prayer commemorating the 1689 fire in the Prague
Jewish quarter. Initial words are formed of foliate letters
or are otherwise embellished.

Reference: Sadek—Šedinová, "From the MSS Collections," 75–6.

252
Prayer Book and Memorial Book
for the Altschul Ms. 114
Prague, 17th-18th century
Paint and ink on parchment
26.5 × 18.5; 24 fols.

Besides prayers and lists of deceased members, this
manuscript contains an elegy commemorating the 1689
fire in the Prague Jewish quarter and another for the
Jews of Strakonice in southern Bohemia. Initial words
of paragraphs are formed of enlarged red letters and
many of the pages are bordered by bands of foliage
inhabited by birds and animals.

Reference: Sadek—Šedinová, "From the MSS Collection," 86–87.

253
Scroll of Esther Ms. 417
Bohemia or Moravia(?), beginning of the 18th century
Ink, gouache, and gold paint on parchment
17.5 × 206

The text is written within rectangular frames surround-
ed by flowering vine scrolls inhabited by birds. The
treatment of the outer flap, its irregular contour and
central cartouche, as well as the inhabited vine scroll
motif, recall Italian scrolls.

254
Document Appointing David Oppenheim
as Rabbi in Prague 60.786
Scribes: Meir son of Elazar Perls and Isaak son of
Issachar Strashits
Prague, 1712
Ink on parchment
39.3 × 31; 2 fols.

This document was copied from the records of the
community meeting at which David Oppenheim was
appointed rabbi, head of the rabbinical court, and dean
of the *yeshivah* (seminary) of Prague. (See ch. II, p. 78)

Reference: S. H. Lieben, "Oppenheimiana," *Jahrbuch der Gesellschaft
für die Geschichte der Juden in der Čechoslovak[ischen] Republik,*
7(1935), 419–25.

255
Yozerot **(Additional Morning Prayers)**
for the Meisel Synagogue Ms. 242
Scribe: Shabbtai (Sheftl) son of Zalman Auerbach
Prague, 1719
Ink and gouache on parchment and paper
35 × 25; 45 fols.

This manuscript is decorated in a manner characteristic
of the "Moravian" school of illuminators. The title page
bears the figures of Moses and Aaron flanking the text;
above and below them are narrative scenes. Within the
book, initial words of major paragraphs are emphasized
by placement within panels embellished with inhabited
foliage or by enlargement and decoration of their
constituent letters.

Reference: Sadek, "Aus der Handschriftensammlung," 149.

256
Sefer Ma'avor Yabok Ms. 241
Aaron Berekhyah son of Moshe; Scribe:
Samuel Hayyim son of Judah Finklash Reich
Mikulov (Nikolsburg), Moravia, 1722
Ink and gouache on parchment
30 × 19.5; 32 fols.

This text concerning laws for visiting the sick, burial, and
mourning was commissioned by the officers of the Burial
and Benevolent Society of Mikulov whose names are listed
on the title page. The painted frontispiece also includes two
vignettes showing the work of society.

Reference: Sadek, "Aus der Handschriftensammlung," 147–148.

257 (Fig. 193)
Circumcision Book Ms. 243
Scribe: Aaron Wolf of Jevíčo (Gewitsch)
Vienna, 1728
Ink and gouache on parchment
14.4 × 9.5; 14 fols.

The text of this work is actually more extensive than its
title and frontispiece decoration would seem to indicate.
Beside the laws and prayers relating to circumcision, the
manuscript also contains the Grace after Meals and the
Wedding Service. Aaron Wolf of Jevíčo was a well-
known artist/scribe of the "Moravian" school who
executed commissions for wealthy court Jews, prin-
cipally in Vienna where he served as scribe to the
Imperial library.

References: Namenyi, "Illumination of Hebrew Manuscripts," p. 158;
Sadek, "Aus der Handschriftensammlung," 147.

258 (Fig. 43)
Haggadah **(Service Book) for Passover** Ms. 240
Scribe: Nathan son of Samson of Mezeříč (Meseritsch)
Moravia, 1728/9
Ink and gouache on parchment
31 × 19.5; 29 fols.

The text and illuminations of this manuscript are
largely based on the decoration of the Amsterdam
Haggadah printed in 1712, a debt which is acknow-
ledged on the frontispiece. Title pages that follow this
Amsterdam model feature standing figures of Moses
and Aaron flanking the text; above them is a scene of
Moses at the burning bush.

References: Sadek, "Aus der Handschriftensammlung," 145-147; "The
Michael Zagayski Collection," Parke-Bernet Galleries, New York, sales
catalogue, January 27–8, 1970, no. 149.

259
Prayer Book Ms. 256
Slavkov (Austerlitz), Moravia, 1734
Ink on parchment
37 × 21; 35 fols.

Reference: Sadek, "MSS Collections . . . (Illuminated Manuscripts),"
106.

260
Reader's Prayer Book Ms. 56
Scribe: Hayyim son of Abraham from Holešov
Kojetín (Kojetein), Moravia, 1740
Ink on parchment
19 × 16.5; 20 fols.

Reference: Sadek, "MSS Collections . . . (Illuminated Manuscripts),"
106–107.

261
Statutes of Moravian Jewry Ms. 203
Moravia, 1754
Ink on paper
34 × 21.5; 26 fols.

This book of statutes is written in Judeo-German (German written in Hebrew characters with an admixture of Hebrew words). Its full title is *General-Polizei-Prozess- und Kommerzialordnung für die Mährische Judenschaft* (General Policies, Procedures, and Commercial Regulations for Moravian Jewry).

References: W. Müller, *Urkundliche Beiträge zur Geschichte der mähr. Judenschaft im 17. und 18. Jahrhundert* (Olmütz: Laurenz Kullil, 1903), pp. 81–102.

262
***Mohel* (Circumcision) Book of David Mohr** Ms. 109
Scribe: Naftali Perl Weil of Wallerstein
Hořetice, Bohemia 1750–1804
Ink on paper
21 × 15; 28 fols.

This work is the record of circumcisions performed by David Mohr.

263
Book of Calendars Ms. 116
Bohemia, 1783
Ink on paper
23 × 18; 29 fols.

Several types of calendars are recorded including the record of market days.

Reference: V. Sadek—J. Šedinová, "De la collection des manuscrits du Musée Juif d'État de Prague (Miscellanea)," *JB*, 12, 2(1976), 114–5.

264
Privilege of Emperor Joseph II Allowing H. M. Jeitteles to Open a Pharmacy Sign. 32330
Vienna, 1783
Bistre on parchment
33 × 25; 8 fols.

On May 17, 1783, Joseph II granted the Jewish pharmacist Hirshl Mikhel Jeitteles the privilege of opening a pharmacy in the Jewish quarter of Prague. Each page of the text is surrounded by beautifully executed pen and ink marginalia of both general and specific character; for example, several drawings depict the preparation of pharmaceutical materials. A circular metal box enclosing the sealing is suspended from the back cover. The Jeitteles family pharmacy was still in existence in the 19th century.

References: V. Hamáčková, "Aus dem Archivmaterial—Das Apothekerprivilegium für H. M. Jeitteles aus dem Jahr 1783," *JB*, 16, 1(1980), 52–3, fig. 8; Lieben, *Jüdische Museum*, pl. 9.

265
Prayer Book from the Pinkas Synagogue Ms. 93
Prague, 1790
Ink and gouache on parchment
32.5 × 26; 73 fols.

This prayer book was commissioned by benefactors of the Pinkas Synagogue after the old one was destroyed by a flood in 1784. An entry concerning the disastrous fire in the Jewish quarter of Prague in the year 1689 is included. The composition of the frontispiece recalls those of printed books, but the elements are rendered in a folk style that is surprising in a work executed in the capital.

References: Sadek—Šedinová, "From the MSS Collections," 77–78.

266
Ziyyun le-Nefesh Ḥayyah
[Notes on the Talmudic tractate *Bezah*] Ms. 95
Ezekiel Landau (1713–1793)
Prague, 1799
Ink on paper
39 × 24.5; 64 fols.

This manuscript appears to have been the basis of the printed edition of this work (Prague, 1799), since both the text and the imprimator of the Prague Hebrew censor, Carolus Fischer, agree word for word.

Reference: V. Sadek, "The MSS Collections of the State Jewish Museum in Prague: Manuscript Works by Jewish Scholars in Bohemia and Moravia (18th–19th Centuries)," *JB*, 8, 1(1972), 20.

267
Cookbook Ms. 324
Bohemia or Moravia(?), 18th century
Ink on paper
16.5 × 21.5; 53 fols

One hundred and eleven recipes are contained in this Judeo-German cookbook which also features a table of contents.

Reference: V. Sadek—J. Šedinová, "De la collection des manuscrits du Musée juif d'Etat (Manuscrits en Juden-deutsch)," *JB*, 11, 2(1975), 111.

268 (Fig. 157)
Statutes of the Burial Society of Kounice Ms. 98
Scribe: Yaakov son of Benjamin, sexton of Kounice
Kounice, Moravia, 1801/1817
Ink and gouache on paper
41 × 25.5; 420 fols.

Burial societies were responsible for all aspects of preparations for interment. This text includes statutes of the society, annual financial statements, lists of graves, and contracts with individuals. One interesting miniature depicts the stoning of a heretic.

References: H. Flesch, "Zur Geschichte der mährischen 'Heiligen Vereine Chewra kadischa'," *Jahrbuch der Jüdisch-Literarischen Gesellschaft*, 21(1930), 217; H. Flesch, "Aus jüdischen Handschriften in Mähren," *Jahrbuch der Gesellschaft für Geschichte der Juden in der Čechoslovak[ischen] Republik*, 2(1930), 277; Sadek, "MSS Collections . . . (Illuminated Manuscripts)," 109–110.

269
Memorial Prayers for the Maisel Synagogue Ms. 73
Scribe: Abraham son of Isaac
Prague, 1813
Ink and gouache on paper
30 × 24.5; 20 fols.

The dedicatory text notes that this manuscript was
commissioned by Zalman son of Wein and his wife
Zeldi daughter of Izak Harfmar so that the memorial
prayers would be written in their proper order, a motive
that also inspired the donor of a similar volume for the
Klaus Synagogue of Prague (cat. 273).

Reference: Sadek—Šedinová, "From the MSS Collections," 93.

270
Prayer Book Ms. 1
Miroslav, Moravia, 1814
Ink and gouache on parchment
27.9 × 22.5; 80 fols.

This large prayer book for the synagogue in Miroslav
was commissioned by Joseph son of Solomon Koenig
and his wife Hindl daughter of Aaron Ber on the
occasion of the marriage of their oldest daughter Bilah.
It contains two miniatures, one of King Solomon
praying in the Temple that is based on printed models,
and another showing a quorum *(minyan)* of men in a
synagogue. The men are dressed in antiquated 18th-
century garb.

Reference: Sadek, "MSS Collections . . . (Illuminated Manuscripts),"
109.

271
Scroll of Golčův Jeníkov Ms. 253
Simon Meir
Golčův Jeníkov (Goltsch-Jenikau), Bohemia, 1817
Ink on parchment
23.5 × 53

Simon and Rina Meir commissioned this scroll to
record the survival of their child who was buried under
a collapsed house for three hours. It is an example of a
family's commemoration of a life-saving incident that is
modeled on the Scroll of Esther.

References: S. H. Lieben, "Megillat Samuel," 312-337; Sadek, "From
the MSS Collections of the State Jewish Museum (MSS of Historical
Contents)," *JB,* 10, 1(1973), 17–18.

272
Memorial Prayers for the Pinkas Synagogue Ms. 74
Scribe: Simhah Plon
Prague, 1822
Ink and gouache on parchment and paper
31.5 × 22; 20 fols.

This manuscript was commissioned by the Burial
Society associated with the Pinkas Synagogue. Above
each memorial citation is a pocket to hold a movable
metal marker for indicating which name is to be read.
A prayer for Emperor Ferdinand I is also included.

Reference: Sadek, "MSS Collections . . . (Illuminated Manuscripts),"
108.

273
Memorial Prayers *(Hazkarot)* **of the Klaus
Synagogue** Ms. 78
Prague, 1824
Ink on paper
32.5 × 20.5; 14 fols.

In the dedication recorded on the title page, the donor
Simon son of Leib Austerlitz notes that he commis-
sioned this work, which includes memorial prayers for
holidays as well as Sabbaths, so that the cantor would
no longer have to search among various books for the
prayers.

274
Statutes of the Prostějov Burial Society Ms. 65
Scribe: Michael, scribe in Prostějov
Prostějov (Prossnitz), Moravia, 1825–71
Ink and gouache on parchment and paper
31 × 22.5; 55 fols.

Prostějov was a leading Jewish community in central
Moravia whose origins dated back to the 15th century.
This work contains decrees, lists of numbers, and
records from 1767 until 1871. The year 1825 given on
the title page is the date the scribe began this
manuscript.

Reference: Sadek, "MSS Collections . . . (Illuminated Manuscripts),"
111.

275
Wash Book of Netti Winter Ms. 310
Těšetice, Moravia, 1832
Ink on paper
18.7 × 11.5; 37 fols.

Each page of this Judeo-German manuscript is devoted
to a different type of household linen, and is cut into
numbered flaps which could be folded back to indicate
the total sent out for laundering. According to the
dedicatory inscription, the book was a wedding gift.

276 (Fig. 187)
Scroll of Esther Ms. 327
Moravia (?), 19th century
Ink and gouache on parchment
32.9 × 292

The text is framed by a series of arches filled with
flowering scrolls executed in green and red gouache.

Reference: J. Šedinová, "From the MSS Collections of the State Jewish
Museum in Prague—The Scrolls of Esther," *JB,* 15, 2(1979), 85.

277 (Figs. 58, 161)
**Sabbath Songs, Grace after Meals
and Blessings** Sign. 64981
Printed by Gershom son of Solomon ha–Kohen,
Meir son of Jacob Halevi, Hayyim son of David
Schwartz and Meir son of David
Prague, 1514
Ink on paper with hand-painted woodcuts
13.6 × 18.8; 48 fols.

This rare text is one of the first Hebrew books printed
in Prague, and the earliest complete book that is
preserved. Its fine, clear typeface is a hallmark of
Prague printing of the 16th century. The book is
decorated with woodcuts including two fully realized
narrative scenes, each of which is repeated twice and
hand painted: a hare hunt (see above pp. 62–65) and a
festive meal.

References: O. Muneles, *Bibliografický přehled židovské Prahy* (Prague:
Orbis, 1952), p. 13; Namenyi, "Illumination of Hebrew Manuscripts,"
171; Nosek, "Drucke der Gersoniden," 15 ff.; B. Nosek, "Les imprimés
hébräiques les plus anciens de Prague provenant des fonds du Musée
juif d'État," *JB*, 16, 1(1980), 42–43.

278 (Fig. 57, 135)
**Pentateuch, *Haftarot* (Passages from
Prophets) and *Megillot* (Scrolls)** Sign. 2361
Printed by: Gershom son of Solomon ha-Kohen,
Mordecai son of Gershom ha-Kohen, and Solomon son
of Gershom ha-Kohen.
Prague, 1530
Ink on paper
35.5 × 24.5; 545 pp.

These three texts are often published together as all are
required reading during synagogue services. The 1530
edition of the Pentateuch was the second produced in
Prague by this family of printers, known as the
Gersonides. Each of the title pages of the five books of
the Bible are decorated with Renaissance figural,
architectural, and vegetal motifs.

References: O. Muneles, *Bibliografický přehled židovské Prahy* (Prague:
Orbis, 1952), p. 14; Nosek, "Drucke der Gersoniden" 13; B. Nosek,
"Les imprimés hébräiques les plus anciens de Prague provenant des
fonds du Musée juif d'État," *JB*, 16, 1(1980), 42–46; M. Steinschneider,
Catalogus Librorum Hebraeorum in Biblioteca Bodleiana, Vol. I
(Berlin: Friedlaender, 1852), no. 64; L. Zunz, *Zur Geschichte und
Literatur* (Berlin: Louis Lamm, 1845), pp. 253, 278.

279
Responsa Concerning the *Aguna* Sign. 4778
Rabbi Jacob Pollak
Printed by Solomon son of Mordecai ha–Kohen Katz
and Moses son of Joseph Bezalel ha–Kohen Katz
Prague, 1594
Ink on paper
17.9 × 14; 20 fols.

This work printed by the Gersonides family contains
opinions of Rabbi Jacob Pollak of Poland delivered in
answer to legal questions concerning the *aguna* (desert-
ed wife). A responsum of Rabbi Pollak's teacher, Rabbi
Judah Loew of Prague, is also included. Perhaps due to
the subject matter, woodcuts of Adam and Eve were
chosen to decorate the frontispiece.

References: L. Zunz, *Zur Geschichte und Literatur* (Berlin: Louis
Lamm, 1845), pp. 253, 278; O. Muneles, *Bibliografický přehled
židovské Prahy*, (Prague: Orbis, 1952), pp. 35:22; Nosek, "Drucke der
Gersoniden," 34.

280
At the Crossroads Sign. 6046
Vojtěch Rakous
Illustrated by A. Kašpar
Prague, 1914
Ink on paper
10.2 × 5

281
**Česko-Židovský Kalendář
(Czech-Jewish Calendar)** Sign. P. C. 16/49
Prague, 1933-34
Ink on paper
32.5 × 20.5 (open)

282 (Fig. 60)
Flag of Solomon Molcho 32.755
Probably Italy, before 1628
Silk embroidered with silk; silk fringe
50 × 95

Solomon Molcho (ca. 1500-1532) was born in Lisbon of
a Marrano family. He had attained a high position in
the Portuguese government when he met David
Reuveni, the pseudo-Messiah, in 1525 and decided to
declare his Jewish faith. After fleeing Portugal, Molcho
appears to have traveled through the Mediterranean
littoral, studying *kabbalah*, and arrived in Italy in 1529.
By this time, Molcho was convinced that he was the
Messiah. The next years were filled with various
attempts on his life. In 1532, Molcho and Reuveni
visited Emperor Charles V at Regensburg. He was said
to have carried this flag on that mission. Subsequently
Molcho was burned at the stake and the flag and his
robe were acquired by members of the Horowitz family
who installed these relics in their synagogue (the
Pinkas) by 1628. The lengthy inscriptions embroidered
on the flag are drawn from the Prophets and Writings.

Side 1:

*"Vindicate me, O God, champion my cause against
faithless people; rescue me from treacherous, dishonest
man"* (Ps. 43:1). *"Speak tenderly to Jerusalem,/ and
declare to her/That her term of service is over,/ That
her iniquity is expiated;/ For she has received at the
hand of the Lord/ Double for all her sins"* (Is. 40:2).
*"Let the heavens rejoice and the earth exult; let the sea
and all within it thunder"* (Ps. 96:11). *"[The Lord] of
hosts is with us; the God of Jacob is our haven. Selah"*
(Ps. 46:8). *"Pour out Your fury on the nations that do
not know You, upon the kingdoms that do not invoke
Your name"* (Ps. 79:6). *"Deal with them as You did
with Midian, with Sisera, with Jabin, at the brook
Kishon—who were destroyed at En-dor, who became
dung for the field"* (Ps. 83:10– 11). *"Oh, pursue them
in wrath and destroy them/ From under the heavens of
the Lord!"* (Lam. 3:66). *"O God, do not be silent; do
not hold aloof; do not be quiet, O God!"* (Ps. 83:2).
*"God ascends midst acclamation; the Lord, to the blasts
of the horn"* (Ps. 47:6). *"God of retribution, Lord, God
of retribution, appear!"* (Ps. 94:1). *"He subjects peoples
to us, sets nations at our feet"* (Ps. 47:4).

Side 2:

"God reigns over the nations; God is seated on His holy throne" (Ps. 47:9).
"Who trained my hands for battle, So that my arms can bend a bow of bronze!" (II Sam. 22:35).
"I pursued my enemies and wiped them out, I did not turn back till I destroyed them" (II Sam. 22:38).
"Strike fear into them O Lord; let the nations know they are only men. Selah" (Ps. 9:21).
"Sing Him a new song; play sweetly with shouts of joy" (Ps. 33:3).
"Keeping all his bones intact, not one of them being broken" (Ps. 34:21).
"There He broke the fiery arrows of the bow, the shield and the sword of war. Selah" (Ps. 76:4).
"Give us joy for as long as You have afflicted us, for the years we have suffered misfortune" (Ps. 90:15).
"A song of ascents. Out of the depths I call You, O Lord" (Ps. 130:1).
"They sharpen their tongues like serpents; spider's poison is on their lips. Selah" (Ps. 140:4).

References: EJ, XII, cols. 225–7, ill.; A. Grotte, "Die 'Reliquien' des Salomo Molcho," *Monatschrift für Geschichte und Wissenschaft des Judentums* 67, 167–170; O. Herbemová, "Roucho Šalamouna Molcha," *Věstník židovských náboženských obcí v Československu,* XX/1957, 1, 5; Muneles, *Prague Ghetto,* p. 32, pl. 16.; V. Sadek, "Etendard et robe de Salamon Molko," *JB,* 16, 1 (1980), 64; Volavková, *Průvdoce,* 10.

283
Seal of Rabbi Salomon Judah Leib Rapoport (1790-1867) 63.768
Prague, ca. 1840
Engraved brass and laquered wood
10 × 3.4

German inscription around rim:

Salomon L. Rapoport Rabbiner und Erster Oberjurist in Prag
". . . Rabbi and First Chief Jurist in Prague."

In the center of the seal are three columns, linked together, inscribed:

Recht—Wahrheit—Friede
"Right—Truth—Peace"

Rapoport was appointed chief rabbi of Prague in 1840.

Provenance: Old Jewish Museum, Prague
Reference: Berlin, *Historica Hebraica,* no. B46.

284
Medal and Case 61.756
Wenzel Seidan (1817-1870); Manufacturer: Desaide-Roquelay
Paris, 1860 (designed in Vienna)
Medal: silver; case: leather, velvet and satin with printed gold lettering
Medal: 7.5 dm; case: 8.8 dm.

This medal was issued in 1860 to commemorate the granting of the right to own real property by Emperor Joseph I to the Jews of the Austrian Empire. Numerous examples of this medal are in the Prague Museum, since most Jewish communities proudly acquired one in individualized cases inscribed with the name of the community. The case for this medal is inscribed on the outside:

נעשה ונגמור בכי טוב להיות לעדה לקק בשנת בריתי
אקים בני ובניכם לפק
הזכרון הזה יהיה לכם לברית שלום עד עולם אמן

"Made and completed successfully to be for the community of the h[oly] c[ongregation] in the year 'but my covenant I will maintain between Me and you'[1] [variation on Ex. 17:10, 21]. May this be a reminder of the everlasting covenant of peace. Amen."

Inside the cover of the case there is a German inscription:

Gewidmet der ehrsamen Isr:Cultus-Gemeinde in Trebitsch.
"Dedicated to the honorable Je[wish] religious community in Třebíč."

The obverse of the medal bears a German inscription on the bottom:

ZUR ERRINERUNG AN DIE DURCH SEINE MAJESTAET DEN KAISER FRANZ JOSEPH I DEN ISRAELITEN IM GANZEN OESTERREICHISCHEN KAISERSTATE GEWAEHRTE REALBEZITZFAEHIGKEIT. MDCCCLX.

"In commemoration of the real estate activity of the Jews in the whole Austrian Imperial State, guaranteed by his majesty the Emperor Franz Joseph I. 1860.",

and a second one around the rim:

DIE ISRAELITEN DEINES GANZEN REICHS SIE BAUEN EINEN ALTAR IN IHREM HERZEN. EIN EWIGES DENKMAL IHRER DANKBARKEIT.

"The Jews of your whole empire are building an altar in their hearts, an eternal monument of their gratitude."

A woman, symbolizing the Empire, stands at left with a horn of plenty at her feet and holds a scroll inscribed in Hebrew:

גוי אחד ועם אחד

"One nation and one people."

At right, a youth carries a palm branch and a laurel wreath with which to honor the Emperor whose profile portrait appears on an altar in the center, surmounted by Tablets of the Law bearing the Hebrew inscription:

משפט אחד יהיה לכל בך

"One law for all in you" (variation on Lev. 24:22).

On the reverse a German inscription appears around the rim:

DIE ZWEITE HAELFTE DES XIX JAHRHUNDERTS IST FUER OESTERREICHS VOELKER DAS DER CIVILISATION, HUMANITAET UND DER FREIEN INDUSTRIELLEN ENTWICKELUNG.

"The second half of the 19th century is for Austria's peoples that of civilization, humanitarianism, and of free industrial development."

The German inscription in the center of the reverse contains the texts of two imperial decrees of February 18, 1860 regarding the right of Jews to own real property.

Provenance: Třebíč (Trebitsch), Moravia

Note: [1]The gold writing on the velvet is too worn to discern where any diacritical marks might have been placed in the inscription and therefore the chronogram cannot be determined. We can assume, however, a date ca. 1860 because of the date of manufacture of the medal.

References: Berger, *Judaica,* Inv. no. 1053; Daniel M. Friedenberg, *Great Jewish Portraits in Metal* (Schocken Books for The Jewish Museum, New York, 1963), p. 37; The Jewish Museum, New York, *Coins Reveal* (1983), no. 127.

285
Design for Poster Competition for the Second Mánes Exhibition 157.153
Adolf Wiesner (1871–1942)
Prague, 1897
Pastel on paper
Signed bottom center: 1897 Ad. Wiesner
57 × 42; framed: 60 × 45

Adolf Wiesner, a Jewish artist and founding member of the Prague Artists' Union, Mánes, won first prize in the competition for a poster for the group's 1897 exhibition in the Topičův Salon, a Prague publishing house. Three shields, each enclosing a *fin-de-siècle* woman with an attribute, symbolize three branches of the visual arts: painting, sculpture and applied arts. These shields seem to have become emblematic of the Mánes group, as they appear twice on the bow of a ship in the poster for the 1898 exhibition.[1] A white abstracted painter's palette and tall thin trees (a common *jugendstil* motif) comprise the background.

On the verso there is a Czech dedicatory inscription in the artist's hand to Jan Štenc, a publisher of avant-garde art. In 1899 Wiesner went to France to work and exhibit, returning to Prague in 1910. He died in the camp at Terezín.

Note: [1]Poster by Arnošt Hofbauer. See Walter Koschatzky and Horst-Herbert Kossatz, *Ornamental Posters of the Vienna Secession,* (New York: St. Martin's Press, 1974), no. 5, ill. p. 46 (printed upside down).

Reference: Prokop Toman, *Nový slovník československých výtvarných umělců,* II (Prague, 1950), p. 701.

286 (Fig. 218)
Skullcap 174.330
Terezín (Theresienstadt), 1945
Felt embroidered with cotton thread
10 × 17 dm.

Inscription: *"Theresienstadt 1945."*

287 (Fig. 218)
Hanukkah Menorah 101.871
Terezín (Theresienstadt), 1944
Wood inscribed with ink
24 × 24.5 × 11

Inscription: *"Hanukkah / 1944 / Terezín."*

288 (Fig. 218)
Tiered Passover Plate 101.865
Terezín (Theresienstadt), 1944
Wood inscribed with ink and stained; cotton reinforced with copper wire
16.5 × 32 dm.

Inscription: *Die Jugendfürsorge dem Judenaltesten Theresienstadt, den 4. III. 1944.*
"The Child Welfare Board of the Jewish Council of Elders Theresienstadt, March 4, 1944." The names of the symbolic foods eaten during the Passover *seder* also appear.

289 (Fig. 218)
Passover Cup 175.883
Terezín (Theresienstadt), 1941-45
Glazed and painted ceramic
8 × 6.5 dm.

Inscription: *"Passover, 537."*

290 (Fig. 218)
Star of David 174.846
Terezín (Theresienstadt), 1941-45
Carved wood
1.5 × 10 × 1

291
Transport Suitcase 173.012
Prague, 1942-45
Leather; cardboard
50 × 32 × 13

Inscription: *Otto Schwarzkopf, Krásnohorská 4, Praha,* [and the transport number] *AAL 351X.*

292
Interior at Terezín 129.406
Hana Grünfeldová; born May 20, 1935; deported to Terezín February 14, 1941; survived Terezín
Terezín (Theresienstadt), 1944
Pencil and watercolor on paper
Signed: Hana Grünfeld. VI 1944 4B
15 × 21

293
Girl at a Window 121.515
Unidentified Artist
Terezín (Theresienstadt), 1941-45
Pencil on paper
19.5 × 24

294
Sunset Behind the Mountains 121.647
Renka . . .
Terezín (Theresienstadt), 1941-45
Pastel on paper
Signed: Renka
21 × 25.5

295
The Swimming Place 133.567
Eva Wollsteinerová; born January 24, 1931; deported to
Terezín April 8, 1942; deported to Auschwitz October 23,
1944; perished in Auschwitz
Terezín (Theresienstadt), April 26, 1944
Pencil and Pastel on paper
Signed: Block III; 26/IV.44. Wollsteinerová, Eva
23.5 × 25

296
From the Barracks at Terezín 25.437
Walter Eisner; born November 3, 1933; deported to
Terezín November 20, 1942; deported to Auschwitz
January 20, 1943; perished in Auschwitz
Terezín (Theresienstadt), 1942-43
Pencil on wood panel
Signed: Eisner x
26 × 22

297
Princess and a Dragon 133.512
Berta Kohnová; born September 11, 1931; deported to
Terezín October 24, 1942; deported to Auschwitz May 18,
1944; perished in Auschwitz
Terezín (Theresienstadt), 1942-44
Pencil and pastel on paper
Signed: Kohn Berta H m H[a]m[burg]?
19 × 33

298
A Wedding of Butterflies 129.379
Ilona Weissová; born March 6, 1932; deported to Terezín
December 14, 1942; deported to Auschwitz May 15, 1944;
perished in Auschwitz
Terezín (Theresienstadt), 1942–44
Pencil and pastel pencil on paper
Signed: Ilona Weissová. Block IV.
21.5 × 34

ENDNOTES

Chapter I

[1] Thanks are due to the following people who read the manuscript and who generously gave constructive advice: Professor Hillel Kieval, Brandeis University; Professor Arnošt Lustig, The American University; Dr. Sybil Milton, The Leo Baeck Institute; Dr. Robert Wolfe, The United States National Archives.
[2] Documents 171-PS and 286-PS, Office of U.S. Chief of Counsel, International Military Tribunal, Nuremberg, National Archive Record Group 238.
[3] Hana Volavková, *Story* (Prague: Artia, 1968) 28.
[4] *Ibid.*, 60.
[5] The Pinkas Synagogue memorial list currently is being restored and therefore is closed to the public.

Chapter II

[1] See note 5, chapter one.
[2] Franz Kafka, *The Complete Stories* (New York, 1946), 399.
[3] A. Kara, "Et kol ha-tela'ah asher meza'atnu," in H. Volavková, *The Story of the Jewish Museum in Prague* (Prague, 1968), 253–254.
[4] Frederic Thieberger, *The Great Rabbi Loew of Prague* (London, 1955), 1.
[5] Quoted in George Alter, *Two Renaissance Astronomers: David Gans, Joseph Delmedigo* (Prague, 1958), 31–32.
[6] Quoted in Alter, *Two Renaissance Astronomers*, 29.
[7] Yom Tov Lipmann Heller, *Megillat Eva* (Vienna, 1862), 8–11. Translated by the author.
[8] "Statutes of the Jewish Tailors' Guild of Prague, 1690," in M. Wischnitzer, *A History of Jewish Crafts and Guilds* (New York, 1965), 283–285.
[9] A. F. Pribram, ed., *Urkunden und Akten zur Geschichte der Juden in Wien.* Vol. 1 (Leipzig, 1918), 476. Translated by the author.

[10] Ezekiel Landau, *Derushei ha-Zelah* (Warsaw, 1886), fol. 53b. Translated by the author.
[11] Quoted in Guido Kisch, *In Search of Freedom: A History of American Jews from Czechoslovakia*, (London, 1949), 209.
[12] *Selbstwehr*, March 1, 1907, 1. Translated by the author.

Chapter III

[1] *Ethics of the Fathers* 2:4.
[2] Among Ashkenazi Jews, the naming of a female child takes place at the time of the reading of the Torah. All Jewish boys are named at circumcision, a ceremony that normally takes place in the presence of ten men, though if necessary, it may be held without that quorum. An important part of the Jewish marriage ceremony, the seven blessings *(sheva brakhot)* can only be said in the presence of a minyan. The same is true of the kaddish, the prayer recited by mourners.
[3] Jan Heřman, "Jewish Community Archives from Bohemia and Moravia," *Judaica Bohemiae*, 7,1(1971), 4. (Hereafter, *JB*.)
[4] Jiřina Šedinová, "Old Czech Legends in the Work of David Gans (1592)," *JB*, 14,2(1978), 109.
[5] Zdenka Munzer, *Die Altneusynagoge in Prag*, (Prague) (1978) Heinr. Mercy Sohn, 1932), 39–47.
[6] See Thérèse and Mendel Metzger, *Jewish Life in the Middle Ages* (New York: Alpine, 1982), 59–75.
[7] The second of the ten commandments prohibits the making of "a sculptured image, or any likeness of what is in the heavens above, or on the earth below, or in the waters under the earth. You shall not bow down to them or serve them . . ." (Ex. 20:4–5). Jewish interpretation of this prohibition has varied according to time and place. For example, the strict iconoclasm of Muslim religious art led to a similar avoidance of figural imagery in the decoration of synagogues and Hebrew manuscripts

produced in Islamic countries from the seventh century on, whereas Jews resident in Christian Europe sometimes incorporated human and animal figures into their religious art under the influence of church art. However, during the Middle Ages when the Altneuschul was built, those rabbis who allowed figural decoration in the synagogues generally permitted paintings, not sculpture, since sculpture was considered to be more closely associated with idolatry; though Maimonides, in a lenient view, saw nothing amiss in the sculpture of animals. [See Cecil Roth, *Jewish Art: An Illustrated History*, rev. ed., (Greenwich, Conn.: New York Graphic Society Ltd., 1971), 14–5, for quotations from various rabbinic writings.] In any case, the incorporation of human figural sculpture similar to that found on the doorways and columns of most Gothic churches would have been unthinkable in a contemporaneous synagogue.

[8]Hana Volavková; *The Pinkas Synagogue* (Prague: Státní pedagogické nakladaetství, 1955), 43–49.

[9]For a discussion of this epitaph, see Volavková, *Pinkas Synagogue*, 82–83.

[10]Richard Krautheimer, *Mittelalterliche Synagogen* (Berlin: Frankfurter Verlags-Anstalt, 1927), 239.

[11]See George K. Loukomski, *Jewish Art in European Synagogues* (London: Hutchingson & Co., 1947), pls. 150–1.

[12]Ex. 25:17; 26:31–4.

[13]For laws governing the writing of a brah, see Shulḥan Arukh, Yoreh Deah, ch. 271 ff.

[14]The imperative to perform religious commandments in the most beautiful way is known as *hiddur mitzvah* and is based on a biblical passage (Ex. 15:2). For the sources which discuss this concept, see M. Berlin and J. Zevin, eds., *Talmudic Encyclopedia*, vol. VII (Jerusalem: , 1957), 271–84 (Hebrew).

[15]Volavková, *Pinkas Synagogue*, 94.

[16]Metalwork signed by Jewish goldsmiths is rare prior to the establishment of the Jewish goldsmiths' guild in the early 19th century. (See Mark Wischnitzer, *A History of Jewish Crafts and Guilds* (New York: Jonathan David, 1965), 160.

[17]Ludmila Kybalová, "Die ältesten Thoramäntel aus der Textiliensammlung des Staatlichen Jüdischen Museums in Prag (1592–1750)," *JB*, 9,1(1973), 24–5.

[18]Jan Heřman, "Die Wirtschaftliche Betätigung und die Beruf der Prager Juden vor ihrer Ausweisung in Jahre 1541," *JB*, 4,1(1968), 38–9.

[19]Milena Zeminová, *Barokní Textilie* (Prague: ze sbůrek Umělecko průmyslovéhomuzea v Praze, 1974), 7.

[20]Zoroslava Drobná, *Les Trésors de la Broderie Religieuse in Tchécoslovaquie* (Prague: Sfinx, 1950), 7.

[21]Drobna, *Trésors*, 14–15.

[22]Otto Muneles, ed ., *Prague Ghetto in the Renaissance Period* (Prague: Orbis, 1965), 107; Wischnitzer, *Crafts and Guilds*, 156–68; Tobias Jacobovits, "Die jüdischen Zünfte in Prag," *Jahrbuch der Gesellschaft für Geschichte der Juden in der Čechoslov. Republik*, 8 (1936), 57–74.

[23]Bernhard Brilling, "Der Begriff 'Erlentes Handwerk' in den Prager Judenprivilegium von 1627 und 1648," *JB*, 5,2(1969), 140 ff. Jacobovitz, "Zünfte," 74 ff.

[24]Tailoring was one of the few guild-controlled crafts which Jews were allowed to practice on a limited scale even during the Middle Ages, because of the necessity of conforming with the biblical injunction against wearing garments containing a mix of linen and wool *(shaatnez)*. (Lev. 19:19; Deut. 22:11.)

[25]Jana Čermáková, "Rideaux de Tabernacle des Synagogues du 16e et 17e Siècles (partie de la collection textile du Musée juif d'État)" *JB*, 18,1(1982), 30–1.

[26]See Hana Volavková, *A Story of the Jewish Museum in Prague* (Prague: Artia, 1968), fig. 81, for an illustration of the Perlsticker curtain.

[27]See Zeminová, *Barokní Textilie*, fig. 63 (for a fabric similar to mantle no. 12.664), fig. 8 (for embroidery techniques similar to the curtain no. 16.703 and the mantle no. 32.105) and fig. 13 (for a composition similar to that of the curtain just cited).

[28]Čermáková, "Rideaux," 24–5; Kybalová, "ältesten Thormäntel," 31.

[29]*Ethics of the Fathers* 4:17.

[30]Muneles, *Prague Ghetto*, fig. 27.

[31]Jana Doleželová, "Binders and Festive Covers from the Collection of the State Jewish Museum in Prague," *JB*, 10,2 (1974), 103–4.

[32]Jana Doleželová, "Die Sammlung der Thorwickel," *JB*, 16,1(1980), 60.

[33]Doleželová, "Binders and Festive Covers," 100.

[34]For the complete text of the circumcision ceremony, see *Daily Prayer Book*, trans. by Philip Birnbaum (New York: Hebrew Publishing Company, 1949), 741–4.

[35]Josef Hráský, "La corporation juive d'orfèvrerie: *JB*, 2,1(1966), 21 ff.

[36]See no. 22.

[37]Hráský, "La corporation juive," 26; Jacobovits, "Zünfte," 129.

[38]Hráský, "La corporation juive," 21; Jacobovits, "Zünfte," 87–8.

[39]Muneles, *Prague Ghetto*, 124.

[40]Similar alms boxes once also belonged to Hessen synagogues. (See Heinrich Frauberger, "Über alte Kultusgegenstände in Synagoge und Haus," *Mitteilungen der Gesellschaft zur Erforschung jüdischen Kunstdenkmäler*, 3–4 (1903), figs. 91–2.)

[41]Muneles, *Prague Ghetto*, figs. 42 and 56–7.

[42]Vladimir Sadek, "R. Loew—sa vie, heritage pédagogique et sa légende," *JB*, 15,1(1979), 32–3; Lecture by Ismar Schorsch, The Jewish Museum, April 10, 1983.

[43]Alms are shown being collected at various phases of the funeral described in the burial society cycle of paintings discussed below. (see cats. 177–191)

[44]For a brief discussion of the evolution in communal responsibility for burial, see "Hevra Kaddisha, " *Encyclopaedia Judaica, vol. VIII (Jerusalem, 1971)* col. 442–3.

[45]See figs. 138–152 for illustrations of the entire cycle.

[46]For a detailed discussion of Bohemian and Moravian beakers and their function see Isaiah Shachar, "'Feast and Rejoice in Brotherly Love': Burial Society Glasses and Jugs from Bohemia and Moravia," *The Israel Museum News* 9 (1972), 22–51.

[47]For example, see J. Rawson, ed. *Animals in Art*, London: 1977, pl.1.

[48]Shachar, "Feast and Rejoice," no. 1; Stephen Kayser and Guido Schoenberger, eds., (Philadelphia; The Jewish Publication Society of America, 1959), *Jewish Ceremonial Art*, nos. 174–174a.

[49]See Shachar, "Feast and Rejoice," no. 2, for an illustration of the second.

[50]I am indebted to Emily D. Bilski for this and other observations relating to the paintings and beakers which are incorporated in this discussion.

[51]Shachar, "Feast and Rejoice," 37 ff.

Chapter IV

[1]Babylonian Talmud, *Kiddushin*, 29a.

[1a]Abraham Joshua Heschel, *A Philosophy of Judaism: God in Search of Man* (Philadelphia: Jewish Publication Society of America, 1956) 418.

[2]Jana Doleželová, Jana Čermáková, Arno Pařík, "Acquisitions to the Collections of the State Jewish Museum in Prague in the Years 1976–1980," *JB*, 18:1(1982), 33–42.

[3]For a discussion of the relationship between Jewish ritual requirements and style, see New York, The Jewish Museum, "Introduction," by Vivian B. Mann, *A Tale of Two Cities: Jewish Life in Frankfurt and Istanbul 1750–1870*, exhibition catalogue, 1982, 17–23.
[4]The binding of the words on the hand and forehead will be discussed below.
[5]For examples of silver mezuzot in the Prague collection, see Renata Krüger, *Die Kunst der Synagoge* (Leipzig: Koehler & Amelang, 1968), pl. 79.
[6]Ex. 23:19, 34:26; Deut. 14:21.
[7]Jana Doleželová, "Die Sammlung der Thorawickel," *JB*, 16:1 (1980), 62.
[8]For a listing, see New York, The Jewish Museum, *A Tale of Two Cities*, no. 77. Two other examples are in the collection of Det Mosaiske Troessamfund, Copenhagen, nos. 242 and 243.
[9]For the requirements, see Babylonian Talmud, *Pesaḥim* 108b; *Berakhot* 51a.
[10]The two loaves symbolize the double portion of manna gathered by the children of Israel in the wilderness in preparation for the Sabbath (Ex. 16:22 ff).
[11]Mordecai Narkiss, "Origins of the Spice Box," *Journal of Jewish Art* VIII(1981), 30.
[12]For examples of fruit-shaped spice containers of East European provenance, see Stephen Kayser and Guido Schoenberger, eds. *Jewish Ceremonial Art*, (Philadelphia: The Jewish Publication Society of America, 1959), nos. 91–94.
[13]Shofarot were also owned by individuals skilled in their blowing. Also, a single synagogue might possess more than one shofar, so that no exact correspondence should be made between the number of shofarot now in the State Jewish Museum and the number of pre-World War II synagogues.
[14]In some Jewish communities of southern Germany, women wore a special garment on Yom Kippur known as a woman's tallit.
[15]For an illustration of synagogue procession with etrog and lulav see Krüger, *Kunst der Synagoge*, pl. 22.

[16]See "Purim Furhang," *The Jewish Encyclopedia*, vol. VII, (New York: 1907), 281.
[17]See "Hanukkah," *Encyclopaedia Judaica*, vol. VII, (Jerusalem: 1971), cols. 1283–4.
[18]Babylonian Talmud, Shabbat, 21b.
[19]For examples of Hanukkah lamps with architectural decoration and their counterparts in actual buildings, see Jerusalem, The Israel Museum, *Architecture in the Hanukkah Lamp*, exhibition catalogue, 1978.
[20]For an extensive discussion of the earliest medieval lamps see Bezalel Narkiss, "Un objet de culte: la lampe de Hanuka," *Art et archéologie des Juifs en France médievalé* (Toulouse: Privat, 1980), 187–206.
[21]For example, The Israel Museum, *Hanukkah Lamp*, pl. 1.
[22]For example, Manchester, *Treasures*, no. M145.
[23]I Kings 19:10,14; Malachi 1:23.
[24]For the text, see ch. III, no. 32.
[25]Hana Volávková, *The Synagogue Treasures of Bohemia and Moravia* (Prague: Sfinx, 1949), no. 89.
[26]I Samuel 2:35; II Kings 1:38.
[27]See note for cat. 203.
[28]Vladimir Sadek, "Grabsteine mit Figurmotiven auf dem alten jüdischen Friedhof in Prag," *Judaica Bohemiae* 14, 2 (1978); 276–78.

Chapter V

[1]Thanks are due once again to Professor Arnošt Lustig and Dr. Sybil Milton for reading the manuscript.
[2]Volavková, *Story*, 294.
[3]Karel Lagus, "Overture," *Terezín* (Prague: Council of Jewish Communities in the Czech Lands, 1965) 11.

BIBLIOGRAPHY

Adler, H. G. *Theresienstadt 1941–1945.* 2d rev. ed. Tübingen: Mohr-Siebeck, 1960.

———. *Die verheimlichte Wahrheit: Theresienstaedter Dokumente.* Tübingen: Mohr-Siebeck, 1958.

Alter, George. *Two Renaissance Astronomers: David Gans, Joseph Delmedigo.* Prague: Česko Slovenská Akademia Věd, 1958.

Barnett, R. D., ed. *Catalogue of the Permanent and Loan Collections of the Jewish Museum, London.* London: Harvey Miller, 1974.

Berger, Max. *Judaica; Die Sammlung Berger, Kult und Kultur des europäischen Judentums.* Vienna-Munich: Jugend und Volk, 1979.
[Berger, *Judaica.*]*

Bergl, J. "Die Ausweisung der Juden aus Prag im Jahre 1744," in *Die Juden in Prag,* pp. 187–247. Prague: Loge Praga I.O.B.B., 1927.

Berlin, Jüdischen Gemeindehaus Berlin, *Historica Hebraica. Jüdische Kunst—Kultur und Geschichte aus dem Staatlichen Jüdischen Museum Prag,* exhibition catalogue, 1965.
[Berlin, *Historica Hebraica.*]

Beuque, Emile. *Dictionnaire des Poinçons.* Paris: Imprimerie C. Courtois, 1925.
[Beuque]

Bihl, Wolfdieter. "Die Juden," in *Die Habsburgermonarchie, 1848–1918.* A. Wandruszka and P. Urbanitsch, eds., Vol. 3, pp. 880–948. Vienna: Österreichische Akademie der Wissenschaften, 1980.

Blaschka, Anton. "Die jüdische Gemeinde zu Ausgang des Mittelalters," in *Die Juden in Prag,* pp. 58–87. Prague: Loge Praga I.O.B.B., 1927.

Bondy, G., and F. Dvorsky, eds. *Zur Geschichte der Juden in Böhmen, Mähren und Schlesien von 906 bis 1620.* Prague: G. Bondy, 1906.

Bratislava, Slovenské národné múzeum v Bratislave, *Ars Judaica Bohemiae,* exhibition catalogue, 1968.
[Bratislava, *Ars Judaica.*]

Brilling, Bernhard. "Der Begriff 'erlentes Handwerk' in der Prager Judenprivilegien von 1627 und 1648," *Judaica Bohemiae* 5,2 (1961): 140–42.

Celakovsky, J. *Prispevky k dejinam zidu v dobe Jagellonske* [Contributions to the History of the Jews during the Jagiellon Dynasty]. Prague: J. Celakovsky, 1898.

Čermáková, J. "Rideaux de tabernacle des synagogues du 16e et 17e siècle (partie de la collection textile du Musée Juif d'État)," *Judaica Bohemiae* 18,1 (1982): 22–32.
[Čermáková, "Rideaux."]

———. "The Synagogue Textiles," *Judaica Bohemiae* 16, 1 (1980): 54–59.
[Čermáková, "Synagogue Textiles."]

Cohen, Gary B. *The Politics of Ethnic Survival: Germans in Prague, 1861–1914.* Princeton, N.J.: Princeton University Press, 1981.

Cologne, Kölnisches Stadtmuseum, *Monumenta Judaica: 2000 Jahre Geschichte und Kultur der Juden am Rhein,* exhibition catalogue, 1963.
[*Monumenta Judaica.*]

———. *Europäische Seidengewebe des 13.–18. Jahrhunderts,* by Barbara Markowsky, Cologne, 1976.
[*Seidengewebe*]

Danckert, Ludwig. *Le Nouveau Danckert. Manuel de la porcelaine européanne.* Translated by Tamara Préaud. Paris: Bibliothèque des Arts Friburg, Production Office du Livre, 1980.

Diviš, Jan. *Silver Marks of the World.* London: Hamlyn, 1976.
[Diviš]

Doležal, Jiří, and Veselý, Evžen *Památky pražského ghetta.* Prague: Olympia, 1969.

Doleželová, Jana. "Binders and Festive Covers from the Collection of the State Museum in Prague," *Judaica Bohemiae* 10,2 (1974): 91–104.
[Doleželová, "Binders and Festive Covers."]

———. "Die Sammlung der Thorawickel," *Judaica Bohemiae* 16,1 (1980): 60–63.
[Doleželová, "Thorawickel."]

———. "The State Jewish Museum Collection of Wedding Dishes and Plates," *Judaica Bohemiae* 13,1 (1977): 29–43.
[Doleželová, "Wedding Dishes and Plates."]

———. "Thoraschilde aus den Werkstätten der Prague Silberschmiede in den Sammlungen des Staatlichen jüdischen Museums," *Judaica Bohemiae* 19,1 (1983): 22–34.
[Doleželová, "Thoraschilde."]

Doleželová, Jana, and Čermáková, J., Pařík, A. "Acquisitions to the Collections of the State Jewish Museum in Prague in the Years 1976–1980," *Judaica Bohemiae* 18,1 (1982): 33–42.
[Doleželová, et al., "Acquisitions to the Collections."]

*Frequently cited works are abbreviated, as indicated, in text and catalogue references.

Dorobná, Zoroslava. *Les Trésors de la Broderie Religieuse in Tchécoslovaquie*. Prague: Sfinx, 1950.
[Drobná, *Trésors*.]

Ehrmann, František, Heitlinger, Otta, and Iltis, Rudolf. *Terezín*. Prague: Council of the Jewish Communities in the Czech Lands, 1965.

Encyclopaedia Judaica. Jerusalem: Keter Publishing House Ltd., 1972.
[EJ]

Engel, Alfred. "Die Ausweisung der Juden aus den Königlichen Städten Mährens und ihre Folgen," *Jahrbuch der Gesellschaft für Geschichte der Juden in der Čechoslov. Republik* 2 (1930): 50–96.

Flesch, Heinrich. "Aus Jüdischen Handschriften in Mähren," *Jahrbuch der Gesellschaft für Geschichte der Juden in der Čechoslov. Republik* 2 (1930): 285–92.

_____. "Zur Geschichte der mähr(ischen) 'Heiligen Vereine' (Chewra Kadischa)," *Jahrbuch der Jüdisch-Literarischen Gesellschaft* 31 (1930): 217–58.

Frauberger, H. "Über Alte Kultusgegenstände in Synagoge und Haus," *Mitteilungen der Gesellschaft zur Erforschung Jüdischen Kunstdenkmäler* 3,4 (1903).
[Frauberger, "Über Alte Kultusgegenstände."]

Georges, Eliane. *Voyages de la Mort. Iconographie réunie par l'âgence Explorer*. Paris: Berger-Levrault, 1982.
[Georges, *Mort*.]

Gervers, Veronica. *The Influence of Ottoman Turkish Textiles and Costume in Eastern Europe*. History, Technology and Art Monograph 4. Toronto: Royal Ontario Museum, 1982.
[Gervers, *Influence*.]

Gold, Hugo, ed. *Die Juden und Judengemeinden Böhmens in Vergangenheit und Gegenwart*. Brno: Jüdischer Buch und Kunstverlag, 1934.

_____. *Die Juden und Judengemeinden Mährens in Vergangenheit und Gegenwart*. Brno: Jüdischer Buch und Kunstverlag, 1929.

Grotte, Alfred. "Die 'Reliquiem' des Salomo Molcho," *Monatschrift für Geschichte und Wissenschaft des Judentums* 67:167–70.

The Hague, Haag Gemeentemuseum, *Uit Het Joods Historisch Museum te Praag*, exhibition catalogue, 1968–69.
[The Hague: *Praag*.]

Hamačková, V. "Aus dem Archivmaterial—das Apothekerprivilegium für H. M. Jaiteles aus dem Jahr 1783," *Judaica Bohemiae* 16, 1 (1980): 52–63.

Heller, Yom Tov Lipmann. *Megillat Eva* [Scroll of Hatred]. Vienna: Adalbert della Torre, 1862.

Herbemová, O. "Roucho Salamouna Molcha," *Vestnik Židovskych nabozenskych obci v Ceskoslovensky* xx/1957.

Heřman, Jan. *Jewish Cemeteries in Bohemia and Moravia*. Prague: Council of Jewish Communities in the CSR, n.d.

_____. "Jewish Community Archives from Bohemia and Moravia," *Judaica Bohemiae* 7,1 (1971): 1–44.

_____. "La communauté juive de Prague et sa structure au commencement des temps moderne," *Judaica Bohemiae* 5,1 (1969): 31–71.

_____. "Die Wirtschaftliche Betätigung und die Berufe der Prager Juden vor ihrer Ausweisung im Jahre 1541," *Judaica Bohemiae* 4,1 (1968): 20–63.

Hoch, Simon. *Die Familien Prags: nach den Epitaphien des Alten Jüdischen Friedhofs in Prag*. Pressburg: Adolf Alkalay, 1892.

Hráský, Josef. "La corporation juive d'orfèverie à Prague" *Judaica Bohemiae* 2,1 (1966): 19–40.
[Hráský, "La Corporation Juive."]

_____. *Výrobniznačky zlatnických, stríbrnických a ozdobnických mistrů v Cechách v letech 1806–1860*. Prague: Uměleckoprůmyslové Muzeum v Praze, 1981.
[Hráský]

Jacobovits, Tobias. "Die jüdischen Zünfte in Prag," *Jahrbuch der Gesellschaft für Geschichte der Juden in der Čechoslov. Republik* 8 (1936): 57–143.
[Jacobovits, "Zünfte."]

Jahrbuch der Gesellschaft für Geschichte der Juden in der Čechoslov. Republik 2 (1930), 50–96.
[JGGJČR]

Jerusalem, The Israel Museum. *Architecture in the Hanukkah Lamp*, exhibition catalogue, 1978.
[Jerusalem, The Israel Museum, *Hanukkah Lamp*]

The Jewish Encyclopedia. New York and London: Funk and Wagnalls Co., 1906.
[JE]

The Jews of Czechoslovakia. 2 vols. Philadelphia: The Jewish Publication Society of America, 1968, 1971.

Judaica Bohemiae. Státní židovské Muzeum Praha. 1–19 (1965–1983).
[JB]

Jüdisches Lexikon. Berlin: Jüdischer Verlag, 1927.
[JL]

Kayser, Stephen, and Schoenberger, Guido. *Jewish Ceremonial Art*. Philadelphia: The Jewish Publication Society of America, 1959.
[Kayser-Schoenberger, *Jewish Ceremonial Art*.]

Kedourie, Elie, ed. *The Jewish World: Revelation, Prophecy, and History*. London: Thames and Hudson, 1979.
[Kedourie, *Jewish World*.]

Kestenberg-Gladstein, Ruth, *Neuere Geschichte der Juden in den böhmischen Ländern Bd. 1: Das Zeitalter der Aufklärung, 1780–1830*. Tübingen: J.C.B.Mohr, 1969.

Kieval, Hillel J. "Nationalism and the Jews of Prague: The Transformation of Jewish Culture in Central Europe, 1880–1918." Diss., Harvard University, 1981.

Kisch, A. "Megillat pure ha-kelaim (Firheng Purim)," *Jubelschrift zum siebzigsten Geburtstage des Prof. Dr. H. Graetz*, pp. 48–52. Breslau: S. Schottlaender, 1887.

Kisch, Guido. *In Search of Freedom: A History of American Jews from Czechoslovakia*. London, 1949.

Krautheimer, Richard. *Mittelalterliche Synagogen*. Berlin: Frankfurter Verlags-Anstalt, 1927.

Krüger, Renate. *Die Kunst der Synagoge Eine Einführung in die probleme von Kunst und Kult des Judentums*. Leipzig: Koehler E. Amelang, 1968.
[Krüger, *Kunst der Synagoge*.]

Kybalová, L. "Die ältesten Thoramäntel aus der Textiliensammlung des Staatlichen jüdischen Museums in Prag (1592–1750)." *Judaica Bohemiae* 9,1 (1973): 23–42.
[Kybalová, "ältesten Thoramäntel."]

———. "Die Thoramäntel aus der Textiliensammlung des Staatlichen jüdischen Museums in Prag (1750–1800)," *Judaica Bohemiae* 10,2 (1974): 91–104.
[Kybalová, "Thoramäntel."]

Landsberger, F. *A History of Jewish Art*. Cincinnati: The Union of Hebrew Congregations, 1946.

———. "Old Time Torah Curtains," *Beauty in Holiness*. Edited by J. Gutmann. New York: Ktav, 1970.

Lieben, S. H. "Oppenheimiania," *Jahrbuch der Gesellschaft für die Geschichte der Juden in der Čechoslov. Republik*, 7 (1935): 437–83.

———. *Das Jüdische Museum in Prag*. Prague: Josef Flesch, 1912.
[Lieben, *Jüdische Museum*.]

———. "Megillat Samuel," *Jahrbuch der Gesellschaft für Geschichte der Juden in der Čechoslov. Republik*, 9 (1938): 312–37.
[Lieben, "Megillat Samuel."]

Manchester, The Whitworth Art Gallery. *Jewish Art Treasures from Prague, The State Jewish Museum in Prague and its Collections*, exhibition catalogue, 1980.
[Manchester, *Treasures*.]

Meyer, Hans. *Böhmisches Porzellan und Steingut*. Verlag Karl W. Hierschmann: Leipzig, 1927.
[Meyer, *Böhmisches Porzellan*.]

Muneles, O. *Bibliografický přehled židovské Prahy*. Prague: Orbis, 1952.

———. "Die Rabbiner der Altneuschul," *Judaica Bohemiae* 5,2 (1969): 92–107.

Muneles, Otto, ed. *Prague Ghetto in the Renaissance Period*. Prague: Orbis, 1965.
[Muneles, *Prague Ghetto*.]

Munzer, Zdenka. *Die Altneusynagoge in Prag*. Prague: Heinr. Mercy Sohn, 1932.
[Munzer, *Die Altneusynagoge*.]

Namenyi, E. "The Illumination of Hebrew Manuscripts after the Invention of Printing," in *Jewish Art*, rev. ed. by B. Narkiss. Greenwich: New York Graphic Society Ltd., 1971.
[Namenyi, "Illumination of Hebrew Manuscripts."]

Narkiss, Mordecai. *The Hanukkah Lamp*. Jerusalem: Bney Bezalel Publishing Co., 1939 (Hebrew).

———. "Origins of the Spice Box," *Journal of Jewish Art*, 8 (1981): 28–41.
[Narkiss, "Origins of the Spice Box."]

Neuwirth, Waltraud. *Lexikon Wiener Gold-und Silberschmiede und Ihre Punzen 1867–1922*. Vienna: Selbstverlag Dr. Waltraud Neuwirth, 1976.
[Neuwirth]

———. *Wiener Keramik: Historismus- Jugendstil- Art Déco*, Braunschweig: Klinkhardt and Biemann, 1974.

New York, The Jewish Museum, *Danzig 1939: Treasures of a Destroyed Community*, exhibition catalogue, 1980.
[New York, The Jewish Museum, *Danzig 1939*.]

———. *Fabric of Jewish Life*, by Barbara Kirshenblatt-Gimlett, exhibition catalogue, 1977.

———. *Kings and Citizens: A History of the Jews in Denmark 1622–1983*, exhibition catalogue, 1983.
[New York, The Jewish Museum, *Kings and Citizens*.]

———. *A Tale of Two Cities: Jewish Life in Frankfurt and Istanbul 1750–1870*, by Vivian B. Mann, exhibition catalogue, 1982.

Nosek, Bedřich. "Les imprimés hebräiques les plus anciens de Prague provenant des fonds du Musée juif d'État," *Judaica Bohemiae* 16,1 (1980): 42–43.

———. "Katalog mit der Auswahl hebräischer Drucke Prager Provenienz, I. Theil: Drucke der Gersoniden im 16. und 17. Jahrhundert," *Judaica Bohemiae*, 10,1 (1974): 13–41.
[Nosek, "Drucke der Gersoniden."]

Nosek, Bedřich, and Šedinová, Jiřina. "Le fauteuil de circoncision," *Judaica Bohemiae* 16,1 (1980): 80.

Novák, Luděk. *Antonín Machek*. Prague: Nakladatelství Československé Akademie Věd, 1962.
[Novák, *Machek*.]

Pařík, Arno. "Die Bildersammlung," *Judaica Bohemiae* 16,1 (1980): 75–8.
[Pařík, "Bildersammlung."]

———. *The Old Jewish Cemetery in Prague*. Translated by Olga Berntová. Prague: The State Jewish Museum in Prague, 1982.

Polák, J. "Nápisy pražskych peroches z lit," *Kniha o Praze* 2 (1931): 25–45.
[Polák, "Peroches."]

Prokeš, Jaroslav. "Der Antisemitismus der Behoedren und das Prager Ghetto in nachweissenbergischer Zeit," *Jahrbuch der Gesellschaft für Geschichte der Juden in der Čechoslov. Republik*, 1 (1929): 41–262.

Rosenberg, Marc. *Der Goldschmiede Merkzeichen, Dritte . . . Auflage*. Frankfurt am Main: Frankfurter Verlage-Austalt A.-G., 1922.
[R³]

Rubens, Alfred. *A Jewish Iconography*. rev. ed. London: Nonpareil, 1981.
[Rubens, *Iconography*.]

Sadek, Vladimír. "Argenterie des synagogues," *Judaica Bohemiae* 16,1 (1980): 68–71.
[Sadek, "Argenterie."]

———. "Aus der Handschriftensammlung des Staatlichen jüdischen Museums in Prag (illuminierte Handschriften des 18. Jahrhunderts)," *Judaica Bohemiae* 5,2 (1969): 144–51.
[Sadek, "Aus der Handschriftensammlung."]

———. "Étendard et robe de Salamon Molko," *Judaica Bohemiae* 16,1 (1980): 64.

———. "From the MSS Collections of The Jewish Museum in Prague (Illuminated MSS)," *Judaica Bohemiae* 10,2 (1974): 109–110.
["MSS Collections . . . (Illuminated Manuscripts)"]

———. "From the MSS Collections of The State Jewish Museum (MSS of Historical Contents)," *Judaica Bohemiae* 9,1 (1973): 16–22.

———. "Goblets and Jugs of Czech and Moravian Burial Brotherhoods," *Judaica Bohemiae* 16,1 (1980): 79.
[Sadek, "Goblets and Jugs."]

———. "Grabsteine mit Figurmotiven auf dem alten jüdischen Friedhof in Prag," *Judaica Bohemiae* 14,2 (1978): 75–88.

———. "Die jüdische Version der Familienmegilla 'Vorhang purim' aus dem Jahre 1623," *Judaica Bohemiae* 4,1 (1968): 73–8.

———. "The MSS Collections of The State Jewish Museum in Prague: Manuscript Works by Jewish Scholars in Bohemia and Moravia (18th–19th Centuries)," *Judaica Bohemiae* 8,1 (1972): 20.

———. "Rabbi Loew—sa vie, heritage pédagogique et sa légende," *Judaica Bohemiae* 15,1 (1979): 27–41.

Sadek, Vladimír, and Šedinová, Jiřina. "De la collection des manuscrits du Musée juif d'État (Manuscrits en Juden-deutsch)," *Judaica Bohemiae* 11,2 (1975): 105–112.

———. "De la collection des manuscrits du Musée juif d'État de Prague (Miscellanea)," *Judaica Bohemiae* 12,2 (1976): 114–5.

———. "From the MSS Collections of The State Jewish Museum in Prague (Manuscripts of Liturgical Content)," *Judaica Bohemiae* 13,2 (1977): 74–95.
[Sadek-Šedinová, "From the Mss. Collections."]

Sarfatti, Gad B. "Some Remarks about the Prague Manuscript of Mishnat ha-Middot," *Hebrew Union College Annual* 45 (1974): 197–204.

Scheiber, A. "The Prague Manuscript of Mishnat ha-Middot," *Hebrew Union College Annual* 45 (1974): 191–96.

Šedinová, Jiřina. "From the MSS Collections of The State Jewish Museum in Prague—The Scrolls of Esther," *Judaica Bohemiae* 15,2 (1979): 74–85.

———. "Old Czech Legends in the Work of David Gans (1592)," *Judaica Bohemiae* 14,2 (1978): 89–112.

Seling, Helmut. *Die Kunst der Augsburger Goldschmiede 1529–1868.* Munich: Beck, 1980.
[Seling]

Shachar, Isaiah. " 'Feast and Rejoice in Brotherly Love' Burial Society Glasses in Bohemia and Moravia," *The Israel Museum News* 9 (1972): 22–51.
[Shachar, "Feast and Rejoice."]

———. *Jewish Tradition in Art.* Jerusalem: The Israel Museum, 1981.
[Shachar, *Jewish Tradition in Art.*]

Singer, Ludvík. "Zur Geschichte der Toleranzpatente in der Sudetenländern," *Jahrbuch der Gesellschaft für die Geschichte der Juden in der Čechoslov. Republik* 5 (1933): 231–311.

Sommernitzová, Ivana. "Der Trebitscher Machsor- eine Beschreibung und Analyse des Manuskripts mit Übersetzung von Probepartien. Diplomarbeit, Prag 1969," *Judaica Bohemiae* 9,2 (1973): 91–3.

Stein, Adolf. *Die Geschichte der Jüden in Böhmen.* Brno, 1904.

Steinherz, Samuel. Die Einwanderung der Juden in Bohemen," in *Die Juden in Prag.* Prague, 1957: 7–57.

———. "Geirush ha-yehudim mi-beim be-shnat 1541" [The Expulsion of the Jews from Bohemia in 1541], *Zion* (1950): 70–92.

Steinschneider, Moritz. *Catalogues Librorum Hebraearum in Biblioteca Bodleiana,* vol. I. Berlin: Friedlaender, 1852.

———. *Die Geschichtsliteratur der Juden.* Frankfurt a.M.: J. Kaufmann, 1905.

Stölzl, Christoph. "Zur Geschichte der G. Bondy böhmischen Jüden in der Epoche des modernen Nazionalismus," *Bohemia* 14 (1973): 179–221; 15 (1974): 129–157.

Stránská, D. *Lidové kroje v Československu I. Čechy.* Prague: I. Otto, Společnost S.R.O., n.d.

Thieberger, Frederic. *The Great Rabbi Loew of Prague.* London: The East and West Library, 1955.

Thornton, P. *Baroque and Rococo Silks.* London: Faber and Faber, 1965.
[Thornton, *Silks.*]

Tischer, Friedrich. *Böhmisches Zinn und Seine Marken.* Leipzig: Karl W. Hiersemann, 1928.
[Tischer]

Vienna, Museum für Völkerkunde Wien-Hofburg, *Kunstschätze Staatliches Jüdisches Museem Prag,* exhibition catalogue, 1970.
[Vienna, *Kunstschätze.*]

Volavková, Hana. "Grafické portrétní dokumenty pražského ghetta z počátku 19. století," *Hollar-sborník grafického umění* 28 (1956): 156–58.
[Volavková, "Grafické portrétní dokumenty."]

———. *Guide to The Jewish Museum of Prague.* Prague: Uněleckábeseda in Prague, 1948.
[Volavková, *Guide.*]

———. *Guide to the Jewish Museum in Prague. Part II. Museum of Jewish Town in Prague.* Prague: The Jewish Museum of Prague, 1957.
[Volavková. *Guide II.*]

———. *The Pinkas Synagogue.* Prague: Státní Židovské Museum v Praze, 1955.
[Volavková, *Pinkas Synagogue.*]

———. *Průvdoce po Státním Židovském muzev v Praze I. Klausova synagóga.* Prague: 1956.
[Volavková, *Průvdoce.*]

———. *A Story of The Jewish Museum in Prague.* Prague: Artia, 1968.
[Volavková, *Story.*]

———. *The Synagogue Treasures of Bohemia and Moravia.* Prague: Sfinx, 1949.
[Volavková, *Synagogue Treasures.*]

Volavková, Hana, ed. . . . *I Never Saw Another Butterfly . . . Children's Drawings and Poems from Terezín Concentration Camp 1942–1944.* 2d rev. ed. New York: McGraw Hill Book Company, 1971.

Wischnitzer, Mark. *A History of Jewish Crafts and Guilds.* New York: Jonathan David, 1965.
[Wischnitzer, *Jewish Crafts and Guilds.*]

Yerushalmi, Yosef H. *Haggadah and History.* Philadelphia, 1975.

Zinger, Z. *Česka heraldika.* Prague: Nakladatelství vyšehrod, 1978.

Zunz, L. *Zur Geschichte und Literatur.* Berlin: Louis Lamm, 1845.

INDEX

**Italics indicate illustration.*

Italics indicate illustration.

PICTURE CREDITS

Studio photography by Quicksilver Photographers. Except as noted below by figure number, all other photographs and illustrations are from the archives of the State Jewish Museum, Prague.

Michael Baumbruck: 212; The Brandeis University Collections: 11, 12; Jindřich Eckert: 17, 31, 53, 81–85; Mark Gulezian: 4, 49, 91, 202, 211, 214; Alex Jamison: 52; Jewish Publication Society of America: 59; Leo Baeck Institute, N.Y.: 32; Jan Lukas: 92; National Archives: 37; Edward Owen: 215; Pražské nakladatelstvi V. Poláčka-Praha: 54, 56, 62, 63; Martin Stein: 42.

THE PRECIOUS LEGACY

Prepared by the
Smithsonian Institution Traveling Exhibition Service
under the direction of
Andrea Price Stevens, Publications Officer.

Designed by
Judy Kirpich and C. Beth Brownlee,
Grafik Communications Ltd., Alexandria, Virginia.

Studio photography by
Quicksilver Photographers, Washington, D.C.:
Mark Gulezian, Alex Jamison, Edward Owen.

Teleprocessing by
Dodge Color, Inc., Washington, D.C.

Typeset in
Aldus Text and Bauer Text Initials by
Carver Photocomposition, Arlington, Virginia,
and in Hadassah Light by
King Typographers, New York, New York.

Color separations by
Creative Lithography, Inc., New York, New York.

At Simon & Schuster production coordinated by
Howard M. Goldstein and Richard L. Willett.

Printed on
Warren's Lustro Offset Enamel Dull and
French Chambray Grey Text by
R. R. Donnelley & Sons, Willard, Ohio.

Exhibition design by
Chris White Design Associates, Alexandria, Virginia.